NIGHT AND FOG

VISIBLE EVIDENCE

Michael Renov, Faye Ginsburg, and Jane Gaines, Series Editors

(continues on page 365)

NIGHT AND FOG
A FILM IN HISTORY

SYLVIE LINDEPERG

Translated by Tom Mes
Foreword by Jean-Michel Frodon

VISIBLE EVIDENCE, VOLUME 28

University of Minnesota Press
Minneapolis
London

#87/820494

This work, published as part of a program providing publication assistance, received financial support from the French Ministry of Foreign Affairs, the Cultural Services of the French Embassy in the United States, and FACE (French American Cultural Exchange).

Originally published in French as *Nuit et Brouillard: Un film dans l'histoire,* by Odile Jacob. Copyright 2007 by Odile Jacob.

English translation copyright 2014 by the Regents of the University of Minnesota

Published by the University of Minnesota Press
111 Third Avenue South, Suite 290
Minneapolis, MN 55401-2520
http://www.upress.umn.edu

Library of Congress Cataloging-in-Publication Data
Lindeperg, Sylvie.
 [Nuit et brouillard. English]
 Night and fog : a film in history / Sylvie Lindeperg ; translated by Tom Mes ; foreword by Jean-Michel Frodon.
 (Visible evidence ; volume 28)
 Includes bibliographical references and index.
 ISBN 978-0-8166-7991-1 (hc: alk. paper)–ISBN 978-0-8166-7992-8 (pb: alk. paper)
 1. Nuit et brouillard (motion picture). 2. World War II, 1939–1945 – Motion pictures and the war.
3. Holocaust, Jewish (1939–1945), in motion pictures. I. Mes, Tom, 1974– translator. II. Title.
 D804.3.N853L5513 2014
 940.53'18–dc23
 2014001553

Printed in the United States of America on acid-free paper
The University of Minnesota is an equal-opportunity educator and employer.

20 19 18 17 16 15 14 10 9 8 7 6 5 4 3 2 1

IN MEMORY OF ALAIN RESNAIS (1922-2014)

CONTENTS

FOREWORD
JEAN-MICHEL FRODON

BEFORE SHE WROTE *"Night and Fog": A Film in History*, Sylvie Lindeperg had published two innovative books that intertwined historical research and cinema. *Clio de 5 à 7, les actualités filmées de la Libération* (Paris: CNRS éditions, 2000) and *Les Ecrans de l'ombre: La Seconde Guerre mondiale dans le cinéma français 1944–1969* (Paris: CNRS éditions, 1993) were both already devoted to films on World War II and their effects over the following decades, and they investigated the singular and sometimes paradoxical or involuntary power of inherently cinematic devices: framing, various combinations of images and sounds, editing, etc. The two volumes were also groundbreaking in how they researched the migration of images between films, their reuse in different contexts and with different effects, here, too, sometimes involuntary. Employing methods rare for a historian—for example, her ability to capture differing voices in *Clio de 5 à 7*—Sylvie Lindeperg on both occasions took a vast corpus of films into account.[1] This time around, however, she has chosen to build her research around a single title: a thirty-two-minute documentary.

In more ways than one, *Night and Fog* has played a major role in our history. Its release in France in 1956 and in a large number of countries in the years that followed, plus the fact that it has been screened in French schools many thousands of times, was a significant step in the construction of a collective consciousness of the tragedy that was World War II. It was also the film that gave its director, Alain Resnais, his first public recognition—a promise he would fulfill three years later with *Hiroshima Mon Amour*, which marked him as one of the most important figures in modern cinema. It furthermore represents a turning point in the intellectual, political, and

moral process that sought to articulate, without confounding them, the horrors of the Nazi past, horrors contemporary to the film's creation (notably those of colonialism in a time of independence wars), and other horrors yet to come, whose extent would only be revealed later, like the crimes of other totalitarian regimes.

Night and Fog also embodies the very moment at which the tragedy of a century became linked with the cinemagoer. The film critic Serge Daney doubtlessly expressed this shift most precisely and poignantly when he wrote that "it was through cinema that I learned . . . that the worst had only just taken place." This concerned his generation, that of people born in 1945, and those that followed, but perhaps even more significantly those alive when the worst was happening, and even to a large extent those who experienced it firsthand. Alain Resnais's film, through cinema's inherent power, at once stabilizes and unfolds the scale and the nature of the crime, while placing it in relation to each of us personally. When Daney, borrowing an expression by the philosopher Jean-Louis Schefer,[2] talked about "films that watched me" and films "that watched my childhood," he was referring most directly to *Night and Fog*. Resnais's film forms the touchstone for reflections on the ethics of mise-en-scène that would guide the entirety of Daney's activities as a critic, in a direct lineage with a certain tradition of thought (that of *Cahiers du Cinéma*) and practices of mise-en-scène that Daney would articulate in an essay published just before his death that was destined to become a reference and was itself inspired by Jacques Rivette's short review in *Cahiers du Cinéma* of another film about the Nazi camps, Gillo Pontecorvo's *Kapo*.[3]

The particular if not unique nature of Alain Resnais's film legitimizes the decision to devote to it an entire, autonomous initiative of historical research in tune with its importance as a political and artistic accomplishment, as well as with the immense consequences it has had. In taking this monographic approach, Sylvie Lindeperg immediately reopens it by multiplying its modalities. This manifests itself particularly in the thematically and stylistically special place she accords to her fellow historian Olga Wormser, who played a fundamental role in the film's existence. The book is divided into a "classic" two parts: the first detailing the conditions under which *Night and Fog* was made, the second devoted to its circulation and reception. This binomial is embedded into an evocation that opens and closes the

tome: the evocation of Olga Wormser, woman, scholar, activist, and decisive figure in the process that led to the making of a film that would profoundly affect her own life. Through Lindeperg's treatment, Wormser's extraordinary life story sheds light, in ways both revealing and moving, on the things of which *Night and Fog* forms a clear and powerful marker: the vagaries, paradoxes, and stakes of the political and emotional construction of memory and discourse. These are the memory and the discourses of the deportation perpetrated by the Nazis, which have not ceased to reconfigure themselves over the past sixty years.

SYLVIE LINDEPERG'S BOOK first and foremost describes the chain of events that, from the liberation onward but particularly since the exhibition *Resistance, Liberation, Deportation* organized in 1954 at the initiative of associations of former deportees and resistance fighters, would lead to Alain Resnais's being commissioned to make the film. What her work truly investigates, though, is the significant processes of giving shape to the perception and transmission of an event, or rather an aggregate of historical events influenced by numerous parameters. The weight of immediate political interests, the progressive awareness of the singular nature of the extermination of Europe's Jews, the distinctions made over the course of the decades between victims of the Nazis, the difference between concentration camps and extermination camps—all these processes in which cinema had its role to play are elucidated in a thoroughly convincing manner by means of a film that, in retrospect, has too often been made to serve as a foil.

Like any historian worthy of the title, Sylvie Lindeperg reveals the entirety of pertinent historical elements as well as their modes of interaction—and it makes for fascinating reading. However, unlike most historians, she simultaneously takes into account the nature of her subject: a film. Being a historian, Lindeperg approaches this story by revealing the workings of layers upon layers of processes, which, echoing Michel Foucault's "archaeology," she refers to as "palimpsests." Treating the procedures at work in the making of a film, she does equal justice to formal practices—choices of framing and editing, the connection between sound and image, between words and music, between monochrome and color, between silence and speech—as to the mechanisms a historian would normally take into account: the

material and political conditions of production, institutional limitations, the desire to explain, and the unspoken aspects of decisions and actions.

She naturally receives support in this matter from the acute intelligence of Alain Resnais's cinematic concerns and the way in which they agree with or, whenever appropriate, confront his various partners: the commissioning organizations, the two historians who formed the project's guarantors, the production company, but also his closest creative partners. The author of the text, Jean Cayrol, the poet and camp survivor, had his own goals, as did Hanns Eisler, the communist composer. While never truly in conflict, these objectives rarely if ever coincided. Alain Resnais, sometimes with the decisive help of Chris Marker and with the support of producer Anatole Dauman, made efforts to at once convert these various intentions into choices of mise-en-scène and construct an internal logic that was intensely cinematic. Sylvie Lindeperg follows step-by-step the research efforts, the gathering of a visual archive, the failed attempts, the decision to show or not to show, the decision to film new footage or to opt for color or black and white, the exploration of archival footage of various origins (images filmed by the Nazis, by the resistance, by the liberators, fictional images, etc.). She unearths the discussions between filmmaker and writer, as well as the *philosophy* of the relation with words used by Cayrol, who worked with an invented language influenced by the camp experience—a language that was perhaps more cinematic than literary all along. The book also provides access to the very heart of the work of Eisler, who is both the composer of the East German national anthem and a veritable adventurer of modern musical composition.

This is still not sufficient to understand what happens *right there*, in the making of a film, which is hardly an abstract activity, even if thought does underlie every action in the never-ending struggle against the return of the monsters. It is also necessary to talk about money: how much does it cost? Who is paying the bill? Why? Therefore it is also necessary to talk about power: which institutions? Which groups? What interests? It is necessary to talk about location: films are not made while sitting at a desk. This is the development, the deviation: the resulting film would prove different from the one originally intended by either its commissioners or its creators, because Resnais and his crew, going beyond what had been asked of

them, decided to go to Poland. They headed for Auschwitz, they passed the threshold of Birkenau, they saw with their own eyes the mountains of hair, of glasses, of suitcases. They understood something, something still unspoken at the time.

It was too early to articulate what Léon Poliakov, from 1951 onward with *Bréviaire de la haine*, and Gerald Reitlinger in 1953 with *The Final Solution* had just begun to make discernable, and which Raul Hilberg with *The Destruction of the European Jews* and Claude Lanzmann with *Shoah* would establish. But "das ist der Platz," as Simon Srebnik says at the start of *Shoah*, "that is the place." And Sylvie Lindeperg shows us little by little how the experience of that place came to affect the film. She makes clear that this was a major moment, including its lacks and confusions, in the construction of a contemporary understanding of the World War II period and the extermination.

This is not all. It takes a researcher with an extreme sensitivity to the substance of cinema to understand, and make understandable, what is at stake in the distinction between documentary and fiction, between archive footage and newly shot footage, between still shot and moving shot, between a sound image and a silent image. The "sensitive knowledge" this historian possesses is what makes her book so strong and so original. It allows her to understand and make understandable what it meant for Alain Resnais to spend hundreds of hours watching *those images*. No image is "any image," but those from the camps exist on the extreme end of where gaze and conscience reach crisis point. This experience contributed to making the film what it is. Lindeperg is all the more aware for having spent countless hours looking through archives about the extermination. She is not alone in this, as many other historians who worked with those same documents have also had to confront this phenomenon. None of them, however, used it as part of an approach that nevertheless seems essential: making visible the *work on images* Resnais and his collaborators did, and how those *images worked on them*. Images that "watched them," them too, them already. The chapter on "the darkness of the editing room" is exemplary in this respect, delivering a meditation with a rare degree of intensity on the very process of film editing.

As such, step after step, this study that never compromises on the demands inherent in the field of historical research (the names, the places, the dates, the sources) and never loses itself in generics,

remaining focused on its sole subject, the film *Night and Fog*, becomes a magnificent tool for comprehending the cinematic process. In a purely factual manner, Sylvie Lindeperg reconstructs the miracle that is the birth of an object so fragile, thanks to the courage and endurance of its creators.

EQUALLY ILLUMINATING is the second part of the book, devoted to the film's life after completion. The author describes its tribulations with the censors, bringing the excessively publicized "gendarme's kepi affair"[4] back to its right proportions and revealing the complex if not outright contradictory reasoning behind government interventions. The tome also recounts the tragicomic rambles of the scandal surrounding the film's presentation at the Cannes International Film Festival. It perceptively outlines the paradoxes of its reception by politicians, film professionals, critics, audiences, academics, associations, and educators. Taken together, these processes form a screen on which unspools, aside from the truly exceptional case that is the film itself, the portrait of an era—a portrait all the more interesting because it also shines light on our own times.

However, what sticks in the mind above all is the film's international odyssey and the way in which the crossing of each border elucidates certain political and artistic issues. Each choice of image, each edit, each of Cayrol's words and silences, each note of Eisler's was minutely adjusted to create a work that contains quite distinct intentions: Cayrol's aims were not the same as Resnais's, which were different from what was intended by the historians who were supposed to scientifically validate the project (Olga Wormser and Henri Michel, who hardly agreed on every point either), as well as from the associations that were at the project's origin. And yet, in its very strength as an open work of art, *Night and Fog* accomplishes each of these parties' projects—and several more besides.

But what happens when translation is required? An admirable response came from West Germany, where a different film was created, of which Sylvie Lindeperg details the variations, a film every bit as beautiful and powerful as the original, since it was Paul Celan who, with Cayrol's blessing, appropriated the original text as much as he translated it. At the other extreme (the book describes several cases, all fascinating), we find the calamitous hijacking of the film by American television, after five years in which the film had been written off as

impossible to exhibit in the United States (too complicated, too unsettling—in short, a *film d'auteur*). Dismembered, rebuilt, and saddled with a voice-over and interruptions by an awful, condescending presenter, it became the TV fodder titled *Remember Us,* suffering a fate for which the perpetrators indeed deserve to be remembered.

The book also evaluates the incredible role the film played in education. We come to understand the director's creative process, with, as main case studies, *Statues Also Die,* the 1953 documentary on how colonialism extinguished indigenous culture, which Resnais codirected with Chris Marker, and *Hiroshima Mon Amour* (1959), a film haunted by the horror of the atomic bomb.

Sylvie Lindeperg's book is like a constellation constructed around a single film, yet it radiates in innumerable directions. Beyond its intrinsic qualities, it offers a rare and necessary example. For quite some time now (or perhaps not that long after all), historians have been considering films, in increasingly consistent ways, as valid sources for their research. However, too often the risks of the academic approach have been apparent, when the institutionalized procedures of historical science seem to appropriate films without taking the unique nature of cinema into account, mechanically transposing methods elaborated for the treatment of documents of a very different nature.

This risk is equally present for historians who employ the cinema (to study any field of history) as for film historians, who make it their specific field of study, without necessarily treating it much better, anxious as they are to come off as serious academics in the eyes of their peers for focusing on such a frivolous topic—one still too often relegated to the margins of academia. Sylvie Lindeperg's book, on the contrary, is exemplary for being the work of a historian who makes no compromises in terms of the rigors of her discipline doing full justice to the cinema. It is evidence of how much history and historians as well as cinema and those who concern themselves with it have to gain from sharing.

ACKNOWLEDGMENTS

THIS BOOK COULD NOT HAVE BEEN WRITTEN without Annette Wieviorka. Without Marc Ferro, it would not have been published by Odile Jacob. Their support was early and invaluable, and I express my deepest gratitude to both of them.

Frédéric Wormser gracefully allowed me full access to the archives of his mother, Olga Wormser-Migot, and spoke about her at length. Thank you.

I also owe a debt of gratitude to Florence Dauman, who allowed me to consult the Argos Films archives, which were essential for my research on *Night and Fog*, and to Thierry Frémaux and Nicolas Riedel of the Institut Lumière in Lyon, who provided the access.

This book benefited from a network of friends and professionals that was unparalleled and borderless. In Germany, my research was greatly aided by an invitation from Gertrud Koch, who welcomed me during the winter of 2004 as professor in her department at the Freie Universität Berlin. Numerous colleagues, researchers, and students gave me their support, in particular Franziska Kast, Judith Keilbach, Geneviève Rossier, Alexandra Schneider, Jeanpaul Goergen, Jörg Frieß, Vinzenz Hediger, Thomas Heimann, Wolfgang Jacobsen, Thomas Lindeberger, and Matthias Steinle.

Jean-Charles Szurek made it possible for me to travel to Poland and to establish contact with Grzegorz Balski and Ageta Zalewska (Filmoteka Narodowa in Warsaw), Teresa Swiebocka (Auschwitz-Birkenau State Museum), and Malgorzata Janczak (Film Polski).

Stuart Liebman had the generosity to introduce me to and provide me with a copy of the American television program *Remember Us*, stored in the Holocaust Memorial Museum in Washington, D.C.,

while Annette Wieviorka entrusted me with a copy of the filmed recording of Eichmann watching *Night and Fog* during his trial (Steven Spielberg Jewish Film Archive in Jerusalem).

I thank Henry Rousso for pointing my attention toward and giving me access to the reels of rushes of *Night and Fog* kept at the Institut d'Histoire du Temps Présent.

I was able to consult many different archives, thanks to Sylvie Hubac and Pierre Chaintreuil at the Commission de Classification des Oeuvres Cinématographique of the CNC; Valdo Kneubühler, Régis Robert, and Marc Vernet at the Bibliothèque du Film; Jacques Beaujean at the Centre National de Documentation Pédagogique; Agnès Moinet-Lemenn at the French Ministry of Foreign Affairs; Olivier Corpet, Martine Ollion, and Albert Dichy at the Institut Mémoires de l'Édition Contemporaine (Cayrol archives); Patricia Reymond at the Centre d'Études Edmond Michelet (Brive); Jean Astruc at the library of the IHTP; Irena Steinfeldt at Yad Vashem (Jerusalem); Jörg-Uwe Fischer at the Deutsche Rundfunkarchiv (Potsdam Babelsberg); Doris Eggert and Wolfgang Schmidt at the Bundesarchiv-Filmarchiv (Berlin); Christine Barbier-Bouvet and Michel Raynal at the Inathèque de France; Patricia Gillet and Christèle Noulet at the twentieth-century section of the French Archives Nationales.

Madeleine Morgenstern, Sylvie Dreyfus, Marie-Laure Basuyaux, Hélène Liogier, Henriette Asseo, Danièle Baron, Sylvie Pierre, Sylvie Pras, Vanessa Schwartz, Jean-Louis Comolli, Jean-Michel Briard, Stewart Tryster, Tom Hurwitz, Alain Bergala, François Thomas, Jacek Leociak, and Pierre Laborie all supplied me with texts or information.

In Paris I was able to interview some of the players in this story: André Heinrich, assistant director to Alain Resnais on *Night and Fog*, on February 5, 2004, and April 7, 2005; General Pierre Saint-Macary, president of the Amicale de Mauthausen and the Réseau du Souvenir on February 9, 2004; Jean Gavard, jury president at the Concours de la Résistance et de la Déportation, detained at Mauthausen with Jean Cayrol, on March 11, 2004.

Béatrice Houplain and Gérard and Michèle Lindeperg affectionately and efficiently proofread the manuscript. My parents also flawlessly carried out the demanding task of drawing up the index. How can I ever thank them enough?

Janine Altounian, Frédérique Berthet, Michel Laffitte, Claude Mouchard, Valérie Nguyen, François Porcile, and Vivien Villani proofread certain chapters and gave me invaluable comments.

Jean-Michel Frodon proofread and enhanced the chapter on cinephilia and coordinated a *Cahiers du Cinéma* seminar at the Moulin d'Andé (September 17 and 18, 2005). This seminar, whose other participants were Arnaud Desplechin, Jacques Mandelbaum, Marie-José Mondzain, and Annette Wieviorka, contributed to my reflections on the subject of this book.

Dominique Trimbur provided decisive assistance in translating archives and documents from the German language.

I thank my colleagues of the group "Théâtre de la Mémoire" (Paris III), notably Christa Blümlinger, Pietsie Fienstra, Michèle Lagny, and especially Sylvie Rollet, whose thoughts helped shape several passages of this book.

Thanks to Bernard Stiegler, Roger Rotman, and the entire team at the Institut de Recherche et d'Innovation of the Centre Georges-Pompidou (Thibault Cavalié, Jean-Pierre Mabille, Vincent Puig, and particularly Xavier Sirven), the book could take advantage of experimental tools of analysis and annotation, as well as a space for exchange.

Photographs and stills could be reproduced in this volume thanks to the selfless help of Argos Films (Florence Dauman and Raphaël Streit), Joël Daire and the image library of the Bibliothèque du Film, Christian Bogey, Nicolas Pignon, Frédéric Wormser, and Jeffrey Écoiffier.

I owe a debt to Michael Renov, and to Steven R. Ungar, who did everything in his power to make this American edition a reality, as well as to Polly Hammel, Stuart Liebman, and Bill Marshall, all of whom provided valuable assistance.

An affectionate word of thanks to Alain Resnais, with whom I had a lengthy discussion after the French publication of this book, during preproduction of Jean-Louis Comolli's film about *Night and Fog: Face aux fantômes* (2008).

And finally, a thought for my friends at Ravel and for Nadja.

INTRODUCTION

"'AUSCHWITZ IS A PART OF FILM HISTORY now,' she tells me, and her observation seems terrifying at first. But the despondency and the horror, so far from Auschwitz spatially and ever further in time, are forever and always near in Alain Resnais's film *Night and Fog*. To Gabriela the places shown in the film are where her grandparents lost their lives, just as my parents did. More precisely, *in the film itself.*"[1]

To the heroine of Alain Fleischer's novel *Les angles morts*, Auschwitz is the place "where *Night and Fog* was shot." Alain Resnais's film has gained the function of mausoleum, one that contains the very location of effacement, "of a ruin that, in spite of everything, is preferable to its complete disappearance."[2]

Fleischer's novel appeared the year I undertook my first voyage to Poland, in the footsteps of *Night and Fog*. I introduced a screening of the film in Lublin, and, accompanied by a group of French and Polish researchers, I visited the Majdanek and Auschwitz-Birkenau camps. These are the places where Alain Resnais, alongside historians Henri Michel and Olga Wormser, shot his film in September 1955. Wormser knew these sites well, having visited them repeatedly since May 1946 in the hope of finding clues to the whereabouts of French deportees. As she entered the gates of Auschwitz, Olga Jungelson (soon to be Wormser) tried to "see" the camp "through their eyes." Any glance at the scene after the fact, even a first glance, is the result of a sedimentation of visions that also confirms their irreducible difference: the flow of time cannot be reversed—it separates the victims of the tragedy from those who came after. Olga Wormser returned to Poland with Henri Michel in May 1955 to attend the commemoration

of the tenth anniversary of the opening of the camps. They already carried within them *Night and Fog*, the film they originated and that would be made soon after. It was a scouting trip to prepare for Resnais's visit—a visit during which the director would find a form that allowed him to hold his own in the face of the event. Almost fifty years later, I, in turn, walked through the camps of Majdanek, Auschwitz, and Birkenau, those places where people were exterminated *and* where *Night and Fog* was shot, and felt like I was at once discovering and recognizing. I was seeing them at once with and after my precursors.

"There always comes a time when history erases itself," in favor of art[3] but more often in favor of imagery.[4] I realized exactly why this observation is so terrifying during a visit to Krakow, in the old Jewish quarter renovated after the release of Spielberg's film, while looking at signs offering "Schindler's List Trips" through the old streets of Kazimierz to Auschwitz-Birkenau. In this neighborhood, renovated for those who come to see a "Potemkin-like Judaism,"[5] cinematic imagery was slowly replacing history; in filling the voids, it ended up recreating its own version of reality.

Precisely because it offers deposition,[6] because it contains absence, emptiness, a gap, *Night and Fog* does not replace the event—it receives it. In this way, history as present in the images captured at the moment of shooting contributes to reassessing the gazes that viewers have been directing at it for fifty years.

In the onsite museums of the Majdanek and Auschwitz camps, Alain Resnais's film forms an antidote to memorial tourism. As I followed, not without a degree of embarrassment, the words and route of a Polish guide, I remembered the words of former deportee Pierre Daix upon seeing *Night and Fog* in 1956:

When I visited Auschwitz in 1948 I stayed away from the guide, himself a former deportee, because I needed to be alone in that large brick camp, like in that vile hole named Birkenau two kilometers down the road.... Time has passed. It is not the museums' fault that they can only offer an abstract, recorded version of the horrors.

It is not the memory of the camps that I refer to. The families of the victims make their pilgrimages alongside the survivors. Every rock, every rusty remnant of barbed wire, and every board that once formed part of a watchtower tells a story. This is the memory of the deporta-

tion, what must remain of our dead and of our wounds.... This is what I found. This miracle took place. It was no longer the camps, nor us, nor our dead, but our experience in the light of eternity.... This miracle was *Night and Fog*.[7]

For those of us who travel in the opposite direction, from the film to the camp, the experience is no less miraculous. In *Refus de témoigner*, Ruth Klüger questions Auschwitz's function as a museum and "the camp as site": "Location, surroundings, landscape, seascape—we need a word, timescape perhaps, that expresses a site in time, a site at a certain moment, neither before nor after."[8] During that trip to Poland, filled with images from both *Night and Fog* and *Shoah* that superimposed the landscape without covering it up, this untraceable timescape suddenly became accessible to me.

Arriving in the blocks of the Auschwitz I camp, so different from the desolate expanse of Birkenau where Resnais filmed so many of his color tracking shots, I felt an intimacy with the filmmaker's work. Facing the renovated *kapo*'s room, at the foot of the displays of block 4, I thought I saw and understood his choice to discreetly revert to black and white for certain shots in *Night and Fog*. Resnais went against the grain of his employers and kept Auschwitz's process of becoming a museum at arm's length, then and in the film, forever. The superimposition of the film and the site revealed what had hitherto been present only elusively, waiting for *Night and Fog*, though never intended to be visible.

Daniel Arasse experienced the same troubled illusion of intimacy from the scaffolding in the church of Arezzo, when he came face to face with the murals of *The History of the Cross* at exactly the same distance from which Piero della Francesca had painted them. After hours of study, he finally noticed a tiny detail that signaled to him from the inner edge of *Battle Between Herclius and Chosroes*: a disembodied head stared at him blankly, as a "theoretical and individual signature" of the artist, lying in wait for over five hundred years. This little wink aroused the sentiment of being as close as possible to what Piero della Francesca thought and imagined. This discovery was the result of close scrutiny, certainly, but it could only have happened with the devotion of time, not through a shortcut. It is precisely because Arasse took the time to observe the entire mural that this hidden detail could appear to him.[9]

Patience and learning to see. It took me exactly twenty years to arrive at this close confrontation with *Night and Fog*: a 1987 dissertation on the film's reception, several dozen pages from my previous two books, and finally a self-examination of the tunnel vision that had made my gaze stray from Resnais's images. I needed to return one last time to this film that, until then, had looked at me more than I had watched it.[10]

While working on this book, studying the creation of the film and the feelings expressed by its originators, I discovered that *Night and Fog* was in fact the painful result of fleeting glances, of combined failure, and of accumulated helplessness that needed to be overcome, readdressed, and elucidated in order for the film to exist. This battle with the Medusa in which each combatant made his own shield formed, perhaps, the condition for its fragile existence and its incredible resistance to the ravages of time: it lifted a corner of the veil over the secret of its righteous distance.

I returned to my work on *Night and Fog* by considering it as a story of perspectives playing with variations in scale and changes of focus. Rather than a monograph on the film, what I propose here is a *microhistory in movement*, extensively observing its object to later move it around in space and time.

The first part of this book deals with the origins of *Night and Fog*, exploring the mysteries surrounding its gestation, revealing its pentimenti and the stages of writing of the script, penetrating the "black box" of its creation.[11] In the creases of a work in progress we discover a confrontation between art, history, and archive. The question the film raises extended into the writing of this book, as research yielded discoveries and obstacles. The changes in scale implied by a microhistory breed knowledge, but they also raise questions and create new problems: "A change in focus is more than simply enlarging (or diminishing) the size of the object in the viewfinder: it is to modify its shape and its framework."[12]

Which modalities and which sources to use in retracing the history of the production, in discovering the stakes of its iconographic research, in gathering the viewpoints of its makers on images from the camps, in studying the use of Hanns Eisler's musical score, in entering the dark editing room? These all formed problems that needed to be solved along the way. In addition to the archives that formed the familiar terrain of my research—contracts, budgets, drafts

of the script, correspondence, etc.—emerged new, often tenuous, traces, including invoices, equipment orders, continuity notes, lab memos, layouts of unused film archives, leftover film stock due to the film's various transformations, and so on. Those bits of paper and celluloid that I gathered like a street sweeper soon became signposts along the road I was traveling.[13]

The same process of gathering continued with regard to the period after the making of the film—the second part of this book deals with the views others have brought to *Night and Fog* and how these varied within different national contexts and time frames. The documentation gathered here does not discuss the traces of the film's desquamation but rather the layers of meaning and the stages of interpretation that have over the years turned the film into a palimpsest of perspectives.[14] *Night and Fog*'s longevity and its wide international distribution have made it, in the strongest sense, "a portable memorial"[15] at the service of many interests: its ambivalent handling in France and West Germany; a diplomatic struggle in Cannes; Cold War quarreling and the specter of the Gulag in the Soviet bloc; the radical change in the public debate on the victims of the Nazis in the United States; the film's exhumation in Israel for the Eichmann trial; the generational conflict of Germany's Years of Lead.

These different uses of *Night and Fog* can be found not only in written documentation, but also in the shape of the film itself—the forms in which it was distributed in certain countries by way of excised scenes, erased musical cues, intentionally faulty translation, and rearranged links between image and sound that provoked entirely new connections. These reinterpretations of *Night and Fog* are most clearly found in the use of extracts, its *mise-en-abyme* in works of fiction, its absorption into other documentaries. From this fragmentation of *Night and Fog*, its function as a recyclable archive, and its shots transplanted to feed new imaginations, I have tried to gather the remainders, the way one gathers the debris of an explosion. Even though they often contradict the film's original intent, the many uses and counteruses do form a part of its history. They shed light on the scansions of memory, the evolution of perspectives, and the social and symbolic demands made of these images, whose nature has changed profoundly over the course of the intervening fifty years.

In an invigorating essay on Antonioni's *Blow-Up*, Jacques Revel draws an analogy between the logic of the microhistory and the

protagonist's investigation by way of seemingly innocuous photographs taken in a London park.[16] What emerges is, in the historian's words, "a corpus that allows for the creation of a story, or rather of multiple stories, since each new print of the image reveals a different, previously invisible reality that in turn leads to a new intrigue."[17] The second part of this book is written in the context of this dynamic of accounts sparked by reprinting, reframing, and enlarging the image, the bifurcation of its meaning, and interpretations guided by the interplay of perspectives. *Night and Fog*'s microhistory in movement follows the path laid by Walter Benjamin when he invited historians to "discover in the analysis of the small individual moment the crystal of the entire event."[18]

Given that we are dealing with a historian's task, I chose to frame this book with a portrait of two stages in the life of Olga Wormser. While the reader might legitimately expect the focus to be on Alain Resnais, the lens is from the start aimed at a rather neglected supporting character, whose life, career, and work all shed a great amount of light on the film—which conversely sheds light on them.

The idea of following Olga's traces emerged when I hit a major obstacle in investigating the oft-debated question about the writing of the film, the historical awareness that underlies it, and the memorial concerns that shaped it. I failed to solve what seemed at the time to be an enigma: the oscillating screenplay, the changes of "perspective," the often impenetrable notes, the divergence between what certain images in the film *could* or *seemed to* say and what Jean Cayrol's narration did not say. An overhanging approach mapping out what was known at the time, which historical publications existed, and which were the dominant memories did not result in a satisfying conclusion. The problem therefore needed to be reassessed from the inside. It was necessary to penetrate the "historiographical operation"[19] by following the historian at work, even before her involvement in the film.

I began to comprehend, once I studied Olga Wormser's life and career up close,[20] her first confrontation with the deportation and her discoveries and hypotheses on the concentration camp system and its logical connection with the Final Solution. If Olga's knowledge and theories infused *Night and Fog,* then so did her doubts, her contradictions, and her inconsistencies. I had been wrong in my initial reasoning: the point of view and the perspective needed to be reversed. In

fact, when a historian serves as an adviser on a film, he usually does so from an existing, solidly argued body of writing, which he puts in the service of the mise-en-scene and the construction of the cinematic narrative. In the case of *Night and Fog*, aside from the fact that two historians accompanied a filmmaker they themselves had hired, the film was not the by-product of an existing body of work—it formed both the rough draft and the first synthesis of a story in the making. Olga Wormser wrote it in gradual steps over a period of fourteen years, until the publication of her thesis. From that point, Olga's portrait, far from being the "biographical illusion" Bourdieu so rightly denounces, allowed me to use "the first person to break the excessive coherence of the historical discourse, in other words to question not only what was and what happened, but also the uncertainties of the past and the missed opportunities."[21]

Night and Fog subsequently struck me as a work full of holes, with few certainties, fed by the dialogue and the doubts of those who offered the solutions to its own writing. The film therefore reveals a pure moment of historiographical uncertainty. It forms the point at which two operations crystallize and meet: that of a work of cinema in the process of completion and that of a long-term historical production from which the work of cinema sprang.

After emerging from the editing room, Alain Resnais let his film live its own life, acknowledging that it was beyond his grasp. Henri Michel, who saw himself as one of its parents, had loved but finally distanced himself from this film that tended too strongly toward the artistic. Olga Wormser, on the contrary, had marveled at this same transformation from document into work of art. Like a slightly abusive mother, she held on to *Night and Fog* to the point of incorporating it in her own writing, prolonging the dialogue and breathing belated life into its dormant images, clarifying the distinctions it had failed to make so as to turn it into the matrix of her own understanding.

In *Blow-Up*, the desire and the gaze of the female half of the couple in and for the photograph are what set the investigation into motion. Her pressing need to get hold of the negative raises a question: the off-center point she observes from inside the image reveals another scene: that of a crime the photographer witnessed without noticing. It is because Olga's path allowed me to look at *Night and Fog* differently that I constructed this book around a portrait of her, within a context of interlocking gazes.

Marseillaise and *Les Lettres Françaises,* her fraternizing with the intellectuals and artists of the "Party," including the painter Édouard Pignon, for whom she would leave Henri Wormser.

Olga's diary paints a picture of a sensitive and already wounded woman, whose dissatisfaction with herself reached its annual apogee on the eve of her birthday. On the fourth of July 1942, Olga was reading *A Woman of Thirty* and became convinced that her life was a failure. On the fourth of July 1944, she wrote how happy she would be if she were an "incontestable beauty." On the fourth of July 1945, she notes, "Thirty-three years old. I can feel the years slipping by. I can feel myself getting older, a failure in the eyes of others for having no great work to create or labor on."

A great work. But which work? Eluard sent back a poem of Olga's that he had proofread, on which he graded each verse with a "yes" or a "no"—the two words appeared in equal numbers. A gentle note read: "Forgive my indecisiveness."

In 1944, Hélène, the "little one," found her calling. Olga was still looking for hers. She excitedly followed the Parisian insurgency and rejoiced at the return of Gania at the side of his commander, Henri Rol-Tanguy. On August 26, 1944, she marveled at the crowds that gathered to welcome General De Gaulle on the square outside Notre-Dame. When the gunfire started, she and her mother ran the length of the cathedral to escape the snipers' bullets. Any happiness on Olga's part was always short-lived. She averted her eyes when the crowd hurled insults at German prisoners and felt the same embarrassment in Fresnes prison, where she was sent to look for inscriptions in jail cells packed with humiliated collaborators: "I have to remind myself that these men are responsible for those inscriptions, those names that we look for on the walls, under the cruddy legs of stools and on the window frames, in an effort to hate them."

At first amused by the "last-minute resistance fighters," her feelings quickly turned to irritation and nausea at the dissolution of an ideal. The prewar order was restored and the divisions between the resistance movements looked uncomfortably familiar. Her disillusionment, however, formed no hindrance to her lucidity: "Those who denounce hammering down the nail that sticks out—like I do, perhaps—probably were not so firmly rooted themselves." She rebels against De Gaulle's decision to disarm the patriotic militias and to ask the FFI to join the regular armed forces. Reaction once again triumphed over revolution:

"Hope is being dismantled at a rapid pace." She could already sense the "harsh, sad winter" of *Gates of the Night* behind the "glorious summer of the Parisian liberation."

FIRST DISCOVERIES, FIRST VIEWPOINTS ON
THE DEPORTATION

At the end of August 1944, friends from the resistance asked Olga to enter Henri Frenay's Ministry for Prisoners, Deportees, and Refugees, alongside philosopher Jacques Maritain's niece, Évelyne Garnier, and Andrée Jacob, cousin of the poet Max Jacob, who died in the Drancy camp. She happily accepted the offer. The adventure of these "mad nine months" proved to be "painful and fascinating" but above all decisive for her career as a historian:

> September 12, a date I will never forget, was my first day at the Ministry for Prisoners, Deportees, and Refugees. In a large, luxurious, dilapidated bathroom I submerged myself in files on the deportation. There is something unnerving about the bathtub, even though it has only ever been used to harmless ends. The task seemed temporary but today, twenty years later, I still have not completed it.[5]

In these former headquarters of the Gestapo, Olga established the first research database files, while realizing that her experience working at the Center for Information on Prisoners of War would be of no use in her new function. More precisely, the contrast between the two positions allowed her to recognize the specifics of the concentration camp system and to quickly seize the fundamental difference between the two conditions: an absence of official lists of those interned in the camps, linked to an overall policy of secrecy; an absence of liberated prisoners susceptible to supplying information on the fate of their fellow interns; an absence of international conventions to lend the deported an official status; and so on. During a mission to the International Committee of the Red Cross in Geneva in February 1945, she noticed that the Swiss files contained as many omissions as the French.

Olga attempted to decipher mysterious entries in the Romainville register, noted down names and slogans on prison walls, and was present at the exhumation of mass graves in Lille, Arbonne, and

Clermont-Ferrand. "Firing squad, deportee, internment, torture victim, hostage—these are the words I use most often," she wrote in January 1944. Yet, the image that Olga and her colleagues had of the deportation and the camps remained quite blurry up until the spring of 1945. She described the period as "akin to moving around in a darkness occasionally interspersed with shocking revelations: the discoveries made during the liberation of Struthof camp, or the eyewitness reports by the first people to return from Auschwitz in February and March of 1945."[6]

That February, the first prisoners of Auschwitz-Birkenau arrived from Odessa after being liberated by the Russians. "They gave us a brutal introduction to the process of the selection and extermination of the weak, while the tattoos on their forearms gave us an immediate understanding of the system of numbered registration. They also informed us about the evacuation of the able-bodied toward the Western camps in January 1945, without giving us much hope for their return."

In its quest for documents and information, the ministerial team found itself "competing amicably with a certain 'little Mrs. Leroy,' member of the MNPGD[7] created by François Mitterrand." Marguerite Duras spoke to Olga at length during her preparation of the exhibition *Labour Camps and Hitler's Crimes*, while desperately awaiting people's return.[8] In her journals, discovered thirty years later, Duras wrote:

> On April 3, De Gaulle exclaims the following criminal words: "The days of grieving are over. The days of glory have returned." ... De Gaulle makes no mention of the concentration camps. It is astonishing to see how he systematically refuses to mention them, how he refuses to incorporate the suffering of the people into this victory.[9]

On the same day, Olga wrote the following:

> On April 3, De Gaulle leads the liberation celebrations in Paris without mentioning the revolutionary days of the liberation itself. For me, though, that day above all revolved around Mrs. Bich-Mochet's revelations about Auschwitz. Without the slightest hint of pathos, she rolled up her sleeve to show the number inscribed in the flesh of her arm. "You have no right to give people hope that they will ever return—not the elderly, not the children, not the pregnant women, let alone any of the others."[10]

Families throughout France awaited anxiously, a state made all the more painful by rumors and the alarming news that filtered through. The only thing Olga and her colleagues could offer was an "ignorance badly hidden behind formulaic statements."[11] Still, Olga promised to inform "poor little Mrs. Leroy," the publishing house Corti, Mrs. Jean-Richard Bloch, and Alexander the tailor of any kind of news she might hear—a promise she had "the greatest difficulty keeping."[12]

While preparing for the return of the survivors, the ministry realized that the Orsay train station was not equipped to handle these people in their current condition. In April Agnès Bidault,[13] Denise Mantoux, and Yanka Zlatin set into motion Operation Lutetia. What followed were the intense, heartrending weeks of the "great homecoming, meager though it may be." Twenty years later, Olga gave a sensitive account of the experience in her book *Quand les Alliés ouvrirent les portes*, as a tribute to Jean Cayrol's narration in *Night and Fog*. In it, she demonstrates a keen ability for clearly painting the overall picture by way of individual destinies, rendering each deportee their humanity. At the Hotel Lutetia, where she could regularly be seen, Olga formed part of the team responsible for recording the first testimonies, reformulating the questionnaires that quickly proved unsuitable, and drawing up briefing cards.

On May 3, 1945, Olga Wormser left Paris to head for Germany. The ministry had received a list of 1,200 names from the camp of Bergen-Belsen, liberated by the British on April 15. However, the French deportees had not returned, and in order to relieve some of the suffering of their families, Frenay decided to send over a delegation. Traveling on the papers of a certain "Mrs. Jacob," who had to stay behind in Paris, Olga was a last-minute addition to this diverse group of officers, medics, female auxiliaries of the infantry, priests and nuns, a social worker, and the Swiss nurse Jeanne-Aimée, sister of Carmelle Dosse. She borrowed a cap and a military uniform from Évelyne Garnier, an outfit that was both too large and rather peculiar, leaving perplexed the British officer who joined them in Brussels during a ten-day delay (Figure 1).

The British intended to burn the camp's wooden barracks, which were infested with typhoid, before allowing anyone access. It was in Brussels, where Officer Philippe de Rothschild took care of the group, that the team learned about the Third Reich's complete surrender. After finally arriving in Germany, they were taken by jeep to Belsen's

FIGURE I. Mission to Belsen. Olga Wormser is on the right. Courtesy of the
Frédéric Wormser Collection.

camp no. 1, where the barracks had been incinerated and silence
reigned over an empty landscape. "They tallied the number of cadav-
ers on blackboards. That day there were 132. I saw one on a stretcher,
its body entirely rigid. The smell still pervaded the camp." The stares
of the survivors, the first pieces of bread handed to the French survi-
vors, a man crying on his bunk, the open mass graves, and the stag-
nant odor that still permeated the moribund camp—these memories
would continue to haunt Olga: "For over a month I had trouble
adapting to life back home. I keep reliving my experiences in Ger-
many. My entire life takes place between Orsay station and the Hotel
Lutetia."

Following this first revelation, Olga traveled to Poland in May 1946
to search local archives for the names of deported French citizens. It
was a six-week mission, undertaken in the company of two photogra-
phers at the behest of Laurent Casanova, Frenay's successor. Her re-
port appeared, under the pseudonym Fanny Vergen, in the August 28,
1946, edition of *France d'abord:*

> "Enough!" say the blasé—those who feel that the words "gas chamber,"
> "selection," and "torture" belong to the past, not to the present, just like

9

anything to do with the resistance. Yes, we do need to talk about these things before the cornflowers that grow around Auschwitz (which are as blue as those in the meadows of France) have absorbed all the human ashes from which they have sprung.[14]

In the Auschwitz I camp, Olga's mind was entirely on the French deportees who had dwelled there:

> We tried to look through their eyes at the wrought-iron inscription over the gates—"Arbeit macht frei" (labor liberates), impossible to comment on—and at the barracks that lined the stages of their transformation into corpses. But we knew that we would leave again through those gates, that we would reemerge from the dark cells of the penal section where, by the light of an electric lamp, we recognized the time schedule from Fresnes prison and the name of that Belgian who had managed to escape but was recaptured and hung. The taciturn guard, a former detainee himself, led us to Birkenau, where the overall air of death and desolation is even more relentless than in Auschwitz. . . . The crematoria have been blown up and the gas chambers demolished, but the train tracks remain silent witnesses and the human bones can still be seen in the open graves in the surrounding woods. We found rusty spoons, a wooden shoe, a medal featuring a ship's anchor, and cornflowers, lots of cornflowers. A barrack remained in its original state, complete with one pathetic frying pan that the women fought over and the three-layered wooden bunk "beds" where they slept in their own filth. Soon, all that will be left of Auschwitz will be this one barrack turned into a memorial museum, because the inhabitants chased across the Vistula by the Germans wish to regain their lands. But the mass graves in the woods will not be filled that quickly, and the taciturn guard will lead around the tourists who will buy postcards in the gift shop.

One year before the creation of the State Museum, Olga already had a clear notion of the fate of these places. Her first impression of Auschwitz, only marginally corrected by later visits, would come to haunt *Night and Fog*.

After the cornflowers of Birkenau came the weeds of Majdanek and the daisies picked by the director's little daughter amid the ashes and the bones. "When the wind blew through the camp, it made breathing impossible," said a lady from the Polish Red Cross. The oven in the crematorium was intact, its doorway a gaping hole. "The bathtub just next to the oven is where the executioner Hoffmann relaxed after a hard day at work." "How bland the poems of Edgar Allan Poe

seem on a Sunday morning in the crematorium, which holds the remains of so many merry bands of accordion players."

An old custodian asked them to take his picture in front of the graves while he continued to recount the executions that took place there at an unbridled pace. They visited the various barracks, photographed the tanks of Zyklon gas lined up along the wall, the mountains of shoes of all sizes and for all seasons, the piles of torn clothes. They noted down a number in a red triangle and one in a yellow triangle: "They designate a French political prisoner, a French Jew. Will we ever know their names? We who so desperately wish to find survivors. . . . No French in the hospital, no French in the asylums, no French in the camps. . . . No one got out alive."

The word "Jew" appears only once in Olga's account, in keeping with the dominant discourse of the immediate postwar. This discourse was motivated on the one hand by a "French Jacobinism that detested isolating the Jews from the rest of the nation"[15] and on the other by the predominance of a heroic model that privileged the figure of the deportee as resistant fighter. We can imagine, though, that Auschwitz-Birkenau would evoke in Olga the memory of the children from Izieu and of those of the tailor from Odessa, as well as those of the women of the transport of January 24, 1943, among them Danielle Casanova, the wife of the minister for combat veterans. Though the fate of her countrymen remained her priority, in Lublin and Warsaw Olga investigated the ruins of the ghettos: "Words fail to describe the Warsaw ghetto, the only part of town where no workmen come to clear the rubble and no farmers' wives come to sell their produce."

This first visit to Poland gave Olga little occasion to seize the logic and functioning of the camps. As she admits in the introduction to her thesis: "At that point, we were not particularly concerned with the history of the camps, but all the more with gathering evidence that would allow us to locate any of the fewer and fewer survivors or to confirm their passing."[16]

The information she gathered for the ministry initially functioned as evidence for the French prosecution at Nuremberg: the files she compiled on the crimes committed against French nationals by the Germans are added to reams of documentation assembled by investigators at the Center for Contemporary Jewish Documentation (CDJC) to help prosecutors Edgar Faure and Charles Dubost prepare their line of questioning.

In 1946 Olga contributed to an anthology on camp Ravensbrück, coauthoring with Andrée Jacob an "Essay on the History of the Deportation of Women," one of her first publications.[17] Around the same time she served, again alongside Andrée Jacob, as secretary to a committee for "political and racial deportees and detainees," officially established by Frenay in October 1945 and consisting of representatives from the principal camps and the ministries concerned.[18] Her mission consisted of gathering materials that would serve as documentation for compiling a "Black Book" scheduled for publication in 1947. Jacob and Wormser describe this project as follows: "The objective of this volume is not to publish an account of horrors or to start a polemic, but simply to establish, thanks to authentic texts and original documents, that the acknowledged [*sic*] 250,000 people deported, the 75,000 executed, and the anonymous victims that are still being discovered in new mass graves on a daily basis, were the victims of a willful determination that could not have been applied with such rigor if the German police forces had not found a great number of accomplices among France's civil servants."[19]

The first attempt to write the history of the detainment and the deportation was therefore characterized by its strictly internal, French focus, the desire to unite in one community the suffering of all of France's martyrs of the occupation, and a denunciation without favor of the Vichy administration.

This volume would never see the light of day. The committee saw its funds progressively cut, while the investigation and research reverted to the state of a simple archival depot: "With the end of the repatriation ... the problem of the history of the deportation lost its priority in the eyes of the ministry."[20] The same thing, unfortunately, also held true for denouncing collaborators in government circles. This history of detainment, commenced at such an early point but never completed, did lead to a groundbreaking publication by the CDJC, Joseph Weill's *Contribution à l'histoire de camps d'internement dans l'Antifrance*, a book that had no immediate impact.[21]

Laurent Casanova's departure from the ministry in 1947 led to the suppression of Olga's position. She was offered a lower, more junior position, which she refused. In the previous three years of intense activity, during which the dead were a constant part of her life, Olga discovered another way to be a historian: by researching and writing. At last, perhaps, there would be a great work.

Still in 1947, she followed in the footsteps of the father she had now surpassed in age and presented a subject for a thesis at Sorbonne. A very broad subject indeed: "National Minorities and the Displacement of Populations in Europe from the Thirty Years War Until the End of World War II." In 1948 Olga joined the venture named *Encyclopédie de la Renaissance Française*, edited by Marcel Prenant,[22] who chose her to be his personal secretary. Every Saturday on Sorbonne Square she met with "Party" intellectuals and a nebula of sympathizers. Olga was a "companion" but, contrary to her sister Hélène, never became a party member. She motivated this choice by referring to the tears her mother shed during the Moscow Trials. Following the Lyssenko affair, the encyclopedia project petered out after having its funding cut.

Olga decided to devote herself to her first book, *Les femmes dans l'histoire.* In later years she found it necessary to emphasize that this publication did not make her a suffragette, while regarding her first book with a mixture of severity and tenderness: "It is a work riddled with errors, notably on the Immaculate Conception and on a verse by Lamartine attributed to Hugo (or vice versa), but it is dear to my heart because I finished it during the period that I was alone with Frédéric, who functioned as my analgesic."

Henri Wormser had by this time completely disappeared from the lives of the two sisters, leaving Olga to care for their eighteen-month-old son. Doubtlessly more painful was the passing of Vera, the beloved mother, who died during Olga's pregnancy. "I spent the last night of her life keeping an eye on her respiration. For the last time I brushed her braids, her soft hair with its still golden ends."

In 1952, Henri Michel invited Olga Wormser, now herself head of the family, to join the Comité d'Histoire de la Deuxième Guerre Mondiale (Committee on the History of the Second World War, CHDGM) as a researcher, later adding a position as archivist at the Institut Pédagogique National. The jobs she held displayed no measure of her growing talents. The French government, always unwilling to recognize the merits and qualities of its own civil servants, particularly those who did not fit the mold, refused for a long time to incorporate the years that she was deprived of employment by the Vichy administration in calculating her seniority. Still, Olga continued to believe in the academic system.

During the 1950s, she valiantly battled on several fronts. She multiplied her activities with determination and passion: working for the

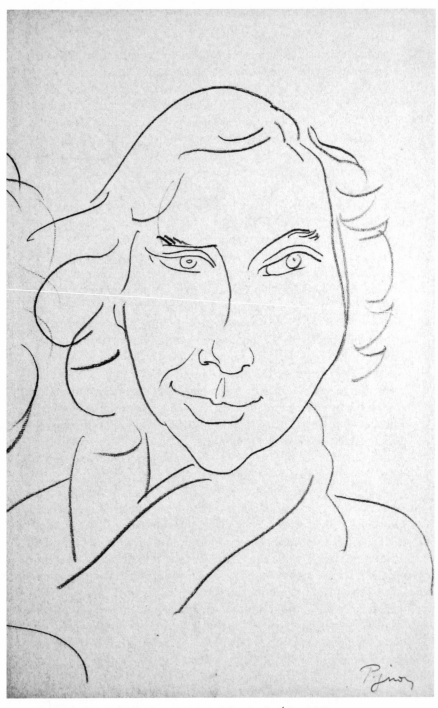

FIGURE 2. *Portrait d'Olga Wormser,* a pencil drawing by Édouard Pignon (1947–1948). Copyright 2013 Artists Rights Society (ARS), New York / ADAGP, Paris.

Comité in the morning, research at the archives in the afternoon, being a mother upon returning home, and writing at night. To help care for her son Frédéric, a friend of her mother recommended a sixty-eight-year-old Russian lady with free time and character: "Elisabeth Uxkull von Gyllenband, a Baltic baroness, daughter of imperial prosecutor Nicholas II, former lady-in-waiting to the empress." Her appearance was impressive to such a degree that Olga was afraid to discuss the terms of the lady's employment. When they had grown to become close friends, Olga pointed out that Elisabeth's father sent Olga's father to Siberia and that they have the revolution to thank for their unlikely encounter.

During this same period, at the Comité and at the Réseau du Souvenir (Memorial Network, an association founded in 1952 in an effort to promote remembrance of the deportation[23]), Olga crossed paths with a number of deported former resistance fighters she originally met during those intense weeks in the spring of 1945. Working in academia as well as within associations helped her attain new levels of competence and shaped her planned historical study of the concentration camp system.

To properly evaluate her pioneering contribution and to define the historiographical configuration from which *Night and Fog* emerged, it is necessary to widen our perspective around Olga and to study the activities of the subcommittee on the history of the deportation, established within the CHDGM in 1951.

THE HISTORIOGRAPHICAL OPERATION

It was the committee's "godmother,"[24] Annette Lazard, who assigned it the mission to "safeguard the memory of the martyrs" and to produce a scientifically accurate history that future generations "have the duty to know impartially."[25] The subcommittee's compass would often vacillate between these two poles of remembrance and history, struggling to define its tasks and objectives.

The new body, like that of 1945, consisted of representatives of government ministries[26] and notable figures of the deportation, most of them members of the Réseau du Souvenir (Cain, de Bouard, Waitz, Tillion, Riquet, Fawtier). Also a member was Andrée Jacob, then head of documentation at the Ministry of Combat Veterans. History held the stronger position, on paper at least, thanks to the presence

of Febvre, Labrousse, Renouvin, and Vermeil, who were joined in 1952 by Olga Wormser.[27]

During the inaugural session on June 20, 1951, the participants agreed on the double necessity of gathering statistics on the deportation in France and of "safeguarding, uniting and cataloguing" existing sources.[28]

Large gaps existed in the information available to them on the nature and locations of the written archives that initially represented their main interest. To expand the corpus of sources, Henri Michel suggested interviewing the survivors, an idea that met with little enthusiasm from the ex-deportees. In the opinion of Julien Cain, a history of the deportation could not be written "by adding testimonies." No matter how "precise" or "authentic," they would never "provide the explanation" that must be pursued "methodically," "in investigating the mechanism of the deportation."[29] The priest, Father Riquet, was distrustful of the unreliable nature of memory and suggested focusing primarily on the search for photographic evidence, specifically the images taken at Mauthausen, which he felt had far greater historical value. Brunschwig and Fawtier went so far as to deplore some deportees' tendency to "confabulate."

In spite of some hesitation, the subcommittee decided to launch a broad effort of investigation throughout the country.[30] What remained was to define the categories of former deportees suitable to be interviewed. Henri Michel suggested leaving out "nonpolitical prisoners" in order to "avoid the suggestion that we are offering them a form of rehabilitation." Germaine Tillion did not share Michel's scruples and felt that they could question "everyone." The secretary felt that there was at least a need for an order of precedence in which "we first interview the deportees of whom we are certain! We will start with members of the resistance, followed by those deported for their race, political deportees," and so on.

Although the members did not reach a consensus during the session, the interviewers and their guides, mostly members of veterans associations, gave precedence to deportees with ties to the resistance movement. The issue of the nonpolitical prisoners, who had no association to represent them, would be relegated to the sidelines and has indeed still not been properly recorded. The subcommittee's choices and the absence of an official statute for nonpolitical prisoners would lead to an insurmountable shortage of sources.

The question of the deportation of France's Jews was equally com-
plex, their fate falling partially outside the scope of the subcommit-
tee's inquiry. "Those deported for reasons of race are often people
who spent four years continuously on the run! Subsequently they
were unknown in the places where they wound up," Germaine Til-
lion noted. Henri Michel reassured her that local correspondents
were making efforts to meet with rabbis. To this remark, so revealing
of Michel's views of France's Jewish population, Fawtier replied
that "large numbers of Israelites . . . have no ties with any rabbi
whatsoever."

All involved finally agreed on the need to establish contact with
the Centre de Documentation Juive Contemporaine (Center for
Contemporary Jewish documentation, CDJC) for any queries related
to "deportation on racial grounds." Julien Cain and Pierre Renouvin
paid the CDJC a visit in October 1951, where they realized that its ef-
forts were in a far more advanced state than they expected "and that
the extent of the assembled documents is very impressive indeed."[31]

In fact, the center's researcher did not stop at gathering docu-
ments;[32] they also partially put them to use as sources for the publica-
tions of the indefatigable Isaac Schneersohn, who founded the CDJC
in Grenoble in April 1943.[33] As early as 1945 Schneersohn started *Le
Monde Juif*, the world's first journal devoted to the genocide. He also
published Joseph Weill's study on France's internment camps,[34] as well
as Georges Wellers's testimonial book *De Drancy à Auschwitz*. These
books had only limited print runs and readerships. Léon Poliakov
estimates that they "reached about two to three hundred subscribers,
nearly all Jews already committed to the cause. No bookstore could
sell them and no critic could even mention them."[35]

Quite a different fate awaited Poliakov's own *Bréviaire de la haine*,
published in 1951 by the imprint edited by Raymond Aron at
Calmann-Lévy,[36] with a foreword by François Mauriac. It met with far
greater media coverage than Schneersohn's books. Its author worked
on it from 1946 through 1950, in the immediate aftermath of the
event, thanks to the CDJC's rich collection of documents to whose
gathering he contributed. It formed the first major publication on
the genocide of the Jews, making Poliakov, alongside Britain's Gerald
Reitlinger (in 1953) and the American Raul Hilberg (in 1961), "one of
the first chroniclers of a history that no one cared a great deal about
at the time."[37]

Poliakov established the general framework, the chain of cause and effect, and the chronological stages in the decision-making process that led to the persecution and finally extermination of Europe's Jews: the rise of anti-Semitism, confiscation and persecution, ghettoization and deportation, a "chaotic" followed by a methodical extermination. Poliakov succeeded in providing a detailed description of the workings of "the industry of rationalized murder" in the "Polish extermination camps" Chelmno, Belzec, and Treblinka. He next described the phases and the practical details of the executions (selection, killings by means of Zyklon gas, description of the functions assigned to members of the *Sonderkommandos*).

After gradually understanding how advanced the existing research was, the committee members mounted occasional collaborations with the center to complement their respective resources. This led to Henri Michel's devoting an entire issue of the journal to "The Condition of the Jews" to coincide with the unveiling of the tomb of the unknown Jew, a memorial subscription project initiated against all odds by Isaac Schneersohn. To fill this special issue, the general secretary naturally turned toward the question's greatest specialists, requesting the CDJC to provide summaries of its previous publications.[38]

During promotion of the issue that appeared in October 1956, Henri Michel commented that it should "interest Israelites of all countries and all those concerned with the martyrdom imposed on the Jews during the war."[39] The story of the persecution and the genocide of the Jews remained, in his eyes, largely "exogenous,"[40] of interest primarily (and perhaps exclusively) to the "community"—a Jewish history for the Jews rather than a universal event central in the history of humanity.

Throughout the 1950s, the contrast between the tentative research effort on the concentration camp system and the early advance in studying the genocide was striking—even if the latter's conclusions rarely reached beyond "the cenacle of interested individuals."[41] We could hypothesize that it was precisely the lack of interest, including in the Jewish world, that formed one of the reasons that study of the genocide was so diligently elaborated. This history could be written without delay because it was as yet free of vested interests, carried out on the margins by men transformed into historians through the sheer will to understand the persecution—stemming from the Jew-

ish tradition of scripturally recording massacres—and whose discoveries met with polite indifference.

Neither were the efforts to study the deportation and the concentration camp system the result of public opinion in 1950s France. The initiative came from within the community of former deportees, who closely followed developments and awaited the results.

Henri Michel's words betray that even within the subcommittee there existed a constant concern for the opinion of the deportees, an acute awareness of working under their scrutiny. "I would not dare venture to define the deportation. There are too many people I do not want to risk upsetting," he admitted at the very first session. As general secretary of both the CHDGM and the Réseau du Souvenir, Michel feared nothing more than "controversy," a term he used frequently, despite being fully aware that a historian's work is by nature "at odds with memory."[42] Would the history demanded by the eyewitnesses sit comfortably with the politics of remembrance of the associations and federations? Of this Michel was not at all certain.

The subcommittee experienced this difficulty first-hand, and painfully so, in February 1974, when it finally published the result of the statistical research efforts initiated twenty-three years earlier. On the results, which proved far lower than the canonical figures habitually employed by the associations, Michel declared it "unwise to publish a conclusion that would risk provoking discourteous comments toward the deported. . . . The associations are divided and we should avoid controversy surrounding the deportation that could serve as a means of propaganda."[43] Olga Wormser agreed, saying that it would be "delicate to release figures that are very different from those normally used within the associations." Julien Cain approved these arguments, albeit with a side note that the committee should not be "too sensitive to excess." Mrs. Chevalier, invited especially for the occasion, was not of the same sensitive nature, asserting that "neither public opinion nor the deportees are familiar with the rigors of historical research" and would risk "being hurt by these conclusions." And so, in the words of Annette Wieviorka, the Comité found itself embarrassed by its own offspring: "It has given birth to a monster and screams of horror will resound around the cradle."[44]

Henri Michel sensed what difficulties would come as early as 1951, which influenced his belief in a method that would "step back" from

the event and let "documents settle." "Step one: we gather documenta-
tion. Step two: Once all the documents have been gathered, we might
consider using and studying them."[45]

The shortage of archival material was at that moment a very real
problem, which Germaine Tillion summed up succinctly as: "We
labor under fantastically inferior conditions, since we have nothing at
all!"[46] The painstaking task of gathering documents fell upon Olga
Wormser throughout much of the 1950s, during which she crisscrossed
the European continent scouring various archives.

As early as March 1952, Julien Cain showed signs of impatience: "I
would like to underline that the war is seven years behind us. What is
expected of us is not simply to add documents to other documents,
but to provide a certain number of testimonies and clarifications. We
are not working merely for the historians of the year 2000."[47] "The
necessity of publicizing our findings exists," Henri Michel admitted,
"since France's deportees expect it." Not to fail in this "mission,"[48] the
general secretary took a two-tiered initiative in 1953: he launched *Tra-
gédie de la déportation*, an anthology of testimonies edited in conjunc-
tion with Olga Wormser under the wing of the Réseau du Souvenir,
and a special issue of *Revue de l'histoire de la Deuxième Guerre mondiale*
devoted to the "German concentration camp system."[49]

The latter volume appeared in July 1954, featuring a foreword by
Julien Cain and several "partial studies" by subcommittee members:
Michel de Bouard on Mauthausen and its *kommandos;* Olga Wormser
on "Efforts at Concentration in Germany's Wartime Economy"; Ger-
maine Tillion refining her *Ravensbrück*[50] hypotheses with "Reflec-
tions on the Study of the Deportation." Nearly all the essays in the
volume prioritize the concentration camps and the deportation of
French citizens. Only Marie Granet's text treats the issue of the
genocide of Jews and Gypsies at length, in an essay centered on the
Nuremberg trials that investigates the notion of crimes against hu-
manity. This collection also took stock of the statistics per region and
of centers of research: Henri Michel outlined the subcommittee's ac-
tivities, while Léon Poliakov traced the history of the CDJC and pro-
vided a presentation of its archives. The first tangible result since the
subcommittee's inception,[51] this special issue met with great suc-
cess.[52] The general secretary presented it as "complementary" to *Tra-
gédie de la déportation*, "a publication equal parts literary and histori-
cal" aimed at the "widest possible readership."[53]

The foreword to that particular volume, by Henri Michel and Olga Wormser, places it within the context of the Réseau du Souvenir's policies of remembrance:

> Although the general workings of this horrible system are known, too many uncertainties remain to allow us to write a complete history of the concentration camp system. The subcommittee on the history of the deportation is making an effort to gather materials, documents, and testimonies for the day when a sufficient volume of documentation and the distance necessary for historical research will allow us to create an exhaustive and scientific body of work. . . . In the meantime, we should not allow the concentration camps to be erased from the mind of man. Forgetting would be a crime as well as a mistake; an entire set of ethics, an entire civilization—ours—are at stake.[54]

The moral dimension given to this act of remembrance was combined with a heroic vision of the deportation, which was presented as a glorious and tragic battle. The event was portrayed as a struggle for values articulated around the figure of the combatant, not that of the victim, since "suffering is the breeding ground of heroism."[55] This text, verified and advocated by the Réseau du Souvenir, was preceded by a short preface cosigned by the three great federations ADIR, FNDIRP, and UNADIF.[56] Paul Arrighi presented the project to them as a conciliatory venture that would unite all deported resistance fighters around the memory of their "tragic saga":

> We ask you to add your signature at the bottom of this brief preface. In this manner, all those who—today in particular—prefer to forget the glorious past shall know that the deportees of the resistance, regardless of their current standing, are united in their determination to preserve the memory, to bear witness, and to proclaim their pride.[57]

In planning this volume, Olga Wormser immersed herself in existing literature on the concentration camps, gathering fragments of over two hundred testimonies by former deportees. If the structure of the book and the preliminary text were the work of Henri Michel, it is Wormser who contributed nearly the entirety of the contents as well as the critical apparatus. This uneven distribution of tasks sparked in her the audacity to demand a renegotiation of the contract, initially drawn up in favor of the general secretary. This would be Olga's only act of rebellion against her abusive mandarin, to

whom she nevertheless remained deeply grateful. Was it not Michel who introduced her into this cenacle of historians little inclined to welcome a woman into their ranks, a woman without proper teacher's qualifications no less, devoid of symbolic capital or the halo of the martyrs of the deportation? There was an additional reason for her loyalty, one even fiercer because steeped in admiration, which bound her to the circle of deported resistance fighters to whom the book was primarily intended to pay tribute.

As such, the general philosophy of the project, the preliminary texts, and the contents and the structure of the volume essentially ignore the fate of the Jewish deportees killed in the centers of extermination. The map of camps included in the early pages is most revealing in this regard: Majdanek and Auschwitz are listed under the generic label "deportation camps," alongside Buchenwald, Ravensbrück, Dachau, and Mauthausen. The camps Belzec, Chelmno, Sobibor, and Treblinka, mentioned in Poliakov's book, are not listed. Birkenau is mentioned as a "commando" of Auschwitz, following the same logic that assigned Dora and Ohrdruf to Buchenwald. In this way, *Tragédie de la déportation* imposed the uniform model of a great, generic camp that borrows most of its characteristics from the Western concentration camps, most notably Buchenwald, the dominant name in the corpus of testimonies.

Nevertheless, Olga Wormser managed to arrange some space in the book's interstices for what was not yet referred to as the "destruction of the European Jews" or as the "Shoah." She had no trouble mentioning the fate of Jews in the first chapter, devoted to the departure of the transports: a quote from Georges Wellers' book mentions both the Drancy and Compiègne camps, while an epigraph taken from the Black Book mentions children huddled together in railway cars at the Gare d'Austerlitz after being separated from their mothers. Later chapters do not lend themselves as well to the subject, since most of the victims of the Final Solution were sent directly into the gas chambers and never properly set foot inside the camps. It is therefore in the chapter devoted to death that the deportation of the Jews is again broached. The testimony of Dr. Bendel, one of the rare survivors of the Birkenau *Sonderkommando,* mentions the murders of the aged, women, and children in the Lodz ghetto; an extract from *Bréviaire de la haine* studies the construction and functions of the gas chambers/crematoria at Birkenau; a transitional paragraph written by

Olga Wormser explains the "sinister meaning" behind the word "se-
lection" that sealed the fates of those who had to "die because they
were Jewish." The annotations and the addition to the corpus of testi-
monies of "writings by qualified personalities" (Léon Poliakov and
Vasily Grossman, who as a Russian war correspondent had investi-
gated *The Hell of Treblinka*[58]) indicated Wormser's wish to discreetly
fill this particular blind spot.[59] This explains why it is so difficult to
analyze this section of the book: to conclude from a few short pas-
sages and remarks that she understood the specifics of the extermina-
tion of the Jews is to give the book a quality that any truly critical
analysis will prove it does not contain. Conversely, to claim that the
volume denies the Jewish identity of the victims would be equally
erroneous. What is revealed is a genuine, if imprecise, awareness of
the past acquired amid confusion, a difficulty in imagining these two
aspects of the deportation side by side and in all their differences, at
a moment when the enunciative framework that served as the proj-
ect's premise was still dominated by the words and viewpoints of
deported resistance members. It would take Olga Wormser another
fifteen years and the completion of her thesis to fully comprehend
the two processes.[60]

To get to that point, she had to gain confidence and consolidate
her knowledge, to emancipate herself from the dominant French dis-
courses and from the demands of remembrance that assigns a moral
function to history. She needed to adopt a perspective entirely differ-
ent from that of the eyewitnesses. She explains this process in the in-
troduction to her thesis:

> *The goal of our efforts is not to describe life in the concentration camps, but
> to study the elaboration and application of the norms of those who conceived
> of them.* We will attempt to adopt not the position of the deportee judg-
> ing the system to which he was subjected, but that of a member of the
> SS concentration camp hierarchy trying to understand the system he is
> supposed to enforce.[61]

This radical shift, in which *Night and Fog* constituted an important
step, was hardly a painless one. The night before she handed in her
manuscript, Olga admitted to the members of the subcommittee "the
difficulty she experienced, after several years of close contact with
those who were subjected to this system, to align myself with those
who organized it."[62] Was the position of the historian alongside the

participants, be they heroes, victims, or perpetrators? Her emancipation from the witnesses in any case allowed her to cross the line on an issue that would become very sensitive in the decades that followed. The closer she approached the black sun of the extermination, the more Olga burned her wings.

In 1954, however, she still basked in the joy of achievement. The anthology met with great critical and commercial success, further buoyed by an award from the Académie Française and the gratitude of members of the Réseau. The two historians mounted, with the same success, the exhibition *Resistance, Liberation, Deportation* at the Musée Pédagogique in Paris.[63] While hard at work preparing the exhibit, Olga amused herself with the sensitivities her work revealed: "We need to soothe the wounds that exist between Marshalls Leclerc and de Lattre, each fearful that his side will be less well represented than the other's."

Contrary to the recriminations of those hanging on their glorious past, Olga's happiness was a promise about to come true. On January 22, 1955, Jacques and Odette Monod introduced her to André Migot, a veteran of World War I twenty years her senior, physician and mountaineer, occasional author and filmmaker, acknowledged expert on Tibet and indefatigable traveler. "The time of solitude has passed." The time of separations was yet to come.

It was within this context of professional exhilaration and romantic passion that she threw herself into the adventure of *Night and Fog*. Olga Wormser, soon to become Olga Wormser-Migot, seemed to have finally found her path.

PART ONE

THE FILM'S INCEPTION
A FAILURE OF GAZES

1 THE "INVISIBLE AUTHORITY"

The Stakes of a Commission

STUDIES OF *NIGHT AND FOG* consistently mention that Alain Resnais received the commission to shoot his documentary from the Comité d'Histoire de la Deuxième Guerre Mondiale (CHDGM). While not exactly wrong, this popular belief paints an incomplete and simplified picture. Aside from the fact that the commission was given to production house Argos Film, which was in charge of finding a suitable director, the initiative of the project rests not only with the CHDGM, but also with the Réseau du Souvenir.

The systematic oversight of this major player is notably due to the strong presence of the CHDGM in the opening credits of *Night and Fog*, where it is mentioned at the top of the second title card, whereas the Réseau has a more discreet presence in the list of "numerous supporters." In contrast with the CHDGM—a ubiquitous presence in historical writing on World War II whose stamp lent the film a scientific guarantee—the Réseau can be more correctly described as an "invisible authority."[1]

However, reintroducing this discreet backer into the story is indispensable for a complete comprehension of the project, since *Night and Fog* existed from its inception at the crossroads of history and memory. It is precisely in this tension between two distinct but closely involved approaches that the film's origins lie.

DOUBLE BACKING

The general history of the CHDGM is well known: it was created in December 1951 through the merger of the Commission d'Histoire de l'Occupation et de la Libération de la France and the Comité

d'Histoire de la Guerre.[2] Adopting the tasks of both its components, the CHDGM united archival material on the German occupation of France from the different government ministries, while also launching its own inquiries and historical studies into the period 1940–1945.[3] Though the lion's share of its publications pertain to the resistance movement,[4] the *Revue d'histoire de la Deuxième Guerre mondiale* also devoted its pages, as we have seen, to studies of the concentration camp system, provided in part by members of the subcommittee on the history of the deportation.

The role of the Réseau du Souvenir, which was as discreet as it was influential, remains largely overlooked. It is necessary to give an overview so as to have a better understanding of the interests of the parties that commissioned *Night and Fog*.

The Réseau du Souvenir was created at the instigation of Annette Lazard (whose husband died in Auschwitz in 1943) and president of the bar Paul Arrighi (former head of the movement Ceux de la Résistance, himself deported to Mauthausen, where his son Pierre died), who were both "disappointed with the memorial efforts of the larger federations."[5] As its final chairman, Pierre Saint-Macary, explained, the association was born from a double wish on the part of Arrighi:

> To create a structure exclusively devoted to the memory of the deported and those who died for freedom; to organize said structure like a network, after the wartime resistance networks.[6]

Defined by these specific goals, the Réseau du Souvenir expanded "gradually, acquaintance by introduced acquaintance, from an original tight-knit circle." Aside from chairman Arrighi, vice chairperson Annette Lazard, and general secretary Henri Michel,[7] the initial circle included Father Michel Riquet, professor of medicine Gilbert Dreyfus, Maurice Azoulay, Germaine Aylé, and Rémy Roure.[8] They were soon joined by other prominent figures from the resistance and the deportation, including Julien Cain, Edmond Michelet, Louis Martin-Chauffier, and Germaine Tillion.[9]

This list immediately draws attention to the predominance within the organization of deportation survivors and relatives of deceased resistance members, many of whom furthermore belonged to the "country's elite."[10] The expression "died for freedom" that flowed so smoothly from General Saint-Macary's pen[11] is symptomatic of the

weight the heroic and patriotic model carried. The chairman freely admitted that it held sway in the postwar years.[12]

During the first decade of the association's existence, the figure of the deportee as resistance fighter dominates its newsletters, the transcripts of its meetings, and the speeches of Paul Arrighi, who interpreted the deportation as being purely a consequence of underground activities, an accepted sacrifice for the sake of freedom and the nation.

The term *réseau* (network) was certainly not chosen by accident, as Henri Michel explained in January 1954:[13]

> This is because most of its members are former resistance figures. One could say that for resistance fighters deportation was, regrettably, the punishment for their bravery and their patriotism, and that, in a sense, the concentration camp was their fate as much as the gallows were.

The choice of this term also indicates that the association was perfectly content with not being too visible on the public's radar and that it had no ambition to become a mass movement (depending on the period, its membership vacillated between several hundred and a thousand individuals[14]). The Réseau's objective was in fact to lobby with the highest political and moral authorities in order to promote remembrance of the deportation in the areas of history, the arts, and religion.[15] The names that made up the membership selection committee, set up in 1955 under the patronage of president of the republic Vincent Auriol, speak volumes. They include Édouard Herriot (chairman of the National Assembly), Gaston Monnerville (chairman of the Conseil de la République), and various acting cabinet ministers in key positions for the association's project (including Jean Berthoin, national education minister; Emmanuel Temple, minister for combat veterans and victims of war; and André Cornu, secretary in charge of the arts). Also featured in this committee were the authorities of the various religious confessions (Archbishop of Paris Maurice Feltin; Grand Rabbi Jacob Kaplan; Si Kaddour Ben Ghabrit, president of the Muslim Institute in Paris; and Pastor Marc Boegner, president of the Protestant Federation of Paris). We can also add several eminent representatives of the République des Lettres et des Sciences, including numerous members of the Institut (André Malraux, François Mauriac, Paul Claudel, Lucien Febvre, Robert Monod, et al.) and some major names from resistance circles (in-

cluding Admiral Thierry d'Argenlieu, Georges Bidault, Alexandre Parodi, and René Cassin).

Ecumenism, irenicism, and an apolitical stance constituted the founding principles of the association, as Henri Michel explained:

> The Réseau is resolutely apolitical. It unites opponents of the German concentration camp system, regardless of their philosophical, political or religious convictions. It should not be confused with the various federations of deportees, since it does not claim to defend the interest of the surviving deportees. Its activities are entirely focused on the past.[16]

Although this rosy view of unanimity would often be torn asunder by internal arguments, particularly during the 1960s, the Réseau's efforts "toward the past" met with great success, thanks to its many friends in high places. The first two years of its existence show impressive results:

> The creation, at the insistence of senator Edmond Michelet, of a "national deportation memorial day"[17] (law of April 1954)

> *Tragédie de la Déportation* (published July 1954)

> The Paris municipal council unanimously votes in favor of a "monument to the martyrs of the deportation"[18] (June 1954)

> A memorial night at the Palais de Chaillot featuring the first performance of *Le château de feu*, commissioned from Darius Milhaud (November 1955)

In his list of projects that saw the light of day in 1954–1955 thanks to the Réseau's tenacity, General Saint-Macary included the commencement of *Night and Fog*, which therefore clearly owes its existence to the association. In fact, the idea for the documentary sprang from the same logic of memorial inscription—in stone and on the calendar, on paper and on celluloid. Film furthermore was the ideal vehicle with which to reach one of the organization's primary targets: the youth, who were seen as forgetful or simply ignorant of the facts and needed to be educated and enlightened.

Reestablishing the Réseau du Souvenir and its role as initiator allows us to correct the obliqueness of previous analyses that traced the history of *Night and Fog* back solely to the CHDGM and its interests and actions. However, this does not mean reversing the perspective

and arguing that the film emerged solely from the circle of former deportees looking to perpetuate the memory of victims and survivors. The right point of balance lies in taking account of the interpenetration of the wishes and authorities implicated in the project.

It lies first of all in understanding how the injunctions of memory and the demands of history interconnect: the Comité was, as we have seen, eminently sensitive to the necessity for remembrance and the feelings of former deportees, while the Réseau put all its considerable weight behind promoting historical awareness. These overlapping interests went hand in hand with personal ties between the two organizations. It is most revealing that the subcommittee on deportation was instigated by a future member of the Réseau. On April 24, 1951, "a group of deportees and relatives of victims" gathered at the home of Annette Lazard to share their grievances over "the interruption of activities on the history of the deportation" and to request that these be resumed.[19]

Three days later, those who would soon found the Réseau du Souvenir sent the president of the Council a request for the creation of a committee for the history of the deportation, validated on April 30 by the Comité d'Histoire. Its task was to assume and recommence the efforts of the Commission for "political and racial deportees and detainees," interrupted since 1946.[20]

The Comité and the Réseau therefore had to carry out related but distinct tasks: one would take care of collecting testimonies and setting up and publishing inquiries and scientific studies on the deportation and the concentration camp system; the other handled the dissemination among the public at large, through a wide variety of means.

This two-tiered strategy was facilitated by the intermediary positions of key figures who belonged to both organizations: Julien Cain, Germaine Tillion, Olga Wormser (who joined the administrative council of the Réseau in 1957), Father Riquet, Mrs. Aylé, and Annette Lazard. The position of Henri Michel—the man who acted as the doorway to getting *Night and Fog* off the ground—is exemplary in this regard, since he served, between 1953 and 1956, as general secretary to both the Réseau and the Comité.

Michel proved himself a virtuoso in juggling his dual responsibilities in order to support the projects that were particularly dear to his heart. At the general assembly of February 5, 1955, which evaluated

the exhibition *Resistance, Liberation, Deportation,* Paul Arrighi paid tribute to the historian in the following words:

> Mr. Henri Michel, one of the driving forces of the Réseau du Souvenir, experienced little opposition as general secretary of the Réseau in aiding Mr. Henri Michel, driving force and general secretary of the subcommittee on the history of the deportation. Mr. Henri Michel therefore helped Mr. Henri Michel in setting up this exhibit that took place at the Musée Pédagogique in the rue d'Ulm.[21]

To complete his portrait, Paul Arrighi might have mentioned that Henri Michel also occupied the position of general secretary in the exhibit's organizing committee, founded to coincide with celebrations for the tenth anniversary of France's liberation.

Unveiled in November 1954 and extended until the end of January 1955, thanks to the great numbers of visitors,[22] the exhibit at the Musée Pédagogique played an important role in the inception and commencement of the project *Night and Fog.*

THE ANNOUNCEMENT

It was during preparations for the exhibit, on which they worked side by side,[23] that Henri Michel and Olga Wormser announced the commencement of a film "on the concentration camp system." The documentary was first mentioned on national radio, on November 10, 1954, the exhibit's opening day. Questioned by a journalist about the role of cinema in historical research on World War II, the two historians, after agreeing on the importance of filmed footage, disclosed their new initiative:

> H. MICHEL: Filmed documentation plays a great role in understanding the period in which it was made. Most of the films that came out of the war, particularly those to do with the resistance, are undeniably of historical value, even though they are regrettably often romanticized....

> O. WORMSER: I am thinking of a film on the concentration camps, *The Last Stop,* which contains fine elements but whose ending in particular is sadly very romanticized, which detracts from its historical authenticity....

> H. MICHEL: I believe that it is possible to make truly historical films. The amount of existing footage is impressive. The trials of the conspirators against Hitler were recorded and represent twenty hours of film.

So Mrs. Wormser and I wondered what shape a film on the concentration camp system could take.

QUESTION: Is there an existing project for such a film?

O. WORMSER: We are in the process of setting it up, but the main goal is that it serves the purpose we are pursuing, which is to say a film that contains only purely historical documentation, conclusively verified by all the experience that we have on the subject.[24]

This pioneering interest in filmed archival footage is a profound one. During preparations for the exhibit, Henri Michel drew up an initial list of films suitable for projection in one of the Institut Pédagogique's screening rooms. In the end, nine features and eight short films—most of them on the subject of the resistance—were screened to the public.[25] Only two directly concerned the deportation: *The Last Stop*, a Polish fiction feature film by Wanda Jakubowska, a former Auschwitz detainee and resistance member, and *The Death Camps*, a documentary compilation made in 1945 for the French newsreel services Actualités Françaises.[26]

Michel adopted a noticeably similar filmography in his notes for a proposed museum of resistance and deportation.[27] He passionately advocated the construction of a film archive with accompanying screening room, emphasizing that cinema was the most suitable medium to bring knowledge about recent history to the young. His taste for film did not, however, go hand in hand with a respect for their integrity, as this note on *La Libération de Paris* suggests:

Compilation of newsreel footage that should have its narration redone and that should have images on the occupation and the battle for France added in order to create a feature length film devoid of fictional elements.[28]

In Henri Michel's eyes, the "historical value" of a compilation film was based on the "authenticity" of the archive footage and the factual rigor of the narration, which should be written by a historian whose competence and scientific authority would ensure the absence of any fictional tendencies. This approach, which sacrificed both the historical nature of the original narration and the integrity of the film as a work of cinema, would have serious consequences when the time came to decide who would write the narration for *Night and Fog*.

FIGURE 3. Olga Wormser and Henri Michel at the Musée Pédagogique for the exhibit "Resistance, Liberation, Deportation," 1954. Courtesy of the Frédéric Wormser Collection.

Olga Wormser, altogether more sensitive to artistic integrity, did not neglect archival footage in the inventory she drew up over the course of her research missions for the subcommittee on the history of the deportation. For her thesis she even took the trouble of adding

a two-page filmography to her list of sources on the Nazi concentration camps.[29]

The exhibit proved decisive in launching the *Night and Fog* project. It was decided that the film would use part of the collection of objects exhibited at the Musée Pédagogique and that preparations would be handled by Olga Wormser. The script would largely follow the arrangement of displays and descriptions of the exhibit's deportation section, as well as the narrative structure of the anthology volume *Tragédie de la Déportation*. The initiative led to the two organizers' dissatisfaction that there was no French film in existence on the subject of the deportation aside from *The Death Camps*. The great amount of publicity surrounding the exhibit and the high regard in which the two historians were held also proved beneficial in the search for financing and the first attempts at contacting interested parties.

Among the visitors to the exhibit was one Anatole Dauman, a twenty-nine-year-old film producer, and the filmmaker Nicole Vedrès,[30] who was soon tapped to direct the new documentary.

2 THE "MERCHANTS OF SHADOWS"
A French–Polish Coproduction

SEVERAL DAYS AFTER VISITING the *Resistance, Liberation, Deportation* exhibit at the Musée Pédagogique, Anatole Dauman contacted Henri Michel to confirm the involvement of Argos Films:

> We have decided in favor of joining the production of a short film whose subject concerns the history of the Resistance and the Concentration Camps.
> As you pointed out, it is imperative that this project be diligently researched from a historical viewpoint and that, under the auspices of the Société pour l'Étude de la Seconde Guerre mondiale [*sic*], its impartiality and scientific documentation unanimously convince all associations and personalities involved.
> Having considered the circumstances, we believe we can realize that this project receives the formal innovations and superior technology a subject of this kind requires. Given this, our participation has been decided as no less than five million francs.[1]

The documentary's provisional title—*Resistance and Deportation*—derives from the name of the exhibition[2] and reflects the tendency of the initial project to link the history of the resistance movement to that of the concentration camps. The agreement between historian and producer involved a scientific and a formal objective, with the additional goal of finding unanimous support from the associations of former deportees.

By emphasizing its merits as a work of art, Anatole Dauman gave the future documentary the ability to conquer audiences and a posterity, neither of which the Actualités Françaises newsreel compilation could ever have achieved.

THE ARGOS DECISION

Since its founding by Philippe Lifchitz in January of 1950,[3] Argos Films's reputation had been based on the artistic ambitions of its two owners and the value of a catalogue that included a dozen or so critically lauded, and in some cases award-winning, short films. Following in the footsteps of Panthéon Production founder Pierre Braunberger, Argos aspired to profound innovations within the documentary form. The company's activities reached a decisive point during 1955, with eight new films going into preproduction. The inestimable success of *Night and Fog*, Argos's "magnum opus"[4] in the field of short films, would vindicate the company's ambitions.

The choice for Alain Resnais as director perfectly fit this strategy of artistic innovation. His name was first mentioned during the March 1 production meeting that also saw the failure of negotiations with Nicole Vedrès for reasons of insufficient means for production and distribution. If Alain Resnais would turn down the offer, the producer considered contacting Jean Painlevé and Jean Grémillon.[5] The move from a seasoned filmmaker to a thirty-three-year-old hopeful finds its origin in *Paris 1900*, on which Resnais served as assistant director. In 1955, his name and work were already widely known among short film and art film circles. After his then-unreleased cycle of *Visites* (on painters including Coutaud, Labisse, Hartung, Doméla, Goetz, and Ernst), Resnais first gained notoriety in 1948 thanks to his film *Van Gogh*.[6] Produced by Pierre Braunberger, it won a prize at the Venice Biennale before going on to win an Oscar. A voyage into "the tragic architecture" of Van Gogh's paintings, it shows an impressive mastery of the art of montage,[7] particularly in the scenes of the artist's descent into madness, with its intercutting of close-ups linking the hallucinatory gaze of his self-portraits with the dark eye of the sunflower.

After a less groundbreaking *Paul Gauguin* (1950), Alain Resnais delivered in the same year, in collaboration with Robert Hessens, *Guernica*, the first meeting of art and the twentieth century's tragic history, an evocation of the "prelude to all massacres." Presenting Picasso's piece as the "argument for the documentary" and employing it like an unsequenced treatment,[8] Resnais let his camera explore the canvas while Maria Casarès read a Paul Eluard text in voice-over.

Statues Also Die, a documentary on traditional African art made with Chris Marker, won the Jean Vigo Prize in 1954 but was banned by the censors, who considered it an "anti-colonialist pamphlet."[9] The film strengthened Resnais's artistic reputation but also garnered him the reputation of a rebel, whose battles with the censor would have frightened off weaker producers than Anatole Dauman,[10] who bravely[11] reached out to the young filmmaker, whose body of work he already considered to be "one of the most important among the French school of documentary filmmaking."[12]

The memory of the participants is all that remains of the conversations that followed. Resnais declined a first offer made by telephone, judging that only a former deportee could make the film. Argos Films then brought in a friend of Resnais's, Frédéric de Towarnicki, to plead its case. This man serves as a marker in the filmmaker's life during the war years: the Phoney War (the period in World War II between September 1939 and April 1940 when it seemed that nothing was happening) and the refuge in Nice where they met while preparing for their graduation; the years in Paris (from the René Simon drama school through the first promotion from Idhec film academy) where Resnais brought supplies to Towarnicki while the latter hid in a room of the Hotel La Bruyère because of his Jewish descent; the French occupied zone where Resnais, wearing the uniform of the First Army, filmed and photographed the meeting of Private Towarnicki and Martin Heidegger at the philosopher's home in Zähringen in July 1945.[13] The dialogue between the two men continued in the fall of that same year, as Towarnicki brought Heidegger a leaflet on Dachau "with the rather theatrical notion of playing the righter of wrongs who wants others to confront proof of the horrors."[14] Several years later, it was Towarnicki who informed the philosopher that the young soldier who was present at their first interview had just made *Night and Fog.*

At Towarnicki's request, Resnais agreed to meet Dauman. The deal was finally struck under the condition that the narration be written by author Jean Cayrol, former detainee at Mauthausen, whose participation would "guarantee authenticity."[15] With his accomplice Chris Marker, Resnais often crossed paths with the poet at the headquarters of the publishing house Seuil, while also harboring a desire to adapt Cayrol's novel, *La Noire,* for the screen. In an interview with Roger Vrigny, Cayrol mentioned another earlier but also aborted partnership:

There was this quite astonishing project, around 1950, a film financed by a strange gentleman who was a prince. It was the story of Christ—simple, isn't it? We were supposed to shoot it in Aramaic, Christ's own language, then dub it. Chris Marker and Alain Resnais were on board as well. We had a good number of meetings in the prince's apartment, surrounded by these bizarre people who played music from the twelfth century.... I got to enter this very curious little world. We went to work before him, so to speak, and then, very suddenly, he disappeared. I think he was assassinated. Others took over the life of Christ.[16]

Whatever the nature of the agreement between filmmaker and poet, Alain Resnais's contract, signed and dated May 24, 1955, gives him complete freedom to choose the author of the narration. Cayrol's name was officially announced in July of that year at a production meeting during which Henri Michel and Olga Wormser approved the filmmaker's choice.[17] Cayrol signed his contract on December 1, after shooting had taken place in Poland and on the basis of a screenplay written by the director and the two historians.

To set up the documentary's production, Anatole Dauman and Philippe Lifchitz naturally turned to their partner Samy Halfon, owner of Como-Films, which shared its offices and staff with Argos.[18] The coproduction contract, signed on June 7, 1955, stated a 45 percent stake for Como-Films.[19] This division remained unchanged in the new contract of July 1, 1955, which also mentions the name of Cocinor[20] as a 20 percent production partner.[21]

Founded in 1948 by Ignace Morgenstern, Cocinor was a distribution outfit whose appearance in the contract represented an advance on the rights to distribute the film in France, Belgium, and Switzerland.[22]

The three companies at this point brought in a total of 3 million francs, or slightly more than half of the estimated budget of 5.8 million (a typical lower-range amount for a short film project in those days[23]). Henri Michel and Annette Lazard set to work at acquiring the necessary subsidies to complete the budget.

THE INSTITUTIONAL INVESTORS

The critical success of the exhibition *Resistance, Liberation, Deportation* facilitated the task of finding the financing to complete the budget. Still, not all the institutional investors were easily convinced. In January 1955, Henri Michel secured a subsidy commitment from the

ministries of Education and Combat Veterans, both of which had already supported the exhibit alongside the Paris city council and the Seine region's general assembly. On February 6, Michel's hopes were quashed with the fall of the Mendès-France government. At the start of the parliamentary debate, Michel informed the Réseau of his uncertainties: "As of this morning, we do not know what will happen with the support we had been promised."[24]

The return of the same minister of education under the new Edgar Faure[25] government meant the confirmation of a commitment worth 500,000 francs, to be handed over through the intermediary of the Centre National de Documentation Pédagogique—an indication of the filmmakers' intention to reach younger generations. The arrival of Raymond Triboulet as minister for combat veterans, on the other hand, required a renewal of negotiations. Annette Lazard once again made the pilgrimage and obtained the promise to honor previous minister Emmanuel Temple's[26] engagement. However, further insistence proved necessary after delays in the payment of the subsidy. The nature of Triboulet's hesitations becomes clear in a memorandum to his director of staff, in which Henri Michel explains that he included "a more detailed screenplay" in which the minister will notice that "the role of the resistance has not been forgotten."[27] Michel even noted that the producer would take the minister's "instructions and wishes into serious account." To win over this former resistance fighter—and member of the Ceux de la Résistance movement in the Calvados region—the project needed to follow the heroic model. Triboulet's official letter to the producers showed his desire for a degree of control over the project:

> All parts of this project must receive, as early as the pre-production stage, the approval of the Comité d'Histoire de la Deuxième Guerre Mondiale. In addition, given the nature of the subject it seeks to broach, it must receive my approval. The effective transfer of the above mentioned subsidy shall depend, let it be noted, on these two conditions.[28]

These financial injections were complemented in July by a subsidy from the Paris city council (665,000 francs) and the Seine region's general assembly (335,000 francs). The evaluation report[29] stated that Henri Michel's reputation and the success of the exhibit made the voting process by both assemblies a good deal easier, since it assured members about the project's intention:

This short film aims to explain in images the birth, creation, goals, workings, and the results of the concentration camp system. It should not, as Mr. Michel explained, contain any character linking it to current political tendencies. As previously emphasized in the exhibition, it will explain that the first detainees in the concentration camps were Germans who opposed the Nazi regime.

This reference to a pan-European debate then raging underlines that all levels of government were sensitive to the position of Germany and that this concern informed the film from an early stage.

Thanks to an additional sum of 300,000 francs from national broadcaster RTF (Radiodiffusion Télévision Française), the total outside investment amounted to 2.8 million. This gave the producers the financial backup necessary when presenting the project to the selection committee of the CNC.[30] This document did, however, contain a curious "blind angle": the budget made no mention of the cost of location shooting in Poland, which formed an acknowledged part of the production. Henri Michel brought up the subject to members of the Réseau in February 1955:

This film will partially be made with documents exhibited at the rue d'Ulm, as well as through location shooting in the concentration camps, notably at Struthof and Auschwitz, and through counter samples of footage shot during the liberation of the camps by English, American, and Russian troops.

Polish support was therefore indispensable, as Dauman admitted to the Federation for Polish Deportees:

We are incapable of obtaining by ourselves the sums required to finance such activities, which given the rights clearing would represent an overwhelming burden. Were you incapable to come to our aid, it would greatly restrict this project whose historical and moral interest shall not have escaped you.[31]

THE POLISH CONNECTION

As early as December 1954, Warsaw-born Anatole Dauman contacted the Parisian office of Film Polski.[32] His contact, Jan Korngold,[33] served as intermediary in the search for financing in Poland and authorized access to the organization's film archives in Paris.

During their stay in Poland for the tenth anniversary of the liberation of Auschwitz,[34] Henri Michel and Olga Wormser appealed to the people and institutions with which they had collaborated in the past, including the Institute for Jewish History in Warsaw, the War Crimes Service, Wanda Jakubowska, and the Federation for Polish Deportees (or Zbowid[35]). They also met with Mrs. Radkiensicz, head of the Documentary Film Studio, with the aim of obtaining permission to use its film archives. Response was mixed: Bernard Mark graciously opened the photo collection of the Jewish Historical Institute,[36] but the asking price for the Documentary Film Studio's services proved prohibitive. The Federation for Polish Deportees supported Argos's every initiative and made a plea on the company's behalf with the Polish Film Center but was unable to offer financial assistance before the fiscal year 1956.[37]

The prospect of another shooting delay alarmed Philippe Lifchitz, who expressed his concerns with Zbowid's president: "If we are unable to film in Poland (during September/October) the planned shots inside the concentration camps, we will to our great regret be forced to turn elsewhere, most notably toward Austria."[38] Present in Poland for the Youth Festival, Resnais's assistant André Heinrich[39] made another appeal to the Polish Film Center, which agreed in extremis to cover all expenses.

The contract was finally signed on the spot by Alain Resnais[40] on September 26, 1955. In exchange for distribution rights for the film in Poland and eight other communist countries (Czechoslovakia, Hungary, Bulgaria, Romania, East Germany, the Soviet Union, the People's Republic of China, and North Korea), plus one copy of Night and Fog, the Center agreed to lend equipment and cover travel and accommodation expenses for the entire crew, as well as the cost of shooting in Auschwitz and Majdanek. It also supplied a copy of archival plans concerning "Poland's concentration camps," selected by the filmmakers.[41]

This rather peculiar financial construction explains the absence of an entry relating to the shoot in Poland in the provisional presentation: it was a voluntary omission that allowed the producers to present a balanced and viable budget.

During its production meeting of August 31, 1955, Argos stipulated that the French authorities consider the transaction with the Polish Film Center "not as a coproduction but if necessary as a cession of the

film rights in exchange for certain services on which one must not overly insist."[42] This little arrangement can probably be explained through the criteria for obtaining the CNC's *prime à la qualité*,[43] which could not in fact be awarded to films mounted as international coproductions.[44]

The total sum of the Polish investment is nevertheless difficult to establish. Upon signing the contract, this amount is stated as 250,000 zlotys or around 13 million francs—a sum already superior to the average cost of a film of this kind in the 1950s.[45] In a different, rather mysterious agreement between the various parties,[46] the total expenses declared add up to 400,000 zlotys (over 21 million francs), an astronomical sum that does not correspond to the real cost of location shooting. Nevertheless, this was the amount[47] used as a guideline by the exchange office of the CNC in deciding the price for the film's rights for the Eastern European territories.

While the reasons for this sudden inflation remain obscure, it is a fact that *Night and Fog* was cofinanced to a considerable extent by Poland, for an amount equivalent to almost half its final budget.

INNOVATION AS MERIT

On the French side, the production considerably went over budget: the final cost came close to 10 million francs, a deficit of 4 million that landed entirely on the shoulders of Argos and Como.[48] Without going into details of accountancy, it can be concluded that the essence of this deficit was due to the willingness to provide the director with the means to realize his artistic ambitions. Two examples serve to illustrate the consensual financial sacrifices.

The original estimate included the sum of 300,000 francs for the music, which corresponded to acquiring the rights and remunerating the performers. The synopsis sent to the CNC mentioned the choice of "Peat Bog Soldiers"—a chant composed by the first German inmates of the concentration camps, primarily communists, and still in use among the *kommandos* of Birkenau, and which had become the unofficial hymn of commemorative ceremonies. The scriptwriters' ideas about musical accompaniment were therefore illustrative and conventional and at odds with Resnais's artistic principles. As the director's previous works demonstrated, his approach, as François Thomas has noted, was to make the music "an organic component of

43

the film," indispensable to its narrative structure.[49] Hearing of Resnais's preference for the eminent composer Hanns Eisler, Argos and Como agreed to expand the music budget by 800,000 francs—convinced that the maestro would turn down the offer.

The support for the filmmaker's artistic ambition was also clear in the considerable additional expenses voluntarily incurred because of the choice to film the Polish camp footage in color. Resnais suggested the idea during the June 1955 scouting trip in the company of Anatole Dauman and his historical advisers. Location shooting in the Alsace region had been canceled, but filming in the camps would be an integral part of the project. "I turned to Anatole Dauman," Resnais remembered, "and I told him ... I have an idea that might strike you as mad and that will have important financial consequences: I would like to shoot both in color and in black and white. He said yes, I see, that means printing the entire thing on color stock ... this would alter the budget quite considerably, but you know, we will seriously consider it. He didn't refuse."[50]

As soon as he had returned to Paris, Dauman requested a calculation of the cost of shooting in color, which was subsequently estimated at close to 1.4 million francs.[51] In late August 1955, Argos, Como, and Cocinor gave the director the green light to shoot in color.

This meant a big risk for the executive producers, who committed themselves to a project that was close to their heart for reasons both artistic and moral. By declaring himself convinced that "this project is not a business venture" but that he nevertheless felt closely attached to it,[52] distributor Morgenstern doubtlessly voiced the common position of the producers and distributors involved in the making of an ambitious film whose real cost can be estimated as close to 18 million francs—three times its initial estimated budget.[53]

These sacrifices so readily made were not, however, suicidal. Dauman gambled on obtaining the considerable advantage of the CNC's *prime à la qualité*.[54] Argos's owners had big ambitions for *Night and Fog*, counting on conquering the cinema world with the film's artistic innovation and originality "elevated to the level of merit"[55]—a strategy at which it amply succeeded.

3 A JOURNEY TO THE EAST
Research and Documentation

ARCHIVAL RESEARCH STARTED in the spring of 1955, concurrent with the writing of the script, and continued in Poland during location shooting. In the quest for photographs and filmed footage, Resnais closely collaborated with his historical advisers. The director regularly consulted with Henri Michel, but more often with Olga Wormser, with whom he shared his reading and his doubts: "She helped me a lot in finding photographs and documentation.... We became quite close."[1]

The director's contract betrays the intentions of his commissioners. It specifies three cinematic techniques:

> "an iconographic section, composed of documents illustrated with animated diagrams or objects representing authentic mementos of the deportation"

> "a 'montage' section composed of footage borrowed from French and foreign archives whose historical interest is beyond doubt"

> "a section consisting of new footage shot on locations that formed part of the deportation."[2]

If the location shooting formed the project's originality, the other components form trusted elements of historical filmmaking. The idea of using diagrams, like that of archival footage, is entirely in line with standard methods of making historical documentaries established in the decades preceding *Night and Fog*. The reference to "objects" and "mementos" can be explained by a desire to exploit the collection assembled for the exhibition by the Comité. Catalogues of the exhibit

tell us of the nature of the pieces assembled and the approaches of its two curators.[3]

THE EXHIBITION *RESISTANCE, LIBERATION, DEPORTATION*

Henri Michel and Olga Wormser based the structure of the deportation section of the exhibit on the table of contents of *Tragédie de la Déportation*, itself inspired by the different stages of the deportation: departure and transport by convoy / arrival at the camp / the misery of daily life / labor / categories of deportees and camp hierarchy / "human endurance" (solidarity, spiritual and intellectual life, etc.) / illness and the *Revier* / death / evacuation of the camps and liberation of the inmates. In other words, the exhibit's layout and the placing of signs and display cases describe the typical itinerary of a deportee, compared to the Stations of the Cross.[4]

From the basis of this thread, the space named "Torture and Deportation" presented visitors with a collection of handwritten and printed documents, art (drawings, paintings, sculptures), and objects related to the deportation. Included were sketches, pencil drawings, and wash drawings by Boris Taslitzky[5] and Paul Goyard (Buchenwald), Maurice de La Pintière (Dora), Édith Kiss and Mrs. Frouin-Auburtin (Ravensbrück).

The objects borrowed from former deportees occupied large sections of the display cases and formed an eclectic ensemble:

> camp attire (trousers and shirts, armbands, caps, clogs) alongside items of nonregimented clothing ("brassiere illegally sewn into a camp shirt," "luxury panties");
>
> objects fabricated in the camps (bowls and cutlery, brooches and crucifixes, boxes, puppets, decks of cards) or brought home during repatriation (including a bread crust, a piece of granite from the Mauthausen quarry, and barbed wire from Buchenwald).

Added to these relics were pieces that formed a museum of horrors and which echoed the first newsreel compilations on the deportation and the organized visits to the liberated camps: "desk blotter made of human skin" discovered in Buchenwald; "tongs for remov-

ing incinerated corpses from the crematorium" on loan from the Fédération Nationale des Déportés et Internés Résistants et Patriotes, and so on.

Beside these odds and ends were historical documents of quite a different nature: photographs taken during the Nazi reign and at the liberation of the camps, interrogations of the criminals, eyewitness reports, registers of the deceased. Also on display, thanks to loans from the Centre de Documentation Juive Contemporaine, were "messages illicitly sent from Auschwitz" to the Polish resistance as well as a copy of the "Auschwitz scrolls," a collection of inmates' testimonies and testaments buried in the vicinity of the crematorium by the Birkenau *Sonderkommando.*

The way we regard these documents today is quite different from how visitors of the exhibit regarded them at the time. Their value today results from the rarity of traces from the extermination centers and the fact that they form a resistance to the Nazi policy of secrecy surrounding the Final Solution. At the 1954 exhibit, these testaments from Auschwitz were displayed amid other objects and documents about the "Nazi camps" and were given no special status. People's mental, historical, and memorial frame of reference in 1954 did not allow them to grasp the uniqueness of these documents and to adequately contextualize them.

When it comes to the camps in Poland, advances in knowledge still went hand in hand with persistent fantasies inherited from the war years, which had prospered on the fertile terrain of secrecy. The exhibit mentioned "Auschwitz's factory for human soap," a tenacious rumor that continued to hold sway in museology on the extermination camps and the Jewish genocide. The display of a canister of Zyklon B gas brought back from Auschwitz by a former deportee similarly testifies to the strides made in our historical awareness: it confirms that it had been long known that this gas was employed to homicidal ends and the persistent approximations about its use and its chemical specifics.

In similar fashion, the exhibition's catalogues and inventories teach us a lot about the level of knowledge communicated toward the public as well as fixing the framework of the representation and "collective imagination" of the deportation during the 1950s. They furthermore offer insight into the period's conception of museology,

47

itself stemming from a much older tradition of eventful public display of history and death.[6]

Contemplation, piety, national unanimity—these were the terms chosen by Henri Michel to evaluate the event, terms and a semantic register often echoed in press coverage.[7] To understand the experience of the visitors at the time, it is necessary to be aware that the deportation section was conceived in synergy with the area named "Resistance and Liberation." The curators hereby sought to closely associate the heroism and misery of the French people by presenting the struggle of the resistance and the deportation as two sides of the same coin. The celebration of the honor and sacrifices of the martyrs of the deportation, like the reliquary dimension of the exhibit, fit snugly into the remembrance policies of the Réseau, an active supporter of the Comité. This double-sided message was perfectly relayed by the press, as Jean Boniface's comments illustrate:

> We do not arrive as visitors, but as pilgrims. We pass through it in silence, as if we were in a sacred place populated with relics and invisible presences. We depart deeply moved. "Resistance, Liberation, Deportation"—recto and verso, face and flipside, glory and martyrdom, epic and tragedy. In the first two halls you tremble with admiration, in the last, anguish seizes you by the throat.[8]

The question remains as to how Resnais regarded the pieces assembled by the Comité.[9] It must be noted first that the filmmaker's oeuvre at that point went contrary to any sort of museum-like views of history and art. Even before the silent showcases of Hiroshima, the museum appears in *Statues Also Die* as a funereal, necrophagous place, where African art becomes a "dead object" unseen by living eyes.

From the pieces collected by the Comité, Resnais chose a large number of photographs, while limiting his selection of documents and objects to a strict minimum, contrary to what Olga Wormser and Henri Michel had imagined.[10] The filmmaker used not a single one of the exhibited drawings, even though some of them resembled details of the paintings of Saint-Rémy used in *Van Gogh*, such as the characters (or inmates) in the hospital courtyard. Resnais included one shot of the poster *Eine Laus dein Tod* (One louse means you are dead[11]), brought back from Auschwitz by a former deportee. Along-

side the blueprint and the scale model of the Auschwitz crematorium, it formed the only graphical elements of the film, what with the original intention to use "diagrams" having been abandoned along the way.[12] From among the gathered documents and objects, Resnais chose the Mauthausen death register, a recipe, and Germaine Tillion's linen covered in writing, to which he added a box that belonged to Jean Cayrol and several shots of objects filmed in Poland. These images appear in the sequence on victims resisting the Nazi extermination machine.[13]

Finally it should be noted that an entire panel at the exhibit (featuring photographs, sketches, a poem by Minister André Marie, and various wooden objects, among others) was devoted to the famous Goethe oak at Buchenwald, which served as a gallows until it was destroyed in the bombing raid of August 24, 1944. The parallel with his film on Picasso could not have escaped Resnais, since Eluard's commentary opens with a reference to the oak at Guernica, "sacred symbol of Basque tradition and freedom." The destruction of this tree formed the "prelude to all massacres," while that of the one at Buchenwald was seen by the detainees as a good omen. Included in the *Night and Fog* montage is a photograph of the oak taken by prisoner Georges Angéli, while Jean Cayrol's voice-over announces: "They built the camp around it, but left the oak standing."[14]

Added to the photographs previously assembled by the Comité were images from the archives of the Belgian Mission,[15] the various deportee federations—chief among these the Amicale de Mauthausen—and the CDJC. At the latter, the trio selected the photograph of "Vél' d'Hiv," the Vélodrome d'Hiver, dated on the reverse July 16, 1942. In 1983 Serge Klarsfeld discovered that it does not depict, as previously believed, Jews arrested during the great roundup of Paris, but suspects of collaboration gathered in the same location shortly after the liberation.[16]

At the CDJC the team also chose the photograph of the "Gendarme of Pithiviers"[17] and other images of the persecution of Jews, to which were added a large number of pictures discovered in Poland.

Compared to gathering the photographs, the search for filmed footage that was required for the second element of the film proved more laborious and strewn with institutional obstacles.

FIGURE 4. The Vélodrome d'Hiver During the Liberation. Screen shot. Reprinted by permission of Argos Films.

VOYAGE TO AMSTERDAM

The search began in France in 1955, in the archives of Actualités Françaises and with an eclectic assemblage of scenes, reports, fictional sequences, and documentaries, made available by various associations of former deportees, the CDJC, Gaumont, UGC, and the Cinémathèque Française. The objective of these screenings was to find useful footage, but also to index existing films on the deportation.[18]

According to Alain Resnais, trouble started when the team contacted the French army cinematographic service SCA (Service Cinematographique de l'Armée)[19] and planned a visit to the British Imperial War Museum:[20]

> There existed a strong, almost suffocating solidarity between the military authorities in Europe to erase these films, or at least to never show them. I experienced this as soon as I requested a screening. In England I was thwarted almost immediately and the same happened with the cinema service of the French armed forces. They showed me a few things, but nothing interesting, all very commemorative, very official, unveilings of monuments to the dead, ceremonies of that kind.[21]

Resnais elsewhere explained that "the three or four shots," all quite insignificant, he selected at the SCA were finally refused due to the "nature of the film."[22] "By which they meant the nature of the director," he added, recalling how *Statues Also Die* had hardly won him favor with the French military. However, though his anticolonial viewpoints likely were an aggravating factor, the refusal was most likely motivated by *Night and Fog*'s subject matter. There was effectively a disturbing coincidence between the SCA's response and the debate brought into parliament by communist deputy Pierre Villon in July 1955. Villon questioned the defense minister about a "memo demanding the centralization of all films on war and resistance, which is to say their return to the army's cinematographic service with the intent of destroying the films or the passages considered to be offensive to the Germans."[23] The parliamentarian added: "It appears that among the films scheduled for destruction certain possess undeniable historical value, such as the films shot during the crossing of the Rhine by the First Army and the American wartime propaganda film series *Why We Fight*. Finally we have the films on the camps, the documentary footage, incontestable testimonials against Hitler's crimes."[24] Defense Minister General Koenig confirmed that films were scheduled to be grouped together, but assured the deputy that he would personally see to it that the films mentioned would not be destroyed. In this atmosphere of confusion, in which the military was centralizing its film archives to rather obscure ends, one imagines that the SCA was cautious when it received Alain Resnais's request for information, even though his film was partially funded by the Ministry for Combat Veterans.

Obstructed in their search by the French and British military, the crew turned to the Dutch Institute for War Documentation in Amsterdam.[25] This move to the Netherlands would prove extremely important for the remainder of the project. There, Henri Michel, Olga Wormser, and Alain Resnais found[26] the footage shot by the British during the liberation of Bergen-Belsen, which constitutes the essence of the final part of the film on the opening of the camps. They also discovered the sequences about Westerbork, Holland's equivalent of France's Drancy camp,[27] which Resnais chose to edit into an extended sequence accompanied only by the musical score.[28]

The choice to suppress the narration in this sequence indicates the director's confidence in the intrinsic power of these images. The

footage of Westerbork shows the embarkation and departure of a deportation transport train from the Dutch internment camp on May 19, 1944. We see the preparations for the convoy: a crowd of men and women, packed with luggage, huddled together on a platform loaded with baggage. An aged lady on a rolling stretcher is pushed into the frame twice, in opposite directions. Stars of David are visible on jackets and coats. Members of the *Ordnungsdienst* (Jewish order troops[29]) stand in front of railway cars already full of people, handing passengers a wooden barrel. Impassive and haughty German officers consult lists and give instructions. Finally, soldiers and order troops close and lock the doors. A few faces can still be seen in the cracks between the wooden panels. The convoy begins to move, shaking hands emerge through the narrow openings while officers pull themselves up onto the steps on the side of the front carriages.

This recording ties in with descriptions given by witnesses to the Westerbork transports. Etty Hillesum related that order troops furthermore would cut off all paths leading to the platform, after which the cars were loaded while the head of the request service would attempt to negotiate to save a few human lives from their tragic fate. Commanding officer Albert Konrad Gemmeker[30] would eventually appear "at the end of the asphalted pathway, like a star performer entering the stage during the grand finale."[31]

However, what interests and intrigues us about the Westerbork footage, beyond the factual information it delivers, is its framing and the conditions under which it was recorded. These scenes are striking for the implacable and calm continuity of the stages of embarkation. There is no visible violence—things seem peaceful even: on the edge of the platform, a couple exchanges a furtive, almost distracted kiss; a man already on board chats with a member of the *Ordnungsdienst* charged with locking his car; another even helps to close the door.

A similarly serene ambiance is found in the photographs of what has become known as the "Auschwitz Album," which show the other end of the same voyage (one of which was used in *Night and Fog*). This collection of ninety photographs was taken during the arrival, in May 1944, of a transport of Hungarian Jews at Birkenau[32] and forms a unique recording made within a perimeter where any form of photography was rigorously forbidden.

In this sense, the Album drives a wedge into the policy of invisibility that held sway in the extermination centers. Serge Klarsfeld, who

was in large part responsible for its notoriety, wrote that the Auschwitz Album was as precious as "the Dead Sea scrolls." This photographic "report" neatly shows the stages[33] of the convoy's arrival: transport halted at the platform; waiting on the ramp; "selection"; incursion into the camp for those deemed "apt" to work; the sorting of personal belongings; a view of the other line, that is, those considered "inapt," grouped together for their last stop among the trees. Like the images from Westerbork, the photographs show no sign of violent coercion. They show states rather than actions: opened railway cars; waiting on the platform; neat rows of people. The act is only present in its results, as in the line of shaven-headed women. It is our knowledge about the events that gives these images back the violence hidden within them, that allows us to imagine the gas chamber just outside the frame and to understand that these old people, women, and children are waiting on death's doorstep.

Despite numerous attempts, the reasons why and conditions under which the photographs in the Auschwitz Album were made remain relatively obscure.[34] More information exists on the Westerbork film, which, as Ido de Haan explains, was commissioned:[35]

> To demonstrate the usefulness of the camp, Gemmeker ordered three detainees in the spring of 1944 to produce a film about life in Westerbork. The script was written by Heinz Todtmann, a baptized Jew, member of the *Ordnungsdienst* and a close aide to Gemmeker. After the commander had approved the script, two other inmates, photographer Rudolf Breslauer and his assistant Karl Jordan, filmed activities in the camp between March and May 1944. The film survived the war. In addition to various scenes of labor, it shows a religious ceremony (a Protestant service for baptized Jews), a stage performance, and other leisure activities. But the film's importance rests with showing the arrival of detainees at the camp, and above all the departure of the deportation transport on May 19, 1944.[36]

Whether they were intentional (and sometimes arranged) or simply authorized, the Westerbork and Auschwitz recordings offer the only visible part of the reality, recorded at the criminals' behest. It is on them that these images finally turn, through the concealed violence of the event, through their relationship with their context and the world beyond the frame. Anticipating the montage section, it should be noted that Resnais incorporated a cut and an insert in the Westerbork sequences by integrating two shots, of Polish origin, of an old man slowly walking along a train platform accompanied by

three small children.[37] Through this act, introducing a foreign element discovered at the Warsaw Documentary Film Studio,[38] the director questions the false tranquillity that dominates the Westerbork scenes.

Amid the images from these two series, present in *Night and Fog* and often recycled since the 1980s, there is one from the Westerbork sequences that had a singular destiny as a symbol of the extermination of Europe's Jews. It starts on the side of a railway car inscribed with the text "74 Personen," then pans upward to stop on the face of a child in a headscarf, visible in the space between the doors and staring into the lens.[39] In 1992, Dutch journalist Aad Wagenaar undertook an investigation to uncover the child's identity. After two years of research, he discovered to his surprise that there was quite a difference between the reality of the image and what it symbolized.[40] The girl's name was Anna Maria *Settela* Steinbach, born in 1934 near Born in the south of the Netherlands, murdered in Auschwitz on the night of August 1 and 2, 1944. This girl, however, was not Jewish. Of Sinti origin, she was deported from Westerbork with 244 other Gypsies alongside Jews on the mixed convoy of May 19, 1944.[41]

FIGURE 5. Westerbork: Anna Maria Settela Steinbach. Screen shot. Reprinted by permission of Argos Films.

This movement of identification is typical for our new attitude toward these images. It fits in with a wider evolution that consists of giving names to the anonymous victims long hidden away beneath the overwhelming mass of statistics, in a more global and abstract apprehension of the extermination. This undertaking is largely thanks to Serge Klarsfeld and his association, which published, transport by transport, the names of all Jews deported from France. For several years now, this imperious gesture extends to the images whose use is exponential in commemorative publications, memorials, and museum spaces. As a result, the 2002 re-publication of the Auschwitz Album in the United States included the names of almost two hundred deportees identified in the photographs. The same desire to render names and faces to the victims was noticeable in the conception of the French pavilion at Auschwitz refurbished on occasion of the sixtieth anniversary of the liberation of the camps.[42]

Another image, also present in *Night and Fog* and even more famous—that of the little boy with his arms raised in the Warsaw ghetto—has been the subject of multiple investigations and uses. The original photograph, first released in 1943 in a report by German General Jürgen Stroop, shows the arrest of just over a dozen people emerging from a building at gunpoint and with their arms raised. After the war, the image was reframed to emphasize the child, anonymous symbol of assassinated innocence, a figure both universal and adaptable to any current struggle. This reframing finds its origin in Erwin Leiser's film *Mein Kampf* (1960): the German-born director shows the entire photograph first, then reframes the image on the child.[43] Since then, the image has migrated over into the most diverse set of cinematic works: a work of fiction by Ingmar Bergman (*Persona*, 1966); Marcel Ophuls's *Memory of Justice* (1976), which zooms in on the image in its epilogue; Jean-Luc Godard's *Histoire(s) du cinéma* (1998), in which the director found himself troubled with the resemblance between the boy from Warsaw and himself as a way to mark the difference between his own carefree upbringing on the shores of Lake Geneva and the tragedy that was happening at the same time in Poland.[44] These filmed convocations of the photograph taken in the ghetto do not all follow the same narrative logic. In *Persona*, the image marks a point of revival and collapse, "a figure of the untranslatable" that we, unsuccessfully, attempt to decipher within the economy of the film.[45] In *Memory of Justice* the photograph functions as a

FIGURE 6. A "secular icon" (S. Sontag). The Warsaw ghetto. Screen shot.
Reprinted by permission of Argos Films.

dedication and forms a point of convergence of the various narratives. Godard takes note of its iconic status: through superimposition he adopts a movement opposite to the focus on the child, who is isolated on the right side of the screen, in order to reconstruct the wide view of the original image.[46]

By the end of the 1980s the image of the boy from Warsaw had indeed become an "icon of the Shoah," often retouched by unscrupulous users that had no qualms about adding a yellow star to his little overcoat. The Ghetto Fighters' House Museum, Yad Vashem, and the Holocaust Memorial Museum in Washington, D.C., have received countless letters, visits, and calls from people who thought they recognized themselves or a loved one in the photograph. In 1990, a documentary was made about one of these pretenders, Tsvi Nussbaum, entitled *A Boy from Warsaw*.[47] Seven years later, the boy was plastered all over the walls of Paris metro stations in an ad for the French rock band Trust.[48] During the summer of 2005, the photograph was subject to a particularly dubious political application during a phase of the Israeli retreat from the Gaza strip: a family of settlers in Atzmona

had its eight children parade, arms raised and moaning, in front of the news cameras in a reenactment of the famed image.[49]

Sixty years earlier, Resnais chose it in Warsaw as one trace among many, respecting its meaning and framing.[50] This image then brings us to the efforts of documentation undertaken by the film crew in September 1955.

THE POLISH HARVEST

After the contacts established during the spring with various Polish archives, Alain Resnais, Henri Michel, and Olga Wormser expanded their photographic and cinematic documentation during their stay in Poland for location shooting.

At the Institute for Jewish History, whose director, Bernard Mack, had graciously offered them access, they found, aside from the image of the "ghetto child," several photographs from the Auschwitz Album,[51] some pictures of the construction of the camps, and photographs of executions by the *Einsatzgruppen*. Other images were selected from the collections of the War Crimes Committee, notably those portraying deportees working in the snow.

At Warsaw's Documentary Film Studio they viewed films and scenes, including many preselected by Wanda Jakubowska:[52] extracts from Soviet and Polish newsreels; footage shot by four Red Army cameramen during the liberation of Auschwitz;[53] shots of roundups in Polish cities and ghettos. The final stage of the search for documentation took place at the museums of Majdanek (line of children in pullovers, photographed from the back) and Auschwitz, where they learned about the four photographs taken surreptitiously by members of the Birkenau *Sonderkommando*,[54] as well as the series of photographs taken in July 1942 during Himmler's visit to Auschwitz.

This last discovery also proved of importance to the historical consultants. In March 1956, in *La Voix de la Résistance*, Christian Bernadac wrote about the efforts of documentation in an interview with Henri Michel. The author in particular emphasizes the discovery of a "striking document": "Himmler's visit to Auschwitz. A moving document, since the fate of the Jews depended on this visit. Death would replace suffering." The photograph found by *Night and Fog*'s film crew shows the first part of the *SS Reichsführer*'s visit, as he inspects the construction sites of

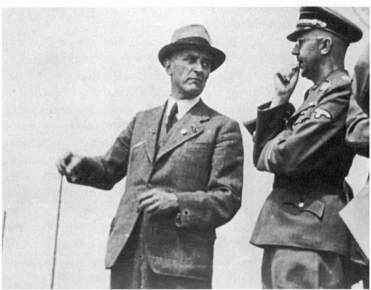

FIGURES 7A AND 7B. Himmler at Auschwitz-Monowitz. Screen shots. Reprinted by permission of Argos Films.

the Buna factory at Monowitz in the company of Höss and several representatives of IG Farben.[55]

In the final edit of the film, this set of a dozen photographs marks an important scansion of the narrative that, as we will see, was more explicitly emphasized in one of the earlier versions of the screenplay.

We can therefore identify a double movement in the efforts of historical documentation: gathering documents already known or whose whereabouts had been verified that would give visibility to a narrative already largely written, and the unexpected discovery of unpublished documents that adjusted knowledge through image, some of which would influence the editing and the writing of the text.

During the month of November, after the film's production, the producers made a final attempt to contact the archives in East Berlin. Veb-Defa sent them an amicable but dilatory reply.[56] Several years later, Erwin Leiser would gain access to the East German archives for his film *Mein Kampf.*[57]

This assiduous quest would leave Alain Resnais with a nagging sense of unfulfillment:

> I had this horrible feeling: that we needed another year of research, that there were other documents in existence. But we were on a deadline, so we did what we could. . . . Plus, we had no money left to travel to Germany and many other places, even to simply search for documents.[58]

On top of budget constraints and institutional rigidity came a merciless countdown: in order to obtain the *prime à la qualité*, the film needed to be finished by December 31, 1955.

Yet, the director's retrospective sense of dissatisfaction does not entirely do justice to what was accomplished in spite of the obstacles. This is particularly true of the ambitious nature of the research and the choice to widen it to include the Polish centers of documentation, which would greatly influence the making of the film.

Whereas the documentary *The Death Camps* consists of a summary montage of sequences provided to Actualités Françaises by the Western Allies, *Night and Fog* was the result of an actual research effort, in addition to that already undertaken for the exhibition. From the project's inception, its backers underlined this ambition by providing 400,000 francs, a generous amount for the period, for securing rights

from archives.[59] The ambition in terms of documents also corresponded to the desire to reach a wide audience, as Samy Halfon explained to Film Polski in June 1955: "We attach the highest value to gathering all the original documents that will attract a greater audience to our film."[60]

What is more, the film *The Death Camps* consists uniquely of footage shot at the liberation of the western camps, while the images selected for *Night and Fog* open up both time and space to offer a glimpse of a different story, one kept largely obscure during the liberation: that of the deportation of Europe's Jews. In this regard, the contacts established by the two historians proved decisive; the photographs and footage gathered in Poland—in addition to the Westerbork footage—show the stages of the persecution of the Jews—ghettoization, arrests, internment, deportation—that preceded their extermination in the death camps. Whether these images—incorporated into the logic of a montage and a commentary that were ignorant of their uniqueness—were understood as such by their contemporary audience forms a different story that we will return to later.

It is worth wondering if Resnais's "bitterness" was fed by an exaggerated, and therefore misleading, appreciation of the wealth and variety of the documents truly available at the time. Certainly, the film crew's access to the American archives' footage of the liberation of the camps in the west was greatly restricted.[61] Yes, their consultation of the Russian archives was limited to footage shot during the liberation of Auschwitz.[62] Yet it is entirely uncertain whether an additional year of research and an extra injection of funds would have made a fundamental difference to the body of the film—for two conflicting reasons.

The scattered corpus of photographs would not actually be catalogued, assembled, and captioned until a renewed surge of interest in these images occurred at the end of the 1980s. As regards the specific issue of the centers of extermination, the film crew without realizing it was already aware of the only documents known at the time to be recorded during the Nazi reign near the gas chambers (i.e., the not yet dispersed items of the Auschwitz Album and the four clandestine photographs taken by the Birkenau *Sonderkommando*). However, this rarity, related to the Nazi policy of invisibility and the destruction of traces of the genocide, was for them simply impossible to perceive. It is within this vacillation between the feeling of incompleteness and

the period's incomplete knowledge of image sources that we need to understand the editorial choices made on the film.

For several decades the films of Alain Resnais and Erwin Leiser functioned as an inventory of documentary research. In Germany as in France, the images selected for *Night and Fog* and *Mein Kampf* were the subject of intensive reuse in a great number of films and television programs. The implementation of these two works as archive catalogs would subside with a growing demand in both countries for "new images" that coincided with the fiftieth anniversary of the liberation of the camps.[63]

4 WRITING FOUR HANDS

NIGHT AND FOG's NARRATIVE CONSTRUCTION is the product of a constant back and forth between research and writing. From the first synopsis through the consecutive versions of the script, the stages of writing reveal a noticeable evolution of the concept.

Olga Wormser and Henri Michel wrote the first synopsis in late February. It laid down the general intent of the project and permitted the search for institutional financiers.[1] A more developed version followed in March–April 1955 and already presented a preselection of document sources.

In June Alain Resnais was commissioned to develop his screenplay on the basis of these synopses and in collaboration with the two historians. Here again, the role of Olga Wormser proved decisive: she brought in her knowledge and most recent discoveries and committed herself "enthusiastically and lyrically"[2] to the writing. In July, Resnais's text was the subject of several writing sessions before emerging as a scene-by-scene screenplay quickly approved by the Comité d'Histoire.[3] During location shooting in Poland, the three authors made some adjustments. It was not until the final stage that a fourth hand entered the scene, that of Jean Cayrol (with some help from Chris Marker). In chapter 7 we will study in more depth this last step in the writing, during which the poet's gesture came to complement the filmmaker's.

FRANCE'S DEPORTED: THE STAGES OF AN ORDEAL

The contract with Olga Wormser and Henri Michel stated that they were hired as historical consultants and scriptwriters of the documen-

tary, functions that would never appear as such in the on-screen credits of *Night and Fog*.[4] Between February and April 1955, the two historians were free to imagine the film as they saw fit—a film that would never be made but that would be absorbed into Resnais's work.

The anthology *Tragédie de la Déportation* served as blueprint to the first draft of their synopsis. "What struck us as the best method . . . was to follow the stages of the ordeal suffered and shared by *all deportees*: internment, transport, arrival, adoption into the concentration camp system, daily life, labor, disease and death,"[5] the historians explained.

The nine chapters of the anthology were reduced to seven narrative units: departure and arrival of the transports, conception and organization of the camp, a day in the life of a deportee, labor in the camps, the *Revier* and death, escape and resistance, liberation and homecoming. A prologue taken from the layout of the exhibit promised to evoke "the atmosphere of occupied France." The sole original element of this first draft consisted of the addition, toward the end of the seventh chapter, of a sequence entitled "Pilgrimage to the Camp."

This synopsis was next developed and slightly reorganized into nine sections tracing "the life of a 'typical deportee' from internment in France through their death." Each of these thematic sequences now also included indications for image sources (filmed footage, photographs, drawings, objects).[6] The desire to privilege the experience of the witnesses also spoke from the suggestion to give them a voice: "We suggest that the narration be made up of the stories of genuine deportees, delivered by themselves as in a tragedy with multiple voices."

It was the experience of the survivors that formed the point of view of the film at this stage, which placed the project within a communication strategy that bore the hallmarks of the Réseau. This did not exclude the ambition (shared by certain deportees such as Eugen Kogon, David Rousset, and Germaine Tillion) to offer a "sociological explanation" for the concentration camp system. The first synopsis already announced that, while former deportees would recognize their ordeals, "ordinary spectators" would come to understand the "systematic nature, in their fusion of cruel barbarism and scientific experimentation, of concentration camp phenomena." This explanatory function was reserved primarily for the sequence named "Conception and Organization of a Concentration Camp":

"Everything is calculated to take millions of men and women out of the world of the living. They live in a tower of Babel of races and

peoples, in complete lack of privacy (a speaker explains this while the different images of the blocks unroll)."

In the second draft of the synopsis, the historians propose instead the topography of a concentration camp:

> "Us, in this space without exit from which millions of people did not return"
> A shot of a camp: Mauthausen (?)
> Visit to Struthof or Auschwitz (+photographs of various camps): the speaker provides indications (no music) about the different sections of the camp, thus providing the spectator with a tour like of a desert populated only by death.

An imperceptible shift was taking place, from stages to functions, from the typical deportee to the typical camp. Space was given to the camera, in the inaugural form of a visit to the site. The first action that placed the narrative in the present, this sequence took into account traces as much as memories.

The choice to shoot in the actual places of deportation had been made in February, but the shoot was still being organized when the two historians delivered this final synopsis. The choice of which camp to focus on mattered little to their structural approach: Mauthausen, Auschwitz, Struthof, and Buchenwald seemed interchangeable, organized according to similar principles that simply needed to be brought to life. Each particular element needed to contribute to the elaboration of a generic model of *a* concentration camp.

This unequivocal vision left little room to consider the genocide of the Jews, diluted to the point of dissolving into the overall concentration camp system. The narrative made no mention of those who never actually entered the camps proper but were gassed upon arrival. Only the section devoted to death—which distinguished "'natural' individual deaths (overcrowding, absence of medical care)" from "induced death (torture, execution, experiments)" and "collective death (gas chamber and crematorium)"—provided, like the anthology, an opening to evoke the extermination of the Jews and the Gypsies.

The synopses did not, however, gloss over the destinies of victims of the genocide. In a "look back" on the rise of Nazism, Michel and Wormser cited "lines from *Mein Kampf* on the extermination of adversaries and inferior races." They envisaged developing the topic of the persecution of France's Jews, inspired by one of the panels in the

exhibit:[7] "The fate of the Jews (census, the star of David, despoliation, the internment camps). A roundup . . ."

From their arrest to their deportation, seen as taking place on French territory, the Jews were thus lumped in with "the entirety of deportees." After all, a "typical deportee" was one deported *from* France. This rigid vision is hardly surprising, since the history of the deportation was initially written within a national framework. Olga Wormser's activities at Frenay's ministry pertained to the reception of and the search for people deported from France; it was their testimonies that had been recorded from 1945 onward and their stories that *Tragédie de la Déportation* focused on.

In the two historians' final synopsis, the "Resistance has not been forgotten," as Michel had assured Triboulet. It likely was this version that was sent to the minister in June 1955. The preamble was enlightening in this respect: it consisted of the triptych Occupation/Resistance/ Terror, whose terms were articulated as a consecutive chain. The resistance thus appeared as a response to the politics of the country's occupation and the persecution of the Jews. The sequence was meant to be illustrated with underground tracts from the collection assembled for the exhibit and with excerpts from other films: *The Battle of the Rails* for sabotage, *Au coeur de l'orage* for the maquis, and *La Libération de Paris* for the French Forces of the Interior.[8]

The dominance of the heroic model underscored the description of life in the camp. The section "Escape and Resistance" places the deportation within the context of a struggle for values that continued within the very heart of the concentration camp system. Each component started from the same narrative principle: "The general idea is presented as a listing of facts that invariably ends with an act of resistance."[9] The sequence tracing the day of a deportee ends on an act of bravado against an SS officer or a *kapo,* that on labor on an allusion to "sabotage," and that on the *Revier* on "scenes of solidarity" (the only proposition retained for *Night and Fog*).

Michel and Wormser's synopses were essentially written to seduce investors. At this early stage of the project, the two historians, fully in charge of the writing of the film, recycled the contents of their previous efforts (book and exhibit) praised by institutional financiers and the circle of former deportees.

From the spring of 1955, the search for documentation was enlarged and Resnais entered the picture, bringing along his own

views on the conception and realization of the film, which thereby gained both ambition and complexity in historical as well as artistic terms.

GENESIS OF THE CONCENTRATION CAMP SYSTEM

The production meeting of May 28 gave the film a new framework: to "explain clearly how the concentration camp system (its economic aspect) flows automatically from fascism."[10] The "birth of the camps" would therefore be evoked "at the same time as the Nazi victory in 1933." Though the filmmakers still planned to insist "a little more on the fate of French prisoners," they agreed to move from a national perspective to a view, from Nazi-Germany, on the genesis of the concentration camp system. It was Olga Wormser's research that inspired them to place the accent on the economic dimension of the camps. In July 1954, she published a well-received essay on the role of camp labor within Germany's war economy.[11]

The initial commemorative emphasis dulled in favor of a meditation on current times: to explain that "the potential for evil exists in all of us" and to warn contemporary audiences that "fascism is always a possibility."

The writing of the film increasingly focused on a specific site, Auschwitz, which gradually shaped the film. "Visiting Auschwitz ten years after, we digress on each object or place encountered in the camp."

While the principle of the interchangeable nature of the camps was reaffirmed, Auschwitz and Birkenau began imposing themselves. Returning from Poland with Olga Wormser, Henri Michel considered that "the spectacle of the empty camps and the museums that hold the personal belongings of the detainees" could not fail to impress Alain Resnais "in the highest degree" and perhaps "influence [his] conception of the film."[12]

During the same meeting, the documentary, initially entitled "Un homme, une chose, une poussière" (A man, a thing, a speck of dust), then "Resistance and Deportation," found its definitive title:

Most likely:

Night and Fog

(if necessary inquire about obtaining rights Odette Amery).

This new title did not fundamentally change the meaning of its predecessor, even if it rendered it more obscure for noninformed viewers, while at the same time lending it an aura of poetical mystery. The NN *(Nacht und Nebel)* procedure was instituted by the December 1941 Keitel decree, after which it was gradually applied across occupied Europe. It stipulated that resistance fighters arrested in their countries of origin would be taken to Germany so that no one would know what happened to them. They would effectively disappear without a trace, into "the night and the fog."[13] Third Reich lingo borrowed the expression from Richard Wagner, in whose *The Rhine Gold* "night and fog" forms a magical formula that allows whoever pronounces it while wearing a helmet to disappear from the eyes of the world.[14] From the tetralogy to the documentary, by way of the Keitel decree, the choice of the definitive title marked a passage into the realm of art, confirming the film's literary dimension.

It is nevertheless peculiar that Argos considered the expression "Night and Fog" to be a registered title, and more so in that it referred to Odette Amery's eyewitness account and not to Jean Cayrol's (himself classed NN) poetry collection published around the same time.[15] As in the case of *Shoah*, its obscurity and air of mystery allowed the title to lodge itself durably in people's minds. Resnais's film contributed to the public notoriety of the expression "night and fog" while at the same time establishing it as a metaphor for the deportation, a metonymic process continued by Jean Ferrat's 1963 song of the same name.[16]

With the new dimensions of the project fixed, the second phase of writing was launched on June 16, 1955. Resnais was given the task of writing the screenplay in two or three weeks and submitting it "to the crew that will assess it with the help of mementos from the locations of the deportation."[17] The function of the document was twofold: it allowed for location shooting in Poland and the selection of photographs and filmed footage. Contrary to the synopsis, it was meant for circulation among the filmmakers only. Its successive changes were the fruits of an assiduous exchange between Resnais and the two historians charged with the decision of approval. With the synopsis as a starting point, the filmmaker proceeded by making additions and more clearly deciding the place of the camera and the function of location shooting.

In this manner, Resnais incorporated into his script most of the color footage of the film-to-be. The sequenced script counted twelve

narrative components, including the prologue ("The deserted camp in 1956 [mixture of the four camps]") and the epilogue ("Auschwitz Museum. The lesson to be learned").[18] July 1955 saw the continued petitioning of the Polish Film Center, while the filmmakers still envisioned additional location shooting in Struthof or Mauthausen. However, the emphasis clearly shifted toward the east as Michel and Wormser's travel experiences inspired the director's imaginary topography. In the section entitled "Locations in the Camp" an allusion to the "bunker" confirmed the central role of the Auschwitz-Birkenau site. Developments on the "Techniques of Extermination" furthermore evoked the "courtyard of block 11" where many inmates of Auschwitz I were executed.[19]

At the same time the structural approach was leavened with the introduction of a chronological dimension and emphasized the principal evolutions of the concentration camp system. Added to the six components retained from the synopsis (Transports, Arrival at the Camp, Quarantine—Daily Life, Locations in the Camp, Techniques of Extermination, Evacuation of the Camps—What the Allies Discovered) were the chronological developments. One was devoted to the rise of Nazism. Another—"Himmler's visit to Dachau. Everything in place"—evokes the first camp opened in March 1933 for the internment of German political opponents. A renewed appearance by the same "character" marks the main innovation of this new draft—"Second visit by Himmler. The history of Nazism continued" is resumed as follows:

> Himmler's second visit in 1942. The German war effort. Multiplication of the number of camps after this visit. The variety of human material transported. The twenty-two countries.
> "Ten thousand Russians to dig anti-tank ditches, etc."
> The "final solution to the Jewish problem," decided in 1942.
> "Inferior races should labor for our sake. The Jews, the Poles, the Gypsies, and the Russians must be annihilated, but productively. Annihilation through labor is the most productive method," etc.[20]

At first glance, this development does not appear to be of the greatest clarity. The precisions contributed by Wormser and Michel allow us to better grasp its meaning. In the version approved by the Comité, the two historians in fact specified that this concerned Heinrich Himmler's second visit *to Auschwitz*.[21] They also modified the

68

third sentence ("Multiplication of the number of camps after this visit")
to read: "Multiplication of the number of *kommandos and crematoria*
after this visit ('*Pohl law*')."[22]

1942: NARRATIVE SEPARATION, CONCEPTUAL INCERTITUDE

Himmler came to Auschwitz on July 17 and 18, 1942. He first visited the
construction of IG Farben's factory for synthetic rubber in Monowitz
(where the photographs discovered by the film crew were taken). This
development in the screenplay pinpointed 1942 as a turnaround year in
which the administration of the camps became subordinate to the war
economy. In February of that year, the Wirtschaftsverwaltungshauptamt
(WVHA), the administrative and economic service of the SS, was cre-
ated and placed under the direction of SS General Pohl, thus incorpo-
rating the concentration camps. In a report of March 3, 1942, he set out
the principles of "extermination through labor": "The exploitation of
labor forces must be applied to its very limit so as to achieve maximum
productivity."[23]

We can more than reasonably suspect that Olga Wormser was at
the origin of this important narrative transformation and that she felt
the desire to infuse the film with newly acquired knowledge. In her
essay, the historian points out clearly how the Nazi concentration
camp system, initially conceived for repressive purposes and not for
supplying labor, underwent a thorough reorganization in 1942, moti-
vated by economical and military imperatives. The war economy de-
manded the mobilization of all productive potential, including de-
ported Jews considered "apt to work" during their "selection." Though
destined for extermination, they were integrated into the concentra-
tion camp system. The end of the paragraph referred to this process:
the quote about "inferior races" originated with Goebbels and already
featured in Wormser's essay.[24]

Himmler's visit to Auschwitz had a second objective: after Monow-
itz, the *SS Reichsführer* went to Birkenau, where he witnessed the gas-
sing of Dutch Jews in one of the two "bunkers." New installations
combining the functions of gas chamber and crematorium were
about to go into use, making Auschwitz-Birkenau Europe's largest
center for destroying Jews. In the Resnais-penned screenplay, the ref-
erence to the "Final Solution"[25] and the addition of the word "crema-
torium" (which very likely referred to these combined installations)

allowed for the evocation of the Jewish genocide. The question that remained was how to integrate this into the actual film.

The reference to Himmler's visits created some difficulty for the narrative, a symptom of a wider conceptual problem, since two distinct phenomena came together in the same spot: the concentration camps[26] and the Final Solution. How to continue the course of the narrative? Should the extermination of Europe's Jews receive special treatment or simply be referred to when it happened to overlap the concentration camp system? How, in fact, to reconcile the diachronic logic introduced by Himmler's inspection with partially retaining a synchronous approach? The uncertitude and awkward position of the authors can be read in the hesitations and the adjustments in the order of the scenes.

They initially attempted to continue the story of the concentration camp system up until its "boom." Following the sequence in 1942, the screenplay evoked the collusion between those responsible for running the camps and German industry: "Camps are built beside factories and factories next to camps." From the industrialization of the camps, they moved on to the industrialization of death, without specifically mentioning the Jews: workings of the gas chamber, recuperating objects, use of the bodies. However, this sequence collided with the next part devoted to "techniques of extermination," whose structure had remained unchanged since the synopsis. It listed various "roads toward the crematorium": exhaustion, sickness, physical violence, execution by firearm, lethal injection, and, again, the gas chamber. In an effort to solve this narrative hiatus, Olga Wormser suggested restoring this sequence to its initial position in the synopsis, namely just after the *Revier*.[27]

Was this a simple adjustment, or did it signal the beginning of a distinction between the concentration camp system and the extermination centers?

Night and Fog's final script tends to favor the latter reading. The section on death is divided into two clearly distinct blocks, one that leads up to and one that follows the sequence on Himmler's visit: the former evoking individual murders, the latter collective killing and the gas chamber. What's more, the sequence on the year 1942 was extended during the editing with a passage about the mass deportations in Europe, immediately followed by references to the mass murders, selection, and the gas chamber. This final adjustment may well

have found its origin with the film crew's stay in Poland, where the main bulk of the footage on the deportation and the extermination were either filmed or discovered.

The silent edit of *Night and Fog* therefore offered space to the destruction of the European Jews. However, this evolution of the film would be "thwarted" by the intervention of the "fourth hand," Jean Cayrol. The poet commented on the sequence in the following very allusive terms:

> 1942. Himmler visits the site. It's necessary to annihilate, but productively. Leaving productivity to his technicians, Himmler focuses on the problem of annihilation. Plans and models are studied and executed, and the deportees themselves participate in the construction.
>
> A crematorium can, depending on the occasion, offer a postcard view. Later, today, tourists have their picture taken there.
>
> The deportation extends across Europe.

The identity of the victims remained unmentioned, and the explicit reference to the Final Solution had disappeared. The gas chamber appeared as one of the methods of executing the deportees. Cayrol closed the window in the narrative opened by the editing. The fate of the Jews also went unmentioned in the passage on the arrests, despite consisting largely of images of Jewish families being rounded up. Yes, the poet refers to "Stern, Jewish student from Amsterdam," while in the final version of his text, "Annette, high school student from Bordeaux," replaced Lucette.[28] However, Cayrol ends his commentary with the following words: "The crowd, taken by surprise, taken by chance, taken by mistake, begins its march toward the camps." These terms do not apply to the Jews arrested at home or rounded up due to a policy that had nothing to do with mistake or chance nor with the repression of individual or collective acts.

Different explanations have been proposed for the absence of the victims of the Nazi genocide in the poet's text. Cayrol was doubtlessly inclined to favor his own experience and perspective as a deported resistance fighter. He also wished to give universal credence to the term "the evil of concentration," in order to better underline the threat to the present day. Poetry, according to Aristotle, is always on the side of the universal and history on the side of the particular.[29] Add to this Cayrol's style, concise and elliptical, which sat uncomfortably alongside the specific historical facts written into the script by

Olga Wormser. Perhaps the poet noticed the hesitation in the final screenplay regarding the separation over 1942 and wanted to leaven the narrative doubt by refocusing the film on its initial subject, the concentration camp system. None of these explanations is satisfactory in itself; taken together, they point toward the nonelucidated blind spot that is the final stage of writing on the film.

Nevertheless, a typescript discovered after Jean Cayrol's passing and acquired by the French Bibliothèque Nationale in 2006 allows us to establish that the passage in the commentary on the turning point of 1942 and the workings of the gas chamber–crematoria did not meet with unanimity among the filmmakers and continued to be a point of unease. Resnais's handwritten notes in the margins of the pages request a more concise style in order to better adjust the commentary to the images, yet also judge the phrase referring to the gas chambers to be "too short."[30]

Many commentators have noted that the absence of references to the persecution of the Jews was sometimes due to the period's lack of historical knowledge, sometimes to Cayrol's "censorship" regarding the Final Solution. These forms of reasoning are equally anachronistic and give a false idea of the historiographical and memorial context of the 1950s. During this decade, as we have seen, the destruction of Europe's Jews was being mentioned, it formed the subject of scientific publication (the works of Léon Poliakov in particular), and was not considered taboo. On the other hand, aside from its specificity not yet being entirely perceptible, the fact that it was mentioned does not make it a memorial issue. In France the paradox lies precisely in the difference between a history only partially written, that of the Final Solution, and a history very much being worked on, that of the concentration camp system whose remembrance dominated the official discourse and the wealth of testimonies.

It would take Olga Wormser twelve additional years of work before she could clearly verbalize the conceptual difficulty encountered by the filmmakers in their confusion.[31] In that sense, the writing of *Night and Fog* formed a shift from the classic perspective of the historical adviser's role in placing a solid knowledge at the service of cinema while also "vulgarizing" it to reach the widest possible audience. Olga Wormser's knowledge in 1955 was certainly solid, thanks to the rich experiences of her years at the ministry under Frenay, her contact with former deportees, and her archival research. However,

with the exception of her essay on labor in the camps, she had not yet reached the stage of historical writing and the conceptual elucidation that allowed her to mention side by side, in all their differences and their points of overlap, the genocide and the "concentration." *Night and Fog*'s palimpsest-like screenplay evolved within the framework of this fledgling history of the concentration camp system. Her repentances clarify the nature of a work at once full of holes and concise, whose gaps reveal the uncertainties of historiography at the time and whose substance already offers a promising first synthesis.

The commemorative monument had transformed into a historical essay, while at the same time becoming a demanding work of art infused with Alain Resnais's formal ambitions. Within this double movement, the site of Auschwitz played an essential role that became concrete during the film crew's stay in Poland.

5 THE ADVENTUROUS GAZE

O God, God!
How weary, stale, flat, and unprofitable
Seem to me all the uses of this world!
Fie on 't, ah fie! 'Tis an unweeded garden
That grows to seed. Things rank and gross in nature
Possess it merely.

—WILLIAM SHAKESPEARE, *Hamlet*, act I, scene 2

AFTER THE WRITING STAGE, the film shoot in Poland formed a first moment of elucidation, during which the director began to apply a cinematic form detached from the screenplay. In Auschwitz, in Birkenau, and in Majdanek, Resnais's camera traced its path through the landscapes and sites during the famed "aimless tracking shots."[1] Giving *Night and Fog* much of its shape and its power, these shots have been so often commented upon that there is little point in covering them again. Instead I will adopt a more oblique approach to comprehend the sequences Resnais shot in Poland. This first involves exploring the increasingly large gap between the project as it was commissioned, the scripted versions, and the way the film-maker viewed the locations he discovered in September 1955. It is well known that in Poland the landscape can merge with the event that it immediately brings to mind. Claude Lanzmann challenged this notion masterfully in *Shoah*, but Resnais was not insensitive to it either as he traversed the ruins of Birkenau.[2] To fully grasp the dimension of his effort, we should look not only at the color tracking shots, but also at another series of shots Resnais made in Poland that are often overlooked in analyses of the film—mainly because

these images, filmed black and white, merge to the point of dissolution with the mass of archival footage. To discern these, we need to pass through the looking glass to the moment before the editing assigned them to a different register of visibility and a different temporality.

This kind of approach, which stretches the film's creases to reveal their origins, is by nature disenchanting—the guardians of the temple will judge it unseemly, and, worse, it would seem to benefit the film's detractors. At the risk of misunderstanding, I would like to do the film justice in a different way: by rediscovering the filmmaker at work. After all, making the creation of a work more comprehensible does not necessarily undermine its impact and sensitivity.

In his *Histoires de peinture*, Daniel Arasse distinguishes two modalities of emotions experienced before a painting: the first revolves around discovery, surprise, and a visual shock; the second, maturing more slowly, emerges over time and through returning to the canvas as its layers of meaning appear little by little, revealing an accumulation of the artist's doubts, attempts, and meditations. This intimacy "is that of the red within Matisse's blue," that rare moment when Arasse detects in Mantegna's *Camera degli sposi* the presence of the man who commissioned it, Ludovico Gonzaga.[3]

By revealing the stratification of the layers of images and meanings, I do not seek to create a conflict between history and art, but to have them collaborate in order to rediscover, in all its uncertainties, the film in the process of being made.

NOTES ON THE SHOOT IN POLAND

On September 22, 1955, Olga Wormser, Henri Michel, and Alain Resnais arrived in Warsaw, accompanied by a minimal crew due to budget restrictions: director of photography Ghislain Cloquet and his assistant, Sacha Vierny, plus assistant director André Heinrich, who also handled continuity. Resnais brought with him the Argos contract, which the Poles had yet to sign. Olga was in charge of the offerings: cigarettes, nylons, lipstick, etc. The following day, the director and the two historians visited the archives to begin the trying phase of viewing footage and searching for images.

The crew meanwhile began scouting locations at Auschwitz to prepare for the shoot. From France they brought a 35mm Cameflex

camera with a set of five lenses and several cans of film, both black and white and Eastmancolor.[4] The choice of film stock throws light on the intentions of director and cinematographer. "Our idea was to go against the constant tendency to supply an abstract image of the camps," explained Ghislain Cloquet:

> We had to show the autumnal trees, the gorgeous, buoyant colors of this place of torture. For this we chose Eastmancolor. People suggested alternatives or Agfacolor, which was widely used in Eastern Europe and gives precisely those colors: autumn, dead leaves, sienna, bright reds. We preferred an emulsion that gave more acidic colors that would get across the almost tidy aspect of the landscape. Resnais wanted a vibrant color. By way of color he wanted to change the common way we look at these things: tributary and gloomy, crowned with a wreath.[5]

The remainder of the equipment (cranes, electrical material, reflectors, dolly tracks) was brought in from Warsaw and Lodz, site of the famous film school where Wanda Jakubowska taught.

FIGURE 8. Wormser, Muszka, and Resnais in Warsaw, September 1955. Reprinted by permission of Argos Films.

THE ADVENTUROUS GAZE

After arrival, the French team was joined by two Poles: Zygmund Ribarsky[6] of Film Polski, whose linguistic talents greatly aided communication, and Édouard Muszka, representative of the Polish Film Center, who served as production manager for the exterior shoots. Those involved remember fondly his complete devotion to the project, which could not be said for the Polish crew, recruited locally in the town of Oswiecim, whose attitude bordered on apathy.

On September 28 Alain Resnais set up camp on the site and visited the blocks of camp-turned-museum Auschwitz I. Filming started in the afternoon and would continue for seven days. After a day of rest in Krakow, the crew headed for Majdanek, where work continued from October 7 through 10.

"Construction of a concentration camp resembles that of a stadium or a large hotel, with contractors, estimates, competition, and no doubt bribes as well," wrote Jean Cayrol. Does one shoot a film about the concentration camps in the same manner as a "regular" film? All those involved remembered the tension between the technical demands of the shoot that required complete focus and the resurgence of the event related to memory of the sites. Sacha Vierny remembered it as a "terribly difficult film to make." Logistical difficulties formed a very real problem, notably in Birkenau, where the crew had to "plan tracking shots through piles of rubble."[7]

In addition to the meteorological uncertainties of the Polish autumn, there were repeated delays due to the slow unloading of equipment or the installation of lighting rigs. Heinrich's continuity notes laconically list the various humiliations inflicted: truck gone dead without apparent reason, the Polish crew arriving late, track disassembled before the shot for which it was meant was made, short-circuiting due to a faulty installation of cables, equipment falling off the truck during transport, and so on.

These hardships were easier to overcome than the weight of the past, however, as when the dolly tracks ran parallel to the train tracks across which convoys of deportees were brought to the ramp at Birkenau. Ribarsky, detained at a work camp during the war, admitted that he was unable to speak about anything else: "I was at the same time in Auschwitz and in the images of that camp where I [survived] seven months."[8]

The evenings seemed to Olga Wormser to be longer than the days:

FIGURE 9. On location: Cloquet, Muszka, and Heinrich. Reprinted by permission of Argos Films.

After the first steps in Warsaw, those nightmarish film screenings, we have moved on to Auschwitz. Resnais shoots the present day of the camp in color. I am working at Auschwitz I from the former office of the camp commander, while the others are shooting at Birkenau. We are based in that sinister hotel for "singles" since the town, despite regaining the name Oswiecim, is still the industrial center created by the Nazis. The atmosphere is good, the work engrossing, but at night you feel an overwhelming solitude. Our loved ones are so far away. At the same time you feel ashamed, knowing that you will return home.[9]

FIGURE 10. On location: Vierny, Resnais, Muszka, and Heinrich. Reprinted by permission of Argos Films.

To Resnais, the start of shooting came as a relief, dissipating the nightmarish evenings of film screenings. Entirely focused on his film, he knew he could count on the complicity and devotion of a crew he knew well[10] and who remained in good spirits in spite of the task at hand. One morning, the crew arrived at Birkenau in a field swarming with ravens. The deadpan Cloquet suggested seizing the occasion for a "Franju shot." Obviously, as Heinrich recalled, "Resnais smiled ... and we did not take the shot. Of course we never had any intention to." No doubt there were spasms of laughter due to the absurdity of the situation and the incongruity of a film shoot at a crime scene. Did Cayrol not note that there was laughter in the "bizarre and outlandish [world] of the camp" because humor is a sign of freedom, but also because the concentration camp environment "randomly resembled Kafka."[11]

Still, the filmmaker could not entirely escape the painful exchange between his professional activities and the spectral presence of the

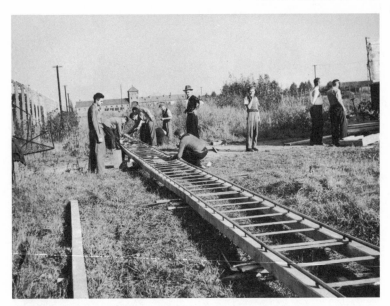

FIGURE 11. During the shoot at Birkenau. Reprinted by permission of
Argos Films.

past, as another of Heinrich's anecdotes illustrates. One evening at
Auschwitz, while they waited for the crew to finish setting up a shot,
the director and his assistant entered the museum blocks where ID
photographs of the detainees were on display:[12] Resnais "wrote down
numbers of the photos he wanted to film, while I held up a flash-
light . . . at a certain point he stopped and told me, 'Let's leave . . . I
feel like I am making a selection.'"[13] This limit set by Resnais, sur-
prised by his assumption of the criminal's gaze, is also present in his
stance as a filmmaker and the place he assigned his camera in these
locations.

"MENTAL AND ROOTLESS WANDERING"

Before his arrival in Poland, Resnais had already imagined and writ-
ten down the functions of the color sequences. The next step would
have been a numbered shot list, no doubt very precise, as part of the
continuity notes.[14] However, in the absence of such a document, my
hypothesis—corroborated by André Heinrich[15]—is that this final

preparation for the film was partially elaborated on location after taking stock of the area. For lack of a better alternative, it is in the gaps between the drafts of the script written in Paris and the sequences devised in situ that we need to search for the gaze of the filmmaker discovering the camps in Poland.

The prologue to the July draft of the screenplay imagines a first series of panning shots leading into the grounds of the camp:

> Color. A landscape that is neutral, calm, normal. The camera moves back. We are inside a ruined, abandoned concentration camp. A pan reveals the camp's entrance in the distance, flanked by a watchtower. (Perhaps we notice a group of tourists dressed in bright colors entering the camp while led by a guide. Perhaps the weather is sunny. Subsequently, though, the sky must be gray and cloudy.) Another set of slow pans should always start from an "exterior" element and end on an "interior" element (ideally each pan should be made in a different camp: Struthof, Mauthausen, Auschwitz-Birkenau, Majdanek).[16]

The film's opening scene is relatively faithful to this outline; the continuity of camera movements inscribes the film with the idea of equivalence between the various camps. *Night and Fog* opens with a fixed shot of a plain in Poland traversed by a horse. The camera then commences a downward tracking shot that reveals a tracery of poles and barbed wire. The next two shots similarly maneuver the gaze from the exterior to the interior of the camp: a backward, slightly diagonal tracking shot moves the camera from a verdant field dotted with haystacks and the aforementioned ravens flying in the distance into the enclosed interior of the camp. A third lateral dolly follows an identical movement from the road toward the watchtower and the barbed-wired enclosure.

The last two shots of this opening scene nevertheless introduce a new approach. The camera follows, at walking pace, the frontier separating the camp and the world outside: a left-to-right tracking shot reveals, behind the fence, the blocks of the camp-cum-museum Auschwitz. The same movement continues in a final shot, through a dynamic link, along the forest of chimneys at Birkenau.

The camera movements therefore are less concerned with allowing the viewer into the interior of the camp than with expressing the contiguity between the everyday and the horrific as expressed in Cayrol's opening words:

Even a calm landscape; even a field of ravens at harvest time; even a road with passing cars, farmers, and couples; even a holiday resort, with a fairground and a bell tower, can lead quite simply to a concentration camp.

Even though the ravens were not filmed à la Franju, this opening sequence nevertheless brings to mind *Le Sang des bêtes* by the same director: the bridge that leads the herd to their death suggests the fragility of the passage and the thin line that separates the slaughterhouses from the market and the poetic space of the zone where the lovers embrace.[17] Another coincidence? Ravens feature on the final canvas painted by Van Gogh before his suicide, which formed the last shot of the film Resnais dedicated to the artist in 1948. This "wave of wheat blemished by the murder of ravens" would also inspire Paul Celan[18] and Antonin Artaud:

> Van Gogh unleashed his ravens like the dark microbes of his failed suicide attempt, a few centimeters from the top and likewise from the bottom of the canvas, following the black slash of the line where the batting of their rich plumage weighs down the recoiling earthly storm with the threat of heavenly suffocation.[19]

Returning to the screenplay of *Night and Fog,* we notice how the epilogue—composed as symmetrical to the prologue—should evoke the feeling of emerging from the camp as if on a "visit": "With the right framing, the final image could be the entrance to Auschwitz quickly disappearing into the distance."[20]

Once on location, the director gave up on this image and replaced it with the ruins of the Birkenau crematorium that keeps the viewer inside the camp, or rather within the floating limbo of the film's opening, between past and present, between the "real world" and the camp, precisely where Jean Cayrol situated the space of "concentration camp dreams":

> We attempted to subsist between two worlds that contradicted and deformed each other: the savage, incoherent world of the Camp took on an unusual light because we still had one foot in the real world through all the subterfuge of our memory and our dreams ... in brief, the image of the real world which the detainee kept inside him became suspicious, yet ennobled, clarified, spiritualized, and could not but distort his return to the real world. . . . Through this internal rupture we

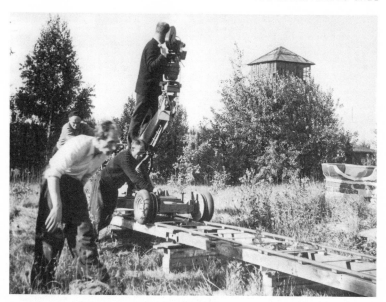

FIGURE 12. During the shoot at Birkenau: Ghislain Cloquet mans the camera. Reprinted by permission of Argos Films.

arrived between two worlds, to live equally *between* two worlds without ever firmly belonging to either of them, and this gave us still, and perhaps forever, the feeling of "floating," of mental and rootless wandering.[21]

The four long tracking shots of this final scene were all shot at Birkenau: the marsh next to the woods where the ashes of the cremations were discharged; the barracks surrounded by grass of the women's camp; the tracery of girders and concrete blocks blown apart by the explosion of the gas chambers-cum-crematoria.

Birkenau's singularity counters the synoptic vision of the generic camp put forward in the script. Arriving on location, Resnais could notice the contrast between the neat rows of wooden buildings at Majdanek and two-story houses at Auschwitz I with the empty space of Birkenau that represents the zero degree of conservation and museumification.

While the blocks of the women's camp remain, German prisoners tore down the wooden barracks in 1945, leaving as a final unnerving vestige the towering silhouettes of the brick chimneys.

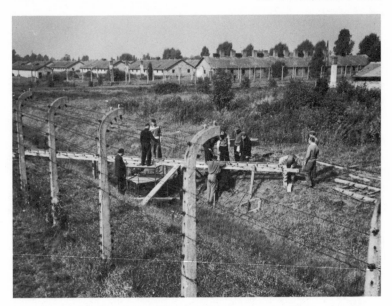

FIGURE 13. On location: the Birkenau women's camp. Reprinted by permission of Argos Films.

This vast wasteland was feverishly plowed for valuables by the "gleaners of death." For a long time it lay abandoned, a "garbage dump of memory"[22] of scattered, perturbing objects. The grounds of the camp are now overgrown, and the cornflowers described by Olga still flourish every spring. When Wanda Jakubowska arrived there in July 1947 to film *The Last Stop*, "inhabitants of Oswiecim came to rip out the weeds and the flowers with their bare hands"[23] and turn over the soil to regain the mud formed by the trampling of detainees' feet.[24]

This landscape of destruction and disaster could not have failed to inspire the filmmaker, who turned it into a vibrant metaphor for oblivion and disappearance. These vacillations between writing on paper and cinematic writing resurge in the color sequences of the film's middle section.

INGRAINING THE IMAGINATION

In Olga Wormser and Henri Michel's synopses, the location footage took the shape of a guided visit, the camera revealing the "different

sections of the camp" while the narrator explained their function. As we have seen, the meeting of May 28 confirmed the use of this enunciative form: "While visiting Auschwitz ten years after, we digress on each object or site encountered in the camp."

The narrative movement of the film as proposed on paper implicitly assumes the style of a flashback. The deserted space had to inaugurate a backward glance that brought up the past. The two historians imagined a camp suddenly coming to life thanks to a diorama of Goyard's drawings of Buchenwald and archive footage. These suggestions, minus their more naïve aspects, were restated in the July screenplay:

> Color. The camera comes out onto the main square. Here we begin the visit of the camp's principal locations. . . . While the camera moves forward between the blocks that line the main avenue, the sequence on daily life commences. . . . As the camera discovers them, the text explains each of the principal locations of the camp. (Whenever possible, the current footage should be intercut with archive footage.)[25]

Not all of these suggestions were abandoned when it came to filming. At two occasions in the film a shot of color in one building is followed by archive footage as if breaking through the set decoration to reemerge in the past: the moving camera halts in front of the *Revier*, when, as if opening a door, the film cuts to footage shot by the Russians and the Western Allies at the opening of the camps. The same procedure is repeated in front of block 21, where the doctors executed their sinister medical experiments.

Still, the majority of the sequences shot by Resnais in the camps distanced themselves from the method outlined in the script and from the logic of the backward gaze. Deleuze even wrote that *Night and Fog* could "be considered the sum of all the ways one can avoid the flashback."[26] The tracking shots exist in an autonomous movement haunted by the incapacity of showing anything more than the vain "skin" of the camp and the poverty of its traces. Far from the tyranny of the visible, they do not fall back on archive footage but fertilize the viewer's imagination. Passing the wooden pallets, the niches of the *coya*, or the latrines at the Birkenau women's camp, the camera traverses the space, traces a concentric movement around Majdanek's crematoria, or hits the brick wall of block 11, on the threshold of an untransmittable experience: "The air vents cannot muffle the screams."

Such sequences escape the format of the visit and abandon the logic of historical explanation as put forward in the synopses and the script. As François Niney remarked:

> Resnais's slow dollies are less an exploration than an "imploration," in the sense that the movement does not project the viewer into the setting but penetrates its inner space. Contrary to the touristic aspect of a traditional documentary, the tracking shot here functions not as transport on location but as the interiorization of a vision, the route of a fatal and unpredictable memory, in which each of us takes part.[27]

This "imploration" is also present in the panning shot across the ceiling of the "gas chamber" that reveals streaks in the concrete, presented as traces of the victims' nails: "They locked the doors. They observed. The only sign, though you would have to know it is there, is the ceiling damaged by scratching nails. Even the concrete was torn asunder."[28]

The combined force of the text and the camera's desolate movement generates a mental image so powerful that it affected the imagination of several generations of viewers. Even today, high school students visiting Auschwitz after a ritual viewing of *Night and Fog* lift their eyes toward the ceiling of the gas chamber and ask the guide about the final traces left by the victims.[29]

Contrary to what these adolescents believe, Resnais filmed this shot at Majdanek. For the last few years, this scene in the film has been the subject of intense criticism doubting the veracity of the fact—the possibility that the victims' nails could have left marks in concrete—and questions the identity of the locations presented in *Night and Fog* as gas chambers. I do not wish to enter this debate, which locks the film inside a logic of proof and examines it from the heights of a knowledge that was acquired later. It would take the publicity surrounding Robert Faurisson's Holocaust denial at the end of the 1970s for attention to be focused on the gas chambers. In response to the deniers, particular consideration was paid to all technical aspects of the execution process. The research done within this new context allowed for the correction of approximations and errors of attribution made when the Poles transformed the camps into museums.

It certainly is important to be unrelenting in tracking down errors and to take note, for example, that the "false shower room" at Maj-

danek is in fact a real shower room, as the Polish guides at the camp explain today. But it is equally crucial to remind one that these facts known and well established today were not known during the 1950s. Holocaust deniers are unrelenting in their use of weaknesses in documentation, transforming postwar approximations into so-called evidence of the nonexistence of gas chambers as tools of murder. Their repeated attacks on Alain Resnais's film—which also concern the figure of nine million dead and the mention of making soap[30]—serve as a false pretext for invalidating the facts. Invalidating the film in a symmetrical movement, as some do, on the basis of the imprecisions it contains comes down to placing oneself in the same spot. This would be cutting it from the context of its elaboration and accepting that a work of cinema can be read as an illustrated manual. If this film is reduced to a factual history lesson, the question of the veracity of its every component becomes the only valid question, whereas *Night and Fog* is at once a historically dated document and a work that is sufficiently complex to not be reduced to its literal meaning. Rather than condemn the film for good, in the name of a positivistic pointillism that seeks to respond to the deniers' hypercriticism, it would be more just to reflect—rather than to condemn—on the often inadequate uses to which it has been put, uses that have varied over time and which themselves also have a history.

While it is necessary to place the shooting of this scene within the museographical context of its era, I am less interested in the question of whether nails can leave traces in concrete (we do not know and probably never will) than in understanding why this sequence remains so predominant in the memory of those who have seen *Night and Fog.*

This mental image that Resnais's film helped to permanently anchor in the collective imagination—and which crops up in the most diverse contexts imaginable—has often been enriched to the point of fantasy through its subsequent migrations. Evoking Resnais's film, the German playwright Heiner Müller refers to "the traces of nails in the concrete of the gas chambers" before deforming this image/memory: "Traces of men's nails above the women's, traces of the women's nails above those of the children."[31] And when Georges Perec describes in *W ou le souvenir d'enfance* the "terrible death" of the singer Caecilia Winckler, he rediscovers this distant image, always available and reappropriatable: "When the Chilean rescue workers found her, her heart

had almost stopped beating and her bloody nails had left deep marks in the oak door."[32] As Pierre Vidal-Naquet mentioned, Perec himself offers the key to this episode at the end of the second account: "Later, my aunt and I went to see an exhibit about the concentration camps. It took place near La Motte-Picquet-Grenelle. . . . I remember photographs showing the walls of the ovens [sic] lacerated by the nails of those who were gassed."[33] This image haunts not only the Western memory: it is in reference to Auschwitz that the Korean novelist Hwang Sok-Yong describes the Sanchon massacre in his book *The Guest*. This author also evokes traces of victims' nails on the wall of an air raid shelter around the air vent, as the ultimate sign of protracted agony.[34]

The potency of the sequence lies in suggestive power and in its resolute placing within the present of the film's production. In choosing to start with the sole imprint left by the past, Resnais and Cayrol demonstrate a strong intuition while refusing to produce a narrative about what could have happened inside the gas chamber. We will never know anything about this black hole, since not a single victim survived the gassing and no image recorded their agony. Only the Nazis behind the peephole witnessed the unfolding. Refusing to don the criminal's mantle, Resnais also did not seek, unlike certain postwar documentarians, to render the executions artificially visible through dubious examples of montage.[35]

On the other hand, in choosing to produce a discreet image of the present, one with few certainties and devoid of "technical" explanation, Alain Resnais awakens an enduring emotion in the viewer; this trace, real or symbolic, forms a gash that wounds him over and over.

It would be futile to infinitely hold forth about a camera movement. A film, no matter how well planned and prepared (and this one was less so than others by Resnais), is the product of chance and circumstance, of groping around and finding answers to the resistance of reality. The production of *Night and Fog* could be interpreted as a constant negotiation between the scripted versions, the contingencies of available archival material, and the situations on location—negotiation in which it is impossible to ascertain the contribution of each component. Nevertheless, the autonomous course of the color tracking shots allow us to discern the filmmaker's gaze on the different sites he discovered, while at the same time attesting to a movement of eman-

cipation from the format established by the stages of scriptwriting. We will rediscover this gap in which the film took shape by examining the footage shot in black and white.

ARTIFACTS ALSO DIE

It is worth repeating that the assignment originally handed to Alain Resnais stated that the film should consist of three components: location shooting in the ruined camps, montages of archival footage, and the "iconographic" part featuring animated diagrams and "objects representing authentic mementos from the deportation." Certain objects had already been gathered for the exhibit at the Musée Pédagogique. However, Henri Michel foresaw upon his return from Poland in May 1955 that Resnais might use other pieces from the camps-cum-museums "where personal belongings of the prisoners and their relics are kept."

Resnais filmed these shots primarily[36] at Auschwitz I, which represented a striking contrast with Birkenau: a conservatory of memory instead of an abandoned landscape.[37] The museum was created in 1947 by a decision of the Polish parliament to "commemorate the martyrdom of Poland and other nations."[38]

During his visit to the site in 1948, author Giorgio Caproni was seized by "the unassuming aspect" of the Auschwitz I camp:

> Everything looks neat and everything is in perfect order in this museum of horrors. . . . As far removed as possible from how one imagines the degrading mass murders for which these abject and most organized cadaver factories were intended. . . . Wide avenues, tarred or at least free of dust, between large houses with colorful, almost cheerful signs: CANADA. Mimosas in bloom, flowerbeds, whitewashed façades (the famous crematoria, the infamy of Hitler and company), and even a small monument in the middle of a courtyard, like in a modern and comfortable barracks or, more appropriately, a sanatorium.[39]

In fact, the red brick buildings served as a barracks after functioning as a center for immigrants and before becoming a concentration camp.[40] Since 1947, visitors have traversed this museum town led by Polish guides, themselves former detainees, most of whom continued

to live in those same refurbished buildings on the grounds of the camp. The blocks and general features remained unchanged when the film crew arrived on location. However, from 1955, the camp-cum-museum would undergo an important phase in its development with the opening of the permanent exhibition that can still be seen there today.

What were Alain Resnais's feelings when he discovered Auschwitz I and its freshly inaugurated exhibit? He certainly could have followed in the footsteps of those brightly attired tourists described in the screenplay's opening scene. He could have taken his camera on a tour along the signs and display cases of the exhibit. But the road was narrow between the pious reliquary logic from which he wished to free himself and the unwelcome pitfalls of derision. One does not visit Auschwitz the way Franju visited the *Hôtel des Invalides*—the opposite of military triumphalism, the artifacts, drawings, and photographs of the camp form the spare traces of the victims' story. It would take Marguerite Duras's subtly nuanced text to find the right tone at the museum in Hiroshima before the photographs of those exposed to radiation, the bits of human skin floating in a jar, and the strands of hair that fell from the heads of Japanese women the morning after:

> Four times at the museum in Hiroshima I saw the people strolling . . . people stroll pensively along the photographs, the reconstructions, for lack of anything else . . . the explanations for lack of anything else . . . I watched the people . . . I too watched pensively . . . the reconstructions were built with utmost sincerity . . . The illusion, quite simply, is so perfect that it makes the tourists cry . . . one can make fun of this, but what else is a tourist to do but cry?

There are no visitors and no exhibits in *Night and Fog.* The documents (an illegal message containing the numbers of SS guards), the artifacts, and the human remains (a Hitler doll, strands of women's hair, etc.) are not offered to the view from behind the pane of a display window or in a museum arrangement. The camp clothes (striped tunics, insignias, and service numbers) are not suspended from hangers but worn by André Heinrich, whose feet can be seen wearing the inmates' old shoes.[41] However, while these objects were taken out of their display cases, they were not presented to us. The figure that

haunts *Night and Fog* is not Orpheus's quest. By choosing to film the exteriors of the Auschwitz I blocks in color and the artifacts and a few shots of the museum's interior (the pan across the *kapo*'s room)—which would be mixed with the archival footage in the editing—in black and white, Resnais kept them at a distance, in the stratum of an impassable past.

The images filmed in the Auschwitz museum do not, however, exclude the expression of a perceptible emotion, as in the intolerably tender[42] shot of the mountain of women's hair kept in block 4.[43] It starts looking downward, in a tight shot of the building, continues as a backward tracking shot before rising again, dizzyingly, to the top of the pile that seems swathed in mist.

This sequence brings to mind a scene from *The Last Stop* that follows the arrival of a transport after a little girl's balloon has flown away from the camp's supply store. Wanda Jakubowska filmed two long tracking shots (connected by a swift dissolve) along the mound of toys, clothes, suitcases, hairbrushes, shoes, and prostheses amassed in the camp's stockroom. Resnais's shot ensues like a caress, recalling Pierre-Jean Jouve's verse on "the blue mountains like hymns of tenderness," and could not have failed to haunt Jean Cayrol. "Nothing but women's hair," wrote the poet in his commentary for *Night and Fog*, exhuming once more Swift's expression that he cited in his essay on "concentration camp dreams":

> We have no erotic dreams. Our physical deterioration, our gnawing hunger, our exhaustion, sometimes complemented with the bitter memory of beatings, left us incapable of thinking, even for a moment, of a woman we could love or desire. Only once could I spend hours smelling a strand of women's hair. "Nothing but women's hair," as Swift put it.[44]

The same shot doubtlessly overwhelmed Olga, who had cried over Vera's braids during her night of agony, thinking of Paul Celan's poem evoking his mother's hair not being given the time to turn white.[45] When Wormser arrived in Auschwitz in the spring of 1955 accompanied by her friends from the Amicale, Commander Borgenko, one of the Soviet officers who liberated the camp, showed them with fury the same pile of hair while declaring: "Look what they did! Is it with them you want to make peace?"[46]

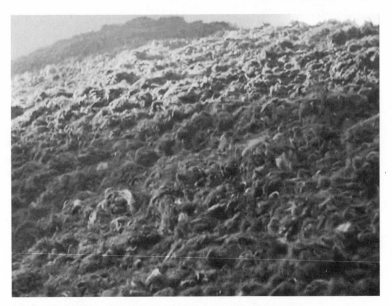

FIGURE 14. "Nothing but women's hair." Screen shot. Reprinted by
permission of Argos Films.

It was, in any case, thanks to this modest act, which liberated the
site of its role as museum, that Pierre Daix, former detainee at Mau-
thausen, could speak of the miracle of *Night and Fog.*

Other shots were filmed in black and white according to a dif-
ferent logic. These seemed to be orders from the editor Resnais to
the director Resnais, foreseeing a shortage of images required to
edit a balanced film. The night sequences fit into this category of
match shots: a fixed shot of a full moon above the watchtowers of
Birkenau, and a long tracking shot along the Auschwitz I entrance
building revealing the sinister portal through a cut to a massive
building lit up by spotlights.[47] This carefully planned shot with its
expressionistic lighting fits into a cinematic imagination inspired
by Wanda Jakubowska and the Czech filmmaker Alfred Radok,
whose fiction film about the camp-ghetto Theresienstadt (*Daleká
cesta / Distant Journey,* 1949) had impressed Alain Resnais. The
image assumed its full meaning in the editing: timed to the men-
tion of the "nocturnal setups so favored by the Nazis" and prepared
for by an extract from *The Last Stop,* this nighttime shot fleetingly

fits into another regimen of visibility. The contrast with the preceding color shot—reinforced by Eisler's choice of instruments—is absolute: a forward tracking shot along the length of the train tracks (constructed in the spring of 1944 to transport Hungarian Jews directly to the gas chambers), revealing in the distance the porch of Birkenau contrasting sharply with the infinite blue sky, the open door to the void.

Another shot merits a mention: the image of a rolling train, filmed from above, which we notice briefly when the text refers to the transports that "lose their way, stop, restart, are bombed, and arrive at last."[48]

André Heinrich confirmed the filming of many shots, but this setup is one he did not recall. There are, however, strong indications that it, too, belongs among the sequences shot by Resnais: the film grain corresponds to the other sequences filmed in 1955. Most of all, notes in the shooting script indicate that it was shot in Auschwitz. The continuity notes back up the hypothesis. The following passage is dated Friday, September 30: "08:30, camera in place to shoot train (Resnais, Cloquet), train supposed to pass at 09:30 but doesn't pass until 10:45." We can imagine the director and his DP making off at dawn, probably for the massive railroad junction of Oswiecim station, and the wait for the train, more than an hour late according to good Polish socialist custom.

The function of this shot catalogued in the continuity notes was no doubt to fill a gap in the available archive footage. While the sequence filmed at Westerbork shows the departure of a transport, no film camera ever recorded its arrival. In that sense, the shot of the train holds a particular status by bringing the real world into the frame, then sending it on a detour into the past.

Can the position of the camera, looking down from what is probably a bridge or a parapet, provide us with information about the filmmaker's position? Perhaps the situation imposed filming from above as the only possible angle. We could also imagine that it was inspired by a discreet backward movement, a symptom of the position of a filmmaker who was a contemporary of the event without being either involved or affected. In this way the sequence fits in with those blank tracking shots whose invention Fleischer credits to Resnais: A "falsely subjective dolly" that "belongs to no particular person" and "presents an invisible camera, a disembodied point of

FIGURE 15. The transport. Screen shot. Reprinted by permission of Argos Films.

view, traversing the empty spaces of a mysterious tragedy as if to read or decipher them."[49]

The furtive image of the transport recalls in turn other trains from the history of cinema. In *Shoah*, Claude Lanzmann and his camera take up a position inside the locomotive to film the arrival at Treblinka as a double act of naming and resurrecting the event—the challenge of one of history's intimate and agonizing experiments.

In his film *Drancy Avenir* (1996), Arnaud des Pallières presents a different image, filmed from below on this occasion. This scene shows the separation of railway cars at a yard near Paris. The carriages enter the frame and approach a point in the shape of an inverted W. They finally leave the yard to either the left or the right side of the screen.[50] This long sequence, shot in a single take by a fixed camera pointing upward, encapsulates the thirty-five-year-old filmmaker's position, undergoing from the outside and with delay this image of "selection," which has migrated through space and time to disturb his present:

The scene of the separation of the railway cars in the yard happens daily, several times each morning, close to where I live. I saw it by accident: it was a scene lost in time that was taking place indefinitely for over fifty years already. It was an image from the extermination that had slowly wandered in my direction, toward my present day. There is no hidden meaning behind this image; it just exists in today's world, available to whoever wishes to seize it. Like it says in the film: "An authentic image of the past appears in a flash. It is a unique image, irreplaceable, which disappears with every present that has failed to recognize itself as its target."[51]

6 THE DARKNESS OF THE EDITING ROOM

THE SHOOTING FINISHED, the painful enclosure in the editing room began at the end of October. It would continue until Christmas, in the daytime and sometimes at night, on weekdays and in weekends.[1] Alain Resnais worked on the editing alongside Henri Colpi, Jasmine Chasney, and Anne Sarraute[2] in the small screening room of Dyonis-Films at no. 15, rue de Poissy, Paris, where he had a cot installed for himself.

This final phase of the filmmaking process proved especially trying for the director:

> It felt somehow unreal to stick those kinds of shots together in order to achieve a certain kind of effect ... it weighed on your conscience and at the same time it forced you to think about the human condition. . . . You have to realize that the film was edited in a sort of state of dizziness.[3]

This dizziness was shared by the entire team. Henri Colpi remembered the young assistant editor Anne Sarraute's panicked reaction when, during a meal break, she was left alone to face the archive footage:

> She was terrified because she had seen this shot on the editing table that she had not noticed before and it showed something horrific. It scared her. She was alone in the editing room ... and she ran out to join us at the restaurant, her heart thumping and terrified.[4]

However, light-headedness does not exclude rigor. Though it may have weighed on the conscience, every shot of *Night and Fog* was

placed, framed, and timed with a precision and skill that demonstrate the exceptional talents of the trained editor Resnais,[5] who considered this procedure as important as direction. Indeed, what transpired was a unique confrontation between art, pain, and tragedy.

EDITORIAL "COLLISIONS"

As early as the writing, Resnais made several suggestions aimed at upsetting the audience's normal methods of perception to bring out the savage and absurd world of the camps: "To show how different a world it is, the editing will make an effort to shorten the wide shots and lengthen as much as possible the close-ups."[6]

Some of this logic remains in the changes and contrasts in scale between the shots that make up the sequence of the "first look at the camps": the straight cuts, used in the entire film,[7] link extreme close-ups of eyes followed by the shaved heads of two deportees to shots of a large crowd gathered in the courtyard at Mauthausen or a line of detainees at roll call. Contrary to the scripted indications, this contrast of scale was not accompanied by shot duration, which is always between two and five seconds. The use of close-ups, which fragment the victims' bodies, also paves the way for the later transformation of human beings into merchandise.

The shape of the film was found after the trip to Poland; its rhythm would be dictated by opposing and alternating the "broad and wide" movements of the color sequences and the "jerky and chopped" movement of the archive footage exposing the "Nazi lunacy" and the horrors of the camps.[8]

Although, as Vincent Pinel notes, the "color passages make up about one third of the film," they consist of only 28 shots as compared to 279 in black and white.[9] "The average length of a color shot is just under twenty seconds, and of a black and white shot four and a half seconds. This means that one color shot lasts on average as long as five black and white shots."[10]

This structural opposition is amplified further by the dynamic of inverted trajectories, which makes itself felt from *Night and Fog*'s opening scene.[11] Here, the horizontal left-to-right of the slow color tracking shots immediately meet, in a sudden shock, the archival footage: brief shots showing the rapid march of black-clad SS soldiers that cross the screen in the opposite direction, from right to left. This

sudden interruption of the past, accentuated by percussion, continues in the jumble of directions in the shots that express the inexorable advance of the Nazi war "machine." The horizontal collusion of two temporal lines paves the way for the vertical editing of the sequence on camp hierarchy, accentuated by a brief pan from the *kapo*'s chest up to his head that forms the film's only real movement across a photograph. (The slight tremble in the recordings of the photographs allowed for their smooth insertion into the archive footage.)

The choice of shots that open *Night and Fog*—extracts from German newsreels and Leni Riefenstahl's *Triumph of the Will*—could also be considered a game of quotations and a tribute to Alfred Radok. In fact, the same selection of images can be seen in the opening sequence of *Distant Journey*,[12] in which the Czech director elaborates a subtle method of using archival material.[13]

Incorporating the temporal gap between the black and white of the past and the color of the present containing traces of that past helped to homogenize, in the eyes of the first audience, the mass of "archival documents." The principle of distinguishing different categories of imagery was narrowed down to this binary opposition marked out by the rhythm of the editing and the dialectic of chromatic interchange. It certainly does not apply to the composite assemblage of horrific images, which the director merged into a single generic entity.

Our view of this "archival" section of the film has changed in recent years. Our knowledge of the "images from the camps" has grown considerably, making it possible to unravel the amalgam of quite diverse sources gathered by the filmmaker. What we have lost in innocence, we have gained in knowledge. One reaction is to disapprove and declare the film untouchable, and forbid any investigation into the origin and status of the documents. We could impose a reading entirely in line with its creator's intentions, rigidly frozen in the past when it was made and the accomplishment it once formed, remaining faithful to the emotions of its first cinephile admirers. Such conservative reflexes are understandable in the light of some of the venomous attacks to which *Night and Fog* has been subjected over the past few years. Yet, it is by no means certain that the guardians of its integrity will not reduce the film to a museum piece no longer seen by living eyes.

Taking note of new knowledge and the renewed demands made of the film and its images, I intend to approach *Night and Fog* as a source of information and reflection on the practices of the historical documentary and on the limits of interpretation of images from the camps in the 1950s.[14]

Although it is impossible to reconstruct with certainty the filmmakers' view of the images from the camps, we can at least deduce the questions this view posed and, even more so, those it did not pose and that we pose ourselves today. It is the gap between the interpretations and perceptions of two different ages that forms the context to the following reflection in the shape of an exchange between the 1955 edit and how it is appreciated, often tainted with misunderstanding, today.

TWO (OR THREE) GENERATIONS OF IMAGES

Watching the film armed with today's knowledge, it is easy to notice how the middle section on the workings of the concentration camp system is a mixture of two generations of images: those from the Nazi era and those recorded by the Allies during the deportees' liberation. The considerable effort made with regard to photographs from the camps over the last decade and more makes this juxtaposition of time frames more perceptible.[15] Side by side with images from the liberation we find photographs of the construction of the camp buildings, visits of Nazi luminaries, the Auschwitz orchestra, deportees laboring as part of the *kommandos* and in underground factories, anthropometric measurements, and those from the "family albums" of SS leaders. Take, for example, the American photograph of the deportees on their bedsteads in Buchenwald, in which Elie Wiesel recognized himself;[16] that of the "Mussulman" taken by the British in Sandbostel;[17] that of the deportee supported by his comrades at Wobbelin under the watchful gaze of the Americans; or that of the moribund man with the bulging eyes—which recalls Van Gogh's stare—taken by Germaine Kanova in Vaihingen camp on April 13, 1945.[18]

Images from the liberation dominate the filmed footage for obvious reasons. With the exception of a shot of a line of people rounded up in Poland, two clips from *The Last Stop* and the black-and-white footage shot by the film crew themselves, all moving images that make up the film's middle part were shot by Allied cameramen. The

FIGURE 16. Vaihingen, April 1945. Screen shot. Reprinted by permission of
Argos Films.

twelve shots[19] borrowed from Actualités Françaises to demonstrate
the conditions of internment, for example, all originate with the
Western Allies: deportees having some soup at Bergen-Belsen, expo-
sure of tattoos at Buchenwald, bedridden deportees in the *Revier,* the
ghost train at Dachau, etc. As for images of Russian origin, though
some remain to be authenticated,[20] Red Army cameramen recorded
the majority during the liberation of Auschwitz.[21]

While some archive footage was doubtlessly attributed mistakenly
to Nazi photographers or cameramen, other images had been suffi-
ciently documented to be identified as dating from the liberation.
The filmmakers were aware that the images of the soup at Belsen and
the tattoos at Buchenwald were of British or American origin. In the
May 3, 1945, report on Bergen-Belsen by Actualités Françaises, the nar-
rator presents the images as witnesses of the terrible discovery made
by British troops upon their arrival at the camp. The hawkeyed editor
would doubtlessly have noticed the British soldier in his beret in the
background behind the deportees. Resnais and his two historical ad-
visers found the images of the tattoos—not used by Actualités Fran-

çaises in their item on Buchenwald[22]—in the documentary *The Death Camps,* in which the iconographic material is entirely arranged as a visit to the sites in the immediate aftermath of the liberation.[23] A longer version of the same sequence can in fact be found among the rushes[24] of *Night and Fog*: its opening shot shows an American soldier entering the frame and walking toward the sinister exhibition stand. In the light of these examples, we can suggest that Resnais, Wormser, and Michel, even if they perhaps overestimated the proportion of images from the liberation inserted into the film's middle section, nevertheless consciously chose to use some of them to express the daily lives of the deportees.

Keeping in mind Resnais's feeling of incompleteness about the search for archive footage and the necessity formulated in the screenplay to make visible the deportees' typical route and the scansions in the history of the concentration camp system, one can imagine that director and historical advisers found it necessary to select certain images for what they "symbolized" (life in a Nazi concentration camp), sometimes to the detriment of what they "documented" (the liberation of the deportees). By the same token, however, one could also advance that they never asked themselves this question: whether knowledge of the origin of the images does not necessarily imply the perception of a fundamental distinction between these two types of imagery.

Our view of them today can, in turn, only be understood through the distance of the past half-century. It should be seen as the conjunction of new historical knowledge and recent demands we make of archival images. The commemorations of the fiftieth and sixtieth anniversaries of the liberation of the camps, enriched by the scientific publications that followed in their wake, have contributed greatly to creating a permanent distinction between the visual documents from the Nazi period and those of the camps' liberation. Despite the brief lapse of time between them, these two generations of images can no longer be considered interchangeable. Aside from showing two distinct events, they also present two radically opposed views of the camps: that of the criminals (and sometimes their victims) and that of the witnesses who arrived after the fact. Today these two points of view strike us as irreconcilable into a single moment of seeing, just as we distinguish, for the period that preceded it, the photographs taken by the Nazis and those by the deportees.

Do the strict rules of this synoptic assemblage, which demanded that the historical narrative be visible, explain the use of shots borrowed from a work of fiction? Incorporated into the editing of *Night and Fog* are two short extracts from Wanda Jakubowska's *The Last Stop* that illustrate the "black transports" and the arrival of the convoys at the camps.[25]

Olga Wormser and Henri Michel had recommended resorting to extracts from fiction films in their synopses. The historians intended using another sequence from *The Last Stop* that shows the women of the Auschwitz orchestra, shots from Alfred Radok's film, and a sabotage scene from *The Battle of the Rails*. Other clips from René Clément's film were still being considered in an advanced stage of the editing. An intermediary version of the screenplay mentions two shots whose descriptions are reminiscent of scenes from *The Battle of the Rails*:

> Two French saboteurs arrested by German soldiers.... The camera pans and follows them; Prisoners crossing a railway bridge.[26]

In their detailed synopsis, Wormser and Michel even considered the use of reconstructions. One would have portrayed an act of sabotage by a deportee during his labors, while the other, cautiously accompanied by a question mark, would have presented a scene "in which a deportee pokes fun of an SS man or a *kapo*."[27]

Since these naivetés disappeared from subsequent stages of the writing and filming, there would be no need to bring them up if they did not reveal something about the intentions of two historians concerned about offering visual support to their knowledge of the camps. When no archival footage was available, the educational function of the film allowed borrowing from fictional works recognized for their "realism." When even these were unobtainable, it became permissible to reconstruct scenes that were faithful to the known facts.

Such practices testify to a period when the use of reconstructions was common, in both newsreels[28] and compilation films. With this in mind, it is hard to see how Resnais, with all the historical baggage of his two advisers, would have second thoughts when inserting two shots by a filmmaker and former deportee who scouted out material in the Polish archives. The editor's fingerprint is evident in the tight reduction of the shot evoking the "black transports,"[29] which shows

FIGURE 17. *The Last Stop.* Screen shot. Reprinted by permission of Argos Films.

the departure of a truck illuminated by the faint glow of the crematoria. This furtive image comes from a highly dramatized scene in which deportee Michèle leaves for the gas chamber while singing "La Marseillaise," to which her comrades provide the choir.[30] Jakubowska shot the transport's arrival at Birkenau in an expressionistic style that refers to the nocturnal settings and rituals used by the Nazis—and prefigures Resnais's shot of the gate of Auschwitz I.

In a text written around the same time *The Last Stop* was filmed, Jean Cayrol resorts to a cinematic imagination to evoke his first look at the Mauthausen camp "arising from a hill under the bright projector lights":

> You saw loom your own Great Wall of China, your own low, squat citadel, Mongolian in appearance. There was the "striking" quality of the setting revealed by a very "expressionistic" staging and above all that "cataleptic" turn this absent and remote world suddenly took.[31]

The Leni Riefenstahl shots Resnais inserted into the opening of *Night and Fog* seem to refer to those of Jakubowska: Nazism as an

"aestheticization of politics" (W. Benjamin) begat the expressionistic and macabre staging of death and extermination.

Let us have a look at another feature of the editing, also criticized by certain historians, that concerns the sequence on the "annihilation." Starting with Himmler's visit to Auschwitz in 1942, it is put together in the following way: tracking shot along a line of people rounded up; bird's-eye view of a transport; the train at Dachau; photograph from the "Auschwitz Album" showing the selection on the ramp at Birkenau; six photographs of men, women, and children, nude or forced to disrobe before their execution; fixed shots of Zyklon B canisters; color shot of the gas chamber.[32]

This montage is the product of the script's ambiguities and Cayrol's text accompanying the last part of the sequence. By omitting any reference to the Final Solution, the narration implies that the gas chamber was one of the methods of execution that awaited all deportees. Yet, with the exception of the shot of the train full of corpses, filmed during the liberation of Dachau, all the archival material in this sequence refers to the destruction of Europe's Jews. A different commentary would have allowed reference to the specific fate of the Jews assassinated in the gas chamber after the stages of what Poliakov calls the "chaotic exterminations": executions of the Jews of the Soviet Union by the *Einsatzgruppen,* and pogroms, massacres, and "liquidations" in the ghettos by auxiliary police forces in the Ukraine and Lithuania. In fact, the six photographs used in *Night and Fog* show victims before their execution by firearm.[33] In the shooting script, the fifth photograph in this sequence is accompanied by this description: "German photographs taken in the USSR." The fourth image, of nude women huddled together in a ditch (some of them cradling babies in their arms), is well known: they are women and children from the Mizocz ghetto, photographed before their execution by Ukrainian police in October 1942.[34] As Clément Chéroux notes in his inventory of misused photography, this "famous image," often reproduced, has "long and in countless history books been presented as the 'entry into the gas chamber."[35]

Comparable criticism has been formulated against *Night and Fog,* some viewers imagining that the series of six photographs portrays victims about to enter the gas chamber. These attacks are not entirely justified. Certainly, it seems a curious montage that places these images after a photograph of the selection at Birkenau, while the narra-

tion refers to the fate of those deportees considered "inapt" for labor. However, Cayrol's text corrects this initial impression by adding, in reference to these same images, that "manual killings take time."[36] In the provisional version of his commentary, the poet was even more explicit, having written the following phrase: "They kill out in the open, in the clearings."[37] These contradictions between text and image nevertheless make for a confused narrative, indicative and symptomatic of the hesitations incorporated at the scriptwriting stage.

It is important to understand why this selection of images of massacres is the subject of such sensitive attention these days, in contrast to how they were regarded by the filmmakers back in 1955. If the misinterpretation of the image from Mizocz features as the worst on Clément Chéroux's scale of misuses, this is because it exists at the heart of the controversy surrounding the "absent image"—a polemic that began during the 1990s in the wake of Claude Lanzmann's *Shoah*.

ABSENT IMAGE, MISSING IMAGE

The film *Shoah* profoundly changed our view of the event and its representation. The two-pronged question of the destruction of all traces of the mass murder and of the "invisibility" of the extermination of the Jews in the centers of execution forms the heart of Lanzmann's approach, which calls up the event by choosing a cinematic form that rejects all use of archival material to ingrain the filmmaker's quest in the present moment through site visits and eyewitness testimonies. Unlike *Night and Fog*, *Shoah* follows the trajectories of those who never entered the camps because they were gassed upon arrival. By choosing to begin his film in Chelmno in December 1941, the filmmaker marks out one of the singularities of the destruction of the European Jews. As Vidal-Nacquet rightly notes, Lanzmann here shines a light on the specific nature of murder by gas, which has less to do with "the industrialization of death" than with the removal of the need for murderer and victim to meet face-to-face—a vanishing that forms "a denial of the crime during the crime itself,"[38] further enhanced by attempts to erase all traces of its ever having happened. In the execution centers, the Nazis' eagerness to render the genocide invisible manifested itself in the use of coded language, a ban on photography, the destruction of material traces, and the disappearance of the corpses that could be considered the ultimate proof. In

1943, for example, when Belzec, Sobibor, and Treblinka had ended their function as places of execution, the still uncremated bodies were dug up and burned, their bones ground, all buildings torn down, and the sites replanted with trees as an additional measure of precaution.

By refusing to resort to the use of decontextualized archival documents in elucidating this unique event so long absorbed into the overall context of the deportation and the concentration camp system, Lanzmann took measure of the full extent of the deficiency of images that was itself constituent of the event. He clarified how previous documentaries repeatedly misused photos and footage from the liberation of the concentration camps to "illustrate" the genocide, which contributed to creating imagery that was inappropriate to the event. This filmmaker's approach allowed an entire generation of viewers, historians included, to confront what until then had only been suggested, by Serge Klarsfeld in particular: the radical difference in visibility between the centers of execution ruled by a politics of secrecy and the concentration camps where photography, legal or illicit, occurred regularly.[39]

The debates and controversies began during the film's long exegesis. Lanzmann's own declarations and the countless comments and theoretical reflections his film provoked contributed to both clarify and radicalize the achievement of *Shoah*. Over the course of an increasingly entrenched pro-and-con debate, an image dispute of sorts took shape. From the factual assessment that formed one of the foundations of the film (the willful destruction of traces of murder and the deficiency of images of the execution centers), an imperceptible expansion and displacement took place toward the essentially philosophical thesis that the Shoah was by nature unimaginable and unrepresentable. This in turn created a list of proscriptions, notably with regard to any form of reconstruction. The issue of archival images, the only issue of interest here, was often dragged into this restrictive game.

The filmmaker's refusal to use archival imagery from the period has led to an oft-repeated affirmation that there exist no "images of the Shoah." The pertinence of this declaration obviously depends, as Georges Didi-Huberman remarked, on how one defines the event.[40] Everyone agrees on the existence of a sizable number of images recorded during the stages of the persecution and murder that preced-

ed the mass exterminations in the gas chambers: images of raids in the ghettos of Poland, photographs of massacres committed in the Soviet Union, exterminations and "liquidations" in the ghettos by the *Einsatzgruppen* or auxiliary police forces, and so on. The wealth of this corpus of images, however, stands in sharp contrast to the extreme dearth of images taken within the extermination centers, with the few exceptions previously mentioned: the "Auschwitz Album" and the four photographs taken in Birkenau by members of the *Sonderkommando*. These two series, recorded in the same location,[41] come as close as possible to the blind spot: that of the murders in the gas chamber, constituent of the definition of the event as employed by the filmmaker, and of which to this day we do not know of even a single image.

One of the ramifications of the debate that raged in France, and that reached its zenith in 1994 around the release of *Schindler's List*, centered precisely on this "dead angle." Claude Lanzmann professed to the French daily *Le Monde* at the time that if there existed a film shot by the SS that shows "how three thousand Jews, men, women, and children, died together, asphyxiated in a gas chamber of crematorium 2 at Auschwitz,"[42] he would destroy it. This extreme standpoint radicalized, to the point of the hypothetical destruction, his rejection of archival imagery—even the "absent image." In reacting to this declaration, Jean-Jacques Delfour approached it from the angle of the "ethics of the gaze":

> Lanzmann would destroy this footage filmed by the Nazis because it *contains and legitimizes* the Nazi's position: to watch it would mean inhabiting the same position, exterior from the victims, and therefore to adhere *filmically*, perceptively, to the Nazi position itself and to fix this image into the memory.[43]

This increasingly prominent status of what lies beyond the image and the circumstances of its recording could be felt in later additions to the polemic, rekindled by Jean-Luc Godard in an interview with French weekly *Les Inrockuptibles* in 1998. Reasoning from the basic premise that the Nazis "obsessively recorded everything," Godard declared that these "images from the gas chamber" most likely existed and that he would be able to uncover them "within the next twenty years" if he devoted himself to the task "with the help of a good investigative journalist."[44] Having previously analyzed the terms of this dispute,[45] I will suffice to note here that this reasoning effectively

declared "missing" the images that Claude Lanzmann considered "absent," infusing them with a dangerous power of attesting to something real[46] and rendering their discovery an urgent necessity. Such words could not help but create new junctures: on the one hand, they helped relaunch the search for these documents, and on the other, they contributed to a movement of seeing their nonexistence as something sacred—to the point of excess.

It was this new horizon of anticipation that inspired the unearthing, by the curators of the exhibition *Memory of the Camps*, of the four illicit photographs taken in August 1944 by the Greek Jew Alex, with the complicity of four other members of the *Sonderkommando* assigned to work at crematorium V at Birkenau.[47] These snapshots do not show the interior of the gas chamber in operation. They registered what our historical knowledge of the event allows us to identify as the "before" (naked women in the woods at Birkenau) and the "after" (corpses in a ditch being incinerated in the open by members of the *Sonderkommando*). This conclusion by no means diminishes the importance of this truly unique set of photographs, which portray two consecutive stages of what the Nazis referred to by the code term "special treatment." It does note that the *Sonderkommando* snapshots do not, on the face of it, form a revision of the fact voiced by Lanzmann that to this day we do not know of any images showing the destruction of the Jews in the gas chamber.[48]

Nevertheless this is what Clément Chéroux suggested when he dragged these documents into the widely publicized polemic:

> These images that would take twenty years of investigation to uncover exist and are in fact well known. These images in which "we see the deportees enter and in which state they came out" (Godard), are precisely those made during the summer of 1944 by members of the *Sonderkommando* and the Polish resistance at Auschwitz around—but also from within—the gas chamber of crematorium V at Birkenau. These images can be *shown* and have been, without any form of hindrance, since the end of the war. They were not made from the *point of the view of the Nazis*, but of the deportees. They hold a value not only as evidence but also documents. They are far from *useless* and there can be no talk of *destroying* them. They should simply be analyzed as historical documents allowing us to deepen our knowledge of the events they portray.[49]

A peculiar form of reasoning by this champion of the "positivist" cause, which proposes restoring each photograph from the Nazi

camps to its original documentary purity by liberating it of successive layers of mistaken interpretations and symbolic uses: inaugurating the entrance of these photographs into the scientific arena after first charging them with this bothersome heritage that allows him to declare to the reader: here are the images Godard is looking for.[50] Lanzmann said they did not exist and considered them incommunicable, but they exist, and they can and must be shown because they are useful to our historical knowledge and portray the victims' point of view.

Instead of extinguishing a heated debate, this conjuring trick only served to set it ablaze.[51] Readers who wish to catch up with the latest entries in this "violent discourse"[52] can do so if they choose. It only concerns us here to the extent in which it contributed to changing the way we look at these photographs that have been shown and published regularly since 1945, and of which one is featured in *Night and Fog*.

The filmmakers, in fact, preselected two of the four illicit photographs while consulting the collection of the Auschwitz museum. The picture of the naked women at Birkenau can be found in one of the reels of rushes, where it forms the subject of an attempt at reframing to correct its decentered diagonal angle—the result of having been taken blind.[53] This unused sequence, which shows the director's gaze at work, allows us to grasp one of the reasons why the photograph was removed from the final film.

One of the two images of the cremation of bodies,[54] on the other hand, was used in the film and accompanied by the following narration: "When the crematoria can no longer cope, they build pyres." Argos's shooting script contains, under the typed shot description ("photograph of corpses burned manually"), the following handwritten indication: "*Sonderkommando* illicit photograph Schmouleski [*sic*] Auschwitz museum."[55]

The image's very discreet presence in *Night and Fog* and the confirmation that Resnais was more or less aware of its origin demonstrate the scansions inherent in the history of gazes. This history exists as part of a specific configuration consisting of the advances in historical knowledge, the dominance of memory, and the variety in symbolic and social demands made of images.

Though it is by no means certain that this specific photograph allows us to considerably deepen our factual knowledge of the event, it

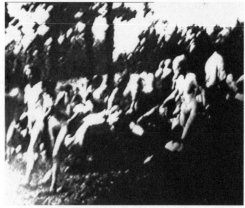

FIGURES 18A AND 18B. An attempt to reframe one of the four photographs taken by members of the Birkenau *Sonderkommando.* Screen shots. Reprinted by permission of Argos Films.

is undeniable that it derives much of its current value from this progressively constructed historical knowledge. It was necessary to consider in what ways these two events—the concentration camp system and the Jewish genocide—overlap, as well as how they radically differ, including in terms of visibility, for this series of photographs, once submerged in an indistinct mass, to finally gain the power to regard us.

What makes this series of photographs unique today is that it opposes a resistance to the efforts of invisibility implemented by the Nazis in their extermination centers.[56] The value of these images is now indexed by point of view, by the testimonies of the victims, as well as by the conditions under which they were recorded—conditions that, in Didi-Huberman's words, allowed them to exist "in spite of everything." On the contrary, it was because the specificity of the Jewish genocide still remained to be acknowledged and because the shortage of images from the extermination centers was not yet clear that Alain Resnais was not in a position to appreciate the photograph's singularity—based today on its rarity. He selected it for what it showed: a pyre in the open air that allowed him to mention the final stage in the executions of deportees. He associated it with both the shot from the Auschwitz Album and the images of corpses and mass graves that end this sequence in the film, which is a mixture of footage shot by the Russians and the Western Allies.[57]

Paradoxically, this eclectic assemblage imposed by a lack of images, which the filmmakers blamed on an incomplete documentary search, is criticized today in the light of new understanding of the true reasons behind this deficiency. The footage that makes up *Night and Fog*'s final sequence, on the other hand, is strongly homogenous.

"WHEN THE ALLIES OPENED THE GATES . . ."

The film's finale dispenses in more than one way with the principle of alternating montage: the archival footage of the camps' liberation is not interspersed with the color tracking shots,[58] and, with the exception of the photograph taken at Dachau showing a deportee lost in thought, the entire section consists of filmed footage predominantly stemming from the same source of images recorded by British cameramen at Bergen-Belsen.

This camp, where many French deportees were transferred, has a complicated history. In fact, this atypical place does not resemble a "classic" concentration camp: in 1943, by order of Heinrich Himmler, this former stalag was transformed into a holding camp for deportees from other camps and in particular for Jews susceptible for exchange or use as hostages. For most of these detainees temporarily suspended from extermination, Bergen-Belsen formed an intermediate step on

the road to the death centers in Poland.[59] Under the pressure of the Soviet advance in the East, it once again became a place of transit: from the summer of 1944 for Hungarian and Polish Jews evacuated from the labor camps in the east and from October–November of the same year for the first transports from Auschwitz, whose evacuation was then in progress. Arriving at the beginning of April were deportees evacuated from the western concentration camps, notably from Dora.

When the Eleventh Armoured Division of the British army arrived at Bergen-Belsen on April 15, they found 60,000 detainees living under atrocious hygienic conditions: sanitary facilities were entirely absent, a typhoid epidemic raged, the sick were left without any form of care, and countless corpses had been left lying around due to the insufficient capacity of the crematorium. The photographs and footage recorded at Bergen-Belsen by members of the Army's Film and Photographic Unit (AFPU), who remained on the spot for several weeks, testify to their horrible discovery and the taxing task of burying the corpses, which subsequently took place there under military supervision.[60] The resulting images played a significant role in publicizing the liberation of the camps as undertaken by the Western Allies after Eisenhower's visit to Ohrdruf.[61] Photography and film thus formed the heart of this "administration of proof" and the prosecution of defeated Germany—images intended to conquer disbelief in the Western public opinion, to support the coming trials of Nazi dignitaries, and to confront any possible denial from German civilians.[62]

Out of these images first viewed in Amsterdam, Resnais retained the shots of the corpses and of the burials, including that of the bulldozer pushing piles of emaciated cadavers into mass graves. *Night and Fog* played an important role in anchoring these images forever in the minds of several generations of viewers. The latter horrid scene, recorded at the same time by British photographers and cameraman Bill Lawrie, was widely disseminated in the press and the newsreels of the English-speaking world. Many were the viewers and commentators of the period who, overcome with horror, believed that it was the Nazis who had recorded these images. Attributed to the Germans, the bulldozer became a symbol of the industrial enterprise of dehumanization and destruction in which the torturers of the Third Reich had indulged.[63] Later, when remembrance of the Jewish genocide

came to dominate, the same footage of the bulldozer was again misused, this time as symbolic of the extermination of the Jews in the gas chambers of the death centers.[64]

In *Night and Fog* the footage from Belsen, which had haunted Olga since her visit to the site, is clearly indicated as dating from the liberation of the camps. In an interview with Alain de Baecque and Claire Vassé, Alain Resnais had the following to say about his criteria for inclusion:

> I watched a lot of footage shot in Poland by the Russians. But I did not use that much of it. There is not really any American material either. I used none of the footage shot by George Stevens and his crew, for example. I saw those films recently and I have to say they are interesting, but mostly for showing how Americans reacted to the situation. It almost becomes a saga, an adventure story, where you follow Stevens from the landing all the way through 1945 when we see him in the images. It is all very American. For *Night and Fog* I mostly used British footage. It seemed closer to me; it was very direct and very powerful.[65]

Beyond the differences in national cinematographic practices, there is little doubt that the tragic power of the British footage stems essentially from the particularly ghastly state of this dying camp, which presented "a horrible extension of the event."[66]

Alain Resnais's other comparison, when he professes to having less interest in the Russian footage shot in Poland, also needs to be placed within the context of the liberation of the camps. In November 1944, nothing remained of the extermination centers Belzec, Treblinka, and Sobibor, which were all dismantled in 1943 and reabsorbed by the surrounding landscape. The first images the Russian and Polish cameramen recorded were at Majdanek, where the piles of shoes and victims' personal belongings were filmed and photographed.[67] Next came the photographs and footage recorded by the Red Army from January 27, 1945, onward, in an Auschwitz-Birkenau largely emptied of its prisoners during the "death marches," and whose gas chambers and crematoria had been blown up with dynamite by the Germans prior to departure.[68] It was difficult to visualize traces of the crime that had been committed there. Referring to the testimony of filmmaker Aleksander Voronzov, Marie-Anne Matard-Bonucci also notes how the cameramen had to forgo filming in the barracks due to "human and technical difficulties":

The prisoners must have been transferred in haste. They almost died of hypothermia. . . . The cameramen carried no lights, which made it impossible to film inside the barracks.[69]

Voronzov was forced to later ask the deportees to return to their barracks so that he could record the conditions under which they had lived.[70] Also worthy of note is that the Soviets doubtlessly felt less of a need to gather visual evidence of Nazi crimes to which their people had been subjected since 1941.

For all these reasons, the footage filmed by the Russian was considered less impressive and less "powerful" than that shot by the Western Allies in the concentration camps. While Resnais did select a few Russian images for the final part of his film (three fixed shots of detainees behind barbed wire in Auschwitz[71]), he was all the more inclined to privilege the footage from Bergen-Belsen because the basic premise of the interchangeability of "images from the camps" left the comparative visual impact as his main criterion. For this same reason he overlooked several Russian sequences conserved in the reels of footage but not used in the final edit: children at Auschwitz walking amid a labyrinth of barbed wire, and Russian soldiers in the snow gathering the summer dresses of murdered little girls.[72]

The Belsen footage, particularly of the bulldozer and whose exact content remains unknown, was the subject of a discussion among the crew. We do know that Henri Michel worried about "the excess of nudity."[73] Since some of the archival material would cause difficulties for the film's distribution, the plan was taken up to create two versions of *Night and Fog*: one "complete and without concession" with a running time of thirty minutes and the other a commercial version of fifteen minutes that never saw the light of day. Finally it was a forty-minute rough cut that was shown to Jean Cayrol[74] for the writing of his narration.

7 SUFFOCATED WORDS

A Lazarian Poetry

AFTER COMPLETING HIS ROUGH CUT in November, Alain Resnais contacted Jean Cayrol, who came to the editing room to watch this as yet silent version. Silence also formed the author's reaction to his second confrontation with the Medusa. "I remember him being very quiet after the screening was over," Resnais said. "I don't believe he wanted to watch it a second time."[1]

Back home after the screening, it was Cayrol's turn to be struck with dizziness: "When those unbearable images came up again at home, I was suddenly thrown back into the camp. It drove me mad."[2]

Unable to return to the screening room, the anguished author wrote a text on the deportation that was beautiful but entirely out of synch with the film, and which took considerable reworking to make it fit.[3]

Resnais found himself in a tight spot: the film was on hold and his producers were in the dark about its fate.[4] The director was pressured to work on the narration with his historical advisers, but he refused to compromise the poetry of the text. At this point "a bit like Zorro or Robin Hood, Chris Marker arrived on the scene."[5] Resnais handed him the text, showed him the rough cut, and listened to Marker's comments. It was Marker who handled rewriting Cayrol's text, adjusting it to the images and the rhythm of the film.

The commentary served as Perseus's shield: after studying it attentively, the poet found the force to confront the images of the camps again.[6] "He rewrote . . . Chris Marker's text but . . . this time he did it in the editing room . . . late at night . . . and that's how we progressed . . . sentence by sentence . . . we'd try them out . . . so the structure of the text is very Chris Marker-like but at the same time those are definitely Cayrol's words and thoughts."[7]

Which words and which thoughts? As noted earlier, Resnais chose Cayrol on the basis of his double guise as a writer and as a survivor of the deportation.

"DURING MANKIND'S SLEEPLESS NIGHT"

In January 1941, Jean Cayrol was among the first to join a small resistance group, CND-Castille, formed in Bordeaux by a Free France network.[8] "We would get together on the rue Ausone to transmit naval data over an illegal radio, notably on the new German base from where they launched U-boats against Allied transports."[9]

Cayrol was arrested on June 10, 1942, with his brother Pierre, who would later die in Ellrich.[10] Interned at Fresnes for ten months, he managed to write poems that reached his relatives in packets of dirty laundry. Some of these were read on Radio Algiers before being published in *Cahiers du Rhône*. On March 25, 1943, at Gare de l'Est in Paris, Cayrol mounted a train alongside 52 fellow Frenchmen, all classified *Nacht und Nebel*. After a transit in Trèves, the transport arrived at Mauthausen on March 27. During the terrible voyage in a third-class rail car with boarded-up windows, the poet was overcome with delirium.[11] At Mauthausen, he labored for some time in the murderous quarry before being transferred to the Gusen unit on April 7, 1943. There he was charged with checking the caliber of pieces manufactured in the Steyer factory.

It was with the eyes of Kafka, of whom he was an early reader, that Cayrol discovered—or "recognized"—the world of the concentration camp:[12] "When I arrived, the first thing I cried out was, 'This is Kafka, this is *In the Penal Colony*!' I walked into Mauthausen with Kafka under my arm, so to speak."[13] It was also from the Czech author's work that he gleaned his survival strategy: take care of your appearance; never seem miserable or distressed; look after your memories and your words; never think of the future, or of one's family, or of one's home; never be absent.[14]

At Gusen, Cayrol met two Christ-like figures who would mark him forever and to whom he owed his survival: the Austrian priest Hans Gruber, who was gruesomely tortured for organizing a network of aid within the camp ("I'm still covered in his blood," Cayrol would later write[15]), and Father Jacques, deported alongside the Jewish children of Avon College, who would succumb to fatigue during an "intense ap-

ostolic mission."[16] This priest—to whom Louis Malle would pay tribute with his film *Au revoir les enfants*—encouraged Cayrol to continue writing: "Father Jacques recognized the 'demon' that was devouring me, and during those miserable camp days he helped me, with a true sense of understanding and tremendous fervor, to continue writing poems under those impossible conditions, poems I would copy for him in his little notebook."[17] A number of his comrades extended this invitation, and he was assigned these forbidden writing tasks:

> They gave me paper and a pencil lead, and I wrote about one hundred and fifty poems in Mauthausen and Gusen.... The complicity between the people around me was extraordinary. So that I could write, they sat me down underneath a table and said: "Write your poem." On occasions when I didn't feel like writing, they would tell me: "Write something anyway."[18]

The texts written in Gusen, bitter fruit of this intense solicitation, were lost during the camp's liberation but returned to the author in 1955 by an anonymous German.[19] The coincidence is disconcerting between the dates when Cayrol recovered the words he believed lost for good[20] and his confrontation with the images that were part and parcel of working on *Night and Fog*.

A TESTIMONY WITHOUT AN I

As Marie-Laure Basuyaux notes, Jean Cayrol was a deported author and not a deportee-turned-author: "When he arrived at the camp, he already had the—modest but genuine—status of author. His first poems had enjoyed a degree of recognition, and he had been in touch with renowned writers and figures of the publishing world, all of whom did everything they could to get him liberated when he was arrested and deported."[21] Cayrol told Serge Groussard that his "fiancée at the time immediately warned Jean Pauhlan, who made every effort he could. Aragon, Pierre Emmanuel, and Albert Béguin also put all their weight into their pleas. Drieu La Rochelle wrote Hitler's ambassador, Otto Abetz, a rather beautiful letter that ended with the words 'Sorrowfully yours.'"[22]

Basuyaux concluded: "At the age of thirty-one, Jean Cayrol was already a young master. Valery Larbaud, Robert Brasillach, and Robert Kanters had already praised this incomparable voice."[23]

Contrary to other deportees, Cayrol produced no testimony of his experiences upon returning from the camps. In 1947 he turned to writing prose—a first reorientation in a career until then entirely devoted to poetry. The spectral shadow of the event is nevertheless present in the margins of a body of work haunted by effacement:

> The year 1946 formed a peculiar period for my writing. I was entirely possessed by the hereafter I had encountered in the concentration camps. A curious pallor assailed my days. . . . I remained in that vacuous hole the Gusen camp had left, like a sort of black canvas on which everything had been erased. I saw myself as a wandering Lazarus who had too long touched stone.[24]

It is precisely the Lazarus figure that establishes the apparently paradoxical link between the refusal to testify and the affirmation of the decisive upheaval the concentration camps caused in literature.[25] In 1950 the publication, as *Lazare parmi nous,* of two essays previously included in *Les Temps modernes* and in *Esprit* marked this second junction in Cayrol's writing. The former analyzes the structure and workings of *Rêves concentrationnaires,* while the second, *Pour un romanesque lazaréen,* examines "the intimate affiliation" between literature and the camps and audaciously imagines an art "born directly from the event."[26] Roland Barthes interpreted this manifesto as "the first meeting between the experience of the camps and literary reflection."[27] Whether by experience or by contamination, Lazarian literature therefore bears the stigmata of the concentration camps: "continuous repetition of the same formulas," "panicked world of objects," and elusive and floating characters.[28]

According to Marie-Laure Basuyaux, Cayrol's Lazarian writings are based on a singular poetry that aligns the refusal to center any text explicitly around the experience of the camps and the oblique effects of a body of work that delivers an "illicit testimony"[29] of this same experience through its form and characters but also through the intertextual rapport it maintains with the corpus of writings by deportees.[30]

Seen from this perspective, does the writing of *Night and Fog*'s narration constitute an infidelity to Cayrol's poetry, a departure from illicitness and the start of an autobiographical chronicle of the deportation?

Certainly, it is the intimate, personal experience of the deportee that gives *Night and Fog*'s commentary its authentic tone and under-

pins the meeting of the author's text and the filmmaker's montage. Yet, as Marie-Laure Basuyaux notes,[31] "the style of *Night and Fog* is marked by the generalized wording and even more by the wording itself":

> This text never presents itself as the story of a personal experience but of a collective lot that is subsequently assumed by a collective speech. This very general scope of the words is noticeable particularly in the use of optative infinitives ('To finally lie down anywhere, alone with one's agony . . .'), but most of all by the repeated use of the undefined pronoun "*on*," which has a wide variety of referents.[32]

The word *on* refers most commonly to the entirety of deportees: "*On troque deux, trois cigarettes contre une soupe*"; "*on s'y observait avec crainte, on y guettait des symptômes bientôt familiers*"; "*on fabrique des cuil-lières, des marionettes qu'on dissimule*"; "*on réussit à écrire, à prendre des notes*"; "*on s'occupe des camarades les plus atteints.*"[33] This form appears far more often than the word *deportee*, used on only six occasions in the text, plural as well singular. However, the same undefined pronoun also refers to the criminals (in addition to terms like SS and Nazi, but excluding the noun "German"): "*On trie tout de suite . . . on commande des boîtes de gaz Zyklon; on fermait les portes, on observait . . .*"[34]

The word also, on occasion, refers to the narration itself ("*mais on ne peut rien dire*"[35]) as well as to the present-day visitors who see the camps after the fact: "*Aujourd'hui sur la même voie, il fait jour et soleil. On la parcourt lentement à la recherche de quoi?*"[36] At the very end of the narration, the same pronoun finally refers to the current (or future) victims of the "concentration camp scourge": "*Il y a nous qui regardons sincèrement ces ruines . . . et qui n'entendons pas qu'on crie sans fin.*"[37]

Cayrol's commentary also frequently employs the collective personal pronoun *nous*, which at the end of the text refers to contemporary mankind, in which the author includes himself: "*Qui de nous veille de cet étrange observatoire pour nous avertir de la venue de nouveaux bourreaux? Ont-ils vraiment un autre visage que le nôtre?*"[38]

> This pronoun is also the subject of a semantic switch that sees it moving from a general meaning to more limited representation: "*Cette réalité des camps, méprisée par ceux qui la fabriquent, insaisissable pour ceux qui la subissent, c'est bien en vain qu'à notre tour nous essayons d'en découvrir le sens.*"[39] Here we see the passage from a pronoun representing contemporary conscience, in its effort to comprehend the camps, to a

pronoun whose referent is much more precise, since it designates the film's auctorial authority in its attempt to lay the camp bare.[40]

It is at the end of the text that the pronoun *je* makes its only appearance: *"Au moment où je vous parle, l'eau froide des marais et des ruines remplit le creux des charniers."*[41] This pronoun here does not refer to the deportee, the eyewitness of the tragedy, but to the narrative authority of the film as existing in the present. This *"je vous parle"* presents a deformed echo of Cayrol's first novel, *On vous parle*—also the title of the author's first short film, in which a former deportee confronts the world's indifference and the incomprehension of the woman he loves.[42]

Still, this absence of the word *je* does not necessarily negate the testimonial value of *Night and Fog*'s narration. In an interview with Pierre Dumayet on the writing and status of the text, Cayrol had this to say: "I think after all there was a testimony to get across, but I didn't have the right to say 'I' within that story."[43] A testimony without an "I" and virtually without a witness, but a testimony nevertheless—such might be the paradoxical status of this text.

We sense a surviving, spectral voice that expresses from the inside the lives and deaths of the inhabitants of the "other planet." "Though there is nothing to explain,"[44] though it is almost impossible and maybe futile to try to transmit, writing should not entirely abdicate since it also testifies to its own survival. The voice pronounces the actions and noises of the camp, the mud formed by inmates' feet, the heat and the cold, the obsessive search for food, the madness, the sleep interrupted by roll calls, the endangered nights. It pronounces the arbitrary bullying, the orders passed on in several languages, the signs of impending death on the bodies of the weak read from the observatories in the latrines. It recalls the Nazi precepts and speaks the camp jargon (the *"Prominents"*; "making blood"). It outlines the rules of survival: "Don't get noticed, don't pray." It privileges the familiar and execrated figure of the *kapo*[45] over the inaccessible commander, and in this sense remains loyal to the "myopia" that according to Primo Levi characterizes the deportee's view of camp hierarchy.[46] It maintains a part of the mystery of the elusive reality of the camps and of a system that retained its impenetrability even to those who suffered it.

It is still that spectral voice, though inhabited by different writing, that lets slip some dry humor through which Cayrol, and possibly

Chris Marker as well, reconnects with Kafka.[47] As the poet confessed to Xavier Grall, it was still insufficient: "We should have made a caricature out of *Night and Fog*, directed by Alain Resnais. That world was so strange, so bizarre, so apart from anything. It was a kind of Princedom."[48]

In his autobiography Cayrol repeated this same regret at not having pushed the Kafkaesque caricature of the concentration camp: "I would have liked to have made a *comédie-bouffe* about that period during which I lost my youth. The film shows a Dante-like vision where death stares you in the face."[49]

In *Le Droit de regard*, a book-length essay cowritten with Claude Durand, Cayrol adds, however:

True death is rare in film: it exists in the horrid corpses in *Night and Fog*, those in the mass graves of the camps, hauled off by bulldozer, dismembered and farcical. It exists in Varda's film, in Cléo[50] who carries death inside her lively self.[51]

Between Kafka and Dante,[52] *opéra-bouffe* and *Divine Comedy*. If Cayrol considers the images from Belsen as belonging in the very rare category of a cinema that does not cheat with death, they also provoke in him a very ambivalent feeling. In fact, his confrontation with the images from the camps was all the more painful because the very form of a montage of archival footage clashes with his view of cinema as an art form. Against the newsreel image that gathers "evidence" and places the viewer in the cold bath of history, against the archival documents that pretend to provide the definitive truth of the event, and against the cinema of the stomach that provokes the tetany of the mind, Cayrol and Durand make a fervent plea in favor of an art capable of fertilizing the imagination:

The documentary, with its overabundance of proof, wants the event to be richer than it was *when it happened*. In spite or because of this richness of detail, we are not free to imagine such butchery in all its horror. Blood and smoke blind us. We've soon had our share of corpses. Since the imagination is not given time to render excessive what the images show, to wander, to turn a single dead into countless, the documentary again and endlessly distances the event into the past. Its merciless images no longer provoke pity. We no longer dare intervene in history's *fatal* course. The selective bits and pieces they inflict upon us contribute to desensitizing us to our own present. We form part of a reality

that is suddenly aimed at us at point-blank range. Although the imagination can only work on allusion, we do not allow it to foster its own images.[53]

In Cayrol's refusal to continue writing in the editing room—"I told Resnais that I wanted to stop, I thought it was a vile thing we were doing"[54]—there was the categorical rejection of this iconography of horror[55] that in his case was twice as violent. In his decision to return to the writing, there was doubtlessly, aside from Marker's support, that intimate knowledge that Resnais's color sequences admirably expressed Cayrol's own view of cinema as an art form and paved the way for his poetry. This appropriateness is expressed in the first few shots of the film, in the perfect harmony between the author's words about a "calm landscape" full of menace and the filmmaker's images, "tranquil" but in no way "tranquilized"—images "worked from inside" that, like Cléo, carry death within them.[56] By way of Resnais's images, Cayrol the survivor found the means to speak, in the name of an "incapacity to speak," not "in place of the disappeared" but "of the place of their disappearance."[57]

In this final version of the commentary, perfectly adjusted to the editing, the game of rhythm and of the conjugation of time prolongs the filmmaker's gesture. Over the color tracking shots, the author's sentences are rich, full, and vast in scope. They accompany the movement of the camera as it travels through the ruined site in search of marks and traces:

Today the sun shines down on that same road. We traverse it slowly in search of what? Traces of the corpses, which tumbled out as soon as the gates were opened? Or of the shuffling of the new arrivals as they were pushed by the butts of rifles toward the camp entrance amid the barking of dogs and the beams of searchlights, with the flame of the crematorium burning in the distance, in one of those nocturnal settings the Nazis enjoyed so much.

This voice admits the inability of cinema and the makers of the film to pass "behind" the set, into the background of the camp:[58] "for us in turn it is in vain that we try and understand it"; "no image, no description can give them their true dimensions"; "of this brick dormitory, of that threatened sleep, we can only show the surface, the color." Faced with these images that capture "the past's present state,"[59]

the commentary can conjugate in the imperfect. This voice placed on the doorstep of the present past is, according to Cayrol, the voice of cinema linked to history. In his own short films, the poet proposes the art of surveying, which harvests images "intending and alluding to the event" and contaminates them with an active memory:

> Blockhouses, shelters, poles, prisons, and battlements that fall to ruin like houses, hollow trees, or villages abandoned to the sea breeze. Images that are no longer alive, that can be misappropriated to benefit a memory that needs them in order to be imagined.[60]

The opposite of these images open to the imagination is archive footage. "How can you impose what you yourself cannot endure? How can you dream over old nightmares?" wonders the protagonist of *L'Espace d'une nuit* before arriving at the conclusion: "Our past lies before us."[61] In its painful confrontation with archival images, Cayrol's commentary comes across as nervous, "choppy," bumpy, rhythmic. Sentences are short, stripped of excess, sometimes to the point of omitting entire verbs: "Closed trains, locked, huddles of deportees, a hundred per car, no day, no night, hunger, thirst, suffocation, madness." Enumeration replaces narration ("deportees from Lodz, Prague, Brussels, Athens, Zagreb, Odessa, and Rome"). These sparse, chattering sentences take their vow of sobriety to the point of incompleteness ("they select immediately, those on the left are put to work, those on the right . . ."), of abstinence ("but there is nothing to say . . ."), and, finally, of silence. Over the sequences from Westerbork, over the photographs of victims on death's doorstep, over the women's hair, over the Belsen bulldozer, the silence sounds like a mouth opened for a scream that will not emerge. Those brief, discreet phrases are in the present tense, a present that could be that of the "trauma" or the awakened nightmare: the present time of the survivor in whom the "illness of the past is incurable,"[62] or the present time of a Lazarus who never stops returning and who finds that his way back is forever cut off.[63] As Vincent Pinel notes, alternating the present (for the black-and-white photographs and footage) and the past tense (for the color tracking shots) is systematic to the extent "that a single sentence straddling two sequences sees its grammatical tense transforming": "Then the real world, that of calm landscapes, of time moving forward *may* well appear on the horizon, not far away. . . ." (black and white) ". . . for the deportee, it *was* an image" (color).[64]

A different instance of the present, armed with "a combative vo-cabulary,"[65] affirms itself in the last sentences of the commentary.

A POETICS OF ANXIETY

We cannot clearly discern and compare the different drafts of the commentary, but the final version contains no direct reference to Germany. The text also rejects the notion of "culpability" and "obedi-ence to orders" employed at one point by the authors, in favor of a focus on individual "responsibility." In the final edit of *Night and Fog*, the footage of the trials showing various Nazi figures is accompanied by the same repeated phrase: "I am not responsible," and leads to the question "Then who is responsible?"[66]

Indeed, *Night and Fog* ends, without concluding, on a vigilant present:

> There is us sincerely watching those ruins as if the old monster of the concentration camp system lay dead under the rubble, who pretend to regain hope before that ever distant image, as if one could recover from this scourge, we who pretend to believe that all this is the work of one period and one country, who do not think to look around us and who fail to hear the endless screams.

The poet's sentences, seriously pruned to "remove the Péguy as-pect,"[67] here answer to Cayrol's own prescript for a cinema capable of "bringing in the present, which is to say to search for continuations, remorse, consequences."[68]

Seen in the context of the closing months of the year 1955, the cries are firstly those of the colonized, particularly the Algerians against whom France had, for over a year, been at war without admitting to the word. Animated by this moral of commitment that had earlier motivated his fight against the Nazis, Cayrol sought to make the French Republic feel guilty for abandoning in northern Africa the principles it had forged in the resistance: "The face of France had hardened in si-lence, over the course of unremarkable actions in a faraway land, through its inability to recognize the situation of another in its own: unable to comprehend the universality of its resistance struggle, France had passed through the looking glass."[69]

Cayrol confirmed the meaning of this anxious warning[70] in the pages of *Les lettres françaises*:

The only time we remember is when the present reminds us. Though nothing remains of the crematoria but pitiful skeletons, though silence falls like a shroud over the overgrown grounds of the former camps, let us not forget that our own country is not innocent of racist scandal.

It is at these moments that *Night and Fog* becomes not merely an example to ponder, but an appeal, a "warning mechanism."[71]

Resnais was even more direct in an interview with *L'Express*:

I don't enjoy stirring up horrors. If I did so, it wasn't to make people feel sorry for what happened ten years ago but to let them think about what's happening today. In Algeria, for example.[72]

In the refusal to assign the concentration camps to the past, in the painful awareness that evil is contagious, in the moral of anxiety, the voices of the survivor and the director of *Statues Also Die* united to testify of their own times, like they would again seven years later with *Muriel ou le Temps d'un retour*. They construct the "us" that includes the viewers and the alert consciences, and they affirm that mankind, "once history has been written," cannot sit back and relax.[73] The endless scream, replacing the incantatory "never again" of countless monuments to the victims, gives meaning to the floating definitions of victims and perpetrators. It appeals to them both in the acknowledgment of a disenchanted postwar, in an "era of suspicion" that deeply marks Lazarian art.

While the ventriloquism of the *Night and Fog* text allowed at least one of Cayrol's voices to meet that of the federations of former deportees, his particular conjugation of an event mobilized in the present and anxious about the future complemented the undermining of the commission that Resnais had already initiated.

For Jean Cassou, president of the artistic committee within the Réseau du Souvenir, the highest function of art should be: "To perpetuate a great memory . . . to ensure that recollection becomes monument, that memory becomes memorial."[74] Complicit with Resnais, Cayrol went beyond this logic of monumental recording and the solidity of memory to conform *Night and Fog* to a different definition: "The image becomes art when it imposes a regard to which we cannot accustom ourselves."[75]

Cayrol, who showed the additional elegance of quietly donating his remuneration to the Amicale de Mauthausen, finished his text in

December. It was now adjusted to a thirty-minute final cut that was only missing its credit roll. What remained was the issue of narration and giving it a voice.

ABSENCE OF BOUQUET: A VOICE WITHOUT AFFECT

It was agreed upon that the name Michel Bouquet, who had been chosen to narrate, would not appear in the credits, for fear that mentioning an actor would seem frivolous. After Resnais, Sarraute, and Cayrol, it was Bouquet's turn to suffer the shock of the archive footage. The director showed him the rushes, various unused footage, and finally the film's final cut. The actor was flabbergasted and experienced a belated revelation:

> Resnais's film surprised me ... into an absolute awareness of the reality of what I had sensed but not understood of the human horror fully expressed by the few bits of celluloid he showed me, which represented something of which, even though we lived through it, we hadn't the slightest idea.[76]

Michel Bouquet was fourteen years old when the war broke out. The occupation years formed his adolescence and passage into adulthood, education, and apprenticeship. At seventeen, under the occupation, he decided to become an actor and set his first foot on stage in a state of wonder and discovery. This is why, when referring to those days, Bouquet calls them "happy in spite of everything," echoing Sartre's famous blind man: "Will anyone understand when I say that the occupation was intolerable and that we adapted to it very well ...?"[77]

This ambivalence weighed heavily on the belated awareness and readjustment that *Night and Fog* imposed:

> I tried to say Cayrol's text while taking into account all the feelings I had in the moment. But Resnais made considerable efforts to undermine my emotions. He made me redo lines ... so that we arrived at absolute neutrality in spite of the emotions I was feeling.... This is why I believe the result is more Resnais's work than mine. My memory of the experience is one of humiliation.

It was therefore an exercise of disappropriation, of absenting one's self (doubling that of the credit roll) that the director imposed on his narrator. He succeeded in obtaining the blank voice that extends his

own gesture and bolsters *Night and Fog*'s "terrible softness." Added to this painful ordeal were a few less dramatic pronunciation exercises under the friendly guidance of Olga Wormser, who was present at the recording: "With an angel's patience, Michel Bouquet, who agreed to being the anonymous voice, did a dozen retakes according to my instructions: 'No! Not *Oria*nenburg, but Oran*ien*burg!'"

Wormser confided in her memoirs that the recording of the narration and the music formed for her a "fascinating experience." While Michel Bouquet worked on the text, Hanns Eisler finished the film's musical score. The final act of making *Night and Fog* was marked by the arrival of the maestro from Berlin.

8 EISLER'S NEVERENDING CHANT

ON NOVEMBER 30, producer Anatole Dauman wrote to Édouard Muszka of the Polish Film Center: "Tonight we welcome to Paris the great musician Hanns Eisler, whom Alain Resnais requested to write the music and who agreed to leave his home in East Berlin for the task."[1] The entire crew was in a state of excitement, particularly the young director, who considered the occasion a miracle.

The miracle was born one Sunday in Ville-d'Avray, again at Chris Marker's instigation. Marker suggested Eisler's name and played some of the composer's records, brought back from Germany.[2] Resnais was immediately won over by the work of this prolific[3] former pupil of Arnold Schönberg, who was best known in France for his theater scores for Bertolt Brecht and music for the films of Jacques Feyder, Slatan Dudow, Fritz Lang, Jean Renoir, and Joris Ivens.[4] Resnais had also read Eisler's groundbreaking book on film music, cowritten with Theodor Adorno.[5]

With the accord of a skeptical Dauman, Resnais wrote the composer a "very lyrical"[6] letter, with little hope of receiving a reply: "It was really like a message in a bottle thrown into the sea. I had about as much hope that it would reach its destination as a survivor of a shipwreck has of being rescued."[7] Luck, however, was finally on the production's side: when Eisler opened the letter in his study, he happened to be accompanied by Vladimir Pozner, who strongly urged him to accept. A telegram of pithy sobriety followed: "I'm on my way! signed: Eisler."

During October and November, in the correspondence between the composer and Dauman to prepare for the contract and his stay in Paris, Eisler repeatedly mentioned "the importance of the subject,"[8]

which played a crucial role in his agreement to work on the film. Eisler's musical oeuvre is strongly tinted by political commitment, which also motivated his rupture with the apolitical Schönberg at the end of the 1920s. Against the latter's precepts of pure art, Eisler placed "the music of struggle," in touch with sociopolitical reality, a music that engages with and draws its subject matter from history. As early as 1933, Eisler left Germany to become a notable figure in antifascism. He formed part of the Parisian circles of German exiles at the Café du Dôme before undertaking an international concert tour that would take him to Denmark, England, Czechoslovakia, and the Soviet Union, among other places. In 1938, as things began to heat up in Europe, he composed chants for the International Brigades before departing from the Old Continent. He taught successively in Mexico and in New York, then joined the colony of German exiles in Hollywood,[9] where his social circle included Ava Gardner, Charles Laughton, Artie Shaw, and Peter Lorre. He also renewed his old acquaintance with Charles Chaplin—for whom he would publicly express his deep friendship during the dark years of Senator Joseph McCarthy's anticommunist witch hunt. Eisler would himself become an emblematic figure of this persecution, which led to his expulsion from American soil in 1948. After a return to his native Austria, he settled down in East Berlin two years later, where he became a favorite of the communist regime, with which his relations nonetheless were ambivalent and complex.[10]

Eisler's personal trajectory and his commitment formed one of Resnais's arguments in convincing Anatole Dauman: he argued that the engagement of a German Jewish composer persecuted by the Nazis would add to the film's moral integrity.[11]

Arriving in Paris on November 30, 1955, Eisler passed two weeks in a room of the Hôtel de La Trémoille, where the producers had a Bechstein grand piano installed. The crew did its best to entertain him: Olga Wormser invited him to her apartment in Montparnasse, where the composer treated her to a rendition of his music for *Le Grand Jeu*. But the warm French welcome could not dissipate the melancholy ambiance of a taxing visit. Confronted with the film, Eisler, too, cracked up. As Ida Pozner, who paid him regular visits during this period, recalled: "He was in despair . . . he wanted to write this music, but he absolutely couldn't handle it . . . he was very, very depressed . . . working to those images every day was very difficult for

him."[12] Eisler "took shots of brandy to keep himself going"[13] but was subject to a vacillation of both mind and inspiration that Olga Wormser also noticed: "He had been deeply impressed by those images . . . they really shocked him . . . they formed a universe of horror which the mind could not easily approach, and it hit him quite hard."[14] But time was of the essence, and Eisler finally managed to overcome, though not without pain, the breakdown that echoed the experience of Cayrol.

AT THE RISK OF FORMAL EXPERIMENTATION

Night and Fog's music takes the shape of a continuous score, following the same principle Resnais applied to his previous short films: "I didn't feel any need for silence in those short films. There was always something that needed accompaniment."[15]

The choice for a continuous score combined with an audacious formal experimentation was hardly obvious, as the director admitted:

> To ask Hanns Eisler to write the music—and to me this was essential!—exasperated many. I still get reactions to this day. They told me I shouldn't have brought a genuine musician, that what was needed was silence . . . but after all . . . maybe you need to be stylistically audacious if you want people to sit up and take notice.[16]

The uninterrupted music, presented as an alternative to the total absence of an orchestral score, is *Night and Fog*'s only continuous voice.[17] Fulfilling the role Cayrol requested of the music—"standing in where words fail"[18]—Eisler's chant never reneges. If the music "accompanies something," to use Resnais's expression, this is because it fills the gaps, holds together the film's eclectic mix of materials, and puts into practice the director's thoughts—influenced by the composer's own theories—on music in cinema.[19]

In the book he cowrote with Adorno, Eisler expresses his refusal to submit to the clichés and prejudices that prevailed in conventional film composing: to redundancy, pleonasm, illustration,[20] and amalgamation, Eisler opposed the virtues of distance, asymmetry, counterpoint, harmonic alternation, and dissonance.[21] Resnais was fascinated with both the theoretical and practical implications of the composer's working methods. Several years later, the director reminisced about their exceptional collaboration in the pages of *Sinn und Form*:

I learned a great deal from Eisler about my own profession and about music in film, particularly on how to work on a scene with a musician.... Above all, he showed me how to avoid redundant music. Even though it is something you are fundamentally aware of, he nevertheless taught me how to apply it to the music in order to create something like a "second level of perception," something additional with an opposite meaning. For instance, you can completely simplify the music during a very dramatic scene and, vice versa, greatly elaborate it when the eyes are no longer completely engaged. This way you can create a harmony by which the viewer can find a balance between seeing and hearing. I believe my preference for this comes from Eisler. He pushed me in the right direction, so to speak, and elucidated all these concepts.[22]

The result of this perfect understanding between director and composer is the opposite of the original commission, which proposed "Peat Bog Soldiers," a well-known European protest song, as the film's leitmotiv.

In their analyses of *Night and Fog*'s musical score, Henri Colpi and Vincent Pinel agree that it features four constantly evolving themes. Beginning over the film's opening sequence and reprised and reworked over the archive footage referring to the deportees' suffering and death, the first theme is dominated by duets of flute and clarinet. Its (orchestral, melodic, and rhythmic) lightness, which refuses to side with the atrocity of the images, surprised the musicians tasked with performing the score in the studio under the direction of Georges Delerue.

Resnais remembers the overall astonishment the compositions provoked:

As you know, during the recording of a piece of film music, the corresponding sequence is projected simultaneously. This is to verify whether the orchestra is playing in sync. The recording staff thought that, during the particularly brutal passages, the thirty-two musicians would perform with increased vigor. But Eisler simply said: "No, it's just a small piece. We'll use a flute and a clarinet. That's all." You could sense a certain unease in the studio. The musicians were truly taken aback, because the usual rules no longer applied.[23]

To Albrecht Dümling this nimbleness had another function besides creating effects of surprise or dissonance: "The small orchestra size and even the solos that accompany the scene of the piles of

corpses function to divert attention toward the individual lives they represent. As the almost tender melody lines suggest, each of these bodies was once a fully human individual."[24]

Night and Fog's second musical theme is typified less by its melodic form than by the dominance of brass and the "falling trumpet." It appears notably over the images of roundups and deportation and marks the successive stages of the concentration camp system. During certain passages of the film, these two themes are enriched by the addition of a piano or a string instrument that lends a more intimate accent to viewing the film's images (think of the shots of the pallet beds or the latrines). In this sense, Eisler's refusal to illustrate and dramatize does not necessarily imply renouncing emotion. However, as Dümling notes, the emotion carried by the music must originate from the score's concurrent attempt to reveal its origins.[25]

Emotion is absent from the third theme, devoted to the Nazis and introduced over the images of the SS parade, where it creates a pervasive feeling of unease due to the effects of dissonance. As Dümling again notes, a conventional composer would doubtlessly accompany this sequence with a military march or an extract from the *Horst-Wessel-Lied*. Eisler ignores this cliché by opting for thin *pizzicati* and some percussion. When the camera moves from Himmler to Hitler, the composer adds the melody line of a somewhat bitter sounding violin with a noticeable vibrato. Vivien Villani sees in the "putting into motion" of this musical motif a correspondence with the narration and the images of the parade that suggests the acceleration of the "Nazi machinery": "The *pizzicati* are quite discontinuous and separate at first" before progressively approximating to finally form an "ostinato."[26] The "Nazi" theme returns at the end of the film to underline the tragic consequences of the rise of Nazism. The *pizzicati* subsequently resurface upon mention of the year 1945: the camps-turned-towns, German industry's moral compromise, the first sight of the corpses at Bergen-Belsen, and the bulldozer. This time the violin enters on the shot of a woman's dead body, carried toward a grave by a camp guard. This third theme emphasizes the chronological turning point of a narrative that began with the rise of Nazism and ends with its defeat. The pivotal date of 1942 is accompanied by a succession of powerful timpani beats that introduce the photographs of Himmler's visit to Auschwitz.

In one of his final works, composed for *Ernste Gesänge* (1962), which deals with the twentieth congress of the Soviet Union's Communist Party, Eisler reused these *pizzicati* in a manner identical to their appearance in *Night and Fog*. Eisler connoisseurs see this as the composer's attempt to draw a parallel between Hitler's crimes and Stalin's.[27]

The executioners' theme is occasionally enriched with ironic accent expressed in the movement of a farcical waltz that underlines the more Kafkaesque aspects of the world of the concentration camp (the commander's bored wife, the brothel, the prison, etc.). Cayrol no doubt had these passages in mind when he said that Eisler's score achieved his vision of the film as an *opéra-bouffe*: "This is why the German musician composed what are almost waltzes over Hitler. I wanted it to be funny."[28]

The film's fourth theme has a very different function. Introduced with the opening credits, this funereal music for strings consisting of a "long, melodious, broad, and painful phrase"[29] is reprised in minor key during the sequence on the gas chamber before finding its "resolution" in the film's finale. Pinel refers in this regard to Max Bruch's concerto for violin, while Günter Mayer compares it to Händel.[30] Paradoxically, this theme that, for many, forms *Night and Fog*'s musical signature, was not composed for the film but borrowed from a previous Eisler creation. To understand the reason, we need to look at the subtext of this quote to which Resnais must have had no access, since he believed the score of his film to be entirely original.

A GERMAN TRAGEDY

If Eisler, in the themes for *Night and Fog* mentioned above, borrows a few notes from his *Sturm-Suite für Orchester*[31] and reprises the flute solo composed for Brecht's *Galileo Galilei*,[32] this borrowing is of a different kind. Eisler in fact reused the fourth theme from the film in its entirety for the prelude to the theater score he composed in 1954 for *Winter Battle (Winterschlacht)*. This play by Johannes R. Becher follows soldiers of the Wehrmacht during the invasion of the Soviet Union and during the battles that ended in their defeat. The German poet and playwright (turned minister of culture of the GDR) wrote a first version in 1941, entitled *Deutsche Tragödie*, during his exile in the

Soviet Union.[33] Eisler's music was first performed on January 12, 1955, at the Berliner Ensemble under the general direction of Brecht. As both Albrecht Dümling and Günter Mayer note, the score for *Winter Battle* is marked by an extreme ambivalence that succeeds in tying together both triumph and affliction. To Eisler, the play's Gordian knot lies in the contradictory process that provokes critical reflection on Germany's past and history: Hitler and the savagery of war, the absurdity of death and the meaning of "military honor," the complex articulation between the defeat of the Third Reich and the question of Germany's possible future. This ambivalence sparked numerous debates during the play's rehearsals, as director Manfred Wekwerth recalled:

> In Becher's *Winter Battle*, the directors of the Berliner Ensemble had imagined a scene of panicked retreat. . . . Eisler came to the rehearsal and shocked everybody by laughing out loud—the scene reminded him of his military service under old Franz-Joseph. . . . During a later rehearsal he showed up holding a piece of paper and demanding a full orchestra. . . . When Eisler later played us the recording, we were astonished. He had deleted all the text of the final scene, the retreat. Instead he wanted "a slight pantomime of retreat, like Napoleon's withdrawal from Russia," and he described this movement musically with great affliction. This is precisely what made the whole thing so strange. "Why this affliction?" "They are Germans. It's sad." During the second half, the music demonstrated a wild triumph, like Beethoven would have done to show victory. "But this is about defeat," we objected, feeling oddly uncomfortable. Eisler replied: "Why?" . . . The music described both affliction and triumph. It turned a scene performed by a handful of actors on stage into an expression of immense and grotesque social contradiction.[34]

The idea of the reversibility of defeat and victory, depending on one's nationality or ideology, resonated strongly with former exiles Eisler and Becher. The latter had plenty of time to reflect on it after being evacuated to Tashkent along with his émigré countrymen in the fall of 1941, following the German advance on Moscow. The ambivalence of Eisler's score, however, also stemmed from his theoretical precepts, which gave the music a critical function that allowed for analysis of and comment on the cinematic or theatrical image it accompanied and, if necessary, continued and complemented it.[35]

The prelude to Becher's piece showed a smattering of soldiers on stage. According to Dümling, Eisler's music had the task of suggesting that these few solitary figures formed the visible part of a much larger collective, the remains of a gigantic army vanquished at Stalingrad. To the musicologist, the reprisal of this orchestral prelude during the opening credits of *Night and Fog* had the same function: "The music reminds us that these deserted landscapes were once populated by millions of men. Through a dramaturgical counterpoint, the music relates back to what is not explicitly shown."[36] In the same movement, the author adds, the score refers to what is not explicitly heard. Manfred Grabs's research has shown that Eisler composed the prelude to *Winter Battle* referring to Horatio's monologue in *Hamlet*:[37]

> And let me speak to the yet unknowing world / How these things came about: so shall you hear / Of carnal, bloody, and unnatural acts, / Of accidental judgments, casual slaughters, / Of deaths put on by cunning and forced cause, / And, in this upshot, purposes mistook / Fall'n on the inventors' reads: all this can I / Truly deliver.[38]

The invisible link between World War II and the Shakespearean drama revealed itself after the fact, in the spring of 1956, when Eisler recorded a *lied* entitled "Horatio's Monologue," which set the verse from Hamlet to the prologues from *Winter Battle* and *Night and Fog*. This ghostly convocation of the Shakespearean play is worth investigating. Dümling writes of the tragic sight of the battlefield in the aftermath and the thematic continuity of the collapse of tyranny whose leaders precipitated their own defeat. We could add Horatio's desire to tell the world and especially Hamlet's attitude when confronted with the massacre of his kin. The subtext of Eisler's score could therefore refer to the origins of the Danish prince's "madness." Hamlet's "melancholy" state is born from a painful conjunction: the king's murder at the hands of his uncle and his mother's criminal betrayal; the impossibility of assuming the mistake of which he feels guilty as a member of his dynasty; the sense of guilt at his failure to prevent the crime and to answer to the law of the father appearing to him as a ghost to demand justice; and finally the impossibility of living with and after the murder committed by his kinfolk.

In this sense, the prologue and final notes of *Night and Fog* add to the German tragedy evoked by Becher the sentiment of an irreparable fault that smothers Eisler's laughter. The reprise of *Winter Battle*'s musical theme did not happen out of facility, like a palliative for a writing pressed by time. Instead it provided the key to the malaise that inhabited Eisler during his stay in Paris. Hamlet's depression came to haunt the composer, who was confronted with images of murder committed by his fellow Germans. The musical emotion is inseparable from the score's attempt to elucidate its origin.

The musical theme from *Winter Battle* returns, in a new orchestration, in the credits of the collective film *Far from Vietnam*, to which Resnais contributed alongside Chris Marker, Jean-Luc Godard, Agnès Varda, William Klein, Claude Lelouch, and Joris Ivens. With that same melody line, Alexander Kluge quoted *Night and Fog* in his 1979 film *Die Patriotin*, a virtuoso exercise in montage that elaborates a counterhistory of the German past. The film opens with images of a field riddled with corpses after a battle, over which are heard the funereal strings forever associated in the viewer's mind with Resnais's film.[39]

This German voice of Eisler's music, which interrogates the Nazi past by awakening the ghosts of the *Schuldfrage*, is also present in a different section of *Night and Fog*, inspired by the scenes from Westerbork. Over the images of the preparation for transport the composer presents a pastiche of the German national hymn. He willfully shatters the melody line from the "Lied der Deutschen," suppressing the string section so as to keep only the rhythmic articulation that amplifies the harshness of the drums. Hereby Eisler creates an "aggressive caricature of the national anthem that reflects what the Nazis did to Germany."[40]

We are aware of the history of this hymn, also inappropriately named "Deutschland über Alles," in reference to the opening line of the first verse. Composed in 1841 by Fallersleben to music by Haydn, it was meant as an appeal to unity for a Germany torn by strife between kingdoms and princedoms. At the time of its composition, it also held liberal and revolutionary connotations, since the champions of German unity also labored for human rights and freedom of the press. After becoming the official German national anthem in 1922, Fallersleben's chant became reinterpreted in the context of the rise of Nazism, its words perverted into an appeal to conquest and

the Third Reich's domination over nations and peoples. Banned by the occupation forces in 1945, it was later reinstated, minus its first two verses, as the West German hymn. Eisler's pastiche could therefore be interpreted as referring not only to the chant corrupted by the Nazis, but also to that of the Federal Republic of Germany (FTG), whose economic imperatives of reconstruction outweighed the political demands of denazification. The subverted quote from the "Lied der Deutschen" did not fail to offend the authorities in Bonn: in West German prints of *Night and Fog* distributed by the Bundeszentrale für Heimatsdienst,[41] the musical passage that opens the Westerbork scene was omitted, leaving in its place a sudden and brutal silence.[42]

Eisler's musical parody found even less favor in West Germany for his having composed the German Democratic Republic's national anthem to words by none other than Johannes Becher.[43] Tellingly titled "Auferstanden aus Ruinen" (risen from ruins), this pacifist chant formed a conscious part of the politics of remembrance by an East Germany that proclaimed itself the heir of the antifascist struggle by conscribing the Nazi error entirely to the FRG.

The subtleties of Germany's internal rupture and the question of the anti-Nazi heritage naturally went over the heads of the French, as the following anecdote by Olga Wormser, present during the film's finishing stages, demonstrates:

> During Delerue's recording, Eisler declared in German: "The clarinet is out of tune on the G!" To which the vexed clarinet player replied: "This Jerry is trying to tell me how to do my job!" An imperturbable Eisler repeated his objection until he obtained satisfaction: "The clarinet is out of tune on the G!"[44]

Such old sentiments would emerge again during the Cannes Film Festival. But in mixing a multitude of voices, *Night and Fog* already contained the first readings to which it would be subjected on both sides of the Rhine.

The recording of the music and the sound editing formed the final stages of the making of *Night and Fog*. "Between the documents he used and the (color) sequences shot in Poland, Resnais achieved an extraordinary osmosis after which only a single chant remained,"[45] wrote Jacques Doniol-Valcroze. The filmmaker's art also lies in how this cobbled-together virtuoso work, constricted by historiographical

uncertainties, limited by incomplete research, and scarred by its ago-nized, suffering voices, was delivered before the cut-off date of De-cember 31, 1955. Next began a different story, no less wondrous, that saw this fragile, anxious, and lyrical film go up before its first specta-tors and remain standing before successive generations.

PART TWO

PASSAGE AND MIGRATION

9 TUG OF WAR WITH THE CENSORS

NIGHT AND FOG'S TROUBLES with the censors are public knowledge these days, what with the repeated raking up, even in schoolbooks, of the "kepi affair." Too often, the mere mention of this fact suffices, unfortunately rarely with any investigation into a context that proves very revealing indeed: the roles and stakes of all parties concerned form an intrigue that is more complex than a mere list of taboo subjects could imply.

OMENS

Night and Fog was submitted to the censors on December 30, 1955.[1] Philippe Lifchitz informed the CNC that Argos would accept the classification of "not suitable for all audiences" in case the film "provoked, through some of its particularly powerful images, certain reservations in members of the Board." This concession by anticipation, motivated by a desire to obtain a certification "at all costs" before the end of the year, seems contradictory for a film whose vocation was to inform young viewers of the history and memory of the Nazi camps. However, it fits in with the official stance of the 1950s, which wished to inform the young, but only those over the age of sixteen. Such "protective" measures with regard to younger audiences were already in effect during the exhibition *Resistance, Liberation, Deportation,* whose organizers[2] arranged numerous school tours, albeit with restricted access for some: the "older pupils" would be guided through the entire exhibit, while younger children would be barred from entering the section on the deportation "because of its extremely distressing character."[3]

The same age restriction can be found in the censor board's first report: the representative of the Présidence du Conseil[4] demanded that access to *Night and Fog* "be banned for minors by reason of the film's criminal nature [*sic*]." The producers sought a reassessment for an additional reason: the representative for the Defense Ministry demanded "the suppression of the figure of the gendarme guarding the Pithiviers camp." In a plenary assembly, the board had to reach a decision on two quite distinct issues: the age of the film's audience and the contested image.

The photograph in question has become symbolic of the French state's collaboration in the arrest and internment of Jews before their deportation to Eastern Europe. Contrary to what was presumed at the time and for decades after, this image was recorded not at Pithiviers, but in Beaune-la-Rolande, a different camp in the same region.[5] Taken from an observation post along the camp's "chemin de ronde," it shows a background where one can distinguish, behind the barbed wire perimeter, a good dozen inmates on a clearing beside the barracks. In the foreground, on the very left, we see the silhouette, from the back and cut off at the waist, of a gendarme, his right arm leaning near the edge of the frame and wearing a kepi, the cap worn by the French military and police. By demanding the removal of this unwanted figure, the armed forces representative requested modifying the composition and point-of-view of the photograph.[6]

The board had its plenary session on February 22, 1956, where it decided to postpone the decision by a week to allow Defense Minister Christian Pineau to view the film. In this way, even before the Cannes controversy, a government official questioned the diplomatic consequences of the film's unrestricted distribution in the international market. At the same meeting, several members of the board, seized by the "horrifying scenes," asked Argos to submit a written warning that would point out the "particularly powerful or shocking nature of certain scenes" to audiences. This text would accompany the trailers of the "feature presentation" with which the documentary shared a bill, be mentioned on the film's poster, and be displayed at theater entrances. This new request formed an improvement, since it allowed the film to avoid being completely inaccessible to minors. Deliberations, however, once again stumbled over the image of the gendarme. The minister suggested putting the issue to a vote, which squarely opposed the representatives of public office to the members

hailing from the film industry. The former, by a show of hands, voted in favor of "cutting the photograph of the gendarme." The four others, refusing to ratify "the procedure requested by the minister," demanded a secret ballot.

As transcribed in the meeting report, this disagreement seems to fit into a logic of opposition between the public powers and the film industry that was characteristic of the 1940s.[7] A different interpretation is also possible, however. The refusal to vote by show of hands could also point to a division among the industry representatives concerning the issue of the gendarme. The request for confidentiality could therefore have been motivated either by fear that an impressionable colleague would be influenced by pressure from the civil servants, or by the intention of some professionals to secretly vote in favor of cutting the image. Administrative reports from the 1950s show that public officials also often favored voting by secret ballot. In a memo to the minister of information dated February 16, 1954, the chairman of the board of film classification argues that "the nature of the initiative can relieve the conscience in difficult moments," before adding that this practice facilitates respect for a professional confidentiality endangered by repeat indiscretions: "It is unavoidable that the board operates in a glass cage as well as in a resonance box; its decisions affect too many interests and its activities attract too much curiosity from professionals and the media."[8] Clearly, a secret ballot would avoid having any board member, particularly those belonging to the cinema sector, publicly taken to task for voting against the distribution or in favor of the mutilation of a film.

The delayed vote gave the industry professionals respite from having to speak out on the matter of the gendarme. As was their custom, the censors used the adjournment to start talks with the producers. On February 28, the eve of the new board meeting, Anatole Dauman informed board chairman Henry de Ségogne of his mediation:

> We have asked the director, Mr. Alain Resnais, if he would be amenable to modifying the shot of the Pithiviers camp. Mr. Resnais replied that before he could consider such a modification, the classification board would first need make such a request.

The director's stance outmaneuvered the chairman: by refusing a form of self-censorship that would have relieved the "conscience" of

certain censors, Resnais confronted them squarely with their responsibility. This remarkable firmness of principle was the product of previous experience with and knowledge of the board's practices. In spite of his relative short career as a filmmaker, Resnais had already had several brushes with the censors.

FLASHBACK

On February 8, 1950, while assessing *Guernica* (which Resnais codirected with Robert Hessens), the censor board had demanded[9] that the word "German" be replaced by "Nazi" during a passage of Paul Eluard's commentary. Contrary to a dominant postwar public discourse, which only the French Communist Party effectively still practiced, the tendency to accuse one nation and its people for Hitler's crimes had already revolved. During this era of the Cold War and the maturation of the idea of a unified Europe, the French government, eager to firmly attach Germany to the Western bloc, ratified Chancellor Adenauer's policy of remembrance. Forged in the name of the country's indispensible reconstruction, it consisted notably of laying the "blame" squarely on the shoulders of Nazi dignitaries.[10]

If the minor concession in the text of *Guernica* likely caused Resnais little trouble, his confrontations with the censors would take a very different turn during the assessment of *Statues Also Die*, a documentary on "Negro art" codirected with Chris Marker at the request of the quarterly *Présence Africaine.*

The March 25, 1953, screening resulted in a ban from distribution, "in the light of the tendentious character of some of the images and the accompanying narration."[11] This gave its production company, Tadié-Cinéma, two options to untangle the situation: to plead its cause with the minister of information or to request an assessment of a modified version of the film. There was little hope of ministerial clemency: while the decree of July 3, 1945, gave the supervising minister the right to supplant the board's decision with a more lenient one, it was hardly customary for the ministry to rein in its own officials. In the case of a film judged to be an "anticolonialist pamphlet," the matter was already sealed. The minister of information had in fact been warned about the film by his colleague in charge of overseas territories. On April 14, 1953, shortly after the film's selection for

the Cannes Film Festival, the latter had informed the former that he could not "allow the screening of said film during this event, nor at any other public occasion," concluding with the request that his colleague in the ministry of information "pronounce with regard to this film a ban for cause of the denigrations it contains toward France's efforts in Black Africa."[12]

Tadié-Cinéma clearly had no other option to save its investment than to submit a modified version of *Statues Also Die*. On June 23, 1953, the producer told the CNC that, "wishing to obtain as soon as possible the permission to distribute this film," he was "with the imminent return of the codirector, about to undertake the desired changes." With this aim, the producer requested that the censors "send him a list of texts and documents it wishes to see omitted."

The chairman's reply clearly demonstrated his predicament:[13]

> While the first part of this production offers no difficulties until scene 15, the second part on the other hand raises numerous objections so severe that it is unlikely the Board can formulate an assessment in favor of the film's distribution.
>
> I will add that the Board is not in a position to suggest cuts, neither in the order of the images nor in the narration, without risking to be accused of substituting itself for the authors.
>
> We also believe it useful and in accordance with your interests to suggest that you use summer recess to incorporate the desired modifications. This way, the new version could be presented to the Board with the greatest chances of success.

Scene 15 effectively corresponds to a turnaround in the film's paradigm:[14] after considering a "Negro art" bastardized by missionaries and transformed into cheap knickknacks by the white man's trade, Chris Marker broadens the argument by referring, with subtle irony, to the colonizers' "civilizing" mission.[15]

The corrections and changes submitted to the board several months later were all made to this final part of the narration, which corresponded to the film's third reel. In the meantime, Resnais had received a visit from two representatives of the board who explained, "one serious and bitter, the other good-naturedly, and taking turns, that certain references to Hitler, Nazism, and racism could not be tolerated and that it was in this area that I should contemplate making changes."[16] Without more precise indications, some creases were ironed out and expressions omitted that the censors would likely

deem objectionable: "colonialism"; "home of the oppressed"; proletarianization of the black man; "merciless exploitation of man by his fellow man"; etc. Yet, the modified text had lost nothing of its suggestive power or its subversive beauty. In fact, for each deleted word, Marker had invented an equally effective, and sometimes more troubling, circumlocution.

Original version:[17]

The black man learns how to cure his ailments and share ours. Our wars, for example. First steps into greater community—without hesitation we associate our African brothers with the massacre of our own children.

Modified version:

We cure the black man of his ailments, this is certain. He catches ours, this, too, is certain. Whether he gains or loses, his art will not survive the change. The magic that served to protect him when he died on his own account is powerless when he dies for ours.

Original version:

In this respect, Africa is a magnificent laboratory where, despite a few hiccups, *colonialism manufactures its ideal human being.*

Modified version:

In this respect, Africa is a magnificent laboratory where, despite a few hiccups, *the good white man patiently manufactures the ideal good negro.*

The directors also relinquished their stab at the FRG during the sequence on boxer "Sugar" Ray Robinson's match in front of a German audience hurling insults and full of hate. Edited in parallel with Jesse Owens's victory borrowed from Leni Riefenstahl's *Olympia*, the sequence seems to suggest that Germany's denazification had not been completed.

Original version:

When a black boxer takes the liberty to correct a white man *in a postwar Germany* marked by Hitler's racism, the insults, threats, and projectiles teach him that he has overstepped his boundaries.

Modified version:

> When a black boxer takes the liberty to correct a white man *in a country* marked by Hitler's racism, the insults, threats, and projectiles teach him that he *would do better to know his place.*

The polish of the text depended therefore at once on the board's precedents, the few suggestions made by the board's representatives, and the impression the two directors, lacking more precise indications, had of the censors' opinion. The refusal to submit a list of changes probably had very little to do with a fear of "substituting the authors" (the board did this on plenty of occasions during the 1950s) but because the task made them uncomfortable. Marker's metaphorical art, those scratches of "a cat leaving its mark,"[18] did not lend itself well to the censors' lexical surgery. The unusual weaving of text and archival images in the final reel left the censors powerless. Through the twofold ingeniousness of narration and montage, Marker's prose lent the passages that seemed most harmless[19] a sudden power of accusation that radically changed their reading.

Little wonder then that the "rectified version" presented to the board on March 24, 1954, met with the same repudiation. The unfavorable decision ("for cause of tendencies expressed by certain images as well as their narration that are likely to provoke reactions counter to the public interest") was the result of a vote that opposed the public officials and the industry professionals, while the sole representative of the national union of family associations cautiously abstained.[20]

In spite of questions from Senegalese deputy Léopold Sédar Senghor to France's minister for overseas territories (Senghor considered the ban "a form of racial prejudice condemned by the constitution"[21]) and in spite of petitions from the film industry in support of the documentary, *Statues Also Die* was still banned from release by February 24, 1956, the day André Tadié made a renewed attempt to plead with the director of the CNC to "obtain a new *written* and *motivated* opinion from the censor board regarding the text and images."[22] "While it does not establish an absolute juridical obligation, article 8 of the decree of July 3, 1945, regarding the censorship of cinematographic films requires the Board to expressly motivate its decision to the producer involved."

At this point during a case that was still far from closed,[23] the circumstances aligned themselves for the assessment of *Night and Fog* by a board with vivid memories of Alain Resnais's previous work. The *Statues* precedent created a climate of mutual apprehension: Pavlovian resistance by certain public servants regarding a filmmaker deemed suspicious; the predicament on the part of the professionals who opposed the ban of an important work of art but who lacked the spirit to show the same solidarity in the gendarme affair;[24] Resnais's likely vacillation between a legitimate anger against dictates that required him to be steadfast and an absence of desire to play the martyr for a point in history that was doubtlessly further from his heart than the urgent struggle against colonialism; and the fears of producer Anatole Dauman, who had taken a great gamble on this project. In this respect, the chronological coincidence between Argos's letter to Chairman de Ségogne and Tadié-Cinéma's appeal to the CNC was hardly fortuitous. The similar destinies of the two films explain Resnais's refusal to censor himself and his desire to obtain *written* and *motivated* notification of the board's objections. His refusal seems all the more remarkable because of the "deal" presented to Resnais by representatives of the censorship board, which the director sums up as:

"If you cut five seconds of the gendarme, we will let you talk of all the other camps in the world. Better yet, we will allow you to not make any cuts in the third reel. If you do not, of course, you must understand that there will be numerous cuts in the third reel. Because you have shown violent images that could offend the audience's sensibilities."[25]

This curse of the "third reel" further underlined the echo between *Night and Fog* and *Statues Also Die*. A different link united these two films that won their young director the prestigious Jean Vigo Award twice, with a two-year interval.[26] The decision made on January 30, 1956, to award Alain Resnais a second time was not exactly typical of the jury. It was justified by *Night and Fog*'s artistic qualities but also by the desire of the fifteen industry professionals on the jury to address an affront to state censorship.[27] Instead of the custom that saw the awarded film broadcast on national television in early February, the two documentaries in a tangle with the censor were quietly removed from the schedule, as a critic at the daily *L'Humanité* reported: "Two years ago, at the scheduled time, the announcer apologized for a tech-

nical problem and wished the viewers a good night. The same 'gag' was repeated this year."[28]

FACTS IN THE CASE OF A PHOTOGRAPH

Alain Resnais's steadfastness in his confrontation with the censors was not echoed in the actions undertaken at the same time by Henri Michel. On February 27, 1956, the latter sent a letter to a representative of the ministry of education. After thanking this Mr. Basdevant for keeping him informed of *Night and Fog*'s "trials and tribulations," Michel gets right to the heart of the matter:

> Allow me to inform you of our feelings regarding the retention or dele-tion of the contested photograph: it concerns the internment camp Pith-iviers; it is clear that we chose it for its historical importance; the partici-pation of the gardes mobiles and gendarmes in the arrest of Israelites is an unfortunate historical fact; this has been communicated in multiple publications and mentioned in numerous trials; it testifies less against the poor gendarmes forced into such tasks than against the occupation authorities capable of imagining and executing such procedures.
>
> This is to say that, from the perspective of history and faithfulness to the historical truth, which is the rule in all our activities, we intend to keep the photograph.
>
> Nevertheless, we cannot remain insensitive to the difficulties its re-tention may provoke in an area in which it is not ours to intervene. I would therefore like to inform you that we have a photograph of ap-preciably equivalent historical importance ready to act as its replace-ment, which could without harming the film be inserted in place of the image that caused this dispute.

This letter, read out during the board meeting of February 29, 1956, is worth a closer look. While proclaiming the absolute nature of his-torical fact, Michel notes that its transmission had not kept apace: the shameful episodes in the nation's past were brought up during the trial of the gendarmes of Drancy and the judgments in high court, and mentioned in several (rather restricted[29]) historical publications, but they were still considered inappropriate in a film destined for a wide audience.

Henri Michel also refers to the historical fact portrayed in the image—the gendarmerie's participation in the arrest and imprison-ment of Jews—then bypasses the issue by ignoring the wider event of which it formed a part. By laying the blame squarely on the "occupation

authorities," the historian minimizes the question of state collaboration, which forms the very issue the photograph addresses. The initiative for the arrest of foreign Jews imprisoned in camps in the Loiret region on May 14, 1941, came from the German military command. It was nevertheless carried out by French police and gendarmes after the implementation of the Vichy law of October 4, 1940. What is more, different from the roundups of the summer of 1942, these ordered arrests were quite widely publicized. There can therefore be no surprise, though it may seem almost comical today, that the photograph from Beaune-la-Rolande was actually authorized by the Propagandastaffel.[30]

The newspapers that sympathized with the occupiers shamelessly applauded the operations launched in May 1941, which were covered in more or less detail by the press in France's northern zone. On May 15, for example, *La Dépêche du Centre* published a short article that describes in a factual manner the procedure of ordered arrests, concluding that these were carried out "in the most correct manner possible." As the header above this article indicates ("Five thousand Jews of foreign origin were arrested by Paris police. Pursuant to the decree of October 4, 1940, the order came from Vichy"), there was no mention of the occupiers, and the article focused entirely on the French authorities responsible for or in charge of the operation. This runs contrary to Henri Michel's point of view, which glossed over the role of the state.

This mental restriction was hardly surprising in the general secretary of the CHDGM, who tried not to offend the board and was very well acquainted with institutional limitations inherent in writing the history of the occupation years. The CDJC could work largely behind closed doors, but the Comité's investigations took place, as we have seen, in the context of a policy of remembrance that had evolved little since abandoning the "Black Book." A good example can be found in one of the subcommittee on the deportation's minutes. During a March 5, 1952 meeting,[31] the participants took stock of the departmental inquiries carried out by volunteers and overseen by prefects. Germaine Tillion suggested launching a series of monographs on French prisons: she mentions Montluc, while Fawtier offers the name of Romainville. At that exact moment, the general secretary raised an objection:

MICHEL: There is a problem here, which is that we will inevitably end up accusing people.

FAWTIER: If you cover a French prison, you will inevitably accuse people.

MICHEL: With the concentration camps, you're talking of Germans only! With the French camps, it gets a bit disturbing!

TILLION: There's nothing you can do as long as you do not have access to the American archives.

BAUDOT: The prefects will never accept any initiative on the French camps.

MICHEL: We will be in hot water with the prefects if they learn that it could embarrass people who may still be living in their department!

People still alive, sometimes still active, including former officials of the Vichy administration. Due to its position as interface between historians and the authorities, through its reporting to the president of the Conseil, the CHDGM could only advance with the greatest caution and circumspection into the minefield of state collaboration. It was Henri Michel who would take the first step in July 1956, when he wrote, in his foreword to the issue of the *Revue d'histoire de la Deuxième Guerre Mondiale* on "The Condition of the Jews," that "the very affirmation of their independence led the Vichy administrations to equal, and exceed, the occupation authorities in the implementation of anti-Jewish measures."[32]

Adept at step-by-step philosophy, and aware of the differences in stature and control between writing and film, Henri Michel was in a position to understand, without necessarily condoning it, the position of the government officials on the photograph of the gendarme. His conciliatory approach naturally led him to suggest a replacement image of "*appreciably* equivalent historical importance," a phrasing that is worth dwelling on.

If we admit that, in historical terms, a document does not speak *the* truth but *of the* truth, a photograph's "historical importance" is not an inherent quality; it is a variable propriety whose value is indexed against the question posed and the broader intrigue that underlies it.

What counted to Michel and Wormser was not to stigmatize state collaboration, and even less that of the French gendarmerie, but the

will to mention the existence of prison camps on French soil and to mark the first steps of a tragic itinerary on their own territory. Within this context, Henri Michel could, from a historical standpoint, qualify any other photograph of a French camp that showed only prisoners as *appreciably* equivalent.[33]

As far as Alain Resnais was concerned, the director admitted thirty years later that he had exhumed the unwanted figure of the gendarme quite by chance and that he had neither searched for nor even noticed it:

> There is one shot I hadn't initially noticed, which is the infamous story of the gendarme's kepi. Because there is this shot that lasts, I believe, just three seconds, over which we list different camps, and you can see—though I tell you honestly that we had not noticed—you can see the backlit figure of a French gendarme in a watchtower . . . it wasn't our aim to compromise the gendarmerie, we couldn't care less. But I wanted to keep the words "Pithiviers camp" because what was important was to show that France had organized departure points for the camps.[34]

On February 29, 1956, the censor board reconvened for its final plenary session to examine the various issues left dangling. The representative of the Foreign Ministry announced that he would not seek a ban. It was decided that the film would be considered suitable for general audiences if accompanied by a warning.[35] Finally, after reading out the letters from Henri Michel and Anatole Dauman, the board moved on to the vote by secret ballot on the Beaune-la-Rolande photograph. The matter formulated as "replacement of the shot of the gendarme by a photograph of equivalent historical importance and unlikely to cause controversy" received fourteen votes in favor, five against, and one blank vote. This result shows that several members from the film industry voted in favor of the gendarme's disappearance, confirming the division among this group regarding this thorny question.[36] In formulating the proposition submitted to vote, the board adopted Henri Michel's expression but removed the adjective "appreciably," which rendered the phrase even more hazardous.

On March 7, Argos submitted the "modified" shot to the board, receiving approval and permission to distribute the film. Yet, instead of the "replacement" demanded in writing (as per Resnais's demand),[37] the filmmakers masked the photograph by placing a dark

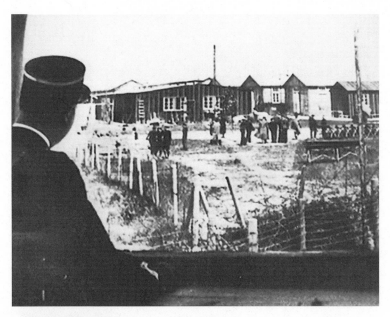

FIGURES 19A AND 19B. Before and after censorship. Screen shots. Reprinted by permission of Argos Films.

strip, like on a "deceased" notice, over the gendarme's kepi. This "lick of paint" was in keeping with the original request from the representative of the armed forces, before Henri Michel's intervention, to remove the figure of the gendarme. This allowed the film to retain Cayrol's enumeration of French internment sites ("those imprisoned at

Pithiviers, those rounded up at the Vél' d'Hiv, those resistance fighters locked up in Compiègne") while slyly displaying visible evidence of state censorship.

The first detailed analysis of this move came from a viewer from Alençon, Gérard Brunschwig, in a letter dated July 10, 1956, addressed to the chairman of the censor board:

> Yesterday I went to see A. Resnais's film *Night and Fog*. ... A small detail motivated me to write you this letter. A small detail I will informally call "the gendarme sham."
>
> A brief shot shows the embarkation of deportees [*sic*], with, in close-up, the face of a dashing gendarme, one of ours. Mister Chairman, you must have seen red: this just could not be. And you decided to erase the gendarme, convinced that this would save the honor of the police forces. As if the honor of humanity, of civilization, cops and censors included, weren't heavily compromised by the cancer that Alain Resnais showed us with such painful sobriety.
>
> But this is not all. You could have chosen to simply cut the incriminated image. This was without counting on your shrewdness, Mister Chairman. The person charged with erasing the gendarme—I'd like to think that you left this in the care of none but yourself—created with offhand facility a harmless-looking little cloud. But look closer and you notice the famed gendarme showing the tip of his kepi. See here what I imagine is the ideal of any censor: to censor without seeming to censor, to censor while directing an infinitely malicious wink toward the viewer in the know.
>
> Mister Chairman, I am ashamed to belong to the same country as you. But no, I am mistaken: you belong to the country of gendarmes, and I to that of the victims. Each of these countries has countless branches around the world. One slight form of solace is the fact that neither coincides, will ever coincide with the other.

Both well and ill informed, since it gives free rein to fantasies about how censorship functions, this letter was hardly representative of the general discourse at the time. The press did not mirror the indignation of this particular viewer, who happened to be a cousin of historian Pierre Vidal-Naquet.

Jacques Doniol-Valcroze revealed the retouched image of Beaune-la-Rolande in *France-Observateur* with the ironic statement, "It is well known that during four years, not a single French gendarme was in any way involved in any operation whatsoever during which people would have been deported."[38] The same day, Simone Dubreuil mentioned the issue in *Les Lettres Françaises*.[39] However, while this in-

stance of censorship mobilized a small section of the media that were hostile to it to begin with, it provoked no particular interest or emotion. The viewer from Alençon seems to have been ahead of his time; state collaboration, while known and discussed in private, was not yet a priority or an issue in the public opinion.

The situation would change radically from the 1970s onward, during the "broken mirror"[40] phase initiated with the tumultuous release of Marcel Ophuls's *The Sorrow and the Pity*. In December 1979, filmmaker René Vautier, tireless scourge of censorship, dragged up the kepi affair in the pages of *Le Monde*,[41] after which the issue was taken up by *Le Canard Enchaîné*. In what was a sign of the times, the satirical weekly described *Night and Fog* as a "cry of revulsion before the massacre of the Jews."[42]

In the early 1980s the photograph of the gendarme embarked on an impressive editorial career: reproduced countless times to illustrate articles and publications on the French state's collaboration, it became a firm favorite, thanks less to what it "documented" than to the air of the times that now allowed denunciation of the taboos of the official account of history. The image's "historical importance" was now derived from its cinematic misadventure.

In 1997, Argos announced the release on VHS of the "complete version" of *Night and Fog* in which the original photograph had been restored. A rather eye-catching sticker that was not at all to Alain Resnais's liking announced: "For the first time: the images censored since 1956."[43] Several television programs eagerly repeated the message.[44] The photograph of the gendarme had become a sales point.

10 THE CANNES CONFUSION
Dissecting a Scandal

ON MARCH 23, 1956, the selection committee of the Cannes Film Festival, made up of film industry professionals,[1] communicated to CNC director Jacques Flaud the list of films suggested for the official competition. Chosen for the short film category were Albert Lamorisse's *The Red Balloon* and Alain Resnais's *Night and Fog.* In accordance with its own statutes, the selection required the approval of Maurice Lemaire as state secretary for trade and industry. On April 7 Lemaire made public the list of French films in competition. Alain Resnais's short film[2] was not among the titles. Thus began the *Night and Fog* affair. During ten days, it would be at the forefront of all media reports and provoke intense turmoil in the wings of the ministry and the festival. Let us begin by retracing the affair as it was reported in and fueled by the press.

SCENE ONE: THE MEDIA

Representatives of the film industry were the first to object to *Night and Fog*'s removal from the official selection. The French federation of cine-clubs, "Cinéma et Vérité," and the Fédération du Spectacle questioned Lemaire by means of letters, petitions, and opinions, adding to the voices of members of the selection committee who felt that they had been overruled by the ministerial decision.[3] Film critics also expressed their support for Alain Resnais, reminding readers of the director's previous clashes with the censors and festival authorities.[4]

This wave of protest would nonetheless have remained weak had it been limited to the world of cinema. The involvement of associations and major figures from resistance and deportee circles changed

the nature of the controversy by moving it into the realm of politics and remembrance. The Fédération Nationale des Déportés, Internés Résistants et Patriotes (FNDIRP) released its first communiqué on April 9, making note of its "painful stupor" before an "inconceivable decision." The following day, the Fédération Nationale des Déportés et Internés de la Résistance (FNDIR) in turn expressed "solemn protest against the measure affecting Alain Resnais's film" and demanded "the lifting of this unjustifiable ban." The national association of former resistance fighters and the Réseau du Souvenir also joined in the chorus.[5]

On April 10, Edmond Michelet took the case before the Council of the Republic. In spoken questions recorded in many newspapers,[6] the senator for the Seine region interrogated Lemaire about the reasons behind a decision that smacked of a "public disowning inflicted upon the French Resistance and the deported." Michelet added that "the government and the people of the Federal Republic of Germany could take umbrage at the argument reported in the press that this measure was taken at the behest of the German diplomatic mission, when the Federal Republic continuously affirms that it strictly and officially distances itself from the Nazi crimes!"

The rumor of German intervention began to take shape in the media. By pretending not to give it credence while at the same time placing French–German relations at the heart of the controversy, the keen tactician Michelet contributed to making it public.[7]

In his triple guise as politician, eminent figure of the resistance, and former deportee,[8] Michelet raised the *Night and Fog* affair to the level of political and diplomatic scandal that would soon be discussed in the Council of Ministers.[9] On April 11, in a long "protest" published in *Le Monde*, Jean Cayrol abandoned use of the conditional and declared himself staggered by the West German embassy's "sensibility." He also called for arbitration by his "German friends," who included the author Heinrich Böll.[10]

Maurice Lemaire could not keep his silence much longer and justified his decision in a communiqué:

> That this short film, which is primarily a compilation of photographic and filmic documents of mostly Nazi origin, should not be selected for an international Festival is first and foremost out of respect for the deported, their families, and their memories.

> Those who will watch elsewhere this very beautiful film—which was put together with all due discretion, but portraying the suffering of human beings, locked up, threatened, tortured, and destined to die, among whom some may recognize their loved ones—will understand that it would have been supremely improper to present such a document in the festive, international ambiance that is the annual gathering at Cannes.
>
> The very particular nature of this film is such that it could in no case compete with fictional films or even historical recreations, which does not prevent this work from possessing the highest value as an authentic testimony and meriting in this regard the widest possible circulation.[11]

This laborious argumentation provoked numerous reactions in the press, some incensed and indignant, others ironic and mocking. Lemaire made his first mistake toward the associations of deportees that initiated, supported, and acclaimed *Night and Fog* since its first private screenings in January 1956. They quite rightly considered themselves in a better position than the minister to judge the respect due to the memory of the deceased and the survivors. Lemaire proved himself uninspired in his adoption of arguments used after the liberation for the censorship of information and images from the opening of the eastern camps and for the banning of screenings of the film *Majdanek*. The military committee in charge of censorship justified its decision at the time by referring to "the emotional reaction it would certainly provoke in families of the deportees" who remained in the dark about the fates of their loved ones.[12] The state secretary also offended the film industry, which resented Resnais's film being lowered to the rank of a "simple compilation film" unqualified to compete. Jean de Baroncelli, critic for *Le Monde*, commented that "everyone knows, and Alain Resnais showed it better than anyone, that a 'compilation film' can be a work of artistic creation and that in this regard nothing prevents it from competing with fictional films or historical recreations."[13] He ended his commentary with the words: "He who seeks to prove too much ..."

The pretexts mentioned serve primarily to hide the diplomatic aspect of the affair. In a letter to the French Foreign Ministry, Lemaire's staff emphasize that he "willingly refrained from mentioning ... the impact the film's presentation could have on our foreign policy."[14]

In hoping to calm everyone's spirits with his mediocre diversion, the state secretary only aggravated the situation. Film critics, associa-

tions, and spokesmen for the resistance and deportees adopted a more aggressive tone and openly turned their sights on the FRG.

Gilbert Dreyfus, chairman of the Comité International de Mauthausen and active member of the Réseau du Souvenir, expressed his indignation: "We had no choice but to bow to German censorship during the occupation. But why should we hide our outrage when a French minister blocks the screening at the Cannes festival of our film *Night and Fog*? And I say 'our film' because it is the film of all of resistance deportees."[15] In *Témoignage Chrétien* former Dachau inmate Joseph Rovan wrote:

> They say this decision was made after an initiative from the embassy of the Federal Republic of Germany. This is hard to believe. We know that the state secretary to the German chancellery once commented on laws of racial persecution. We know that Bonn's diplomatic services include many who participated more or less voluntarily in certain Nazi crimes. But can we imagine finding even one minister, one ambassador, one counselor who would affirm through an initiative of this kind their solidarity with the assassins of Auschwitz whom Germany constantly officially renounces.

The "German diktat" also stoked up the fire in the debate surrounding the European Defense Community, while the issue of the Sarre had yet to be settled. Press and deportee federations of communist leaning considered the issue a continuation of their struggle of two years earlier against the Bonn and Paris agreements. The FNDIRP called for a fight against the "rebirth of Nazism and German militarism," reminding that it already had to rise up "to prevent the implementation of a circular aiming to ban screenings of—even to destroy—films about the deportation" and presenting such measures as "the consequence of the ratification of the Paris accords," which it consistently opposed.[16] In *L'Humanité*, André Wurmser draws his own conclusions from the Cannes affair:

> The revelation of the festival is this: there exists a government, legitimate heir to the Nazis, that gets offended when someone says the Nazis were Nazis, that defends the executioners against the historical truth, that considers itself their successor, the same way President Eisenhower succeeded President Truman or President Fallières succeeded President Loubet, Chancellor Adenauer succeeded Chancellor Hitler.[17]

The rejection of the FRG fit into an "anti-German" line that denounced pan-Germanism and Teutonic militarism and considered Nazis an avatar of Prussian expansionism.[18] André Figueras reactivated it under the header "As long as there are Krauts," in which he got his own back on the German people:

> The images . . . arrive just on time. Just as miserable beings "relaunch" Europe in the guise of "Euratom"—which is nothing but a resumption of the great European Defense Community conspiracy on a wider scale—Alain Resnais's little movie reminds us who we are trying to irrevocably align ourselves with Men who should not be excused just because they tell us they were in the hands of the wrong shepherds. People get the governments they deserve, and Germany got Hitler because it wanted him.
> Let us not be fooled by criminal lies into absolving these monsters. On the contrary, let us remember, as Alain Resnais invites us to do.
> As far as I'm concerned, in spite of Mr. Lemaire this film only strengthens my resolution: as long as there are Krauts, I will oppose with all my might the creation of what they call Europe.[19]

This Germanophobic misinterpretation of the film hardly formed a dominant opinion. Most critics leaned on Cayrol's notable distinction of the German people and the Nazi criminals to more effectively denounce the government in Bonn. In a press release the Réseau du Souvenir wonders "how can anyone admit that the German people's susceptibility could be endangered by accusing the Nazi concentration camp system, stigmatized by a film that shows that the first camps opened in 1933 were intended for the Germans themselves?"[20]

Indeed, Cayrol's text is exemplary and keeps the promise Henri Michel made to Night and Fog's institutional backers: the word "German" is used only once to identify a victim of the deportation (in the shape of the fictional "Burger, German factory worker"). When he later describes the administration and the working of concentration camp system, the poet identifies the criminals solely as "SS" or "Nazis."[21] Backed by this observation, André Bazin wrote in Le Parisien Libéré: "If Bonn feels threatened by a film this noble and devoid of scandalmongering, we may fear that its caution is not a form of susceptibility but an admission."[22] Alain Resnais ironically echoed these words by declaring he did not know that the Nazi government would be represented in Cannes.[23] In short, the distinction between

the German people and the Nazi officials was often abandoned in an eagerness to denounce the federal German government's ambivalent position on the Nazi past. However, it must be noted that the same French journalists who made such an issue out of holding a mirror up to Germany's conscience were themselves none too eager to look into it. Cayrol's allusions to the conflict in Algeria received a lot less attention than the "kepi affair"; the "dictatorship of silence," against which Claude Bourdet had taken up arms two years earlier, was still very much in power in 1956.[24]

The repeated attacks on Germany and Bonn ended up sullying Foreign Affairs Minister Christian Pineau. In *Les Lettres Françaises* his deportation comrade Pierre Daix wrote:

> I am not talking of the intolerable. The Foreign Affairs minister's name is Christian Pineau. He is a former inmate from Buchenwald. It is impossible that he was not aware that this film was more than the film of France's conscience in the face of the camps—that is, was the examination of our own conscience, ours, the deportees. His, in other words
> And Christian Pineau has until now taken no action. He remains silent. So far.

Forced to be on Lemaire's side, Pineau found himself in a delicate situation.[25] Since April 7, he had received an abundant amount of correspondence: telegrams of protest, letters from deported comrades, Paul Arrighi's request to intervene, etc.[26] The chairman of the Réseau du Souvenir had already addressed a less than friendly letter to Lemaire, in which he qualified the film's suppression as an "insult to the resistance and the deportation," warning him that the affair could have "regrettable consequences." His letter to Pineau was less acrimonious, out of respect for their shared past and commitment:

> We at the Réseau know well enough that you share our ideals to trust that you will do everything in your power to take the action required for a decision of this kind.[27]

Faced with this storm of protest, Pineau decided to curb the controversy through a symbolic gesture. He explained it to François Faure, companion from the liberation and chairman of the association for former deportees at Natzwiller Struthof:

> I was not surprised by your reaction to the state secretary of Trade and Industry's decision. . . .
> My reaction was entirely similar and, contrary to what you indicated in your letter, I did not approve the suppression. Mr. Lemaire bypassed the government and could not finally go back on his decision.
> To express my profound displeasure I've decided, counter to my original intention, to not attend the Cannes festival.[28]

Pineau distanced himself from his awkward colleague, and the Foreign Ministry whispered into the press's collective ear that their minister would not go to Cannes as a sign of protest. Pineau himself naturally took a more diplomatic route: he informed the festival organizers that he would be unable to preside over the opening ceremony because he had to be in Lille to welcome the Belgian prime minister who was coming to visit an exhibit.[29]

It was an effective charade: in the days that followed the announcement of this widely praised gesture, the newspaper deflected its attention from the Foreign Ministry to the negotiations between Lemaire's staff, the selection committee, and the deportee associations.[30] On April 17, the state secretary announced that he would "retain the exclusion from competition" of *Night and Fog* and proposed that "the film be presented at Cannes during and as part of the festival, in a ceremony that could take place as part of commemorations for the National Day for the Deported on April 29."

All concerned parties received the compromise with a sense of relief. Jacques Doniol-Valcroze, member of the selection committee,[31] declared the affair closed. The various deportee associations, after deliberation, did likewise.[32] By opposing a unified front to the ministerial decision, the associations rediscovered a sense of shared struggle they had lost during the height of the Cold War. They had officially declared *Night and Fog* the film on the deportation, or more precisely as the film "of all resistance deportees," at a time when this heritage seemed to come under increasing threat due to pardons of certain collaborators, the crusade launched by Colonel Rémy in 1950 to rehabilitate the old marshal Pétain, and the lawsuits against former resistance members.[33]

Not once during the entire polemic did the officials responsible for the decision admit that the choice to remove the film had been made as a result of a German diplomatic initiative. Better yet, although the affair made ripples on the other side of the Rhine and

Bonn's interference was in fact confirmed in the Bundestag on April 18,[34] Maurice Lemaire stuck to his version of the facts. On May 29, replying to Deputy Penoy's written question, he confirmed that his decision had been "taken independent of any consideration concerning possible outside intervention."[35]

While the press reports allow us to trace the chronology and the outline of the affair, as well as revealing the modalities for its transformation into a political scandal, they tell us little about the decision-making process and the roles of the different protagonists. The archives of the Festival International du Film (FIF)[36] and the Foreign Ministry offer possibilities to penetrate the more arcane aspects of a decision that fit the "culture" of an event that formed an important tool for French diplomacy.

SCENE TWO: COMMERCIAL DIPLOMACY

Loredana Latil researched the history of the Cannes festival, whose first gestation was aborted due to the outbreak of war in September 1939.[37] The event was originally conceived as a counterweight to the Mostra in Venice, which was under the fascists' iron rule. Initiator Philippe Erlanger first had the idea in 1938, following incidents at the Mostra where he represented France alongside René Jeanne. After the jury had decided to award an American film, German pressure was such that at the last minute the Mussolini Cup was given to Leni Riefenstahl's *Olympia* instead.[38] The decision provoked an outcry among the participating countries, and the American and British delegations threatened to never take part in the event again. Back in Paris, Erlanger wrote a report to ministers Georges Bonnet, Albert Sarraut, and Jean Zay. Zay approved the creation of a new festival, but encountered resistance among some of his colleagues who, in the spirit of "Munich," judged it inappropriate to offend Italy: "All winter, the decision divided the government. In the spring, after Hitler's occupation of Prague, Jean Zay, with support from Minister of the Interior Sarrault, won the vote."[39] However, the war prevented the first edition from taking place as planned on September 1, 1939. Under the occupation the Vichy government's anti-Semitic legislation cost Erlanger his position, but he held on to his initiative all through the war years.[40] When in 1945 he rejoined the Association Française d'Action Artistique, now placed under the tutelage of the Foreign

Ministry, he decided to see his plans through. And so, on September 20, 1946, "despite the threat of a general strike and the media's aggressive skepticism, under the outcry of a part of its audience, began the first Festival, that heroic and sometimes comical event that its participants always remember with exaltation."[41]

This "festival of peace regained" hardly began as a force to be reckoned with. It took its organizers several years of patient diligence before Cannes found its legitimacy as a film event and achieved international stature. Much of this was related to ironing out the diplomatic creases that stood in the way of the gradual reintegration of former enemies into a much less bellicose arena: Italy took part in the festival's inaugural edition in 1946, whose themes were neorealism and antifascism, and which featured a memorable screening of *Rome, Open City*; Austria joined in 1947; the fledgling Federal Republic of Germany was welcomed in 1949, while Japan followed in 1951. The 1946 edition presented an impressive harvest of films on World War II,[42] but the subject would become less popular with the progressive return to the fold of the former Axis powers. While it is true that the theme was finding less favor in many countries' film industries, the drop was above all due to the Cannes organizers, who felt presenting films on war and resistance in competition to be unseemly. A further complication proved to be the tensions of the Cold War, which reshuffled the cards of international alliances, complicating the festival organizers' task.[43]

In his 1956 assessment of previous edition, festival director Robert Favre Le Bret wrote:

> If the international film festival today enjoys worldwide renown and is at the head of all similar events, this is largely thanks to the vigilance we have always deployed in avoiding having this important international gathering—where only art and technique should dominate—become a political or emotive affair.
>
> More than once have we requested certain representatives to retire their films in order to honor this principle. Those in question have always followed our reasoning dictated by the most elementary courtesy toward other guests of the French government.[44]

The most recent example at the time occurred in 1955, when the West German delegate demanded the retraction of the Norwegian–Yugoslavian coproduction *Blood Road*, directed by Rados Novakovic

and Kare Bergstrøm. The Germans invoked article 5 against this film about the deportation,[45] which gave the organizing committee "the right to refuse admission to a film if it were deemed offensive to a national feeling."[46] The Norwegian delegation politely stepped back.

This precedent weighed heavily on the decision regarding *Night and Fog*. The organizers had in effect already decided that any film referring to the Nazi camps by nature offended the "susceptibility" of federal Germany. What's more, the French hosts believed that the deletion of Resnais's film would occur in the same spirit of cordial understanding. Preparations for the ninth edition of the Cannes festival took place within this context of extreme diplomatic vigilance.[47]

At the Foreign Ministry, officially in charge of inviting the foreign delegations, negotiations had been progressing steadily since January 1956. Key figures were festival president Guy Desson and his director, Robert Favre Le Bret; head of the CNC Jacques Flaud; staff and direction for Cultural Affairs of the Ministry of Foreign Affairs represented by Philippe Erlanger; and the state secretariat for Trade and Industry, which had appointed as Cannes representative its head of cultural affairs, Michel Plouvier, who doubled as the festival's treasurer.

The first difficulties presented themselves when the GDR and communist China contacted the organizers in the hope of receiving an official invitation. Since France had no official diplomatic ties with these two countries, the Foreign Ministry responded with a flat refusal. It nevertheless expressed that it saw no objection to sending the two nations a nonofficial invitation.[48] Jacques Flaud, concerned about French cinema's commercial interests in China and East Germany, quickly jumped into the breach and proposed that Unifrance Film[49] invite observers from the two countries on its own title. This having been done, the festival direction felt a conciliatory gesture was in order, in the form of a parallel event devoted to animated films, to which one film from the People's Republic of China and another from the German Democratic Republic were invited. This intermingling of diplomatic considerations and commercial interests lay at the heart of decisions made in the *Night and Fog* case.

On March 26, 1956, Jacques Flaud unofficially informed Favre Le Bret of the selection committee's choices. He noted that the same list would be sent to the minister in charge with a "favorable judgment," though with an annotation, regarding *Night and Fog*: "We should keep the option open that the secretary of trade and industry will

remove this film if it appears—after deliberation with German representatives in Paris—there might be commercial reprisals from *our main client.*"[50]

This note indicates that the French anticipated a German veto and even leaves room to suppose that the CNC might have taken the initiative to contact the Germans before they had even made an effort.

On March 27, Favre Le Bret in turn addressed a letter to the state secretary of trade and industry, in which he recommended the withdrawal of *Night and Fog* in the name of the festival's tradition and rules of diplomatic propriety:

> [*Night and Fog*] is a film that overwhelmed me personally and which deserves the widest possible distribution, but ... it goes against the very nature of the festival and would open a door to debates that would entirely disfigure the face of this event, turning it into an arena for impassioned discussion—something we must avoid at all costs if we want the festival to survive.[51]

Lemaire therefore had his decision surreptitiously suggested to him by both a CNC concerned about the commercial interests of French cinema and the festival's cautious organizers.

It was most likely at this stage that the Germans entered the scene, through the intermediary of Louis François-Poncet, who handled film distribution between France and Germany. His sensitivity to matters of diplomacy was hereditary: his father, André François-Poncet, was French ambassador in Berlin during the 1930s and occupied the post of high commissioner in Germany in 1956. Questioned about the affair forty years later, Louis François-Poncet explained the diplomatic aspects:

> Both sides of the Rhine did everything they could to bolster reconciliations between France and Germany ... of course we know that the German ambassador at the time was a great Francophile and a firm believer in the European project, and that he was eager to avoid anything that could remind people of a past that had been painful and even, for the Germans, shameful.... The German diplomats at the time were sincere democrats and sought to promote the French-German reconciliation by any means possible. There is no doubt whatsoever that they were displeased about that film.

Presenting himself to Anatole Dauman as agent for the CNC,[52] Louis François-Poncet requested the producer's cooperation in orga-

nizing a screening for the German embassy staff eager to see *Night and Fog*. This was hastily arranged, with thirty-odd embassy employees attending. Cultural attaché Bernhard von Tieschowitz emerged from the screening with a face "as cold as stone."[53] Following this screening the German delegation contacted the festival organizers to once again invoke the famed article 5, while Ambassador Vollrath Freiherr von Maltzan petitioned the Foreign Ministry.

On April 11 Tieschowitz sent a letter to Favre Le Bret to express his satisfaction with the film's withdrawal and resume Bonn's stance on the matter. Although the Ministry of Foreign Affairs of the FRG had no objections to a film that it hoped to see distributed "in all German towns," although it agreed that tribute should be paid "to the murdered and the victims of the Nazi terror," it was nonetheless of the opinion that the international festival in Cannes was "not a suitable forum for a display of this kind" since it should "favor amicable relations between the peoples." A screening of *Night and Fog* in Cannes would risk inflaming "the ambiance at Cannes and would tarnish the reputation of the Federal Republic of Germany, since the average viewer is not in a capacity of distinguishing the criminal Nazi leadership from today's Germany."[54] This argument, which placed little faith in the powers of discernment of "the average viewer," was also adopted in the Bundestag.[55]

Between the festival organizers, the German diplomats, the CNC, and the state Secretariat for Trade and Industry, the withdrawal of *Night and Fog* met with an overall consensus. Only the position of Christian Pineau remains unclear and difficult to judge. Guy Desson personally informed Pineau of the decision on April 5: content at having "pruned" all the difficulties, he added that *Night and Fog* would not be presented "even though the selection committee mistakenly, if perhaps not entirely involuntarily, nominated it."[56] The president finished as follows: "I am no more suspect than you or Lemaire of a hostile attitude toward the Resistance, but my role as host forbids me to spit in the eye of a guest."[57]

By then, however, Pineau had already been contacted by German diplomats. In a 1994 interview with André Heinrich, the former minister confirmed having met the German ambassador but noted that he denied the request.[58] An article published in *Franc-Tireur* on April 13, 1956, provides some detail about this meeting: "During his time with the German ambassador, Christian Pineau reached . . . an agreement

with his guest that the film could be screened under certain conditions, accompanied by another short film, but without being withdrawn from the selection. What happened next between the Foreign Ministry and the Ministry of Trade is unclear."[59] A letter from the Foreign Ministry to Lemaire dated April 10 seems to confirm this information: it was a reminder that the minister approved of the screening of *Night and Fog* "under the condition that it forms the opening part of a program and is not screened by itself."[60] The Foreign Ministry's incomplete records, however, contain no previous memo that clearly indicates the minister's position as outlined in this "reminder."

Was there a delay or a misunderstanding in the communication between the two ministries? Did Lemaire decide to disregard his colleague's opinion? Did certain staff members (Philippe Erlanger and Michel Plouvier[61]) force the issue through, as several newspapers suggest?[62] The archives offer no support in favor of any of these hypotheses. It does, however, appear that the minister's instructions were not very clear and that each person involved tended to place the responsibility on another when the affair took an unexpected turn. Christian Pineau turned his back on Guy Desson and Maurice Lemaire, after which the latter in turn overruled his subordinates, creating an enduring bitterness, as attested to by correspondence from the following year concerning preparations for the festival's tenth edition.[63] Desson, Erlanger, and Plouvier felt repudiated in spite of their consolidated efforts to avoid diplomatic incidents between the delegations. The committee reports provide a breakdown of these exchanges: they place the *Night and Fog* case within the context of an extended process of haggling that ended up a fool's bargain because of the Germans.

SCENE THREE: BACKSTAGE AT THE FESTIVAL

During the board meeting of April 24, 1956,[64] Jacques Flaud regretted that five films in the competition lineup had been subject to protest, marking "a rise of the number of internationally sensitive subjects concerning the sectors that remain unstable despite the general détente [*sic*]."

Already in March, the organizers asked the British delegation to withdraw one of its films for being "hardly friendly toward the

Japanese"[65]—*A Town Like Alice*[66] had raised the ire of the Japanese for portraying Japanese soldiers in a negative light. The English delegates, in a spirit of "courtesy and comprehension" commended by the festival director, agreed to withdraw the film from the competition.[67] But fair play had its limits, as the British pointed out to the Japanese that they had been able to show *Children of Hiroshima*[68] at the festival in 1953 without American objection.

That same month of March, Favre Le Bret believed he could also announce Germany's retraction of Helmut Käutner's film *Sky Without Stars,*[69] which dealt with the separation of Germany from a standpoint deemed too sympathetic to the Western side of the divide.[70]

Following the British gesture and the German promise, the French felt obliged to set a good example by withdrawing *Night and Fog*:

> We will find ourselves in a seriously uncomfortable situation if we, the host nation, ignore the principles that we ourselves erected and which we apply strictly to our guests.[71]

The decision to withdraw was therefore taken in the spirit of good procedure. Not all members of the festival's administrative council agreed with the move, however. Some representatives of the film industry were outright hostile, including Jean Mourrier, also a member of the selection committee.[72] When the issue was back on the agenda for the April 24 meeting, after Maurice Lemaire's suggested compromise, the division persisted, and the idea of organizing a screening out of competition provoked a fierce discussion. Georges Raguis, representing the distribution sector, was of the opinion that the council had overruled itself by deciding to screen *Night and Fog* and created a dangerous precedent since "it is formally understood that no film would be shown at the festival if it is not in competition." He added that having seen Resnais's film, he considered "its appearance in the climate of the festival . . . contrary to the very goal of the deportee associations." The general director for tourism, Georges Septembre, and the representative of the committee for press, radio, and cinema, Georges Lamousse, agreed with him wholeheartedly, displaying an unfettered degree of bad faith when they considered that the film was "not made in the best interest of the deportees" and declared themselves shocked by its "commercial aspects." A majority of council

members finally opted for a minimal screening: there would be no speeches and the text on the invitation cards would be "subject to approval by the chairman of the administrative council."

This caution can be explained by the fear of upsetting the Germans, with whom the festival was in rather delicate negotiations: Germany still had not withdrawn *Sky Without Stars* from their selection. The Soviet delegates were getting restless: during "unofficial talks," the Russians objected to Käutner's film and a feature from Finland, *The Unknown Soldier*, which dealt with the Finnish–Russian war of 1939–1944 in an "unacceptable" manner.[73] Delegate Kalashnikov (!) considered the two nations' choices to constitute a provocation and made it known that the Soviets felt their "national sentiment threatened."[74]

The Finnish case would be tactfully handled by Guy Desson, who had received carte blanche from Christian Pineau, though not without the footnote that the minister wished to "avoid a serious incident with the Russians"[75] on the eve of his departure for Moscow. The festival president managed to convince the Finns to withdraw their film. With the Käutner affair appearing more delicate, the administrative council decided to make a concession by sacrificing a Polish short film, *Under the Same Sky*,[76] despite its subject being the destruction of the Warsaw ghetto. Though no complaint had been lodged against the film, Guy Desson felt that it could "fall under article 5" and justified its withdrawal: "Should we allow the Cannes festival to become an international tribune for all the world's grudges? If we are not careful, this type of film will play a more important part every year."[77] When contacted by the organizers, the head of the Polish delegation bowed, but not without emphasizing that *Under the Same Sky* is not "anti-German but anti-Nazi":

> I have taken this decision in the knowledge that the most important goal of the Cannes meetings is, for you as for us, the development of harmonious relations between all film industries.[78]

The Palme d'Or for propriety, however, went to the Czechs who, also in April, decided of their own accord to withdraw one of their films for possible infraction of article 5.[79] A telegram from the country's delegation announced the replacement of *Jan Žižka*, which ran the risk of being "misunderstood" within the context of the international competition, with the innocuous *Dalibor*, an adaptation of

Bedrich Smetana's opera.[80] What with the incriminated film treating a five-centuries-old event by way of a Hussite hero's life story, we can imagine how the delicate, not to mention confounding, attitude of the Czechs must have touched the festival organizers' hearts.

The council's concessions and the sacrifices made by several countries did little to impress the Germans. On April 27, Philippe Erlanger recounted his unofficial mission to the German delegation, to whom he suggested following the British and Czech examples by withdrawing their film. He found himself "faced with a degree of terseness on the part of the Germans," who refused to comply.[81]

After this letdown, the council decided to exclude *Sky Without Stars* from competition in reference to articles 5 and 3 of the regulations.[82] The Germans were furious, and on April 29, the day of *Night and Fog*'s screening, they left the festival as a sign of protest.[83]

Next point of discussion in the administrative council was the question of whether the West German flag should fly "from the Palais façade." Eternal rep Jacques Flaud gathered a smattering of delegates for an unofficial discussion that earned him a warning from Guy Desson:

> I understand full well that you would like to remain on good commercial terms with the West German representatives, but where official intergovernmental relations are concerned, I do not believe it is in anyone's interest to provoke a double debate in the Reichstag and the Assemblée Nationale.[84]

The rupture with the Germans saw commercial and diplomatic interests at odds for the first time. The festival president had reason to resent his unyielding guests for spoiling the party and "spitting in the eye" of their French host. Guy Desson felt all the more bitter for having shown so much consideration for their sentiments in his efforts to withdraw Resnais's film and discreetly sideline the Polish short *Under the Same Sky*—of which it must be noted that its deletion created not a single reaction despite having been publicly announced by the festival. The Germans, for their part, disapproved of the compromise reached on *Night and Fog* and had no intention of giving in to the Soviets. To save face, they made *Sky Without Stars* a *casus belli*, even though their minister in charge had objected to the choice for Käutner's film in the first place.[85]

In conclusion, the most remarkable event at the ninth edition of the Cannes festival was not so much the deletion of *Night and Fog*—which was in line with festival custom—but that it provoked such a scandal. Given the long line of precedents, none of the organizers had anticipated the angered reactions in the press, the professional esteem enjoyed by its young filmmaker, or the pressure from deportee associations and major figures of the resistance.

Anatole Dauman drew the conclusion that the issue, all things considered, had proven quite advantageous:

> We are most content that certain clumsy interventions by the German embassy in Paris provoked this immense scandal widely reported in the French and even in part of the German press. This unexpected publicity has propelled this film into the public eye and will no doubt prove a tremendous asset to its commercial release.[86]

Indeed, by April 1956, the shockwaves that began in Cannes had already passed the German border.

11 GERMANY GETS ITS FIRST LOOK

WEST GERMANY'S MEMORIAL POLITICS formed the heart of the debate about *Night and Fog* across the border, which began in April 1956.[1] It opposed the government on one side and several major names in new German literature, a part of the press, and the SPD[2] party deputies in the Bundestag on the other. Heinrich Böll[3] started the proceedings alongside Hans Werner Richter, Erich Kuby, and Alfred Andersch. The author Paul Schallück acted as their spokesman during his broadcast on Cologne radio.[4] He gave *Night and Fog* his unconditional support, calling it "objective," "free of demagoguery," and "terribly true," and denounced the government's intervention:

> My friends and I declare, clearly and without ambiguity, that we do not understand the German embassy's actions. . . . We would like to point out to our government that in the eyes of the world it would become an accomplice to the concentration camps if it tried to push them into oblivion. . . . We stand side by side with our French friends to protest against this expression of political opportunism.[5]

The printed press also denounced Ambassador von Maltzan's ham-fisted maneuver.[6] His intervention, intended to avoid unfounded identification between Hitler's criminals and the people of the young republic, created the conditions for an unwanted questioning of the ambivalent rapport the federal German government held with the Nazi heritage. This argumentation was further solidified by the reactions in the French media and the attacks in the East German press that interpreted Bonn's intervention as an admission of identification and solidarity with the national-socialist criminals.[7] The media scandal

prompted members of the social-democratic opposition in parliament to demand that the government provide an explanation.

PROPER DISTANCE

Questioned before the Bundestag during a particularly stormy debate on April 18, 1956, State Secretary Hans Ritter von Lex (representing the Ministry of the Interior) confirmed the diplomatic intervention and adopted the argumentation developed by Tieschowitz.

He emphasized that the festival was not "the appropriate occasion to show a film that, given the Nazi crimes, could all too easily rekindle hatred against the German people as a whole."[8] Speaking for the SPD party, Deputy Annemarie Renger presented the contradiction:

> Don't you think that, in doing so, the government might create the impression that it identifies unnecessarily with something it rejects? Don't you think that the government has more suitable means at its disposal to prevent the German people from being misunderstood and to protect them from suspicion of defending such things?

"Madam, we certainly agree about condemning with the greatest aversion what happened under the so-called Third Reich," Ritter von Lex conceded. To which Renger replied: "Doesn't the federal government feel that the distribution of such films allows it to distance itself from the crimes of national-socialism, to affirm that the German people refuse to identify with those crimes, and to thereby take a step forward in promoting international understanding?"

"I believe we all agree about distancing ourselves from what happened in the past," the state secretary acknowledged, before reiterating his sole argument, "[but] international festivals are not a suitable place to hold such discussions."

Ritter von Lex's words suggested that the controversy was limited to a divergence about the means rather than the ends. In actual fact, the SPD's position revealed a disagreement about the politics of memory (and in this case of forgetting) defended by Chancellor Adenauer. "We do not have the right to forget," affirmed the social-democratic deputy Menzel, to which his colleague Carlo Schmid added: "It's not through silence that we promote the truth." Their comrade Herbert Wehner referred with irony to the use of the Cannes

festival by a federal government eager to "show off the German miracle but not the flip side of that same coin." What was being denounced was the correlation established at the end of the 1940s between economic reconstruction and "repression" of the past. Annemarie Renger, who opened the debate, is a revealing figure in this regard: she served as secretary to the socialist Kurt Schumacher, former deportee at Dachau and major political figure of the postwar period. Hostile to the notion of "collective blame" (*Kollektivschuld*), Schumacher instead championed, in Theodor Heuss's footsteps,[9] the notion of "collective shame" (*Kollektivscham*). In 1952, a year before he died, he pronounced at Bergen-Belsen the famous phrase: "None can relieve us of this shame."

What the SPD deputies were not arguing for, however, was a profound examination of German citizens' responsibility in supporting the leaders of the Third Reich and joining the Nazi party. They also did not question the ambiguous notion of "distantiation" or the peculiar overlap of time that led the minister to oppose Nazi crimes of the past and today's Germans. The debate in the Bundestag, largely structured around the paradigm of "proper distance," rested on a historical consensus and a blind spot. The consensus referred to the distinction between the Nazi notables and the German people—if not cleared, then at least relieved of the Third Reich's crimes. The blind spot consisted of eluding the effects on the present day of the premature interruption of the collective examination of conscience and of the denazification process instigated by the Western Allies.[10]

The parliamentary debate is therefore revealing of the stakes involved in memory in the federal Germany of the 1950s, where "amnesia" had won out over critical introspection, where the error had been too narrowly defined, and where the fight against communism served as a convenient outlet. According to Régine Robin, "Konrad Adenauer's brilliant move" had been to both "limit the denazification as much as possible . . . so as to reintegrate into daily life all those who had compromised themselves with national-socialism to some degree" and "give back their pride to a German people banished by humanity, by affirming that they had suffered much and were themselves also victims."[11]

Night and Fog combined a reminder of the Nazi crimes and a refusal to engage "the question of German guilt"[12] and thereby formed the ideal object for those who pleaded in favor of the partial reexamination

of the past—and therefore for its wide distribution in the Federal Republic of Germany.

TEST SCREENINGS IN THE FRG

The Cannes controversy had the paradoxical consequence of precipitating the film's screening in West Germany. It formed the subject of a special screening at the Berlin International Film Festival, an initiative of the chairman of its organization committee, Senator Tiburtius. This idea, supported by festival director Alfred Bauer,[13] raised the ire of the minister of foreign affairs. The diplomats reassumed the position taken during the Cannes festival, adding that it would be necessary to watch the film to understand how devastating its contents are. Although the final decision was up to the Berlin senate, the minister was openly hostile to the screening.[14]

Berlin's senators took no heed, and so *Night and Fog* was screened in West Berlin on July 1, 2, and 3, 1956. Bauer emphasized his desire to "repair the German mistakes made in Cannes" and to "catch out" the East Germans, who had seized the affair to intensify its attacks on the FRG. Considerations of an internal political nature were also a factor in the decision, as a member of the Institut Français reported to Unifrance head Georges Cravenne: "I add—though I do not say it openly yet—that in the mind of Berlin this is also a political maneuver by the socialist municipality [against the government]."[15] On July 1, Willy Brandt opened the screening by quoting Theodor Heuss: "We Germans must not forget, so that others may."[16]

Around the same time, through an initiative by the German section of the European Youth Movement, *Night and Fog* was also presented in Bonn and Munich.[17] Under European auspices, Resnais's film began a "test career" in the FRG, aimed at evaluating the opportunity of wider distribution.

In Bonn and Munich, the newspaper *Die Europäische Zeitung*[18] asked audiences to fill out a four-part questionnaire. Question 1: According to you, is the film "objective and fair" or "tendentious" or "anti-German and resentful"? Question 2: In Germany today, is this kind of reminder of the crimes committed in the concentration camps: "an urgent necessity" or "unnecessary" or "harmful"? Question 3: What do you believe the effect of this film to be: that "it will shake up the German public" or that "it will leave the German public indifferent" or

that "it will put off the audience with its shock effects"?[19] Question 4: Do you agree that the film should be shown "to the widest possible audience in Germany (in particular the youth)" or "to limited audiences with a specific interest" or not at all?

This questionnaire is not without its flaws. It mixes two types of considerations: personal appreciation of the film and "opinion about an opinion" of future viewers. The phrasing of some questions was precarious. In the space reserved for comments, some of the audience members pointed this out: forty-one people mentioned that the "shock effect" can both shake up and put off at the same time. Some struck out the term "urgent" in the wording of question 2, showing their disapproval of the labored phrasing that forces the interviewee's hand and throws the answers off balance.

The results of the inquiry need to be interpreted against its weak sociological representativeness. The selected audience was far from a representative cross section of the West German public. Invitations were sent to an "elite" judged to be enlightened, consisting of deputies, civil servants, students, and journalists.[20] Out of 700 people invited to the screening in Bonn, 412 filled out the questionnaire; in Munich only 341 people out of 2,000 responded.

Out of the 753 people who responded, more than 93 percent judged the film to be objective and correct, close to 89 percent believed this reminder of Nazi crimes was an "urgent necessity," and 73 percent were in favor of wide distribution in Germany. Answers to the third question were more balanced: 55.5 percent felt that the film could shake up the German public (15.5 percent thought it would leave people indifferent and 21 percent that it would put them off). It is useful to focus on the gap between responses 1 and 3. We have already noted that they form different points of view: the former solicits a personal opinion about the film, while the latter ask for an evaluation of the film's impact on the German audience at large. However, as indicated at once by the composition of the audience, the phrasing of the questions, and an examination of the comments, the interviewees tended to produce an elitist judgment, voluntarily condescending, that distinguished their enlightened reception from what they expected of "uncultured circles" and "normal" or "uncultivated" viewers. We could also advance the hypothesis that, contrary to the first question referring primarily to the spirit of the film and its narration, the third requests an appreciation of the impact and the shock of the images assembled

by Alain Resnais. This dissociation is further amplified by the peculiar conditions of the screening: since *Night and Fog* had at that point not yet been subtitled or dubbed, the screening was preceded by a reading of a translation of the commentary made by the Institut Français in Berlin.[21] This desynchronized presentation favored a separate appreciation of text and images:[22] initially attentive to the commentary being read out and which they believe to be impartial, the audience was subsequently confronted very directly with the shock of images. For some members of the audience, the photographs and footage brought back painful memories of the screenings organized by the Western Allies in 1945.

Images of the Nazi camps played a central role in the first stage of denazification initiated by the occupying powers. The primary function of the photographs and footage recorded at the opening of the western concentration camps was to provide incriminating documents for future trials and to convince the Germans of their guilt.

As early as July 1945 the Americans published a book of photographs entitled *KZ* (short for *Konzentrationslager*) and launched a poster campaign featuring a collage of photographs with the text: "You are guilty of these horrible crimes! . . . You watched and did nothing. . . . You share responsibility for all these atrocities."[23] Cinema played a more decisive role in this process of accusation through images.[24] In June 1945 the *Welt im Film* newsreel, set up by the British and the Americans to replace the *Deutsche Wochenschau*, devoted several weekly editions to reports on Nazi camps.[25] Concurrently the American authorities commissioned filmmaker Hanus Burger to make a documentary consisting of footage of the camps. An elaborate and complex process, which also involved Billy Wilder, resulted in the January 1946 release of a documentary entitled *Die Todesmühlen (Death Mills)*.[26] Despite its late release, the film played to large audiences in Berlin and Düsseldorf. Earlier, in the fall of 1945, Wilder had organized a test screening in Würzburg. This began with the projection of a musical starring Lilian Harvey, after which the German audience was asked to remain in their seats to watch a second film and to give their opinion by way of a questionnaire handed out for that purpose. The results were less than conclusive:

> The film began. The audience began to get nervous. They turned away. They looked at each other. Some suddenly stood up and left the theater.

At the end of the screening, out of four hundred people, only about fifty remained. Not a single questionnaire had been filled out, but all the pencils had been stolen.[27]

One can imagine that *Night and Fog* rekindled memories of these "reeducation" and accusation campaigns in some viewers. The balanced response to the third question corresponds to conclusions drawn in 1945 on the impact of images from the camps. While certain Germans manifested a strong emotional response at the sight of mass graves, others demonstrated what Alexander and Margarete Mitscherlich diagnosed, in their *The Inability to Mourn,* as a "stunning affective rigidity."[28] The reactions then seem to have been as diverse as the responses to the 1956 questionnaire, somewhere between emotional turmoil and rejection.

More than anything, the effort at collective culpability gave very unsatisfying results, as an inquiry carried out by Morris Janowitz in the western occupied zone showed.[29] The campaigns had certainly found their audience: Janowitz reported that four weeks after the surrender, nearly all the Germans questioned had been in contact with the images and information related to the atrocities committed in the camps. But while the majority did not deny the facts, few admitted that these crimes were the collective responsibility of the German people. Most blamed Hitler, the heads of the regime, and the Nazi party.

Similar conclusions are found in the inquiry conducted later by the Information Control Division on the reception of *Die Todesmühlen.* Here too, the "shock effect" on the viewers was very real, but a considerable percentage of the audience sought to place the Nazi horrors in a wider perspective by referring to the Allied bombings and the fate of the Sudeten Germans or prisoners of war. "The vast majority of spectators refused to view the Nazi crimes from the angle of personal implication."[30]

Twelve years later, some of the same arguments reappeared in the comments[31] written down by viewers of *Night and Fog.*

VIEWERS' AGES

In the summary established by *Die Europäische Zeitung,*[32] these observations—more than sixty—were divided by the ages of the interviewees.[33] On the basis of this qualitative section of the inquiry,

journalist Roland Delcour concluded that "the older the spectator, the more their observations demonstrate reservation or hostility."[34] Attentive examination of the comments gives a more nuanced view. If the remarks reveal a correlation between age and opinion of *Night and Fog*, this is perhaps expressed less in a progressive hostility toward the film than through a gradual but significant change in the nature and the type of reflections.

The remarks of the under-twenties, largely favorable to the film,[35] already announced the "questioning of the fathers" that was to come in the 1960s in West Germany. One young viewer wondered "why the Germans" did not have "the courage to make a film like this themselves"?

Observations from those aged twenty to thirty (who were aged between nine and nineteen years in 1945[36]) were more balanced. Some praise the film outright: "It should be shown as opening film on every screen!"; "I believe this film should be shown for four weeks straight in a cinema in every town. . . . I object to the government's regrettable attempt to have the film removed from Cannes"; "It is very important to know the past in order to remain vigilant in the present and the future"; "The film shows an honesty that we do not at all deserve." The negative responses outnumbered the positive ones, however. Their criticism of the film fit into the logic of Adenauer's politics, nurtured by the same fear of a collective trial of the German people: "In any case it is dangerous to show this film abroad, because I fear that it will harm the understanding between people. They will not understand us. We alone must bear our past and assume its responsibility." "Abroad, this film will provoke strong anti-German feelings among uninformed audiences." Several unsympathetic remarks referred to current concerns ("this way we will never achieve European unity") or resort to derivatives:[37] "All warring parties are responsible for these crimes. Where are the films on the bombings of German cities? On the arbitrary killing of women and children?" "As long as the Allies do not recognize the crimes they committed during and after the war, this film will remain negative."

In the category of thirty through forty years of age (nineteen to twenty-nine years in 1945), the emphasis is on the issue of transmission, which leads to conflicting opinions: "This is not a film for the young. They would lose all respect for adults, in particular for us, other Germans." "The young must know what happened so that we will not find ourselves in the same situation again."

Some interviewees in the higher age bracket (forty through fifty years, aged twenty-nine to thirty-nine years in 1945) were tempted to resort to the forms of denial that the Allies had tried to prevent in the immediate postwar: "I doubt the authenticity of the photographs." "I question the figure of nine million, hence my reservations about the film's objectivity." The remarks in this age bracket also reveal veiled allusions to the interrupted denazification process: "The executioners are among us," wrote one spectator, as if to echo Wolfgang Staudte's film.[38] "Everyone in a position of government should be forced to watch this film," another emphasizes. Other remarks were more direct and individual: "They should show this film to the minister of foreign affairs and to Mr. Globke." The name of this personal adviser to Adenauer crops up more than once in the comments. Hans Globke had written the judicial commentary of the Nuremberg race laws;[39] in this capacity, he was seen as personifying the permanence of political and administrative personnel under the two regimes.

More than any other age bracket, the remarks of those aged forty to fifty seem marked by the atmosphere of the Cold War: the same situation exists "in Russia," and the West "collaborates with these criminals like the Nazis before them." "Whoever refuses this film can't distinguish between Bonn and Pankow."[40] Others seemed annoyed that this "history lesson" should come from the French: "Show that injustice exists elsewhere, too. Algiers! The treatment of German prisoners of war after 1944–'45."

In the group above sixty years of age—excepting the comment by a former deportee ("the film is truthful, I can testify to this because I was in a concentration camp myself")—the dominant opinion is a feeling of futility: "This is pointless, the German people have learned nothing." "The guilty won't watch this film." "Which theater would show this?" "There is nothing we can do about the misguided way the Americans tried to erase the Nazi problem. Too much time has passed already." "Today we shame again those who rose to power thanks to the Third Reich," concluded one viewer, while another found the film "too objective" since it "doesn't show the worst atrocities ever committed against humanity." Careful not to forget about German opponents to Nazism, another viewer suggested that *Night and Fog* be systematically programmed alongside a film about the assassination attempt on Hitler of July 20, 1944.

This last remark was hardly fortuitous. In Bonn, Resnais's documentary had in fact been backed with Falk Harnack's fiction film *Der 20. Juli*, which chronicled the action and the trial of the generals implicated in the plot.[41] What with a rival film also made in 1955 by G.W. Pabst (*Es geschah am 20. Juli*), the programmers' cup ran over.[42] Neither film was a one-off in West German cinema. After the questioning and the rifts of the "cinema of rubble" came the time to rehabilitate the "good Germans." Between the "clearing" and victimization of the German people, the sanctification of Wehrmacht resistance came at just the right time for the FRG candidacy to join NATO.[43]

Despite its limitations,[44] this inquest supplied precious indications on the context within which *Night and Fog* was interpreted in West Germany. In particular it emphasizes the importance of the variable of age, expressed as much in the conception of the questionnaire as in some of the additional comments. The latter testify to differing modes of approaching and perceiving the past that prefigure the questioning of the fathers and the strenuous dialogue between generations of Germans.[45]

What's more, while the harshest criticism of the film came from those aged twenty to thirty on the one hand and forty to fifty on the other, these are not all of the same order. The former were very young adults or even children when the war ended, like the character of Edmund in Rossellini's *Germany Year Zero*. In 1956, representatives of this generation seemed most concerned with Germany's place and image on the international stage. The latter went through the Nazi period as mature adults; they seemed above all marked by the interior rift of the German people and the stakes of interior politics. Their positions were particularly divided: *Night and Fog* doubtlessly awakened in its detractors the traumas of defeat and the occupation by stirring up the memory of the Allied campaigns of "reeducation through images." Its defenders, on the other hand, felt entitled to denounce the faults in the denazification process interrupted by the Cold War and the requirements of the reconstruction. Some of the additional comments openly express the unspoken thoughts that surrounded the parliamentary debate around the film.

As far as the organizers of the consultation are concerned, they interpreted the results as an overwhelming vote in favor of *Night and Fog*, which justified its commercial distribution in West Germany. All that remained was to have it translated.

12 EXILE FROM LANGUAGE
Paul Celan, Translator

ON JULY II, 1956, after a suggestion by Christian Democratic deputy Paul Bausch,[1] the Federal Press Office (Bundespresseamt) announced that it would advance the expenses of translating and dubbing *Night and Fog* for distribution in West Germany. In return for what sounded to some as a form of "reparation," the office would be given the right to screen the film in a noncommercial capacity.[2] Intermediary in negotiations with Argos was Rudolf Woller, journalist at *Die Europäische Zeitung*.[3] During talks in Bonn, the producer set the condition that the German translation would be coordinated by the filmmakers and that dubbing would take place in France. While he was in Paris to work on the film's score, Hanns Eisler suggested Bertolt Brecht and Helen Weigel as potential translators, who could provide a more "precise and brutal" commentary than Cayrol's, which Eisler considered too compact and "too written."[4] One imagines what the FRG's reaction would have been had Argos proposed this particular duo of translators. Indeed, not satisfied with deleting the musical cue of the "Lied der Deutschen" from its prints, the Federal Press Office attempted, in vain, to have Eisler's name withdrawn from *Night and Fog*'s credits.[5] Argos had meanwhile forgotten about the composer's suggestions and, at Cayrol's recommendation, sought out Paul Celan to handle the translation.[6] The author wanted a fellow poet to handle this duty, and Celan's personal trajectory, his bond with the French and German languages, and his body of work, entirely haunted by the event, further justified the choice.

183

FREMDE NÄHE

A German-speaking Jew, Paul Celan was born Paul Antschel in Bukovina in 1920. He experienced forced labor from July 1942 through February 1944 and lost his parents in the deportation.[7] After the war he moved to Paris. Alexis Nouss called Celan a "virtual victim" of the camps, who, through his writing, became their "absolute contemporary, whose testimony makes them part of the posthumous present that in turn transforms contemporary readers into witnesses."[8]

His manipulations of the German language, "Babelized"[9] in his poems through the intrusion of foreign words and turns of phrase borrowed from Hebrew, allowed him to turn the "language of the Third Reich" against the executioners, all the while reappropriating German as a language of poets. In his "Bremen Speech," Celan refers to this German language lost in exile:

> Yes, language. In spite of everything, it remained secure against loss. But it had to go through its own lack of answers, through terrifying silence, through the thousand darknesses of murderous speech.[10]

To Claude Mouchard, "the poem exists at the heart of that which always seems capable of denying it, stifling it, being its other—the language itself, German ["the language of the enemy," Celan called it, though without ever renouncing it], which became dangerous in its entirety."[11]

Cayrol first met Celan in June 1954 when the latter began the translation of Cayrol's novel *All in a Night*.[12] Many things separated their two oeuvres: opposite Celan's "hermetic and opaque" qualities stood Cayrol's desire for simplicity and the rejection of a "poetry for those in the know"; even the event that forms their subject is not the same: *concentrationnat* for one, extermination of the Jews for the other. Both of their writings, however, demonstrate that oblique effect that conjures up the event without ever mentioning it in order to emphasize its permanence in the present or to suggest the very impossibility of speaking it and realizing it. When Jean-Pierre Lefebvre notes that Celan's poetry is not *about* the camps but *from* them "and in many regards still their prisoner,"[13] his analysis can be applied word-for-word to Cayrol's writings.

The text of *Night and Fog* would become the same exception in the works of the two poets: Cayrol's only "testimony" and the sole occurrence in Celan's oeuvre of a text directly and explicitly devoted to the Nazi camps, at the same time *about* and *from* the event.

When Celan went to work in the fall of 1956, he was still a relative unknown in West Germany and had received a, to put it mildly, mitigated response from Group 47, the most influential authority in postwar German literature, whose cofounder Hans Werner Richter had signed the petition in support of *Night and Fog*.[14]

In May 1952, at the request of Ingeborg Bachmann, Richter had invited Celan to read some of his poems[15] before members of the group. This meant he had to submit to the peculiar ritual known as "the electric chair," in which each invitee must undergo without retort the comments of the assembled audience, after which "a close associate of Richter's showed his approval or disapproval through a gesture borrowed from Emperor Nero: the clasped fist or the thumb down."[16] As Andrea Lauterwein noted, Celan's appearance before Group 47 formed the primitive scene of a "belated persecution."[17] Not content to slam the "pathos of a lunatic," Richter criticized the poet's voice and diction to the point of comparing him to "Goebbels reading in a synagogue." Mixed in with the group's political ambiguity—it rejected National Socialism but refused to engage the issue of German guilt—was murky resentment toward the figure of the "surviving Jew."[18]

Four years after this traumatizing encounter with "young German literature," Celan was given the delicate task of transposing into that language the words of a French ex-deportee. Cayrol followed and supervised every stage of the process. In November 1956, Anatole Dauman judged that: "This version is the most faithful expression of the author's thoughts in all its intentions. Technically and artistically, it is a valuable as the original."[19]

It would have been proper to mention that Cayrol had approved the liberal adaptation and the variations suggested by his translator. Celan's work is rather far from the classic ideal of "faithfulness" and follows the Benjaminesque notion that a translation should adhere less to the "meaning" of a text than to its "significance":[20] "Because what must be translated is precisely the untranslatable that is transferred from the original to the translation, or which, according to Benjamin, 'survives' it, prolongs it."[21]

Celan's translation of the *Night and Fog* commentary has been the subject of profound analyses that revealed, through the differences between the two texts, a process of adaptation and reappropriation of the original in which the language of the translation transforms itself into the poet-translator's voice.[22]

"DARKNESSES OF MURDEROUS SPEECH"

This voice is heard first in a change in syntax that raises the degrees of abstraction and condensation from the original text and erases some of its characteristics. Celan abandons the declension of tenses employed by Cayrol in perfect symbiosis with the color changes of the image. The translation sticks almost entirely to the present tense and avoids explicit reference to the images, thereby claiming its autonomy from the editing: "These images were taken a few moments before an extermination," wrote Cayrol; Celan translated this as *"Wenige Augenblicke vor einer Liquidierung"* (a few moments before a liquidation), removing the direct reference to the photographs. Similarly, Cayrol's previously analyzed phrase—"and so the real world, that of calm landscapes and of previous times, may well appear in the distance, not very far. *To the deportee, it was an image"*—in Celan's words becomes *"Für den Häftling besitzt sie keine Wirklichkeit"* (to the detainee, *it possesses no reality*). In this sense the translation, as Alexis Nouss noted, "refuses to speak, even in a negative way, of imagery."[23]

Celan furthermore felt hesitant to adopt as his own the theme of helplessness and incommunicability. Where Cayrol writes: "of this brick dormitory, of that threatened sleep, we can only show the surface, the color," the translator resorts to a more condensed phrasing: *"Von Gefahren umlauerter, backsteinfarbener Schlaf"* (a sleep the color of bricks surrounded by threats). "The commentary no longer reflects itself, no longer announces the incommunicable nature of what is shown, since the incommunicable withdrew into the syntax," wrote Andrea Lauterwein.[24]

Celan's conflicted relation with the German language is expressed in certain liberal variations. Where Cayrol, haunted by the figure of the executioner, sometimes adopts its posture to express the Kafkaesque world of the camp, Celan refuses to speak the "language of the Third Reich" and makes an effort to preserve the victims' dignity:

Five o'clock, interminable assembly on the Appelplatz. Those who die at night always distort the numbers.

Fünf Uhr. Appell, Die Rechnung stimmt nicht, die Nacht gibt die Toten nicht her.

In Celan's case "the night refuses to hand over the dead," and the translation attempts to put right the offense to the victims.[25] Distancing himself from Cayrol's witticisms, Celan also neglected to translate the "postcard view" and the Bovary-like "ennui" of the commander's wife.[26]

When the former deportee writes "the dead are crossed out in red," Celan proposes *"Durchgestrichen heißt tot"* (struck out means dead). The condensed German sentence (which omits the red) expresses what the administrative maneuver of striking out lives "signifies" but refuses to "repeat verbally the action of 'crossing out' the dead like listed goods."[27] The executioner's thoughts and his language are not allowed to coexist in the writer's pen, and the translator's German voice forbids itself to reenter the "darknesses of murderous speech."

Andrea Lauterwein also notes how Celan censors the images of the victims' reification:

. . . in search of what? A trace of the corpses that tumbled out as soon as the doors were opened?

. . . auf der Suche wonach? / Nach einer Spur der Leichen (in search of what? / Of a trace of the corpses)

In the final sentences of the commentary, the mass graves are replaced by "funerary chambers" or "chambers of the dead" (*Totenkammern*). The murderous workings of the concentration camp machine whose parts Cayrol dismantles, Celan substitutes with a commemorative logic that honors the victims.[28] Over the final images of Birkenau, those chambers of the dead also appear as a "doublet" of the gas chambers (*Gaskammern*): "The overly general term is replaced by one dictated by principle of reality and the duty of historicity."[29] This same ethics of precision led Celan to complete Cayrol's more vague or elliptical expressions: Zyklon gas becomes the toxic Zyklon B gas, and the black transports "of which no one will ever hear" have a destination in the German text, the crematoria: *"Die Dunkeltransporte—ihr*

Ziel sind die Krematorien.[30] Cayrol transposes himself into the time when the camps functioned, preserving the ignorance of the deportee; Celan assumes the position of he who comes "after" and whose duty it is to know and name the reality. In fact, the chamber of the dead—replacing the charnel house—could be more appropriate for evoking the landscape and the location of the disappearance of the Jews, a majority of whom, gassed, disappeared without a trace in the flames of the crematoria.

THE GENOCIDE BETWEEN THE LINES

An additional innovation of the translation is that it takes into account the genocide of the Jews, which is present in the images but absent from the original commentary. This is expressed first in re-dressing the balance of names and terms referring to the deportation:

- Rounded up in Warsaw, deported from Lodz, from Prague, Brussels, Athens, Zagreb, Odessa, or Rome, detained at Pithiviers, rounded up and gathered at the Vél' d'Hiv, resistance fighters locked up in Compiègne, the crowd of those taken on the spot, taken by mistake, taken by chance, starts its march toward the camps.

- *Aushebungen in Warschau, Aussiedlungen aus Lodz, aus Prag, Brüssel, Wien, Athen, aus Budapest, Rom. Razzia in der französischen Provinz, Groß-fahndung in Paris. Deportierung von Widerstandskämpfern. Die Masse der Festgenommenen, Mitgenommenen, Mitgekommenen, tritt den Weg in die Lager an.*[31]

The first change is in the choice of locations: Zagreb, the capital of Nazi-friendly Croatia (afterward part of Tito's Yugoslavia), and Stalin-ist Odessa were replaced with Vienna and Budapest, the twin capitals of the Austria-Hungary empire, both home to sizable communities of German-speaking Jews. Vienna—like Paris included to replace the names Vél' d'Hiv and Compiègne, unfamiliar to the German public in the 1950s—was also a point in the exiled Celan's itinerary after leaving Bucharest.[32] In the same paragraph, the desire to reintroduce the missing genocide can be read in the substitution of the terms describing methods of arrest: the enumeration of those taken on the spot, by mistake and by chance—all inappropriate terms when speak-ing of the deportation of the Jews—is replaced by "arrested" (*Festgen-*

ommenen), "taken along" (*Mitgenommenen*[33]), and "companions" (*Mit-gekommenen*, "those who came along"[34]).

It is in the translation of the final sentence that the reference to the genocide is expressed most clearly: Celan transforms *"the old monster of the concentration camp system"* into *Rassenwahn* (racial delirium).[35] This use of the word *Rasse* is all the more remarkable because the poet never uses it in his own work, preferring words like *Geschlecht* (lineage, generation) or *Stamm* (tribe, stock).[36] In this way, where Cayrol's commentary ignores the genocide, "where Celan's poetry never mentions the Shoah, the translation does."[37]

GERMANY ON THE MIND

A third characteristic of the text concerns its adaptation for a German audience and fitting it into the political context of the FRG. This is how Andrea Lauterwein interprets the changes made to the first listing of camps: the switched positions of Dachau (which ends Cayrol's list) and Bergen-Belsen (on which Celan ends his) is justified by the German audience's frame of reference.[38] Starting in 1933, the Dachau camp was the subject of a propaganda campaign that presented it as a modern reeducation center. Complete with photo report, Dachau served as an exemplar of the "ideal of concentration," which exalted the Nazi's power of control and the regenerative virtues of the reformatory.[39] Celan may have feared that some German minds had retained this image. Conversely, Bergen-Belsen had become, in the eyes of those same Germans, the camp that symbolized the horrors of the concentration camp system. The images of its liberation by the British had been widely shown in films, in newsreels, and on posters by which the Allies accused the German people.[40] Ten years later, many still associated the name Bergen-Belsen with these culpability campaigns. It symbolized the postwar debates, primarily through Theodor Heuss and Kurt Shumacher's speeches, on the blame and "collective shame" of the German people.[41] It was also in this camp that Anne Frank died—and in the FRG of the 1950s, she had become emblematic of the Jewish genocide.

The adaptation of the commentary to the national context can also be sensed from the implicit denunciation of the politics of forgetfulness. Where Cayrol writes: "This reality of the camps, *despised by*

those that created it, imperceptible to those who lived it, for us in turn
it is in vain that we try and understand it," Celan translates it as:

> *Die Wirklichkeit der Lager:* die sie geschaffen haben, ignorieren sie, *und
> die sie erleiden, können sie nicht fassen. Und wir, die nun zu sehen versuchen,
> was übrig blieb?*

> The reality of the camps: *those who created them ignore them*, and those
> who suffer them can't imagine. . . .

The changes in tense *(those who created them)* is all the more re-
markable here because Celan wrote in the present tense. This bit of
rule breaking could be considered symptomatic, according to Andrea
Lauterwein:

> Where Cayrol described the past attitude of the Nazi leaders toward the
> reality of the camps, their contempt in the same moment they "con-
> struct" (present tense) them, Celan addresses "those who created them"
> (past tense) and "ignore them" *in the present.* If contempt was the *sine qua
> non* for the SS to continue their despicable activities when they were in
> power, then indifference or intentional ignorance—in German, the
> word *ignorieren* does not mean "to not know," as it does in French, but
> always "to pretend not to know"—is the mental state of those who have
> "forgotten" and were reintegrated into German society.[42]

The connection between the politics of forgetting and the re-
quirements of the reconstruction are present in two additions in
which Celan develops, focuses, and complements the commentary.
To Cayrol's list of German companies that employed slave labor
(Steyer, Krupp, IG Farben, Siemens, Hermann Goering), Celan adds
"und anderen" (and others), thereby emphasizing that this list is in-
complete. Accusing German industrialists did not sit well with the
federal authorities. Ewout van der Knaap notes how, in the typescript
of the translation sent to the Federal Press Office, this passage of the
text had comments added in the margin. He explains that the Federal
Press Office tried to have this overly explicit enumeration of the role
of certain German industrialists in the concentration camp economy
reduced.[43] It must be noted that on two occasions Celan opts for a
less implicit tone than the original text. Where Cayrol writes: "the
large chemical plants send the camps samples of their toxins. Or they
buy a set of deportees upon whom to test them," Celan opts for a
more indirect phrasing:

von grossen chemischen Werken kommen Proben ihrer gifthaltigen Präpa-
rate oder sie erhalten *einen Schub KZ-Häftlinge für ihre Experimente
zugewiesen.*

from large chemical factories *arrive* samples of toxic substances or *they
are assigned* a set of deportees for their experiments.

Later, Celan opts for the term *"Industrieplanung"* (industrial
planning) instead of "heavy industry,"[44] more faithfully translated as
"Großindustrie." More likely than possible pressure from West German
government services is Claude Mouchard's hypothesis that Celan con-
sciously avoided a wording too similar to the communist idiom
(which he had experienced even before he settled in France), which
sought to interpret Nazism as an intensified form of capitalism.[45]

These two examples aside, Celan's translation tends to amplify
Cayrol's accusatory action, in particular by suggesting the aborted
denazification. Where the original text says: "Somewhere among us
there remain lucky kapos, *rehabilitated bosses,* unknown informers,"
Celan is more precise:

Irgendwo gibt es noch Kapos, die Glück hatten, Prominente, für die sich
wieder Verwendung fand (for whom they found new use), *Denunzianten,
die unbekannt blieben.*

The impunity of countless former Nazis reinserted into the ranks
of civil servants, politics, the justice system, or industry[46] formed a
major preoccupation for Celan. Gerhart Baumann reports that the
poet had gone through magazines and newspapers published during
the Third Reich and written down the names of every person who
never expressed regret for past actions.[47]

The accusation of a forgetful and erroneous Germany is complet-
ed when Celan translates "I'm not responsible/So who is responsi-
ble?" as "Ich bin nicht Schuld/Wer also ist Schuld?" (I am not guilty/
So who is guilty?). By replacing responsibility (*Verantwortlichkeit*
in German) with guilt—a term also used by Cayrol in earlier
drafts[48]—the poet adds his contribution to the debate that began in
the Germany of year zero.

Finally, there remains a more puzzling intervention, in which
Celan removes the names that Cayrol uses to represent the
deportation:

Burger, German factory worker. Stern, Jewish student from Amsterdam. Schmulski, merchant from Krakow. Annette, schoolgirl from Bordeaux.

The factory worker from Berlin, the Jewish student from Amsterdam, the merchant from Krakow, the schoolgirl from Bordeaux.

Andrea Lauterwein argues, not entirely convincingly, that "Cayrol's text implies that only the 'student' is Jewish, while Celan's figures, described only by their activity and residence, are all potentially Jews."[49]

Alexis Nouss refers back to the motif in Celan's work of the disappearance of names as a consequence of the event, for which he quotes *The No-One's-Rose: "Alle die Namen, alle die mit-/verbrannten/Namen,"* "All the names, all the/names/incinerated along."[50] This is a sensitive interpretation, but it raises the question of why Celan, who refused to assume the position of the enemy, would be willing to commit the same offense to the names of disappeared—even fictional ones—as the Nazis did.

Harald Ollkus sees the passage as a parody of the sequence from *Triumph of the Will,* in which Leni Riefenstahl illustrates the slogan *Ein Volk, ein Führer.* This famous scene shows young Germans responding in turn to the question "Comrade, which region are you from?" by droning out a string of place names from the Great Reich (from Frisia, from Bavaria, from Pomerania, from Königsberg, from Silesia, from the Black Forest, from Dresden). This sequence was lampooned in Erwin Leiser's documentary *Mein Kampf* (in which Riefenstahl's soundtrack accompanied Russian-shot footage of a huge crowd of German prisoners shuffling past residents of Moscow), but why would Celan, who distanced himself from Nazi rhetoric and refused all irony, suddenly resort to these to accompany images of roundups and arrests? What's more, if this were a parody, why would the poet make the effort to substitute "worker from Berlin" (*Arbeiter aus Berlin*) for "German worker" (*deutscher Arbeiter*), which was, through its use by the populist movement, a leitmotiv of the language of the Third Reich?[51]

The variety of theories suggests that no explanation imposes itself upon the interpreters of Celan's text. Though some mystery remains regarding the disappearance of these names—which does conform,

however, to the translator's choice to employ a greater degree of abstraction—the other willfully chosen differences in the translation have a manifesto-like quality. The poet reappropriated the original text by discreetly adding the hidden dimension of the genocide, resisting the ghostly assaults of a contaminated language, repositioning the event at the heart of German history, pointing out the ambiguities of the reconstruction, and, finally, adapting the spirit of the commentary to the modes of reception and the imagination of the German public.

THE VOICE OF GLASS

The narration of Celan's text was entrusted to the actor Kurt Glass, replacing initial choice Erich von Stroheim.[52] At the test screenings, several audience members had praised Michel Bouquet's delivery "devoid of pathos" and suggested that the German dubbing respect this extremely sober tone. Glass refused to grant them their wish, making full use of his range as an actor. Playing with range and tonality, alternating rhythm and intensity, the narrator seemingly seeks to impose the range of his emotions and a singular interpretation of the film upon the viewer. Bouquet's neutral voice left things open to multiple interpretations, without interfering with the confrontation between music, images, and words. Kurt Glass assumes the vacant function of aural illustration. At the risk of redundancy, the actor closely follows the atmosphere of certain scenes: his tone is anxious when pronouncing the word *Revier*, conspiratorial when speaking of the resistance and underground networks, tender when listing deportees'possessions. Though solemn at first, Glass's voice becomes curt when describing the working of the concentration camp machine, overcome with emotion to evoke the fate of the victims, and finally transforms into a commanding indictment to point out the criminals. This accusing diction attains a crescendo in the final sequence, reaching its acme in the sentence *Wer also ist Schuld?* (So who is guilty?). In a new return of the specter, Kurt Glass channeled in this passage the accent of the Allied narrators brandishing images of the camps before German audiences.

This adaptation that changed the film's language and resonance[53] was completed in the beginning of November and distributed that

same month throughout the FRG.[54] Distribution was largely handled by cine-clubs and various associations (European youth movements, Judeo-Christian friendship organizations, international student associations, international conscientious objectors, etc.). The reactions from the press and the public, recorded after the screenings, faithfully reproduced those expressed in the Bundestag debate and at the test screenings in Bonn and Munich.[55]

At the same moment, on the other side of Berlin, the German Democratic Republic also expressed its interest in Alain Resnais's film.

13 TRANSLATION BATTLES IN THE GDR

EARLY NOVEMBER 1956, through Hanns Eisler on a visit to Paris, the GDR expressed its desire to distribute *Night and Fog*. Argos naturally sent over prints of the newly completed German version to East German company Veb-Defa.[1] Six months later, the French producers received to their surprise a telegram demanding the urgent shipment of the "international soundtrack" for the creation of a new dubbed version. Dauman's reply was negative, vaunting the merits of the work achieved by Celan. Yet, Defa director Schlotter persisted: in May 1957 she justified her decision by arguing that the original text had not always been "translated with the necessary precision."[2] Relying on an elaborate study by its dubbing department, she supplied a string of examples of faulty translation. This word-by-word comparison of the two commentaries used the extreme condensation of Celan's prose as a pretext to declare it unfaithful and refuse its exploitation:

> It is precisely because this film has such great expressive power and tells us Germans so many things that, with your approval, we would like to translate the French text with perfect exactitude. We will not change a single word but we would like to avoid a German translation that weakens the film.

Behind this manifesto in favor of a literal translation hides an ideological distrust of the West German version. By expressing her regret at the omission of Odessa and the absence of other Soviet cities, and by pointing out approximations in the sentences devoted to the compromised German industry,[3] Schlotter revealed what was truly at

stake in the battle of translations, which would reach its full scale in the months that followed.[4]

HEATED EXCHANGES

In the summer of 1957, Defa sent Argos its own translation of the commentary. After a detailed examination, the filmmakers delivered their verdict in November: they judged the "longer and more verbose" text "pedestrian" in its laborious search for precision and devoid of "any sense of poetry."[5] It also contained numerous serious omissions, changes, and mistranslations.[6]

The creators firstly criticized the Defa version for replacing Struthof with Stutthof ("if we wrote Struthof, it is to refer to the only camp established by the Nazis on French soil"[7]) and *kapo* with *Aufseher* (the former term "belongs to the international camp vocabulary and is used consistently in German testimonies"). They placed question marks at the cleanup performed on the list of German firms that collaborated with the Nazis: from the six names cited by Cayrol, only one remained: "Why do you only mention IG Farben, which, as we know, is currently the sole company on trial, while many other Nazi firms also performed experiments on deportees?" This piece of criticism gives way to a more specific line of questioning: "What is your reason for removing '*und anderen*' [and others], which serves to blame all other companies that could not be mentioned because they are legion?" They hereby reproached the East German version for not retaining Celan's modification of the original. A certain bias can be detected in the French complaint about the deletion of the "postcard view," which they did accept in Celan's text.

Admitting that these represent minor points, Argos's letter moves on to "the most fundamental discrepancies" that form its reason to reject the new translation. The *casus belli* mainly concerns the last sentences of the commentary leading to Cayrol and Resnais's "warning sign": "There we are, sincerely watching these ruins . . . and who fail to hear the endless screams."[8] Going against the grain of this logic of questioning, the East German translation ends with: "In one part of the world, the dead have ceased to scream because the weed has been thoroughly uprooted." Years later, Olga Wormser would sum up the affair in the following succinct terms: "The representative of East German cinema . . . wants to turn Cayrol's text into policy: 'We who

fail to hear the endless screams'—'Except in the USSR and other people's democracies?' asked the delegate. We refused, naturally."[9]

Though a bit cavalier, this interpretation faithfully reflects the spirit in which Defa elaborated the text. The transformation of the commentary fits snugly into the official East German view of history. Drawing its legitimacy from the anti-Nazi past of its rulers, the GDR immediately did away with any feeling of guilt by placing the blame entirely on West German shoulders. Proudly waving the flag of anti-fascism, the Democratic Republic launched a virulent campaign against its other half in the 1950s, accusing it of pardoning former Nazis and denouncing their presence in the highest spheres of the federal government. In this regard, the reference to the antifascist struggle referred to the present as much as to the past.[10] Defa's willful mistranslation of *Night and Fog*'s epilogue was perfectly in keeping with the official account of history and meant to suggest that the womb of the "infernal beast" is still fertile in the West, but definitively sterile in the East.[11] The sentence in the commentary adopts words from a speech by Otto Grotewohl given on September 14, 1958, at the official inauguration of the Buchenwald memorial, in which he confirmed that while Hitler's fascism was defeated in the military sense in 1945, its roots were eradicated only in the GDR.[12] The decision to distribute the documentary in East Germany fits entirely into this Cold War quarrel. According to film historian Thomas Heimann, the GDR even considered preceding the film by a brief introduction about the Bonn government's diplomatic intervention and the difficulties *Night and Fog* encountered in West Germany.[13]

The rewriting of the epilogue, which appeared as an omen of the partisan reappropriation of the film, angered the filmmakers. They condemned this duplicity[14] and delivered an analysis of Cayrol's text:

> This is not a matter of reassuring the viewer by telling him that only the "Nazi villains" were capable of committing such crimes and that such crimes are now in the past. The viewer, whatever his nationality, must according to our intentions question himself if similar atrocities, with a different face and under a different pretext, are still happening in Greece, in Algeria, or in many other countries.

They furthermore wondered if the "optimism" (an earlier draft reads "clear conscience") expressed in the conclusion was "truly reconcilable

with the screams we should hear, no matter where from or where we are? It is real, living human beings that utter these screams today, not the dead." By mentioning Algeria, the French film crew makes an example out of its own conscience:

> We understand the mindset that made you deviate so far from us, but we cannot approve, because we have given, in a sense, the example of self-accusation. We believe that every living human being in a world where concentration camps exist, no matter under which regime, should feel guilty and proceed to this act of self-accusation.

With this implicit reference to the "Soviet camps,"[15] the authors intended to show that they were not ignorant of the stakes behind Defa's rewrite. At preview screenings of *Night and Fog* in France, certain representatives of the French communist party had already expressed their disagreement with the film's ending. "Communist filmmakers told me: 'But people might think there are camps in Russia,'" Alain Resnais remembered:

> "Okay, listen: you come with us and we'll change that because people shouldn't think that you're referring to Russia." They weren't very happy. Luckily, Louis Daquin, a French film director and communist, saw the film and came out very affected. He told me: "Listen, I can understand what my comrades see in this story, but I think you shouldn't change a thing because, one, if there are French people who believe that camps exist, okay . . . , they will always believe it; and also, if by chance there should be camps in Russia, well, that's too bad for them. It's the Russians who are wrong." And that was it. Thanks to Louis Daquin, there was no more trouble after that.[16]

The squabble over the German translations would perhaps also have ended there, had it not been for the intervention of Film Polski. Solicited on the matter, the Polish outfit confirmed that the distribution rights for the GDR, which it held, included the right to dub the film. Since the contract with Argos stipulated no particular restriction, there existed no legal obstacle to making a new German translation.[17]

In February 1958, after the East German "authorities" confirmed their refusal to distribute the West German version of the film, Schlotter sent over a new text she certified "strictly conformed" to the original, because it was "literally derived from the French translation."[18]

THE DEFA VERSION

The new commentary was written by the author Henryk Keisch,[19] whose career presented all the reassuring characteristics the East German authorities required. In 1933, at the age of twenty, Keisch fled Nazi Germany for France. Under the occupation he formed part of the communist resistance and narrowly avoided deportation.[20] After settling in the GDR in 1950, Keisch worked as theater critic for the newspaper *Neues Deutschland* (the SED party's[21] main publication) while pursuing a career as a playwright, scriptwriter, and translator. When contacted by Defa, he was in the midst of translating Louis Aragon's *Les Communistes* and was the recent laureate of the GDR's national prize for art and literature.

Olga Wormser painstakingly examined the new translation and, on February 23, 1958, assured Anatole Dauman that it was faithful to Cayrol's text, excepting a few "trifles."[22] Argos's comments bore fruit: the epilogue this time respected the original: *"Und wir denken nicht daran, uns umzublicken, wir überhören die Schreie, die nicht enden wollen."*

Wormser did, however, point out a slight alteration in the self-critical exercise, where Keisch translates: "Will the faces of the new executioners be different from ours?" as *"Und ist es immer so leicht, die Mörder zu erkennen?"* (Is it still as easy to recognize the murderers?).

Contrary to Celan's translation, the Defa commentary carries several added details and personal annotations. "The height of cynicism" (*Gipfel des Zynismus*), Keisch declares before the sentence "An orchestra plays an operetta march."[23] And where Cayrol wrote "The machine is set into gear," the translator proposes *"Die Menschenvernichtungsmaschine wird in Gang gesetzt"* (the extermination machine is set into gear[24]). Keisch similarly expands the phrase "the crowd . . . starts its march toward the camps" with the words: *"Und man verfrachtet sie alle in die KZs, in die Vernichtungslager"* (and they are all sent to the concentration camps, to the extermination camps). "They're really afraid their audience won't understand," Wormser comments ironically, overlooking the fact that this addition also signifies a distinction between the two types of "Nazi camps"[25]—a distinction absent from the original. Additionally, where Celan refused to resort to any form of reification to describe the victims' fate, Keisch emphasizes the process of dehumanization and the industrialization of death that characterized the Nazi concentration and extermination systems.

In this manner he modified one of the sentences in the paragraph on the turning point of 1942:

> *Himmler überläßt es seinen Spezialisten, die Leichen nutzbringend zu verwerten. Mit dem Problem der rascheren Menschenvernichtungen befaßt er sich selbst.*

> Himmler leaves it to his experts to productively exploit the corpses. The problem of increasing the pace of extermination he dealt with personally.

In her memo to Dauman, Olga Wormser mentions neither the replacement of the term Nazi with fascist—more along the lines of the Marxist thought and idiom in use in the GDR—nor the transformation of "our faulty memory" into "our short memory span" (*unser allzu kurzes Gedächtnis*). She also overlooked the rewritten paragraph on the resistance and underground networks: by replacing the pronoun *"on"* (*"on s'occupe des camarades les plus atteints ... on donne sur sa nourriture"*) with "they" (*sie*) and "each" (*jeder*) ("they take care ... each gives"), the translator reinforces the idea of an unbreakable chain of solidarity and sanctifies the inmates' struggles inside the camps. This heroic vision fits perfectly with the model of the "resistant deportee" that infuses the original text. While Keisch adopted two of Celan's changes (he also removed the fictional names from the list of deportees and replaced the word "responsible" with "guilty"[26]), he hesitates to reintroduce the genocide. In this sense, the author remained faithful to the text by former resistance fighter Cayrol, all the while conforming to the official history of the camps as employed in Soviet bloc countries (particularly in the GDR and Poland).

Although the new literal translation left little room for criticism, its length did pose a problem, as Olga Wormser indicated: "I wrote down the word count of several paragraphs, comparing them to Celan's text: fifty-one versus thirty-six, fifty-two versus thirty-nine, fifty versus thirty-three, sixty-three versus thirty-nine, and so on. I wonder how the narrator will cope without stumbling or summarizing." She concluded:

> Given the fidelity to Cayrol's text, but in a far less incisive and poetic form than Celan's, this simply proves my suspicion that they don't want a text written by Celan. There's nothing we can do about it besides pointing out that their text is too long and won't synchronize with the visuals.

Anatole Dauman brought this across in his letter of February 26 that ended the dispute. The head of Argos predicted "certain difficulties with recording and editing because of the excessive number of words used in the commentary." He went on to note: "Given our reservations, not about its general meaning, but about how your text will fit the images, for moral reasons we would like you to mention on the title card in the opening credits of your version: *based on Night and Fog.*"[27]

The credits of the East German version[28] show that Defa ignored this request. The order of the credits is furthermore revealing of the stakes of the film's distribution in the GDR: the national composer receives top billing, far ahead of Resnais, and finds himself awarded the Jean Vigo prize for good measure.[29]

The Defa dub confirms the French fears. Actor Raimund Schelcher narrated the text and, like Michel Bouquet, received no credit.[30] Faced with the dense verbiage, the actor had no room to impose any sort of interpretation. He delivers the first few sentences in a husky voice that occasionally resembles Bouquet's in its neutral tone, but quickly find himself at the mercy of a text that runs longer than the shots.[31] At this point his rhythm accelerates but fails to remain in synch with the images: he mentions castration experiments over a shot of a mutilated foot and describes the selection process after the photographs from the Auschwitz Album have already disappeared from the screen. More dramatically, Schelcher is still speaking of the acceleration of the Nazi machine when the first images of Bergen-Belsen appear as prologue to the final part of *Night and Fog* on the liberation of the camps. Thus pushed back, the inaugural phrase "when the Allies open the gates" arrives in this version over a close-up of a corpse. Subsequently, when the narrator adds, "all doors," it doesn't correspond to the images of Kramer and Belsen's female guards being escorted out of a barracks, but to a shot of the bulldozer—a desynchronization that renders the sentence incomprehensible.

In conclusion, the tug of war between Argos and Defa appears to have had only losers. Dauman failed to impose Celan's German translation due to the poet's being persona non grata in the GDR. Defa's obstinacy may have paid off, but the result was stylistically unsatisfying. Above all, it had to give up on rewriting the epilogue, reducing the ideological value of the film's distribution. Indeed, as Jörg Frieß points out, the East German committee for cinematographic control,

which assessed the documentary in August 1958, judged it to be "insufficient in terms of propaganda."[32] Consequently, screenings were limited to matinees and occurred within a strict framework: "For the film to strengthen the viewer's willingness to join the struggle, a prologue and an epilogue must be added that thoroughly explain the film [*sic*]." The introduction could be handled by a "known resistance fighter," while the postscript should employ the available archive material that would emphasize "the GDR's current struggle against fascism." In September 1958, in a second opinion, the committee toughened its stance by demanding an epilogue that convincingly portrayed "the current struggle against West German imperialism, and the GDR's role in the fight against West Germany's neofascism and militarism."[33] In November 1958, Veb-Defa was officially commissioned to create this postiche ending, although it does not appear to have ever actually been made.[34] This version of *Night and Fog,* approved by the censors in June 1960, was only shown in East Germany on rare occasions, as special screenings organized by the committee of antifascist resistance fighters or on location at Buchenwald,[35] until the distribution rights expired in 1963.[36]

However, the history of *Night and Fog* in the GDR takes another turn with a discovery that brings new information to the table. While researching evidence of a hypothetical screening of the documentary on East German television, I discovered in the Deutsches Rundfunkarchiv at Babelsberg the existence of a third German translation.

A CLANDESTINE "REMAKE"?

This East German repeat version was prepared for the broadcast of *Night and Fog* in September 1974 as part of a television program entitled *"Filme contra Faschismus."*[37] Its commentary was written by Evelin Matschke[38] and narrated by actor and former deportee Erwin Geshonneck, a notable figure in East German cinema, recipient of the GDR's national prize in 1954 and 1961.[39] The accompanying materials mention that the music was recomposed thanks to the Hanns Eisler archive,[40] which suggests that the East German broadcaster did not possess the film's international soundtrack. This adaptation was therefore very likely conceived without Argos's knowledge and without acknowledging the authors' moral rights.[41] Indeed, the new text

takes great liberties with the original. One imagines what Olga Wormser's reaction would have been if she had been charged with its assessment.

Defa clearly learned from its previous experience: Matschke's commentary is concise, sometimes simplified to the point of omission, as the film's opening scene demonstrates. Cayrol's long first sentence[42] is reduced to a few words:

> - *Eine stille Landschaft—ohne Stille. Jeder Feldweg, jeder Krähenschwarm, eine Landstraße kann hierher führen: zu einem Konzentrationslager.*
>
> - A silent landscape—without silence. Each path, each swarm of ravens, a country road can lead here: to a concentration camp.

A vague summary of the original text, this commentary is marked by an absence of artistic innovation that dilutes the film's poetic dimension.

The new translation subjects Cayrol's text to a three-part operation: cuts, changes, and additions. Without going into a detailed inventory of the numerous omissions, it must be noted that these are aimed primarily at erasing the original's causticity and to smoothing the image of the concentration camp. Gone are the passages in which Cayrol, rejecting any form of angelism, refers to the strict laws of camp survival: "The obligation to sleep. Wake-up call by cudgel, falling over each other, searching for stolen possessions"; "black market, where one sells, where one buys, where one kills softly."[43] Certain substitutions demonstrate the logic of edification. An inconvenient reference to religious practice—"one might think of God"—is replaced with a more politically convenient alternative:

> *Er übt die höchste Tugend, die an diesen Plätzen möglich ist: Solidarität.*
>
> He practices the highest virtue possible in these places: solidarity.[44]

Evelin Matschke's text conforms to the message of the sanctifying and heroic commemorations organized by the East German authorities at Buchenwald, the camp that symbolized communist resistance. The name Buchenwald was also added to the list of camps, replacing Struthof. The enumeration of the origins of deportees deletes Rome, Lodz, Athens, and Zagreb, retaining only Prague, Brussels, and Odessa.[45]

Unsurprisingly, the new translation emphasizes the antifascist struggle. The passage "1933, the machine is set into gear" becomes: *"1933. Der Faschismus setzt sich in Gang."* (*Fascism* is set into gear). The paragraph devoted to "labor in subterranean factories" receives this addition: *"Der faschistische Raubzug braucht Waffen, immer mehr Waffen"* (the fascist criminal campaign needs weapons, always more weapons). Like Keisch, Matschke makes abundant use of the industrial metaphor. The commander no longer oversees "the rituals," he administrates the death factory (*[er] verwaltet die Todesfabrik*). Same for the passage in which Cayrol describes how the concentration camp machine jams ("Not enough coal for the crematoria. Not enough bread for the men. Corpses pile up in the streets of the camp"), which is replaced by:

Der Henker produziert noch einmal Leichen, deren Berge ihm über den Kopf wachsen.

The executioner still produces mountains of corpses that threaten to topple and crush him.[46]

The notes on synchronization between text and images in the scenario indicate that these words should coincide with the shots of the bulldozer at Bergen-Belsen. Removed from their context, misappropriated and attributed to the Nazis, these scenes become a metaphor for the industrialization of death in Hitler's camps.[47]

The industrial paradigm also serves to denounce the collusion between fascism and capital. The passage on Himmler's visit is transformed into an ostensible and personal attack on capitalism:

1942. Himmler inspiziert. Die Vernichtungsmaschinerie soll rentabel werden, besser durchorganisiert. Wer kann ihn besser dabei beraten als Krupp, der weiß wie man Profite macht?

1942. Himmler's inspection. The extermination machine should become profitable, better organized. Who better to consult than Krupp, which knows how to turn a profit?[48]

This development culminates in the conclusion that fascism and capitalism conspire:

Nachdem die Erfahrungen zwischen Faschismus und Kapital ausgetauscht sind, gewinnt das Ergebnis neue Dimensionen: Die Deportation erstreckt sich über ganz Europa.

After fascism and capital finish exchanging experiences, the result takes on new dimensions: the deportation encompasses all of Europe.

In the final part of the film, the East German broadcaster clearly takes its revenge on Argos by sacrificing the epilogue (from "at the moment of speaking" until "the endless screams"). Cayrol's lengthy build-up is replaced by these three short phrases: "*Eine stille Landschaft—ohne Stille* (repeated from the film's opening scene). *Neun million Tote gehen in ihr um. Ihre Schreie bleiben unvergessen*" (Nine million dead dwell there. Their screams remain unforgotten). From the endless scream to the unforgotten scream, questioning finds itself replaced by a commemorative logic that closes the event by giving it a perfectly contained past.

The official statement announcing the airing of *Night and Fog* confirms the reppropriation of the documentary:

> The confrontation with fascism is part and parcel of our struggle against imperialism. GDR television wishes to present you in this series of films against fascism the French documentary *Night and Fog*, on the occasion of the commemorative day for the victims of fascism.[49]

The task to present the documentary to East German viewers fell, not surprisingly, to Walter Barrel, vice chairman of the international Buchenwald-Dora committee.

The Federal Republic of Germany was the first country to screen *Night and Fog*, provoking its "other half" into competitive emulation. However, Alain Resnais's film also attracted the interest of distributors in other parts of the world.

14 A PORTABLE MEMORIAL

NIGHT AND FOG ATTAINED an impressive degree of international circulation. In the months and years that followed its completion, the film was exported to numerous countries: Argos sold the rights to distributors in Great Britain, Italy, Belgium, Finland, Austria, Sweden,[1] Israel, Czechoslovakia, South Korea, Indonesia, Thailand, Australia, the Netherlands, the Philippines, and Japan. At the same time, the film continued its festival run. After Cannes and Berlin, it was shown in Venice and Karlovy Vary, where it was awarded the Grand Prize for documentary films in 1957.[2]

PRUDISHNESS IN JAPAN AND BRITAIN

In July 1956, prints of *Night and Fog* were impounded by Japanese customs officials because "the scenes of naked corpses, the mountain of tissue made of women's hair, and soap made of human grease" contravened article 21 of the constitution, which states that no book, film, drawing, or sculpture that may form an "affront to public decency" or that threatens "public safety" may be imported onto Japanese soil. After viewing the film, customs officials proceeded to cut out the majority of the archive footage.

Receiving the news from the distributor Denis Frères, Anatole Dauman alerted the Foreign Ministry and the French ambassador to Japan. The latter confirmed that Japanese customs officials had the right to censor films and were authorized to ban a film or "impose all the cuts they deem necessary." He admitted that "this text has been applied to the maximum degree" in the case of *Night and Fog*, "to such an extent that only a few short scenes remain of the film."[3] The dis-

tributor's persistence led to a second assessment of the film, for which customs gathered a group of individuals from related ministries, the academic world, and the press. Out of this group, only two people declared themselves in favor of public screening of the film in Japan. Taking the situations in France and Germany as an example, the distributor envisioned starting a press campaign: maybe prudishness formed merely a pretext for overzealous customs officials to ban a film that would be inappropriate for a former Axis power. However, after consulting with various parties, Denis Frères retreated and temporarily renounced presenting the film to Japanese audiences.[4] Three years later, Alain Resnais would pass Japanese customs with his crew to shoot *Hiroshima Mon Amour,* and in 1960, Nagisa Oshima paid tribute to the censored short film in the title of his feature *Night and Fog in Japan.*[5]

Around the same time, Great Britain also hesitated allowing the film's distribution on its soil. Distributor Gala submitted the English version of *Night and Fog*[6] to the British Board of Film Censorship (BBFC) on February 1, 1960. Judith Peterson reported that after a screening of the subtitled print, the British censors recommended the removal of certain scenes of atrocities.[7] Two BBFC representatives drew up a list of shots and photographs to be cut: "bodies or parts of bodies burning or charred," "decapitated bodies," "human heads in a tub," "bulldozer and corpses," "man throwing corpses into ditch," "corpses in this ditch."[8] Concerned about excessive nudity, the censors furthermore requested removal of images of female corpses, including the shot of a guard carrying a naked woman's corpse.[9] Alarmed by this severe judgment that threatened the film's integrity, Gala pointed out that the incriminated scenes—the last four of which were recorded by British cameramen in Bergen-Belsen—were shown to the public in 1945, both as part of newsreels and at the London exhibit *Seeing Is Believing.* The argument fell on deaf ears, and Gala submitted a new version of *Night and Fog* to the BBFC, implementing all the requested cuts. After viewing this expurgated draft, the censors concluded that more cuts were required: this time, it was the images of male corpses with exposed genitals that were considered shocking to the audience's sensibilities, since "there are limits to what may be shown and the incriminated images cross those limits."[10] In this manner, the British censors argued that times had evolved: in the spring of 1945, the images from Bergen-Belsen had been recorded and shown

to the public to pave the way for the coming prosecution of Germany; the violence and horror formed an integral part of the accusation by way of imagery. Fifteen years later, requirements of decency and protecting the public redefined what was permissible. These new cuts implemented, the BBFC permitted the film's distribution in Britain to viewers aged sixteen and over.[11]

Night and Fog's misadventures on Swiss territory, however, were of a different nature entirely.

SWISS NEUTRALITY

Trouble began in September 1956, at the Rencontres Internationales de Genève, where the film was scheduled for a special screening in the presence of Jean Cayrol. The plan was thwarted after an exchange between the festival organizers and the Federal Political Department. The latter did not demand prohibiting the screening, since such a decision would have been beyond its jurisdiction, but advised against it, arguing that a screening of the film was not "compatible with the exercise of Swiss neutrality."[12] Like in France, some members of the Swiss press pointed an accusing finger at German diplomacy. Others confirm that the federal authorities acted of their own volition, without foreign intervention.[13]

This withdrawal did not make theatrical distribution of *Night and Fog* in Switzerland a particularly attractive prospect; not a single buyer presented itself to Argos. Freddy Buache, head of the Swiss Cinematheque, offered to campaign in favor of the film, but his efforts at contacting distributors proved fruitless: "It appears my countrymen are not sensitive to either the message or the artistic quality of this remarkable film."[14] On April 24, Buache made another attempt by inviting the delegates of the Swiss federation of cine-clubs to a special screening. Reactions afterward were decidedly glacial, and the representatives for the German-speaking part of Switzerland proved particularly hostile, qualifying the film as "a work of propaganda." Buache informed Dauman that *Night and Fog* was notably accused of being "an extension of the current attacks on Mr. Oberländer by the German Democratic Republic!"

Once again, it is in the context of the Cold War that we need to read the Swiss reactions to *Night and Fog*. The reference to Oberländer pertains to the virulent press campaign against Bonn orchestrated

by Albert Norden on the GDR's behalf. In a series of public lectures, speeches, and articles, the director of the committee for German unity had denounced the presence of former Nazis in the federal administration and accused Adenauer as an accomplice of this "whitewashing." After aiming his arrows at West German magistrates, Norden set his sights on the chancellor's aides in 1960. In April of that year, at the moment Buache screened *Night and Fog* in Luzerne, the East German high court was the stage for the "spectacular trial"—in absentia, naturally—of Theodor Oberländer, at that point in charge of relations with Germans expelled from the western territories after 1945. After nine days of "hearings," this collaborator of Adenauer was found guilty of having participated in war crimes during the recent conflict. It seemed to matter little to the GDR that Kurt Schumann, chief justice of the East German high court, joined the Nazi party in 1937.[15] In 1963, Norden would organize, with even more aplomb, the prosecution of Hans Globke, presented as a response to the Eichmann trial in Jerusalem.[16]

What remains unclear, however, is why the German-speaking Swiss would make such an unfounded association between the slander campaign and *Night and Fog*—a film that, as the Defa affair demonstrated, was little inclined to toe the communist line. Their hostility was likely informed by the figure of Buache, of whom these delegates were particularly wary. Some taxed the Swiss Cinematheque's programming of films from Eastern bloc countries such as Poland, Hungary, and Czechoslovakia during the 1950s as veiled communist propaganda.[17]

Blinded by their political hostility, the German-speaking delegates, who had watched the French version of the film, doubtlessly declined to examine *Night and Fog*'s commentary in detail. They rejected the film in a Pavlovian reflex on the basis of its subject and the reputation of its main advocate.[18]

Still, the countries of the communist bloc were hardly beating down Argos's door to acquire the rights to *Night and Fog*.

NO NEWS FROM THE EASTERN FRONT

In December 1956, Yugoslavia requested a print of the film, only to return it a few months later. At the same time, Film Polski tried in vain to sell the documentary to the USSR, informing Argos of its failure in 1963.[19]

The case of Poland is also enlightening. Upon receiving its print in 1956, the Polish Film Center produced a dubbed version of *Night and Fog*. Narration was handled by Anorzej Tapicki, the "official" voice-over for Polish documentaries. However, the film was never commercially distributed,[20] and its circulation remained limited to a handful of special screenings. In October 1993, Edouard Muszka explained the reasons for this banishment in a letter to André Heinrich:

> The Polish people are generally anti-German, anti-Semite, and now also anti-Russian. . . . The French proposal to shoot a film about Auschwitz was, as far as the authorities went, clear-cut: an anti-German film against totalitarianism, all the more trustworthy and authentic for having been made by foreigners. It was quite easy for me to explain the idea to those in charge, who accepted the production and the estimate.
>
> Once the film was completed, they felt that "It's not anti-German enough and we think it's more pacifistic than combative. It's too philosemite." The official account until around 1990 was that there had been no Jews in Auschwitz. The official propaganda mentioned citizens of Poland, France, Russia, etc., maybe of Jewish origin but never simply Jewish. That the Auschwitz museum now mentions this is only the first step in a wider turnaround. This is why *Night and Fog* was never widely shown in Poland, except on a few special occasions."[21]

The finished film did not correspond to the coproducer's expectations. This misunderstanding originated in part with the project's origins: where Argos announced a documentary "on the concentration camp system" its Polish partners of their own volition saw it as "a film about Hitler's crimes in Poland," a reinterpretation of the tragedy that seemed confirmed by the location shooting in Auschwitz and Majdanek.[22]

When they discovered the film, the structural approach to the camps, the lack of distinction between the sites of deportation, the universal extent of the commentary that contained no attack on Germany, and the placing of the prologue in the present day, it provoked a mixture of embarrassment and disappointment. The Film Center could have gone ahead and also rewritten the commentary. Certain variations of the Polish translation show that it did:[23] Stutthof replaced Struthof, slight alterations in the sanctified image of the deportee, and an approximate phrasing of the final sentence that softens the accusation ("We should hear the endless screams"). A further cor-

rection supports Muszka's testimony regarding the suspicion of phi-
losemitism, which today comes across as very peculiar: in the list of
deportees, "Schmulski, merchant from Krakow" was replaced by
"Kowalski, Polish craftsman." The name Cayrol chose is a diminutive
of Solomon, which must have sounded Jewish to the translator, who
substituted one of the country's most common family names. This
name change fits in with the dejudaisation of Auschwitz-Birkenau,
the antifascist remembrance of Polish martyrdom, and the heroic cel-
ebration of the communist resistance. The concealment of the geno-
cide of the Jews, coupled with the antifascist reading of history, ex-
pressed itself overtly during the ceremony for the tenth anniversary
of the liberation of the camps, at which Henri Michel and Olga Worm-
ser had been present; it was confirmed several years later with the un-
veiling of the Birkenau monument.[24]

Compared to the betrayal of the text by the East Germans, the Pol-
ish translator's modifications look very mild indeed. This relative
faithfulness, combined with the presence of images of the racial per-
secution and deportation of the Jews, could only impede the distribu-
tion of *Night and Fog* in Polish cinemas.

Japan, Great Britain, Switzerland, the USSR, Poland: the list of
countries that were reluctant to show *Night and Fog* does not end
there. Toward the end of the 1960s, Resnais's film also had a brush
with the regimes of Franco in Spain and Salazar in Portugal: in 1969,
a bad-quality print circulated illicitly in Spain,[25] and the same year, in
Lisbon, a handful of *Cahiers du Cinéma* editors, including Jean-Louis
Comolli, Jean Narboni, and Sylvie Pierre, presented the film in a closed
circle of "a dozen select friends" after a planned public screening was
prohibited.[26]

In the United States, meanwhile, *Night and Fog* initially met with
polite indifference.

A FILM TO ASSEMBLE

In November 1956, Argos realized that *Night and Fog* had yet to find
itself a North American buyer. Local distributors mentioned the dif-
ficulties of releasing short films theatrically in the United States, adding
that its subject made its circulation particularly risky. Nevertheless, they
insinuated that if the French offered commercial compensation, they
might well be susceptible to changing their minds.

Anatole Dauman subsequently contacted Daniel Mayer, chairman of the Committee for Foreign Affairs in the National Assembly and a supporter of the film during the Cannes affair. Mayer in turn got in touch with Jacques Flaud and Christian Pineau. In his letter to the minister, Mayer insisted on "the great importance this film's widest possible circulation presents for the national interest": "I believe that it is our duty to assist in any way we can the awareness of a document this precious for mankind."[27]

After consulting knowledgeable parties, the CNC and the Foreign Ministry agreed to prioritize *Night and Fog*'s distribution in the United States by allowing the buyer to present an American film in French theaters in a dubbed version. Jacques Flaud accepted this inelegant exchange against his will,[28] judging it "unpleasant to offer a commercial counterproposal to an effort that should, from a moral and human standpoint, hold its own satisfaction."[29] Yet, despite these concessions, no reliable offers arrived on Dauman's desk.

It would take until 1959 before the filmmaker and producer Nico Papatakis decided to promote *Night and Fog* in New York.[30] He organized a series of private screenings for distributors, journalists, TV network representatives, and heads of Jewish organizations. His audiences received the film with respect and admiration, but American film companies and the networks NBC, CBS, and ABC all passed on its acquisition. In this general atmosphere of moroseness, Papatakis received an offer from the independent broadcaster Metropolitan Broadcasting Corporation, which owned four channels in New York, Washington, D.C., California, and Illinois.

Financially the offer was appealing,[31] but the plan for its transmission proved very peculiar: the network intended to integrate *Night and Fog* "in parts" into a one-hour broadcast on the atrocities in the concentration camps. A director named Arnee Nocks had pleaded with his producer Ted Yates[32] to negotiate the rights to Resnais's film, arguing that its inclusion would lend the planned broadcast a degree of artistic value.

Despite these unusual conditions, Dauman approved the deal in May 1960 and sent Metropolitan a print. Two months later, on July 18, the channel broadcast the Nocks-directed program, entitled *Remember Us*.[33]

The form of the program mixed the narrative and visual codes of the studio broadcast with those of the montage documentary. *Night*

and Fog's function was twofold: during the first part, which ran thirty-eight minutes, Nocks borrowed four extracts from the film and made abundant use of Hanns Eisler's score, while the remainder of the program consisted entirely of a re-edited sequence of passages from *Night and Fog*, accompanied by a narration inspired by Cayrol's text.

This program would merit a profound investigation that would place it in the context of American television production in the early 1960s and shine light on its inception and the origin of the material used.[34] I will limit myself here to studying the overall structure and the logic behind the re-edit that radically altered the nature, stature, and meaning of *Night and Fog*.

The choice of title, *Remember Us,* immediately emphasizes one of the characteristics of Nocks's efforts, in which the victims' point of view played a central role. Four eyewitnesses, all Jews, relate their experiences as survivors of the Warsaw ghetto, Treblinka, and Auschwitz, among them a Romanian former deportee named Gisela Perl.[35]

From its prologue onward, the program follows a memorial itinerary. Over the footage shot by the Soviets and the Western Allies, the narrator declares: "My name is Quentin Reynolds . . . the people you see here asked history for only one favor: 'Remember us.'"

Reynolds, aged fifty-eight at the time of the recording, was a journalist, media personality, and veritable star of documentaries. During World War II, he had been stationed in London as correspondent for the American press, where he would serve as author and narrator of Humphrey Jennings's famous British propaganda film *London Can Take It!*[36] A few years later, Reynolds voiced the introduction to the American version of Aleksander Ford's film *Border Street.*[37] His interest in the 1939–1945 period would remain apparent, for example in the essay he wrote on Eichmann in the wake of the latter's trial in Jerusalem.

In *Remember Us,* Quentin Reynolds assumed a double narrative function, both as the program's presenter and as narrator of a text he likely wrote himself. He was filmed in the studio seated behind an imposing desk. Conforming to the television format, Reynolds directly addresses the viewers in order to tell them this story: "Our tale begins with Gisela Perl." From behind his desk, he "launches" the images and testimonies as is customary for this type of studio-bound program. Strongly insinuating himself, Reynolds goes beyond merely

describing facts and events: he comments on them, draws lessons from the past, shows his appreciation, and switches tones, moving from indignation to criticism to compassion, while punctuating his words with various expressions and gestures. The second mode of narration is more in line with classical documentary cinema, with Reynolds reading his commentary over a montage of "archives."

The same anchoring format was used for the testimonies of the four witnesses. These people appear on screen for a few minutes[38] before their testimony continues in voice-over, accompanying an eclectic assemblage of shots supposed to "illustrate" their words, often at the cost of the accuracy between the images and the stories. For example, when Gisela Perl mentions her husband's arrest by the Gestapo, the images shown are those recorded by the Nazis during the pogrom of the Ukrainian city of Lvov executed by the *Einsatzgruppen* in June–July 1941.[39]

During the first part of *Remember Us,* the survivors' eyewitness accounts and the orientation of the commentary place the genocide at the heart of the narrative. The choir of voices speaks predominantly of the fate of Europe's Jews and their "lost world." The narrative begins in 1933, like that of *Night and Fog.* But here this date serves to tie together a different plot, which refers to other events and historical reference points, including the Third Reich's racial politics and the Nuremberg laws, the ghettoization and the pogroms, the deportation, and the extermination of the Jews.

Within this framework of the beginnings and the inauguration of the Final Solution, the director uses four extracts from *Night and Fog.* Nocks first uses the initial black-and-white sequence in which Resnais edited footage from Nazi rallies ("1933. The Nazi machinery is set into gear . . ."). In *Remember Us,* however, these images do not serve to evoke the rise of Nazism but Himmler's 1943 order to liquidate the Warsaw ghetto. The sole justification for this is the glimpse of the *SS Reichsführer* at one of the parades in the company of Hitler. The second quote from *Night and Fog* is less strained. These concern the footage from roundups in Poland and the Westerbork transport selected by Resnais to introduce the subjects of arrest and deportation. Where filmmaker and poet chose silence, Arnee Nocks shows this long sequence with Gisela Perl's account describing her transport to Auschwitz.

The third extract from *Night and Fog* comes from the sequence on the camps' construction and is once more used to support Gisela Perl's story. While she talks about the frightful day-to-day life of the Auschwitz detainees, Nocks arbitrarily recycles the montage of construction sites, watchtowers, and camp gates.

The way these fragments of *Night and Fog* are inserted demonstrates an illustrative approach that denies the visual documentation and the context of recording their own existence, resulting in the loss of their historical value. Used in support of the narration, these shots are in the service of a new economy of visibility: their value now depends on what they can serve to illustrate, without regard for what they document. Arnee Nocks drew from *Night and Fog* the way one draws from an archive, when the extracts from the film are themselves already edited together from a variety of footage and photographs, assembled on the basis of precise formal decisions. By abolishing this gesture, the American director gave these extracts from *Night and Fog* the status of primary sources, reusable in his own edit. He combined the footage from Westerbork with the beginning of the shot from *The Last Stop*, for example. Resnais cut away to Polish footage of an old man and three small children, turning it into a "tertiary archive." In *Remember Us,* it has been re-elevated to the level of pure archive material.

The fourth extract from *Night and Fog*, which closes the first part of the program, falls under a different sort of logic. To accompany Gisela Perl's last appearance, where she talks about the selection, the roll call, the cold, and the bullying guards and *kapos*, Nocks edits together various shots recorded by Resnais in the Polish camps: the latrine sequence, the tracking shot outside the women's camp, the exterior of the shower building at Majdanek, the wide shot looking down from the watchtower at Birkenau, and the long opening sequence from *Night and Fog*. These color shots from 1955 are all reproduced in black and white, and therefore moved back through time, changing their status to that of "archival images."

Arnee Nocks's documentary practices effectively abolish the borders between the different components of *Night and Fog*. The first interference consists of undoing the work of the editor, who provided his own reading, his own interpretation, and his own narrative to the source material. A second intervention mixes into one category the

documentation from the period and the sequences from 1955, which Resnais had diametrically opposed by means of a double shift in rhythm and color. The loss of color and pace cancels the effect of critical distance from the earlier images. By leveling everything, all the original film's strata are reduced to a single function and an unequivocal status. The manipulation of time falls victim to a regimen of total visibility that fills the gaps present in Night and Fog's narrative.[40]

The use of Hanns Eisler's music constitutes another betrayal of the original work. The uninterrupted score was cut into its musical themes (the prologue/epilogue for strings, the *pizzicati,* the duets of flute and clarinet, etc.), which were then reassembled to form the musical accompaniment for the broadcast. This rearrangement goes against the composer's theoretical underpinnings, following the very logic of redundancy that Eisler so vigorously opposed. The best example of this is the dominant use of the Hamlet Prelude, which opens Nocks's program over the images of emaciated survivors; the director subsequently associates it consistently with images of corpses (the dead of the Warsaw ghetto, mass graves in the camps, charred bodies at Thekla, etc.). The function attributed to this theme, turned leitmotiv and signature of the broadcast, consists of creating an overdose of emotion that annihilates any distancing effect. The recycling of Eisler's score continues in the second part of the program through a dissociation between the images and the musical phrases to which they corresponded in Resnais's film. Although Nocks retains the music of certain scenes, he frequently reverses them to establish new connections. For instance, the musical phrase for Westerbork and its ironic use of the "Lied der Deutschen" is successively placed over the shot of the latrines at Birkenau and over the photographs of Himmler's visit to the Auschwitz camps.

Unlike the prelude, these rearrangements of the score do not appear to follow a very coherent principle. One wonders whether the whole exercise at deconstruction was inspired by a desire to render the original work unrecognizable and to thereby modify the status of its quotation. The program's credits do not mention the film, and the only indirect reference to Night and Fog is found in the credit "Produced by Ted Yates *in association with* Argos Films." Neither Alain Resnais nor Hanns Eisler is named, and the same goes for Jean Cay-

rol, whose commentary is nevertheless incorporated into the second part of the broadcast.

In this twenty-two-minute section, the testimonies and Reynolds's studio appearances disappear in favor of a narrated image compilation. The images consist entirely of shots and sequences from *Night and Fog*, used in three ways. Nocks first shows a lengthy extract from Resnais's film, from the sequence of the arrival at the camp until the commander's villa. Here he respects the shot order, but injects several cuts. He logically removes the tracking shots in the Polish camps already used to illustrate Gisela Perl's statement. Nocks also removed the passage on the deportees' political organization, as well as the section on roll call, labor, nourishment, Nazi slogans, and camp peculiarities (the orchestra, the zoo, Himmler's greenhouse, the Buchenwald oak, etc.). Nocks proceeds to show the last eleven minutes of *Night and Fog*, from Himmler's visit through the epilogue's final shot, as a single uninterrupted sequence. However, since the narration runs longer than those final shots of Birkenau, Nocks ends his broadcast on an eclectic mix of unused shots to back up Reynolds's last few sentences and the superimposed end credits. Photographs from Beaune-la-Rolande and the Vél' d'Hiv, children from the Warsaw and Lodz ghettos, the Russian footage taken outside the Auschwitz infirmary, the soup at Bergen-Belsen, and photographs of Mauthausen and the labor units are lumped together without consideration for meaning or order. While it would seem futile to search for any function to this makeshift jumble, such is not the case with the cuts in the preceding section, which reveal a relatively consistent logic.

The removal of sequences on the day-to-day life and the labor of the concentration camp detainees helps narrow the focus down to the theme of the extermination. The cuts allow the makers to use *Night and Fog* as a continuation of the first part of the program constructed around the theme of the Final Solution. This shift of perspective, which radically modifies the film's point of view, is also apparent in the changes made to Cayrol's commentary, parts of which were translated literally and other parts liberally interpreted and adapted.

The first example of the modification of the text is found in the sequence that shows the various national passports followed by pages

from the Mauthausen register. This passage is accompanied in *Night and Fog* by the following commentary: "These women, these men, the administrator's desk preserves their faces, handed over upon arrival. Their names, too, were handed over. Names from twenty-two nations. They fill hundreds of registers, thousands of index cards. The dead are crossed out in red." In *Remember Us* the poet's text is changed into this:

> Nothing was haphazard as the thousands of prisoners packed the camps. Their names were meticuously noted, their papers checked and rechecked. The names of men, and women, and children of twenty-three nations filling hundreds of registers were recorded. Page after page of names. This is the directory of a dead civilization. A list of six million murdered. Hitler's epitaph to the Jews."

In the same sequence of images, the role of the victims changes: where Cayrol referred to a general mass of deportees, the American narration refers explicitly to the murdered Jews. The same reorientation can be found in the sequence devoted to the extermination. From Himmler's visit through the images of the crematoriums, the *Remember Us* commentary once again stays close to Cayrol's text,[41] but adds an extract from Rudolf Höss's memoirs that modifies its referent.

Over photographs of executions, Reynolds recites the famous passage in which the former Auschwitz commander describes the procedure of execution in the camp's facilities: "The Jews selected for gas were taken as quietly as possible to the crematoriums. They were told they were going to be bathed." Reynolds continues by describing the behavior of the children, in which he removes any mention of the *Sonderkommando*: "The smaller children usually cried because of the strangeness of being undressed. But when their mothers comforted them, they became calm and entered the gas chambers playing and joking with one other and carrying their toys."[42]

In my analysis of this sequence in chapter six, I noted how a different commentary would have allowed the same sequence of shots to "mention the specific fate of the Jews exterminated in the gas chambers." This is precisely what the American commentary does, lifting Cayrol's veil of indetermination. In this way, the broadcast reestablishes and prolongs the initial intentions of the script. It also solidifies

the misuse of these photographs, which the new alliance between commentary and montage explicitly transforms into images of the entry into the gas chamber.

Another extension of Cayrol's text occurs in the epilogue of *Remember Us*. The last sentences of the commentary reactivate the "warning sign" and turn it into a battle cry, aimed primarily at communism:

Suddenly we can no longer comfort ourselves by thinking that these enormities are now impossible. Since 1949, when the Chinese communists took power, twenty million Chinese have been liquidated and another twenty-three million are in forced labor camps. Who knows the number of Hungarian freedom fighters dead? What is happening to them today? Instead of the Jews of Germany, the Negro of South Africa is the victim of the government. Like those enemies of Hitler's state, he has been sent to the ghetto, his property has been seized, he has been killed.

I am not responsible, said the German kapo.

I am not responsible, said the German officer.

I am not responsible.

Who then is responsible for these grim and ghastly alternatives to freedom? Grass will not grow in the lime pits of Auschwitz. Even today, as stagnant water puddles the ruins of Hitlerism, new regimes are building new camps elsewhere.... Those who don't learn from history may live to see it repeated. Many seeing these ruins today think the monster is dead and buried beneath them. There are those who pretend that all this happened only once, in a certain time and in a certain place, those who refuse to look around them ... those who refuse to recall and ponder the past and the present for the sake of the future.

Communism is the product of murder. Lenin, revered today as the savior of Russia, liquidated millions and permitted millions more to starve.... Every form of compulsion is hateful. But above all the Caesars who rule the world, man must have his freedom, must enjoy the beauty of his independence.

This is the story millions of murdered of every country and every generation tell us. This is why they urge us to pause.... Remember us. Quentin Reynolds, good night![43]

It is unlikely that the viewers of a program like this, haunted by the ghosts of the past, the omen of new massacres, and the denunciation of the crimes of communism had an easy time falling asleep that night. Hungary,[44] China, the USSR—the American reinterpretation of Cayrol's epilogue accomplished what the French communists and

Defa feared. According to Nico Papatakis, this warmongering played a large part in the success of *Remember Us*:

> The broadcast that incorporated extracts from *Night and Fog* took place on the 18th of this month. Critics were unanimous in their positive reaction. One of the reasons for this, aside from those inherent in the program itself, which I need to emphasize, is the fact that they seized the occasion for anticommunist propaganda, referring to concentrationism [*sic*] in the East. This was to be expected. The program will also sell, thanks to this.[45]

In the middle of this long diatribe against communism, however, Reynolds brings up an unrelated reference to South Africa. Singling out the government in Pretoria was no doubt the result of recent developments: the making of the program coincided with the bloody Sharpeville massacre, which was widely reported in the American media. But the mention of racial persecution in South Africa could also indicate a desire on the part of the makers to give their condemnation of anti-Semitism a universal dimension. In the prologue to *Remember Us*, Reynolds immediately assigns this function to the act of remembering the victims of Nazism:

> The story of man's inhumanity to man is not over. Bigotry changes fashion the way hats change style. In one age, monarchs are declared the public enemy and are killed. In another, the bourgeois or the capitalist, the Jew, or the Negro. Each new plan to save the world takes its human sacrifice. This history of atrocity threatens repetition on all sides of us today. So let us remember these survivors and their ordeal. Such recollections may give us the stamina to defend humanity, justice, and freedom. To prevent faces like these from haunting our future.

In many ways, *Remember Us* marks a transition between two phases of consciousness and public discourse in the United States on the Final Solution and the Nazi crimes. In postwar America, criticism of totalitarian regimes largely led to ignoring the unique nature of the destruction of Europe's Jews. As Peter Novick points out, from the early stages of the Cold War, the qualifier "totalitarian" became "a powerful rhetorical weapon to redirect the horror experienced toward Nazism against the new communist enemy": in this perspective "any suggestion that the extermination of Europe's Jews was a pivotal,

not to mention distinctive, trait of this regime undermined the thesis of a shared identity between those two regimes."[46]

This logic infuses *Remember Us*: the event functions as an equivalent instrumental for the present-day struggle against communism. Comparison becomes the motor for conjuring the past. In this sense, Nocks's program fits into the continuity of stage and screen adaptations of *The Diary of Anne Frank*, which formed two notable successes in American culture of the 1950s. In 1955, the play adapted by the Hackett couple for Garson Kanin became a Broadway triumph. Four years later, millions of Americans went to see George Stevens's big screen version. As Novick again notes, this double success is largely explained through the "universal" approach adopted by both the play and the film. This vision certainly corresponds to the spirit of the text published by Anne's father, Otto Frank; yet, director Garson Kanin knowingly accentuated the universal nature of the suffering of the Jews. He asked "Hackett to remove a passage in which Anne observes that the Jews have always suffered": "From his point of view, this formed a 'plea *pro domo.*' He preferred her to say, like she did on the stage and on the screen: 'We are not the only ones that suffered . . . sometimes one race . . . sometimes another.'"[47] In the adaptations of *The Diary of Anne Frank* as in *Remember Us*, the fate of the Jews persecuted and exterminated by the Nazis appears equal and comparable to that of the victims of totalitarianism and racism in all its forms.

While Arnee Nocks's program distinguishes itself from *Night and Fog* by explicitly referencing the Final Solution, it does not admit its singularity. In the space given to the victims (and no longer just to the heroes evoked by way of the defenders of the ghettos[48]), *Remember Us* exists on the threshold of a new era of American public discourse, inaugurated by the Jerusalem trial. Organized, as Annette Wieviorka[49] has conclusively pointed out, around the "figure of the eyewitness" and the accounts of the victims of the Final Solution, the Eichmann trial would make a decisive contribution to pointing out the uniqueness of the genocide of the Jews—which the Americans henceforth referred to by the term Holocaust, and which they gradually recognized in the course of the following decades "as a distinct entity of Nazi brutality."[50]

Arnee Nocks's television program (in which the name Eichmann is opportunely mentioned twice) exists precisely in the spot where

these two eras join: initiated in March, its production began in May 1960 at the very moment David Ben-Gurion announced the arrest and abduction of Adolf Eichmann before the Knesset. This new circumstance would have direct and significant effects on the destiny of Alain Resnais's film.

The preparations for the Jerusalem trial in the first place awoke the interest of Jewish organizations, whom Anatole Dauman had previously bemoaned as lacking backbone.[51] Without the existence of deportee associations to support the film, the producer had counted in vain on mobilizing New York's Jewish community to help the film's distribution.[52] June 1960 saw the first signs of interest: Nico Papatakis informed Dauman that, in light of the coming trial, "theaters and Jewish organizations" wished to screen *Night and Fog* to the American public.[53] Two days later, the head of Argos replied as follows: "Like you I believe the Eichmann trial is providence."[54] In November 1960, *Night and Fog* was shown in New York at the initiative of the United Jewish Appeal. In December, after a second screening at Cinema 16,[55] Anatole Dauman received several letters from Symon Gould, head of the New York Film Guild and pioneering importer of European avant-garde cinema. This peculiar character declared himself personally interested in the film in his triple guise as humanist, Jew, and vegetarian! He expressed his desire to organize, in the light of Eichmann's trial, free screenings of *Night and Fog* to show the American public "the scope of the Nazi crimes committed against the Jewish people."[56] The first reconditioning of Alain Resnais's film into a "film on the Holocaust"[57] was happening in the United States, imperceptibly. However, the Jerusalem trial would trigger another new use for *Night and Fog*.

NIGHT AND FOG IN JERUSALEM

On August 27, 1956, in Israel, the film was shown to a group of government officials that included ministers, members of parliament, and president Yitzhak Ben-Tzvi.[58] This rather unusual honor proves the awareness of the Israelis, who had followed the Cannes affair with interest. It would, however, take until May 1958 before the film was approved for distribution. According to Nitzan Lebovic, the committee of control, which was made up of representatives of Israeli political and cultural circles (including the poet Haim Gouri), had hesi-

tated for a long time. Initially inclined to limiting access to the film to adults only, it finally opted to rate it suitable for all audiences on the basis of the biblical injunction of remembrance and transmission. The committee expressed the wish that *Night and Fog* be coupled with a film likely to add the "Zionist point of view," missing from Resnais's work: it suggested that the short film be programmed alongside a filmed reconstruction of the revolt of the Warsaw ghetto.[59] The first screenings in 1960 left the Israeli press divided. While the formal qualities were universally praised, certain journalists acrimoniously deplored the absence of any explicit reference to the Jewish victims and the obscuring of the genocide.[60] *Night and Fog*'s career remained restricted to a handful of special screenings in urban cineclubs and kibbutzim.[61] The year 1973 marked a turning point in the way the documentary was circulated: the Yom-Kippur war and ensuing political changes created a resurgence of interest in the film. From that moment onward, *Night and Fog* would be shown regularly in schools and centers of education.[62]

One rather singular screening of Resnais's film merits attention: one organized in Jerusalem as part of the trial of Adolf Eichmann, the Nazi SS lieutenant-colonel who was a primary organizer of the genocide of the Jews.

On May 26, 1961, prosecutor Gideon Hausner announced his intention to present during the tribunal a number of documentary films to "illustrate" events already or yet to be mentioned. Questioned by Judge Landau as to legal precedents, Hausner referred to the Bergen-Belsen and Nuremberg trials. He was, however, careful to point out that the only goal of the screenings was to render the disclosure of the facts "more alive and tangible." The accusation would authenticate the images by having witnesses certify that the events happened as presented in the films.[63] These confirmations were requested not as in Nuremberg from the cameramen who shot the footage in the liberated camps, but by the victims who were present.

Invited to express himself on the principle of the screenings, Eichmann's attorney, Robert Servatius, demanded that he be shown the films in advance and in the presence of the accused. On June 6, 1961, after attending a first screening, Servatius expressed doubts: he asked to know where and when the sequences were recorded; he requested the withdrawal of certain documents made purely for "educational" purposes and made after the fact in order to influence their audiences.

The disputed sequences very likely originated from *Night and Fog,* included in the list of films selected by the prosecution.[64] Hausner's team also chose *Nazi Concentration Camps,* the Soviet compilations on the openings of the camps in Poland, the footage shot by the British at Bergen-Belsen, that from Westerbork, and the brief sequence filmed by *Einsatzgruppen* member Reinhard Wiener that shows the execution in a mass grave of a group of Jews from Liepaja.[65] Hausner clarified that the films would be shown without sound so that no one would be influenced by their narration. "We have returned to the days of silent cinema," wrote Haim Gouri, sent to cover the trial for the Israeli daily *Lamerhav.* The poet/reporter added: "This is a good thing, because now we can imagine our own commentary or give free rein to our imaginations that those words would otherwise have curbed."[66]

On June 8, 1961, began the seventieth day of the hearing, which would finish with a screening behind closed doors of the films. Since the projection required a darkened room, Judge Landau decided for reasons of security to have the room emptied, with the exception of the journalists.[67] An exchange between Hausner and Servatius preceded the presentation of the films. Servatius, who the previous evening had sat through a second screening with his client, did not oppose the principle of the screenings but announced new objections to the selected footage. His reservations concerned scenes of corpses that portrayed the reification of human bodies and the transformation of men into commodities. The lawyers felt that a shot of a pyre had been "prepared for filming and recorded after the liberation." Regarding the bulldozer of Bergen-Belsen, Servatius considered that the "reporter" showed more interest in the intended effect than in a factual description of the events and in their veracity. The third disputed scene came from *Night and Fog*: it shows decapitated bodies and heads in a basket, and ends with a reference to the soap. The attorney admitted that the mutilated corpses and heads were certainly "real," but he had the impression they were placed together for the requirements of the "report." He furthermore demanded proof that the rectangular objects shown on the screen were, as presented, bars of soap made of human bodies. The prosecutor replied that the sequence would show "the Strasburg skeletons," those of the deportees transferred from Auschwitz at Eichmann's orders.[68] These images, Hausner added, served to render the evidence on the matter that would be

presented the following day "more tangible." The prosecutor ignored Servatius's question about the soap, which referred to the commentary and not to the image itself.

In fact, while the filmed footage was screened without sound, the extracts from *Night and Fog*—a large number of them retained by the prosecution—were sourced from the American version of the film, which contained English subtitles that attracted the attention of numerous journalists.[69] In his account of the screening, American correspondent Robert Bird mentioned the shot of scratches made by nails in the ceiling of a gas chamber. For his description of this shot taken from *Night and Fog*,[70] the journalist had relied on the English subtitles.[71]

In attempting to establish precisely what the court and the press saw that eighth day of June 1961, we have different sources: the transcripts of the hearing at which Hausner describes the contents of the film reels and gives additional explanation; the recording of the hearing by the American filmmaker Leo Hurwitz, in charge of capturing the trial on video;[72] a 16mm film held along with the videotapes of the trial at the Steven Spielberg Jewish Film Institute in Jerusalem; the press reports; and the memoirs of those involved.

These sources allow us to determine first that the screening lasted roughly one hour. A 16mm projector was placed on a high stool, to the left of the accused, somewhat in front of his glass cage. The images were projected onto a small screen standing behind the witness box; in this way they spatially and symbolically occupied the space normally reserved for testimonies. The reels contained passages[73] from the films selected by the prosecution, edited back to back and chronicling the successive stages of the persecution and extermination of the Jews: the massacres perpetrated by the *Einsatzgruppen* (photograph followed by the footage from Liepaja); deportations (Westerbork footage); and extermination in the centers of execution (lengthy sequence from *Night and Fog* on the gas chambers, from the canisters of Zyklon B through the crematoria at Majdanek). The fate of those who entered was evoked by way of a compilation of material sourced mainly from *Night and Fog* and Russian footage of the liberation of Auschwitz. The final reel showed through extracts from *Nazi Concentration Camps* and footage shot at Bergen-Belsen the discovery of the camps by British and American cameramen. As in the documentaries shown immediately after the war, the last images presented

in Jerusalem were those of the bulldozer shoving piles of corpses into a mass grave.[74]

Night and Fog therefore supplied a significant proportion of the compilation: some thirty fragments, often cut and shortened, representing a total cumulative run time of roughly fifteen minutes or a quarter of the entire screening. The photographs projected at the start of the first reel all came from Resnais's film: five snapshots of Jewish men, women, and children just before their execution. The lengthy sequence from *Night and Fog* describing different forms of execution was cut into two parts and carefully replaced into their proper historical context. Stripped of the photographs of executions that muddled its meaning, the gas chamber sequence was supplemented with a shot of a document with the letterhead Topf & Söhne; though difficult to read, the addition of this piece of correspondence to the footage shot by Resnais demonstrates the prosecution's desire to show an actual exhibit.

Also worthy of note is that the footage of Westerbork, taken from the archive in Amsterdam, was combined with extracts directly borrowed from *Night and Fog:* the shot of the old man accompanied by three small children and the last part of the sequence about the trains, which included the shot from *The Last Stop.* Not all the 1956 color footage was removed, but what remained was projected in black and white: opening scene of the camps, tracking shot to the entrance of Birkenau, latrines of the women's camp, gas chambers and crematoria at Majdanek, and the exterior of the brick buildings. Also included were images filmed by Resnais in black and white: the nighttime tracking shot toward the Auschwitz gate and the pan across the pile of women's hair.

At the end of the screening, Hurwitz keeps his camera on Eichmann and then on three silent judges, while the prosecutor apologizes to the court for having had to show them these atrocities. Moshe Landau suspends the hearing, Eichmann gets to his feet, gathers his documents, and leaves his box accompanied by his guards.

In the preceding weeks, the international press had speculated freely about the screening. As early as May 28, *New York Times* correspondent Homer Bigart wrote that "this ordeal could be more devastating than any unpleasantness Eichmann might encounter under cross-examination." He goes on to mention the precedent of the Nuremberg trials, citing the prison psychiatrist Dr. Gilbert's observa-

tions of the reactions of the accused when confronted with the film
Nazi Concentration Camps.[75] In his analysis of this screening at
Nuremberg on November 29, 1945, Lawrence Douglas noted that
most reports use the same rhetorical feature, which consists of pro-
viding "the barest description of the actual images projected in the
film,"[76] as if the viewers had become so absorbed in the effect or the
revelation the footage was supposed to produce that they forgot to
actually watch it. During the executioners' first encounter with these
films from the camps, the images seemed to have assumed a punitive
function: by observing the Nazis viewing the films, the witnesses to
the trial intended to measure the effects of a form of visual punish-
ment, as if the accused had been strapped into the machine that forces
the eyes to remain open, like the one later imagined by Stanley Kubrick
in *A Clockwork Orange.*

In Jerusalem in 1961, the results of the screening disappointed the
press: confronted with the impassive Eichmann, they transferred their
attention to the court and, especially, to the films. Homer Bigart opens
his article by denouncing Eichmann's "unmoved" manner, which he
sees as a contrast with the emotional reaction obvious in the judges:
Moshe Landau looked pale, Yitzhak Raveh, "who had been nearest the
screen," covered his face with his hands; no sooner had they suspended
the hearing than they hurried toward the exit. Eichmann, on the other
hand, sat "without flinching or blinking an eye"; "never took his eyes
from the film, never raised his hands to his face." "The man who
claimed that he could not bear the sight of blood, who said he hated
visiting death camps, was the very model of composure."[77]

Haim Gouri, in turn, was surprised by the surprise of his col-
leagues: "Some journalists expected that [Eichmann] would be un-
able to bear the sight of these images. For some reason they believed
that this visual reconstruction would be more effective than witness
testimonies."[78]

Like the other reporters, Gouri circumstantially describes the im-
ages in a way that reveals a new ability of seeing, of questioning their
origin, of forwarding an interpretation. Jean-Louis Comolli suggests
that the British cameramen at Bergen-Belsen in 1945 filmed "without
knowing" and "without understanding" what would be revealed "after
the fact": in Jerusalem the "undiscovered meaning"[79] of the films on
the camps is subjected to a first unveiling, during a silent screening
punctuated by the prosecutor's indications.[80]

Gouri knew these images, which he had already seen in other doc-umentaries, "except for the footage of the *Einsatzgruppen* operations in the East." Nevertheless, it was the tranquil images from Westerbork (the transport's arrival and departure) that caught his eye, like an enigma to be deciphered:

> A respectable looking man stops and looks around, as if he's searching for a porter to carry his bags. Another lights a cigarette and glances at his watch. A woman looks around inquisitively, as if examining a place where she will live for a long time. . . . Like at the movies, we feel the urge to call out to the hero to warn him: "Watch out! Behind you!" because the audience always knows things to which the actors seem oblivious. Then suddenly, the German camera pauses on the face of a young Jewish girl [*sic*] wrapped in a dark scarf, a young girl who, it seems, understands everything.
>
> This face will haunt us for a long time to come and we will even see her at night, like a negative image: a dark face wrapped in a bright scarf.[81]

Watching and rewatching, rewatching while knowing, rewatch-ing while trying to understand, learning to watch, questioning the gazes of the victims and the eye of the camera. In 1961, with shock and disbelief at things of the past, the return of these images from 1945 happened in a context of greatly increased knowledge and capacity of interpretation, which would continue to evolve over the decades that followed.

Haim Gouri noted that this was also not Eichmann's "first time" to watch these films. After the preview screenings the accused had de-clared that he would use the June 8 screening to "identify the impli-cated units on the basis of their uniforms."[82]

However, Leo Hurwitz also filmed Eichmann during his first con-frontation with the images from the camps, during the screening out-side the hearings. A recording exists in which the accused watches *Night and Fog* in its entirety.[83] In this silent reel he has exchanged his dark suit, his striped necktie, and his white shirt for a wool cardigan over a shirt buttoned up to the collar. His counsel sits in his usual place, but the seats for the prosecution and the court are empty. A few scattered people occupy the public bench.[84] A light above the "glass cage" reflects off Eichmann's balding head.[85] To film this moment from the control room, Leo Hurwitz used the four cameras installed

in the courtroom.[86] With the exception of a few wide shots that end with a sharp zoom on the accused, made to mark reel changes, Hurwitz sticks to a shot / counter-shot form, filming alternatively the projected images and the accused, framed in semi close-up behind his glass pane.[87]

The screening of *Night and Fog* thus recorded offers an original point of view of Resnais's film. In his chosen style, Hurwitz recuts and re-edits *Night and Fog* by inserting shots of the viewer Eichmann. He also chooses the sequences he wishes to retain. Certain camera changes, all prepared, create a game of perspectives between the images of *Night and Fog* and the face of the accused.

In the edit, a camera change happens roughly every fifteen seconds. In this situation, the longer shots are very revealing of the filmmaker's intentions.[88] Hurwitz decided, for example, not to cut certain sequences that he films on the screen, as if in tribute to Resnais. These include the tracking shots in the Majdanek gas chamber, and the sequence on the inmates' possessions (glasses, hairbrushes, clothing, shoes) including the pan across the pile of women's hair. Other long shots seem to wait for a specific image on which to place an effect: in the *Revier* sequence, the photograph of the Vaihingen deportee with the wide-opened eyes signals a camera change. Through this well-prepared balancing game, Hurwitz confronts the gazes of the victim and the executioner. He later employs the same strategy to create an encounter between Eichmann and Himmler. Toward the end of the film, two shot changes revisit the questioning mechanism invented by Cayrol and Resnais: when the words "I am not responsible" and "Who is responsible then?" appear on the screen, Hurwitz cuts back to Eichmann twice. Through this time leap in which the Nazi criminals deny in echo, the American filmmaker connects the prosecutions of two different eras, assigning to *Night and Fog* a jurisdictional function it never contained.

Through this precise context, the recording of the screening portrays a filmmaker's gaze on another filmmaker's work. Hurwitz shot this moment in 120 shots and countershots. The shots of the screen are mostly shorter since they contain assemblages of shots edited together by Resnais. If we add these "hypershots" to the whole of shots contained in this recording, we arrive at a total of 307—exactly the number of shots in *Night and Fog*. In this sense, we could consider this recording as more than a filmed screening: as a new version of

the film, as revisited by Hurwitz: a thirty-one-minute montage gone silent, augmented by the occasional subtitles of the American translation, with incorporated into it the executioner's gaze, under the watchful eye of a second filmmaker.[89]

And so, by the dawn of the 1960s, two American directors—Nocks and Hurwitz—had already seized the Alain Resnais film and remodeled it. Such revisitations of the work would grow more frequent in the decades that followed, particularly in France.

15 SHIFTING PERSPECTIVES
Institution

IN 1959, a high school student named Serge Daney discovered, under rather unusual circumstances, *Night and Fog*. It was his literature professor, Henri Agel, who opened the door to cinephilia. Daney exchanged his Latin classes at the Lycée Voltaire for cine-club screenings of *Night and Fog* and *Blood of the Beasts*: "It was through cinema that I learned that the human condition and industrial butchery could go hand-in-hand and that the worst had only just taken place."[1] Trailblazer Henri Agel believed that the art of cinema should be part of the school curriculum as a means of learning different ways of inhabiting the world: "He showed those films because he felt compelled to. And because the issue of film culture in schools was also decided by the unspoken difference between those who would never forget *Night and Fog* and everyone else."

Daney's experience of a meeting between education and cinephilia suggests two paths along which we can follow *Night and Fog*'s process of migration.

Although the discovery of a "cineworld" was not among the priorities of former deportees, it was this circle that had insisted from the outset that the film be shown to young viewers. The Réseau du Souvenir's objectives were adopted into the national education system, a process aided by the fact that Réseau member Louis François was also education supervisor for history. To the associations of former deportees, handing down knowledge was an issue of both education and moral edification—even if the exact contents of knowledge and morality would change over the years.

FRANCE'S OBSESSION WITH TRANSMISSION

The Réseau wanted *Night and Fog* to be made as a means of eternal-izing the memory of its dead and to hand the "flame of memory" down to younger generations. In January 1956, before the film was certified for distribution, the association set up a screening at the Musée de l'Homme for an audience of former deportees. After this screening, Chairman Arrighi praised Resnais for having made "an exceptional document, not only from a technical, but also from a human standpoint." To his comrade Cayrol he explained that his emotions were "due in large part to your text, so intense and dense. You have created something exceptional whose pertinence, more than ever, is proven by the times we live in."[2] A few months later, as we have seen, the Cannes affair tightened the loose bonds between the various associations, and the former deportees unanimously de-clared *Night and Fog* to be *their* film as well as *the* film on the deporta-tion. From the summer of 1956 onward, many of these associations contacted Argos to arrange screenings of the documentary.[3] This form of circulation of the film (which was temporarily blocked due to a disagreement between the producer and the distributor, settled in court in March 1957[4]), however, only marginally concerned the younger generations.

On May 4, 1957, Louis Martin-Chauffier introduced a screening of *Night and Fog* as part of the *Resistance and Deportation* exhibit in Rennes.[5] He reminded the audience that the Réseau's two primary tasks were to safeguard the memory of the fallen and to "teach the young, those too young to have known or been aware of those terri-ble times, an example that they must discover."[6] Yet, given the audi-ence, the chairman of the Amicale de Bergen-Belsen had the feeling of preaching to the converted:

> You are an audience that is particularly sensitive to such awful remind-ers. An audience of deportees and relatives of deportees ... an audience that is closest to my heart; which is not what I had hoped for. I would have liked to see here those who were not aware, those who were mis-informed, those who wished to remain aware, or those who forgot be-cause the facts were too alien for the mind to retain.

After screenings in Rennes and Lyon, Martin-Chauffier attentively observed the younger members of the audience, looking for signs of

hope. On their faces he believed he read "the power of images" and the despondency of "stupor and horror" corrected by "the greatness of the sacrifice": "For it is the sacrifice, and only the sacrifice, that the Réseau du Souvenir persistently keeps alive."[7]

With this ventriloquist's exercise of giving a voice to silent faces, this former deportee searched for signs of the emotions he hoped to inspire by presenting the film. Miles from Cayrol's sobriety and contained emotion, the speaker evoked the sacred fire "that burns in all the souls haunted by the same refusal, prepared for the same duty, without distinction between those devoured by the flames of the crematorium, from which the black smoke rose into foreign skies, produced by the collected ashes of those who died so that freedom may survive and mankind may regain its lost dignity."[8]

Martin-Chauffier's speech was indicative of the message the Réseau sought to impart upon the young, which was to make them the heirs of a set of values, to transform the resistance struggle into an example, and to sanctify the voluntary sacrifice. The great story of the resistance and the tragedy of the deportation, seen from the perspective of sacrifice, formed two sides of the same coin, inseparably linking martyr and heroism. Because, said another member of the Réseau, "the young are not very fond of atrocities" but "they are fond of courage and heroism."[9]

For this reason, Father Riquet was most pleased to introduce, in Épernay in 1958, a combined screening of *Night and Fog* and *Blood Road*, "an inspiring film for young people, since it shows a young man in Yugoslavia deported into a labor unit and escaping under exceptional, but historically correct, circumstances. The evening ends with an eye to the future. It was the inspirational power of courage that broke the chains."[10]

This edifying and inspirational message was not restricted to the children of former deportees. Schools were *Night and Fog*'s preferred destination from the outset. Following the contract signed with the Ministry of Education, in 1956 the Centre National de Documentation Pédagogique[11] made fifty copies of the film available to high school educators.

In the first years of its distribution, *Night and Fog* was mostly screened during National Deportation Commemoration Day, sometimes as part of preparations for the *Concours de la Résistance et de la Déportation* instigated in 1961, and on rare occasions as part of high

school civics classes. French national broadcaster RTF added its two cents by screening the film on Deportation Commemoration Day in 1960 and 1961. It would again be shown on the same occasion in 1975 and 1979.[12]

In spite of all these screenings, Réseau members who made every effort to promote the film[13] complained about the apathy of certain teachers. In 1964, Olga Wormser wondered how to "convince educators, many of whom consider civics class a real cross to bear, that discussing with their pupils the meaning of the resistance and the memory of the deportation every year is more than just a chore? . . . How many freshly qualified young teachers, how many educators who never personally participated in the resistance, who opposed it, or who deny its importance, refuse to follow the National Education Ministry's directives?"[14]

She went on to admit that World War II had become a regular subject of the final year history curriculum since the 1962–1963 school year but added that many teachers lacked the time to properly introduce it at the end of the year, while its absence on the national exams hardly motivated them to make the extra effort. Wormser also regretted that textbooks limited their scope to Free France, making no mention of the resistance struggle against Vichy, the deportation, or the genocide of the Jews.

To Olga Wormser these gross oversights in the transmission of knowledge contributed to a disconcerting symptom: that of "Hitler? Never heard of him!" as revealed in Bertrand Blier's 1963 documentary of the same name.

In a report to the minister, Henri Michel also raised the difficulties encountered with "teaching the resistance and the deportation" and the concern of the various associations. Added to the usual hurdles of teaching a very recent subject (lack of distance and insufficient documentation) were specific problems related to the nature of a period during which the French were deeply divided and whose mention "risks troubling children rather than instructing them."[15] Michel also feared comparison with the conflict in Algeria, of which the youth were "particularly aware" and likely to raise "tendentious and inappropriate [sic] accusations." In short, in the general secretary's eyes a majority of educators, either through ignorance or an acute awareness of the dissension inherited from the occupation period, were little in-

clined to bring up the subject to their pupils. The historian counterbalanced these discouraging observations with the prospects of new teaching programs, the thorough documentation assembled by the Comité d'Histoire, and the successful example of *Night and Fog*.

Henri Michel and Olga Wormser's intention was to promote the film in its double capacity as document and monument, memorial work and source of knowledge on the concentration camp system. They traveled all around France to present *Night and Fog* to high school students and aspiring history teachers. During the fall of 1961, for example, they showed the film at high schools, teacher training colleges, and universities around the Paris area as well as in Le Havre, Périgueux, Valence, Alençon, Besançon, and elsewhere.

Henri Michel did not limit his ambitions to the border. After petitioning the Foreign Ministry to be allowed to present *Night and Fog* to foreign students at the Alliance Française, he included it in a teaching program he proposed to the minister of cooperation—a certain Triboulet—in 1965. His goal was to "offer a reminder of the meaning and the impact of the concerted efforts made during the World War II by the African nations and Madagascar in unison with the state of France."[16]

At the price of an astonishing about-face, *Night and Fog*—in tandem with the documentary *Ils étaient tous des volontaires*—was adopted into an educational project that aimed on the one hand to remind people that the struggle of the French resistance was a struggle for human dignity and on the other hand to analyze the Nazi doctrine in a way that allowed "leaders as well as peoples of Africa and Madagascar to grasp the danger from which people of color had escaped, thus allowing them the possibility to comparatively judge the French colonization more fairly."[17]

Clearly the film was escaping its creators' grasp. While he feared the possibility of inappropriate accusations from French high school students, Henri Michel had no qualms about using the resistance to Nazism as an excuse to reevaluate the "positive aspect of French colonization."

It must be noted that the two historians were far from being in agreement over this particular point. In her 1964 article, Olga Wormser quoted Sartre and Vercors's descriptions of how colonial wars betrayed the spirit and values of the resistance. Regarding the OAS,

she regretted that "heroes of the resistance" could have "in turn become executioners themselves."

A few years later, the two historians concluded that their tour of France's educational institutions had been fruitful. It seems in fact that toward the end of the 1960s, *Night and Fog* became more strictly integrated into historical education. To an entire generation of educators who began their teaching careers in the early 1970s, *Night and Fog* would come to constitute an essential reference, a film that some would show in class every year. Aside from its intrinsic qualities, Resnais's documentary offered two major assets: its brief running time[18] and its status as the only documentary on its subject available from the Centre Nationale de Documentation Pédagogique, one with the added bonus of being authorized by the Comité d'Histoire, the Ministry of Education, and the federations of former deportees.

In the following decades, changes in educational programs (particularly the 1982–1983 reforms) and the development of VHS would facilitate *Night and Fog*'s use in classrooms, while at the same time receiving competition from other documentaries and fiction films.

During the Klaus Barbie trial of November 1987 and the popularization of the contested expression *devoir de mémoire* (the duty to remember),[19] the CNDP entered into negotiations with Argos to acquire home video rights to the film—negotiations that were stranded due to Anatole Dauman's financial demands.[20] In 1992, at the instigation of the minister of education, the CNDP made another attempt and succeeded. Following the emotional reactions to the provisional release of Nazi collaborator Paul Touvier, Minister Jack Lang requested that *Night and Fog* be broadcast twice on the FR3 channel, on April 17 and May 11, as part of the CNDP's *Parole d'école* program. Lang also decided to offer every high school in the country a tape of Alain Resnais's film accompanied by a special issue of the weekly *Téléscope* largely devoted to state collaboration and "Vichy anti-Semitism."[21] In a memo to principals and superintendents of schools, the minister concluded with the following words:

It is the school's duty to contribute to making each pupil, each high school student, into a responsible citizen who cares about truth and is capable of refusing all forms of historical falsification. In this regard,

Night and Fog is more than a mere documentary; it should be a reflection on history and historical truth.[22]

On the radio station Europe 1 on April 27, the day of the film's screening by FR3, Jack Lang placed the film within a context of remembrance by declaring: "The Republic's high schools should be the high schools of the nation's memory, the high schools of the Republic's memory."[23]

From 1992 onward, five thousand VHS copies of *Night and Fog* were sent to all French high schools and some other institutions, as well as made available for loan at the CNDP's regional video archives.[24]

The minister's campaign likely left a number of educators perplexed: if Resnais's film contributed to a reflection on French collaboration, it was by default—the subject was hidden in the retouched image of the gendarme (the original photograph had not been reinstated in the 1992 VHS edition). Some may have rightfully felt *Le Chagrin et la Pitié*, which had received no favorable treatment from the authorities, to be more appropriate in this regard.

What is most striking here is the migration in the types of uses assigned by national education. This film on the Nazi camps became an instrument in the struggle against racism and anti-Semitism. It saw itself endowed with a full gamut of virtues: as an essential component of the "duty to remember," it had to facilitate the acquisition of civility while also presenting a history lesson.

The year 1988 saw a nationwide seminar on "Education Against Racism," held at the request of the SOS Racisme organization in various schools, colleges, and universities. At the Lycée Guillaume-Budé in the Val-de-Marne, the day took the shape of a screening of *Night and Fog* followed by a discussion with former deportees. Television cameras were present to capture, as they would again in May 1992, the teenage faces confronted with the film's images (multiple shots of the screen showed the images from Bergen-Belsen) and to record their reaction afterward.[25]

Once again, television was instrumental in education's new uses for the film. Whether presented in fragments or shown in its entirety, *Night and Fog* became an almost Pavlovian response to any anti-Semitic act or statement by Holocaust deniers—sometimes at the price of a frightening aporia of "evidence through image."[26] Its first use in this manner appears to date back to November 17, 1978, when

extracts from *Night and Fog* were presented on the Antenne 2 channel's *Aujourd'hui Madame* program following assertions by Louis Darquier de Pellepoix in the pages of *L'Express*.[27]

In May 1987, Michel Polac devoted his program *Droit de Réponse* to the Barbie trial, neo-Nazism, and denial. As part of the debate he showed a fragment from *Shoah* and, closing the broadcast, *Night and Fog* in its entirety, saying,[28] "We must all have the courage to watch this, to watch a film we should watch every year. . . . I beg of you, have the courage to watch the film all the way through. We do not have the right to not know *Night and Fog*, we do not have the right to close our eyes to what we are about to see."[29]

This rather paradoxical transformation of *Night and Fog* into a film on "anti-Semitism and the Shoah" reached its apotheosis on May 14, 1990, following a large-scale protest in the wake of the desecration of Jewish tombs in Carpentras cemetery. The Ligue Internationale Contre le Racisme et l'Antisémitisme (LICRA) obtained permission to show the documentary on the national networks.[30]

During the 1990s, *Night and Fog* continued its career in education at the behest of teachers of history but also of literature and philosophy. In Mariana Otero's documentary series *La Loi du collège* (1994), a screening of *Night and Fog* still functions as a coordinated reflex and a cliché of college life;[31] the editing suggests that the film is a means to restore order in class by pummeling recalcitrant students into submission.

More recently, the film has also provoked debate and criticism that led some educators to prefer other works, including *Shoah*, of which the CNDP also distributed a DVD of extracts. Such reflections on the part of national education fit into a wider and constantly updated consideration of the destruction of the European Jews. Would not the brutality of some of the images incite rejection, stupor, trauma even? Or inversely, does habituation at the sight of corpses on television screens dull the impact of images from the camps? Is it not abusive to present *Night and Fog* as a film on the Shoah when the word "Jew" appears only once and it ignores the singularity of the issue of the genocide of the Jews? Is it right for moral education to subsume historical education? Is awareness of the past a means to combat racism? As fascinating and pressing as these discussions are, I will not cover them here[32] because they say less about the film than about how the film serves as their pretext.

GENERATIONAL CONFLICT IN THE FRG

In West Germany, *Night and Fog* was associated earlier, and more centrally, with the persecution and extermination of the Jews. At the film's release in 1956, the conservative newspaper *Frankfurter Allgemeine* called *Night and Fog* a documentary "on the extermination of the Jews," while the united labor unions' official organ *Welt der Arbeit* referred in its coverage of the film to the mass murder of "nine million Jews [*sic*]," borrowing but misinterpreting the figure mentioned in Cayrol's commentary. In the same vein, the social-democratic daily *Vorwärts* tied the film's release in Frankfurt to the tragic fate of the city's 36,000 deported and murdered Jews, among them the emblematic Anne Frank.[33]

The West German authorities and associations were also quick to use the film as a response to certain anti-Semitic acts or statements. *Night and Fog* was shown in this manner in Berlin on January 10, 1960, following a string of incidents during Christmas 1959, including desecrations in the Cologne synagogue.[34] The film's second television broadcast[35] happened on November 9, 1978, to commemorate *Kristallnacht*.

While Paul Celan's text may have played a role in emphasizing the genocide of the Jews, the reasons should above all be sought in West Germany's specific memorial issues. Different from France, where the image of the deportee-resistance fighter, itself part of a dominant heroic model, imposed itself without contest throughout the postwar period, the FRG had to contend with the GDR hijacking the heroes of the resistance to "fascism" for its own ends. During the Adenauer years, commemorative discourse and reparations focused primarily on the Jewish victims of National Socialism. Signs of this interrupted evolution of memory can be found in the uses that West German education found for the film.

Night and Fog's fate in West German schools was one of contrast. Already at the film's release, the press proposed the idea of screening *Night and Fog* at educational institutions. Opinions varied from paper to paper, often stated in a clear-cut manner that reflected the importance adults lent to the thorny issue of transmission.[36]

The federal government considered the film suitable to be shown to pupils over the age of sixteen[37] and college students. Through the Bundeszentrale für Heimatsdienst, a hundred prints of the film

(some in black and white as a cost-saving measure) were put at the disposal of schools and other educational institutions. On the level of the *Länder* (states), however, the federal guidelines were applied loosely.

The ministers of Baden-Württemberg and Bavaria recommended the film for educational use but met with strong resistance from PTA groups, teachers' guilds, and school councils. In Göttingen it was the municipality that opposed screening *Night and Fog* in the city's schools, arguing that "the increasing violence on display" could have no "educational objective" and would only provoke "disgust and repulsion."[38] In North Rhine-Westphalia, on the contrary, it was shown to high school seniors starting at the end of the 1950s.[39]

The effects of these screenings are difficult to measure, although some testimonies credit them as the postwar generation's first confrontation with the crimes of the Nazi period. In 1962, the year World War II was introduced as a subject in the West German national curriculum,[40] one history teacher mentions in his report that seniors showed a "demonstrative refusal" after watching *Night and Fog*. He described the words of one of them:

> For example, that movie *Night and Fog* that they showed in school, it really made us, how do you say, laugh out loud (class laughs), really! It was too much! We made jokes about it, in every class. It bugged us, but we weren't scared by it.[41]

Andrea Lauterwein explains such puerile reactions through a lack of an educational framework. German teachers of the period tended to be passive about *Night and Fog*, which they would present to their pupils without either preparation or explanation. She refers to statements by the German poet Anne Duden, born in 1942, who discovered the documentary in her teens:

> I saw *Night and Fog* by Alain Resnais, which shows mountains of corpses cleared up by bulldozers. We had to watch this film in school, but they gave us no explanation.

Duden added that the shock was all the more violent because these images clashed with the silence of adults on the issue of the camps: "It was always mentioned in one way or another, but at the same time we did not talk about it at all. Then you see this film,

as a child. It is a turning point in your life. What you are seeing is pure madness."

This awareness, which comes about through an unclear sense of alarm, was immediately undermined by the adult world:

> Now Germany was just one zone ... watchtower and pit of murderers; grounds of ruins and hills of rubble, command center and mass grave, presented secretly for a one-time-only visit, at school, by way of *Night and Fog*, the film by Alain Resnais, followed and pursued by the comments of adults: *mere propaganda.*[42]

This absence of confirmation of historical facts, sometimes to the point of denial, would inform the "rejection of the fathers" and the protests of the postwar generations that would gain momentum over the course of the 1960s and the decade that followed. To describe this brutal generational conflict, Michael Schneider refers to Hamlet's melancholia, induced by the double parental figure whose two faces are "the father's ghost and the murderous paternal uncle occupying the throne":

> It's as if the ghost of their father appeared to them in a Nazi uniform, accusing their actual father of the most horrible collective crimes that a generation committed in this century. Little by little the phantasmagorical father replaced the one they had eaten their dinners with the past twenty years. Like Hamlet, they were often not sure whether this phenomenon was just a product of their own imagination, their own sudden suspicion, or whether it brought out their father's until-then-hidden true face. They were more inclined to believe the spectral voice of the Nazi ghost of their father than listen to the father who had become a Christian, liberal, or social democrat. Even if the father had become a committed democrat, his children had to doubt him, since he so long covered his errors with silence.[43]

In this framework of a ghostly reemergence of the past, *Night and Fog* seems to have played an important role as part of the double accusation of the Nazi murderers and the amnesiac silence of an entire generation.[44] To many educators who began teaching in the aftermath of the events of 1968, in sync with the important upheaval these represented in the West German collective conscience, *Night and Fog* offered the opportunity to undertake, with their pupils, a critical examination of the Nazi past that had been missing from their own

upbringing. Starting from the 1970s, Resnais's documentary was widely shown in West German schools, sometimes even on the primary level.

It is significant in this regard that *Night and Fog* opens, by way of Eisler's prelude, Alexander Kluge's film *Die Patriotin* (1979). The protagonist is a history professor who tries to bring to light various hidden episodes in German history. The heroine digs into the past by means of a shovel, "metaphorical object by which she uncovers what was buried," elaborating from recovered fragments of the nation's history a different "memorial mechanism that corresponds to the desire of a different Germany, not that of the FRG in which she lives and where the Nazi past seems to have evaporated, but wanting, flawed, suffering Germany."[45]

It is also no coincidence that Margarethe von Trotta subjects *Night and Fog* to a mise-en-abyme in her film *Marianne & Juliane* (*Die bleierne Zeit*, 1981), which is inspired by the lives of Gudrun and Christiane Ensslin. The German director explained:

> I wanted to show that terrorism is not born in a vacuum. That it was related to our history. The first generation of terrorists all had fathers that had been involved in Nazism and . . . hidden their guilt. So "the years of lead" to me also represent the 1950s, when we—because I am of the same generation as those first terrorists—lived as if under a leaden blanket; we knew something serious had happened in our past, but nobody talked about it, not even in our schools.[46]

Through flashbacks, the director reconstructs the key moments in the childhood and adolescence of the two sisters, Juliane and Marianne, the latter less rebellious but the one who would eventually turn to terrorism. In one of these key scenes, Margarethe von Trotta takes to task the German educational system's rigidity, cautiously folded back onto ancient values. Juliane declares to her literature teacher that she finds Rilke to be kitsch and that she would rather study Brecht and Celan. To the educator who criticizes her evasive strategy, she replies: "And you? What are you trying to avoid?"

The seminal scene, the one that seems to determine the direction of young Marianne's life, shows us the two sisters surrounded by other teenagers at a screening of *Night and Fog*. The pastor who organized it is seen standing observantly in the back of the room. Through this scene, von Trotta's film shows its fidelity to the history

of Gudrun Ensslin's family: her father Helmut was an evangelical pastor who was antimilitarist and antifascist and never compromised himself into collaborating with the Nazi regime (neither, incidentally, did the fathers of Andreas Baader and Ulrike Meinhoff). To these three members of the Red Army Faction, the inheritance of guilt was social rather than familial; their violence was aimed collectively and generically at the generation of "those who created Auschwitz," the ones to whom "no one could talk." Regarding this move toward violent action, Michael Schneider notes:

> The dramatic actions of the German terrorists remind me of the famous scene from Hamlet in which the prince asks actors to replay the murder of his father in front of his uncle. From its inception, the RAF [Red Army Faction] never was what it claimed to be (a liberation through procuration of the still dulled masses), but rather became a murderous and suicidal action aimed at unmasking the killers.[47]

The director's choice to quote *Night and Fog* at length echoes this process of unmasking: the extract begins with the date 1945 and the mention of collaboration by German industry and runs up to and including the *kapos* and officers denying their guilt. In between, the images from Belsen cause Marianne to leave the room, followed by her sister, handkerchief at her lips and discovering her sister in tears in front of the washroom sink.

This quote from *Night and Fog* gives Resnais's film a similar function as that of the aforementioned Shakespearian pantomime. This mirroring mechanism comes across as a distant reminder of the one the Allies employed at Nuremberg in the attempts to read the guilt on the faces of the accused. After being repeated in Jerusalem, it was used in Germany's increasingly sour generational conflict.

Resnais's film returns in German director Christian Petzold's *The State I Am In* (*Die innere Sicherheit*, 2000). This fiction film tells the story of the exile, the escape, and the chaotic return to Germany of a couple of former terrorists and their fifteen-year-old daughter, Jeanne. Here we appear to have come full circle: the girl accidentally joins a group of teenagers during a screening of *Night and Fog*. The screening ends with a sermon by the irritable teacher, who chastises the youngsters for their absenteeism while Jeanne silently gathers her possessions. The girl's only confrontation with the German education system

is therefore through the Resnais film, which appears to have become an obligatory reference that signals its institutionalization in Germany. While it gives a nod to the new German cinema of the 1970s and to *Marianne & Juliane,* as well as to the childhood memory of a filmmaker born in 1960, this reference to *Night and Fog* betrays a looser connection with German history. Petzold, like von Trotta, quotes the final part of the documentary, but limits his extract to the color epilogue that oddly finishes with an end title.[48] This word *ENDE* signals that a page has definitely been turned.

It is a sign of the times that *Night and Fog* is now endorsed for classroom use by the Bundeszentrale für politische Bildung,[49] which recommends it for teaching basic knowledge of cinema. In this context, *Night and Fog* is one of the titles on a list of thirty-five recommended films that includes *Nosferatu, The Gold Rush, Battleship Potemkin, Rashomon, The Wizard of Oz,* and *Vertigo.*[50] Now that the time has passed of mediocre, cost-cutting, black-and-white prints, administered like a potion to recalcitrant pupils, the younger generations of a reunited Germany can appreciate *Night and Fog* purely for its merits as a film.

16 CONSTRUCTING THE CINEPHILIC GAZE

IN THE SLIPSTREAM OF the Cannes film festival in May 1956, *Night and Fog* was presented at an art house cinema for the first time. The program at the Studio de l'Étoile in Paris coupled Resnais's film with Roger Leenhardt's *François Mauriac* and Paul Haesaerts's *Un siècle d'or,* the latter a documentary in color on the art of the Flemish Primitives.[1] A third wave of criticism accompanied these screenings in both the specialist and general press. The articles that appeared in February 1956 on the occasion of the Jean Vigo prize limited themselves largely to the young filmmaker's career. In April, the second set of reviews formed part of the political and diplomatic imbroglio of the Cannes affair. The Parisian release allowed the film critics to ply their proper trade. However, while the articles published on this occasion focus entirely on the film—admiring it unanimously and "without reservation"[2]—they also demonstrate a constricted form of film criticism, a hesitation to engage the issue of cinematic art and language.

PARALYSIS

In February of that year, Georges Léon had already affirmed in the pages of *L'Humanité* that "speaking about this film in normal terms is impossible, even more so in terms like shot, camera, tracking shot, ability, and style."[3] Critic and former deportee André Lafargue considered in *Le Parisien* that "it would be positively insulting to talk about cinema in the face of a document of this kind."[4] Jean Rouchereau, in *La Croix,* went so far as to proclaim *Night and Fog* "so far beyond and above all other films that silence is the only fitting reaction."[5]

The same paralysis of critical thought could also be found in the specialist film press, at *Positif* as well as in the pages of its rival *Cahiers du Cinéma* (which shared a number of authors with affiliated weekly *Arts*). François Truffaut paved the way by claiming, "*Night and Fog* is a sublime film that is difficult to discuss. Every adjective and every artistic judgment becomes inappropriate."[6] Ado Kyrou at *Positif* agreed, feeling that "talking technicalities would be an insult to Alain Resnais and his collaborators."[7] And when Eric Rohmer dares to suggest that *Night and Fog* has the dimension of a "fresco," he immediately calls himself to order: "I hope my comparison will not be seen as sacrilegious. Resnais did not attempt to make art, but simply to inform us with the greatest possible degree of objectivity. If some of his shots achieve the same beauty in horror we find in Callot or Goya, this beauty is additional."[8]

Jacques Doniol-Valcroze opened a new space for criticism of the film in *Cahiers du Cinéma,* one that took into account its dimensions as a work of art and as a document. He initially adopted the general argument that *Night and Fog* does not allow for any form of film criticism: "the very tissue from which this funereal oratorio is woven demands respect, a sort of silence whose rupture could properly be considered sacrilegious."[9] Even if "cinematically speaking" *Night and Fog* were a bad film, one could not permit criticism of it, "since the simple presence of these images provokes a range of emotions in which criticism no longer has a place." However, Doniol-Valcroze subsequently qualifies this posture as "false modesty": "In my opinion it is important to realize that *Night and Fog* is a masterpiece of montage film. . . . Like Goya's torments or Kafka's cruelest pages, *Night and Fog* would not have this power if it were not first a great work of art, the most petrifyingly 'flayed' of all testimonial films."

To Rohmer, *Night and Fog*'s artistic qualities were additional, almost stolen; to Doniol-Valcroze they are necessary and elementary. That the film was born from a double, contrary, and paradoxical movement does not make critical activity impossible: "*Night and Fog* is the impossible film made by possible by Resnais's heart and talent."[10]

It would take cinephiles a few years before they were able to confront the film again, armed with a perspective that now allowed for issues of form. In the meantime, they had already proclaimed the film's uniqueness and singularity, like Ado Kyrou stating that he "could not imagine another film on the same subject."[11] François Truf-

faut, writing in a more mystical and evocative style, celebrated the revelation of an emerging work: "If this film is a film, it is *the* film and the others are nothing more than printed celluloid. *Night and Fog,* the most noble and most necessary 'film' ever made . . . , is the deportation as seen and told by Christ."[12]

Admiration becomes act of faith before cinematic mystery. Instead of an analysis, Truffaut offered his readers the experience of a passion and a shared faith.

THE STAIN ON NEOFORMALISM'S REPUTATION

The release of *Hiroshima Mon Amour* in 1959, celebrated as an "event" by *Cahiers du Cinéma,* led to a first readjustment of views on *Night and Fog.* The debate the magazine devoted to Resnais's first feature film initially saw a softening of the "neoformalist" dogma elaborated by the "hitchcocko-hawksians" over the course of the 1950s. Raised to the level of incandescence by Luc Moullet[13] in his discussion of Samuel Fuller's work, it formed a two-tiered exposition: it relied on the idea that formal accomplishment is infused with a "moral" power *and* that it is proportionately inverse to its subject (a suggestion that could be considered rather paradoxical when applied to a filmmaker whose first act of cinema was filming the victims and the survivors of the Falkenau camp[14]).

In a 1959 essay entitled "Sur les brisées de Marlowe" (Poaching on Marlowe's territory), Luc Moullet opposes saying and doing so as to better attack self-righteous left-wing critics who praise subjects and intentions without considering the autonomous power of mise-en-scène: "The young American filmmakers have nothing to say, even less so Sam Fuller. He has things to do and does them naturally, unrestrained. . . . If you have things to say, say them, write them, preach them if you like, but don't bother us with them."[15] The critic summed up his ethics of pure form as: "Morality is a matter of tracking shots." The statement of a "relation between minimal idea and maximal power,"[16] which according to Antoine de Baecque constitutes the foundation of this neoformalism, would undergo a drastic rephrasing during the debate on Alain Resnais's film.

Participants of this round-table discussion were Rohmer, Rivette, Doniol-Valcroze, and Godard. It was the latter who declared during the course of this meeting that "tracking shots are a matter of morality."[17]

To de Baecque, this reversal formed "a strike": "A generalization that associates every cinematic gesture from the outset with a moral 'message'.... To Moullet, morality is a matter of form; to Godard it is the view on cinema that carries this morality within itself."[18] De Baecque also notes that by "adopting and reversing Moullet's statement, Godard essentially associates it with the representation of the death camps." In fact, while referring to *Hitler's Executioners*[19] to denounce a sensational form of cinema that he likened to pornography, Godard mentioned "the concentration camps" and "torture" in the same breath. With the same vitriol he attacked a documentary made by UNESCO about the earth's destitute (the famished, the crippled, and other disabled), which he qualified as "revolting" for its complacency in holding up shocking images to its audience. Seen in general terms rather than by the yardstick of a singular event, the question posed is clearly that of displaying atrocity. While careful to point out that there is no comparison between *Night and Fog* and *Hitler's Executioners*, Godard adds: "There is one thing that bothers me in *Hiroshima Mon Amour*, which also bothered me about *Night and Fog*, which is that it has a certain facility in showing scenes of horror." Five years later, in his film *Une femme mariée*, Godard would insert the opening scene of Resnais's short film.[20]

Going beyond Godard's reservations, Rivette follows his intuition in proposing an implacable difference between *Night and Fog* and all other films mentioned over the course of the debate:

> What allowed Resnais to do certain things that other filmmakers would not get away with is that he knew in advance all the principal objections anyone could have against him. Resnais not only posed himself these moral or artistic questions, he included them into the very movement of the film.... This is why Resnais succeeds in passing this first stage of the facility in the use of documents. The very subject of Resnais's film is the effort he had to make in resolving this contradiction.

As Rivette sensed from the outset, *Hiroshima Mon Amour* retroactively shone a light on the "rather blind" admiration for Resnais's short films, particularly for *Night and Fog*. Reverence for the subject and the images had initially suspended the critical faculty; unease over their demonstration, formulated after the fact by Godard, allowed for its revival. It led Rivette to reveal the acts of resistance by a filmmaker

grappling with a commissioned work, inscribing the film with his reservations about using the harrowing material at his disposal.

TOWARD AN ETHICS OF MISE-EN-SCÈNE

The ground had been paved for the turning point that came in June 1961, also in the pages of *Cahiers*, with the essay "De l'abjection" (On abjection).[21] The article concerns, as we know, the film *Kapo* by Gillo Pontecorvo. Its author, Jacques Rivette, declares the moral bankruptcy of the Italian filmmaker, who neglected to pose to himself the formal questions imposed by his subject and fell into an "obscene" excess of mannerism (the author adopted Godard's use of the word "pornography"). The critic's protest focuses on the shot in which Emmanuelle Riva (lead actress of *Hiroshima Mon Amour*) throws herself against the camp's electrified fence: "The man who decided at that moment to perform a forward tracking shot to reframe a dead body in a worm's eye view, taking care to place its raised hand precisely in a corner of his final composition, this man has a right to only the most thorough form of contempt."

It is precisely because "tracking shots are a matter of morality" that Rivette focuses on this swift camera movement that probably would not merit this much indignation (no more or less than other elements of the mise-en-scène, such as the orchestral score, for example). Also because he considers that the greatness of the subject demands the most ethical approach to form, Rivette calls up Resnais's film to oppose Pontecorvo's:

> This is where we come to understand that the power of *Night and Fog* emanated less from the documents than from the editing, the science with which it offered us the sadly brutal truth, in a movement that is precisely that of a lucid and almost impersonal conscience, which cannot accept understanding or admitting the phenomenon.... We do not habituate ourselves to *Night and Fog* because the filmmaker judges what he shows and is judged for the way he shows it.

Far from any form of certainty, haunted by the doubt that "Pontecorvo and his ilk lack," Resnais and his formal accomplishments imposed themselves as a fragile attempt at constructing a perspective. Definitively appropriated into the debate on the "morality of the form," *Night and Fog* versus *Kapo* led to a decisive reversal of Moullet's

axiom: "There are things that should only be approached with fear and trembling. . . ." The power of certain subjects therefore demanded an exemplary "morality" of mise-en-scène, a maximal form for a maximal idea.

ON RIGHTEOUSNESS

It would take another fifteen years and the emergence of a new generation of cinephiles, born after the war, for a tightening of the link between an ethics (rather than a morality) of mise-en-scène and the issue of representing the camps and the extermination of the Jews. As Jean-Michel Frodon has noted, the subject of *Kapo* seemed in all regards secondary to Rivette: "He sought to share a requirement in terms of mise-en-scène that could have easily applied to any dramatic scene in a different context."[22] In Serge Daney's writing, on the other hand, the event occupies a resolutely central position: "It took me time to develop this idea that 'modern' cinema, born with me, was the cinema of an *awareness* of the camps, an awareness that changed the ways films were made."[23]

The year 1959 marks the origin of this line of thought on cinema, which would mature in the 1980s. This date, which Daney regarded as a "second birth," is that of his simultaneous discovery, at the age of fifteen, of *Night and Fog* and *Hiroshima Mon Amour*. "All my life I've lived with those corpses that cinema gave me, with whose existence it entrusted me";[24] and by this horrific gift, cinema emerged all the greater in Daney's eyes. Resnais, the "ferryman," revealed the potential for truthfulness of an art form that entered modernity with the century's tragic history.

In 1959, Daney's nascent cinephilia found its positive pole in *Night and Fog*. Two years later, Rivette supplied the negative. "De l'abjection" became the critic's "portable dogma," from which he would never stray: "And so a simple camera move could become an unthinkable movement."[25] Between Resnais's film, which "watched his childhood,"[26] and Pontecorvo's, which he hadn't seen and never would see, Daney built the pedestal of his critical judgment.

In 1992, in the pages of *Trafic* magazine, Daney returned to this emergence from limbo to reengage the issue of "form" intrinsically linked to the history of the camps: "All 'form' is a face that watches us. . . . Only he who stumbled upon *formal violence* at an early age will eventually learn—but this takes a lifetime, his own lifetime—that

this violence too has a 'depth.'"[27] It is through the notion of righteous-
ness that Daney defines Resnais's gesture: *"Night and Fog* is not a
'beautiful' film, it is a 'righteous' film. It was *Kapo* that wanted to be a
beautiful film, and that isn't one."

The author finds this righteousness in the distance established be-
tween "the filmed subject, the filming subject, and the viewing sub-
ject." It is this necessary distance, in which each finds its place, that
Pontecorvo abolished: "The tracking shot was immoral for the simple
reason that it placed us, him the filmmaker and me the viewer, where
we never were."

The right distance defined itself conjointly in the space of the film
and in the time of history. In 1955 and in 1961, Resnais and Pontecorvo
inherited the event with unease or indignity; in 1945 George Stevens
discovered and revealed it in Dachau and in Dora, like Samuel Fuller
did in Falkenau:[28]

> What I understand today is that the beauty of Stevens's film is less the
> result of righteousness of discovered distance than of the *innocence* of
> the gaze. Righteousness is the burden of those who came after; inno-
> cence is the terrible grace accorded to the first arrival.[29]

By being aware that cinema is necessarily an art of the present and
that "its regrets are devoid of interest," Resnais invented "a righteous
moment, meaning a moment that can be shared." Daney finally quali-
fied *Night and Fog* as "anti-spectacle": "The sphere of the visible has
ceased to be entirely available: there are absences and holes, necessary
crevices and superfluous fullnesses, images forever missing and gazes
forever failing."

In Daney's writings, the cinephilic gaze on *Night and Fog* finds its
fulfillment while fossilizing at the same time. His essay "Le travelling
de *Kapo*" (*Kapo*'s tracking shot) exists at the moment of germination
of a critical thinking that would develop with the arrival of *Shoah* and
whose most radical formulation would ultimately turn itself against
Night and Fog.

A SEPULCHRAL WORK

Contrary to Resnais's film, Claude Lanzmann's *Shoah* recenters its
historical referent on the sole event, become autonomous, of the

extermination of the Jews. It ties this to a philosophy of the image that dates back thousands of years, which engages in an absolutely central manner the question of the unrepresentable, the invisible, and "the absence at the heart of the visible."[30] As with *Night and Fog*, the reach of this cinematic act that refigures the bond between the art form and the event would only be truly grasped and understood after the fact, at the end of a long exegesis. Thus the view on the work would progressively mature after the overwhelming shock of its revelation: clarified and extended, discovered and recovered, sometimes rendered rigid and opaque over the course of a sizable theoretical output that largely exceeds the scope of cinephilia; rearmed by the release of *Schindler's List* (as *Night and Fog* was by the Pontecorvo film) that restated the need for an ethics of mise-en-scène; sharpened and displaced by a series of discussion and controversies in which Lanzmann, unlike the sphinx Resnais, occupied a central place.

Daney makes no mention of *Shoah* in "Le travelling de *Kapo*," but he measures *Night and Fog* by the yardstick of a reflection on "the invasion of the visible" to which his writings, as Jean-Michel Frodon has pointed out, largely contributed. Should we consider this cursor frozen "once and for all" on *Night and Fog* as an act of fidelity to a film that revealed to Daney at the same time his cinema and his history, that of the father who died in the deportation? The cinephile inherited a gesture whose righteousness had been tested; he was the son of an image: that of the vanished corpses with which he had been entrusted and which, in a certain sense, had been returned to him.

Through this primitive childhood scene, *Night and Fog* became, as it did for Alain Fleischer's heroine, a sepulchral work, the very resting place of a dead father,[31] Pierre Smolensky, Central European Jew murdered in the camps: "What does a child know? And that child Serge D., who wanted to know everything except that which watched him? At the basis of which absence *from the world* would he later demand the presence of images *of the world*? The corpses of *Night and Fog* . . . watched me more than I saw them."[32]

For other "orphans of the deportation," Alain Resnais's film fulfilled the symbolic function of revealing the death of their parents and triggering a process of mourning.

In December 1959, Élisabeth Gille, daughter of Irène Némirovsky, walked alone, "at a sudden impulse," into a cinema that played *Night and Fog*. The final scenes marked the end of a wait, of an obstinate

will to not know so as to allow the foolish hope of a return to exist inside her: "And well, no, they will not come back. Her mother's hair, cut like her own, is no doubt there, among that grey plane. The bones of her father were shoveled, with thousands of others, into that mass grave."[33]

Doubtlessly because he never stopped waiting, Henri Ostrowiecki stubbornly refused to watch *Night and Fog*. When he finally did discover it, during an exhibition, he could not help himself from looking down to follow the fall of the corpses into the mass graves of Belsen, in search of the faces of his murdered parents.[34] To Daney, Gille, Ostrowiecki, and so many others, the images from Belsen formed substitutes for absent images, those of the gassed Jews whose bodies vanished, reduce to ashes in the crematoria.[35]

In *Les Abeilles et la Guêpe*, François Maspéro tells how his mother—a survivor of Ravensbrück—came home shaken from a screening of *Night and Fog*: "She couldn't help herself from searching my father's body among the pile swiped away by the bulldozer."[36] To the young adult Maspéro, an "unshakable" trust in *Night and Fog* resulted from its offering him "the image of my father's final days. . . . Because it makes no attempt to reconstruct the famous 'unspeakable' of the dead and the survivors: it shows their bodies."

To this "generation of children of those who died in the camps,"[37] *Night and Fog*, through its terrible softness, symbolically achieved the act of revealing and "returning" the bodies of their dead parents.

In this regard, the power and the violence of *Shoah* come from Lanzmann's acknowledging the destruction and the disappearance of the bodies of the murdered Jews, but also of the fact that this death without a tomb created a new relation with time and with the event.

If *Night and Fog* and *Shoah* effectively exist in the instant of the present and respond to "a demand stronger than that of memory,"[38] then Resnais labors the irreducible distance and the gap with the past, while Lanzmann opens his ghostly resurrection on another scene, in a permanently dilated present that ends up containing that past.

In *Night and Fog*, the audience, like modern Antigones, could find a place to bury their dead; *Shoah* is the place where the murdered are resurrected and of the endless dialogue with their ghosts. Like Hamlet before the opened grave of a father who returns as a ghost to ceaselessly remind him of what was not transmitted, time does not regain

its normal course. "If *Shoah* is woven from the present only, if the past seems to melt away and disappear, this is because the order that governs and accentuates the entire film is that of the immemorial," Claude Lanzmann said.[39]

And through what it could not transmit in its own time, the event leads to its failure to make its timely claim, "that hallucinatory return into the real of which no 'judgment of reality' could possibly be made."[40] As Michel Deguy explains, even the order of generations was upset: "The players are like their own sons, each begotten by those they were in their youthful agony, son of their own morition, and thereby reborn in the shape now pale, *gaunt* as they say, of a father who left behind the son who died 'over there,' in Auschwitz; sons of their own survival."[41]

The pulverization of time doubtlessly also originates in the black hole of the executions from which account and duration are absent: "To the Jews driven into the furnace at the moment they believed they were entering a labor camp, the unbelievable did not have time to take place."[42]

This crisis of time and story also appears to be a challenge to history. Following in Jules Michelet's footsteps, Michel de Certeau said that writing history is to visit the dead so that at the end of this "strange conversation" they will return to their tombs less woefully.[43] As Annette Wieviorka writes:

> The historian's discourse redirects the dead, buries them: 'He is deposition. He separates them. He honors them with a ritual they lacked.' Because, as Michel de Certeau points out, every "historical quest" seeks "to calm the dead that still haunt the present and to offer them written tombs"; 'history is founded on the separation between a past, which forms its subject, and the present that forms the place where it is practiced.[44]

In this way "history can also appear as one of the modalities of a task that resembles that of mourning: attempting to achieve—while encountering all manner of difficulties—the indispensable separation of the living and the dead,"[45] assigning each their place on either side of the border of time.

In this respect, *Night and Fog* could be considered a *film as historian*, where *Shoah* (closer to Virgil and Dante than to Michelet) would be, in many a sense, an a-historical film in how gesture joins word to

abolish temporal distance and "melt the present into the past."[46] Like the *Seder* ceremony described by Yerushalmi, "the symbolic achievement of Lanzmann's film is more to do with 'reactualization' than with memory."[47]

It is in this mode of visiting the dead that I intend to continue the portrait of Olga Wormser-Migot, whose work and destiny remained intimately linked with *Night and Fog*. Her life forms an off-center observation point from which to record new displacements that would have their effects on readings of the film: the often conflicting discourses by the directorial team on the ownership of the documentary; the completion of the historiographical task of which *Night and Fog* formed one stage, marking a first emancipation from the perspective and the gaze of the deportee; and major modifications in the memorial landscape that raised a first form of competition from the victims before provoking attacks from the falsifiers of history.

EPILOGUE
Olga's Epitaph

DISCORD

IN JANUARY 1956 at the Musée de l'Homme, André Migot, Hélène Parmelin, and Édouard Pignon accompanied Olga Wormser to the first screening of *Night and Fog*. She would report in her memoirs that after the screening everyone told her: "Now we understand why you were so possessed by this film." She added: "I've seen it and commented on it so many times now that I know every image, every sentence, every note":

> It remains one of Resnais's best. In 1957, when Resnais was supposed to do a film on the atomic bomb, I prepared the documentation and even wrote the first draft of a script that he never saw. In the end, I introduced him to Marguerite Duras, because I never forgot the "Mrs. Leroy" of 1944 and because I love her books. That's how *Hiroshima Mon Amour* came to be.[1]

The respect and friendship Olga established with the director would prove enduring. In 1967 Resnais shot several scenes of *Je t'aime, je t'aime* in the "atelier" at Montparnasse, the place where the Mouvement de la Paix held some of its meetings and where the historian, without participating, had her cell until the end of her association with the French communist party in 1956.[2]

Henri Michel, for his part, severed all ties with the filmmakers. He had felt dispossessed ever since the actual shooting of the documentary. Reading reviews of the film in the spring of 1956, Michel was displeased that the Comité d'Histoire did not receive enough credit.

A note by Jean de Baroncelli in *Le Monde* gave some indication of the extent of his chagrin:

> After my recent report of the screening of *Night and Fog* in Berlin, the general secretary of the Comité d'Histoire de la Deuxième Guerre Mondiale sent me the following clarification: "This film ..., which is unlike any other, was entirely realized at the initiative, under the patronage, and under the guidance of our Comité d'Histoire de la Deuxième Guerre Mondiale. The director essentially served as an editor, the full scope of whose talent came to the fore with sensitivity and intelligence; but the entire documentation at his disposal was assembled by a team of historians over the course of several years."
>
> Let it be noted. But forgive me if I continue to consider Alain Resnais as this film's "poet" (in the etymological sense of the word) and not as the "'editor" of a work "at the initiative ... etc."[3]

Following this first display of discontent, the film's unexpected success would cause a more serious dispute that would lead to a divorce between Michel and Argos. In January 1960, publisher John P. Didier announced his intention to publish a book that would reproduce Cayrol's text and screenshots from *Night and Fog*, for which he quickly opened negotiations with the film's producers and collaborators. Jean Cayrol agreed on the condition that the director would as well. Resnais accepted, on the condition that the commentary would be reprinted in its entirety and that the screenshots follow the order of the editing.

The project was already under way when Henri Michel realized, to his astonishment, that he had been kept in the dark. In May 1960, he reminded Dauman of the Comité d'Histoire's patronage, the part he and Olga Wormser had played in the film, the use of the "result of six years of work," and the public financing from which the film had benefited. Michel also underlined that the photographs used originated from the Comité's collections and from French and foreign archives that had licensed their rights for use in the film only.[4]

Dauman's first reply left him unsatisfied. In June 1960, Michel persisted, in a more acrimonious tone of voice:[5]

> To me, what we have here is essentially a moral problem. Argos Films has had the good fortune of making a lot of money off *Night and Fog*. I believe there should be a limit to the profit gleaned from the commercial

exploitation of the tragedy of the camps. Yet, the contract between Argos and Didier mentions only a partition of rights, making no allusion that these are rights to works by deportees. This to me is a condition sine qua non of the publication of any book based on *Night and Fog*. Anything else would be pure indecency.

The accusation is heavy and largely unjustified. The producer, while indeed holding the rights sought by the publisher, had in fact decided to retroactively transfer these to the author and the director. The two beneficiaries proved equally thoughtful: in January 1960, Alain Resnais initially announced he would donate his share to the "anti-racist association Droit et Liberté,"[6] then sided with Argos's suggestion to give the sum of the benefits to Jean Cayrol,[7] who would donate them to the Amicale de Mauthausen.[8]

Moreover, while *Night and Fog* proved profitable, none of those involved would have predicted this when the project was initiated. The producer and distributor therefore took maximum risk, a move largely motivated by the film's subject and the expression of a "moral imperative" toward the victims and the survivors. In February 1956, Henri Michel in fact paid tribute to this gesture before the members of the Réseau:

We had the great fortune, without abandoning any of our intentions, almost the miracle of firstly meeting these film producers. I believe they are a rare breed, I even believe they are unique, these people who immediately accepted our idea and said: "We will not make a big deal out of this; we will give you the money, too bad for us if we lose it."[9]

Consequently, to reprimand Dauman for his "good fortune" demonstrated a lack of elegance beyond admitting that a project on the deportation should, on "moral" grounds, always be a loss.

Michel's judgment on intent sickened Dauman, who communicated his feelings in no uncertain terms. He reminded Michel that the choice to revert the rights to Cayrol was justified for the latter's twin guise as the author of an admirable commentary and as a former deportee:

Which is not the case for you, Mr. General Secretary, despite your numerous memos to our friends the film critics at the time of the film's release, in order to attract attention to your modest self. The public had

not been informed of your efforts of "documentation," much to your chagrin. One thing explains the other.

We are not alone in thinking that in your status as an archivist of facts of war, it is highly improper to pretend to speak for the entirety of the resistance. We were satisfied to hear that Jean Cayrol sullied your reputation before an audience of witnesses.[10]

The producer concluded with an expression of his "most perfect contempt," adding to his signature the titles and decorations from his time as a member of the resistance.[11]

Dauman also demonstrated a lack of nuance, however. Henri Michel was not a simple "researcher": as originator of the project he worked tirelessly to secure public funding; with Olga he wrote the first synopses, negotiated with the Polish partner, and obtained free use of photographs. Cut to the quick, the general secretary activated his network: over the course of summer 1960, he alerted the CNC and asked Julien Cain, Gilbert Dreyfus, and Marie-Elisa Nordmann-Cohen to intervene on his behalf. These three all reminded Argos that they were the sole rights holders of the borrowed photographs and demanded that the subcommittee on the history of the deportation verify the book and hold final approval.[12] This hardly productive atmosphere would irremediably bog down the project.[13]

During the whole "Michel affair,"[14] Olga Wormser kept her silence. One can imagine her embarrassment and the discomfort of her position, torn between loyalty to her mentor and admiration for Cayrol and Resnais. Her artistic sensibilities flowered in the collaboration with the filmmaker, the poet, and the composer. She saw the progressive transformation of the Comité's project into a demanding work of art as a miraculous gift, renouncing without much difficulty her status as author for the more modest credit of historical adviser. After her mitigated attempts at poetry, Olga Wormser had rerouted her passion for art into interaction with many artists since the end of the war.[15]

She nevertheless remained faithful to her muse Clio and continued her historical efforts within the serenity of a finally attained happy home life. During the summer of 1961, on a film shoot in Poland, André Migot proposed to Olga. Once back in Paris, he donned his white cotton editor's gloves and solemnly requested her hand in marriage from her older brother. The wedding banquet took place in Barbizon at the Bas-Bréau inn, the same place, Olga emphasized,

where Resnais would later shoot one of the banquet scenes of *Stavisky*.

Olga, now named Wormser-Migot, was a rather progressive woman from a political perspective, yet rather conservative in her values. In spite of her pioneering book on women's history, she hardly resembled a suffragette, made no attempt to hide her naïveté, admitted loving sentimental romance novels and demonstrating her qualities as an exemplary wife. Horrified by *The Second Sex* and Beauvoir's theses on motherhood, she defended "the wonderful consented alienation" of a mother toward her newborn child. She expressed her disapproval of *Children of Heaven* to its author, Christiane Rochefort, whom she regularly met in the context of the "movement by intellectuals against the war in Algeria" ("I feel a friendship for her as well as plenty of reticence, not for her talent but for her ideas," she admitted in her memoirs). At the same time, Olga was an impassioned supporter of the struggle for "promotion of women in the work sphere," ceaselessly pointing out the list of higher-level jobs strictly limited to men and criticizing the "lure of part-time work that excludes women from positions of responsibility." She even lost her temper when her husband remarked that "for a woman" she made a rather good living. And while André Migot showed his contempt for "books by good wives," she immersed herself with passion and pride in the writing of her publications, not allowing her marriage to slow the place.

After several contributions to writing the history of the eighteenth century (in the shape of biographies of Catherine II and Frederic II), she returned to the subject of the deportation with *Quand les Alliés ouvrirent les portes*. Published in 1965, this volume was unanimously praised by former deportees: Paul Arrighi lavished her with compliments during a general meeting of the Réseau, and Gilbert Dreyfus was moved by her description of the experience of returning home and the evocation of the atmosphere of the time.[16]

Within the subcommittee, Olga saw her reputation grow and her position increasingly solidified, thanks to her ever-increasing knowledge of the subject and her frequent visits to Europe's archival centers.

While Germaine Tillion may have derived her moral authority from her intellectual stature and her legitimacy as a former deported resistance fighter, Olga conquered hers with her competence and the power of her work, to which the members of the subcommittee paid increasingly fervent tributes. In March 1964 she presented a paper on

the trials of the executioners of Auschwitz in Frankfurt; her hypotheses are reflected with interest and warmth in the subcommittee's reports. Yet, from 1969 onward, the irresistible rise of Olga Wormser-Migot seemed to stop short: her interventions became increasingly rare, her presence increasingly silent. The horizon turned dark once more.

HONOR LOST

The first tragedy was of a personal nature. In February 1967, André Migot died of heart problems. This marked the end of the bright spell: there had been absences, but now there was solitude, which became deeper and more desolate in the difficult months that followed the defense of her dissertation.

When André Migot died, Olga was in fact just finishing up the dissertation that had taken her the better part of twenty years to complete. She had to overcome many an obstacle to arrive at this point. Since 1947, the year she enrolled as a doctoral candidate, she had changed subjects and supervisors, as Dean Renouvin succeeded the retiring Professor Baumont, before himself handing his tasks over to Jacques Droz. Receiving approval for her subject had been no easy task:

> I had trouble getting the historian Pierre Renouvin, famously wounded in World War I, to acknowledge the subject. His brother Jacques had died in Mauthausen. In 1968 the people were still of the opinion that a dissertation worthy of the name demanded time and accessible sources.

Even in February 1957 Renouvin told her that she would have "a lot of trouble gathering the sufficient documentation to treat these problems under the proper conditions for historical research."

Olga Wormser tried to convince him that she "had no shortage of primary sources":

> One could say I had assembled everything by sight, on all the trips I'd taken to Holland, Belgium, Germany (notably the Potsdam archives) to Arolsen, to the CICR in Geneva, and to the Soviet Union, where, thanks to "France-URSS," I was authorized—still a rare favor then—to work in Moscow at the Soviet central archives.

The dean's reticence also stemmed from the chosen problem, which he considered in the margins of the field: "You say you wish to study the birth of a system and to reveal its 'economic' goal or its 'destructive' goal. This conception of the subject comes close to a sociological approach. To the extent that you are studying a system of ideas, I would say you should rather aim for the sociological angle."

Olga's persistence eventually paid off, however: ten years later she submitted the two volumes of her dissertation[17] to the Sorbonne. Her committee consisted of the professors Droz, Duroselle, Grappin, and Renouvin, with the addition of professor of medicine Gilbert Dreyfus in his double guise as a former Mauthausen inmate and specialist of diseases particular to the Nazi camps. Her defense, planned for May 11, 1968, could not take place due to the Sorbonne being closed as a result of student protest.

Olga Wormser-Migot would hold a grudge against the activists, whom she felt undermined the prestige of an institution to which she finally hoped, not without a certain naïveté, to belong.

When referring to the events of May 1968 in her diaries, she admitted to having negative feelings: "Because they happened too close to André's death, whose memory absorbed me completely, and they were symbolized in my eyes by that slogan written on the walls by the students: 'Don't say Professor, say Die bitch!'"

Although she took the slogans of the period as a personal insult, Olga described with irony the solemn arrival and disorderly retreat of Bernard Pingaud and his "two writer/bodyguards" who wished to take over control of the Institut Pédagogique while she was in the midst of "cleaning up a few cigarette butts dropped by leftists."

With the revolution rescheduled to a later date, Olga Wormser-Migot could deliver her defense in November 1968 at a Sorbonne that had trouble recapturing its old serenity. From the auditorium where she presented her work, the candidate heard the rising cadence of a group of students continuously chanting: "*Thèse = Foutaise!*"[18]

A few years later, Josane Duranteau described the hectic proceedings in an article in *Le Monde*:

> She had to pause at the request of the chairman—there was a protest going on in the courtyard, where they yelled: "End the fascism!"—while she was in the midst of analyzing with great freshness and a wonderful detachment the demented logic of the world's best organized killers.[19]

These final twitches of the spirit of May '68 could not affect the unchanging order of academic ritual and of the ceremony later described in Alain Resnais's *Same Old Song*. Duroselle pointed out a few errors in her annex (like the "*Institut für Zut*—instead of *Zeit—Geschichte*"), while Gilbert Dreyfus reminded Olga that there are two p's in Hippocrates. The discussion about the subject matter was of the highest order and, in spite of the occasional noise from the courtyard, the ambiance was all the more reverential for an audience consisting largely of former deportees. It was the first dissertation on the deportation, and for the next twenty-odd years, it would remain the only one.

Rachel Rivière, teacher and deportee's wife, remembered that November afternoon vividly: "Still present and alive in my memory is that silhouette, so slight, so fragile, and at the same time so powerful, of a slender blonde explaining and defending, before that impressive presidium in that hall of the Sorbonne, a sacred work."[20]

What touched Rachel Rivière most was the way she felt Olga had managed to align science and heart, intelligence and faith in mankind:

> I am sure that for the witnesses of this generation and the people of tomorrow, through your long, patient, and often arduous task you have "resuscitated" the millions of victims. That afternoon, during those poignant hours, they were there, present, the victims and the executioners. I feel that through you, thanks to you, our dead and our missing did not depart in vain.

After the good news had been announced came the celebrations and the acknowledgments. The big day ended with a reception at the Pignon couple's house:

> Jacques Monod and Gilbert had a confrontation. Jacques congratulated Gilbert for the way he had exercised his role as "ex-deportee professor," to which Gilbert replied coldly that he did not congratulate him for the way he had supported the student movement in 1968. They reconciled in the months that followed, though.

In her attempts to find a position in French academia, Olga Wormser-Migot doubtlessly had a difficult time with the rigidity of an institution that was little inclined to open its doors to a fifty-six-year-old woman with no official teaching qualifications, regardless of

her merits and the importance of her work. But recognition, at least, she received.

In the May 3, 1969, edition of *Le Monde,* Pierre Sorlin saluted "the exceptional courage" Olga Wormser had demonstrated in completing her research. While also mentioning Joseph Billig's "excellent" book *L'Hitlerisme et le système concentrationnaire,*[21] "overlooked upon publication," Sorlin noted from the outset that before Olga Wormser's work, there did not exist "a genuine account of the concentration camp phenomenon between 1933 and 1945."

A month later, *Le Monde* published the act of accusation that would mark the beginning of a prolonged controversy that Olga experienced as "one of the most bitter moments of my life."

Let us retrace this affair. In the introduction to her dissertation, Olga points out that she will not treat the Final Solution but only the concentration camp system. One of her objectives, she emphasized, consisted of "establishing the fundamentally dissimilar characters of the two processes, at least in origin."[22]

The vacillations of *Tragédie de la Déportation* and the confused approach of the script for *Night and Fog* seemed to belong firmly to the past. As if to make amends for those early works, the distinction is clearly delineated between the two events, which in spite of their occasional overlap should be approached in their singularity and own genealogy.

In setting up her demonstration, however, Olga Wormser-Migot is tempted to exaggerate and commits an error that would have grave consequences. Already in the introduction, she affirms that "there were no gas chambers in the western camps."[23] "At least not in their primitive structure," she adds in an endnote. The historian inserted an additional nuance by mentioning "the small experimental gas chamber" of the Natzweiler-Struthof camp and that at Ravensbrück, which "appears to have been functional in February and March of 1945."[24]

Yet, in the main body of the text, Olga aggravates her case. In a section entitled "The Problem of the Gas Chambers," she points out a string of inconsistencies in the testimonies of victims and executioners alike regarding the Ravensbrück and Mauthausen camps. She remarks that certain statements about the gas chambers at Mauthausen and Oranienburg seem to strike her as being "invented."[25]

This was incorrect: while it is true that there was no gas chamber at Buchenwald and that the one at Dachau was never actually used, those at Mauthausen and Ravensbrück[26] certainly existed.

The historian therefore committed an error, even if the distinction she established remains pertinent. As Annette Wieviorka notes, "beyond the error, Olga Wormser-Migot saw correctly":

> The centers, all located in the East, devoted to the massive executions of Jews by way of gas are different from the concentration camps, which the Nazis established from 1933 onward and which received various categories of prisoners . . . and whose function was not systematic elimination.[27]

To this factual error Olga added a blunder that would offend many a former deportee. In pointing out the confusion between gas chambers and crematoria in witness testimonies, the historian interprets these as "an unconscious desire to revalorize personal suffering in comparison to the Jewish deportees":

> "We also had a gas chamber." The term "gas chamber" is becoming one of the leitmotivs in the deportation's *chanson de geste* for the Jews—with good reason—and for the non-Jews through a very complicated process, in which a psychologist and a psychoanalyst will need to confirm the historian's conclusions.[28]

The same person who recorded the first testimonies of camp survivors, read the vast majority of memoirs published since the homecoming, and followed the migrations of the various accounts, perceptively noted the increasing importance of the theme of the gas chamber. She also had the intuition to notice a competition between victims that would intensify in the 1980s. But at the same time Olga Wormser-Migot contributed to intensifying it by implying a hierarchy of pain and "tragedies endured." In doing so, for the first time she placed herself in an awkward position with the deported resistance fighters in whose company she had spent most of her postwar years.

That her work now took place from a scientific perspective allowed her at last to define a method in which the importance of the document overrode that of the testimony, opposing history to memory:

If we wish to respect historical fact, there is no doubt that we will have to break many taboos and destroy many myths born from the secrets and the terror of the concentration camps, reshaped by the imagination of those who created them in their fear and enhanced them, consciously or otherwise, with the experiences of others, testimonies they read that may or may not have been authentic, to the point of adopting experiences they have not themselves lived.[29]

It had been the ex-deportee members of the subcommittee themselves who had pointed out mistakes in certain testimonies and to express sometimes severe criticism of a number of myth-makers.[30] Nonetheless, some consider, like Cyrano, that no one but themselves is capable of serving them up; was it not after all most often the neighbor's testimony that came under scrutiny?

Olga would pay dearly for distancing herself from the official line of the deportees (a line she had contributed to valorizing), the scientific tone with which she speculated about the deportees' "subconscious" (in contrast to the empathy of her previous works), the shift of perspective that led her, in order to better absorb the system, to adopt the position "of a member of the camp hierarchy," and finally and most importantly for the mistake made regarding Ravensbrück and Mauthausen.

It would not take long for former detainees of these camps to react. On June 7, 1969, *Le Monde* published a letter by Pierre Serge Choumoff, member of the Amicale de Mauthausen, in response to Pierre Sorlin's article. This former deportee vigorously attacked Olga Wormser-Migot's publication, criticizing its "subjective affirmations and considerations." Referring to the files on the Mauthausen gas chamber, Choumoff raises a "solemn protest" against the methods of historical research employed by Olga. He ends on the defining phrase that invalidates and slams the work as a whole: "The true history of the concentration camp phenomenon has yet to be written."

Choumoff's text was reprinted in the *Bulletin de l'Amicale de Mauthausen*,[31] in an expanded version accompanied by a photograph of the camp's gas chamber and preceded by a header that announces a rupture with the historian:

Probably as a result of hasty reading, some felt the need to affirm that this voluminous book riddled with contradictions had the value of a historical source for the study and comprehension of the Nazi concen-

tration camp system. It is this value as a historical source that we must subtract from Olga Wormser-Migot's volume, regardless of its further merits.

After the publication of the article in *Le Monde,* Olga Wormser-Migot received a letter from Luc Somerhausen, head of the newsletter for political prisoners, resistance fighters, and veterans.[32] In a tone foregoing any acrimony, he announced his decision to start an investigation to "make clear the issue of whether or not there was a crematorium [*sic*] in Mauthausen."

A few days later, Somerhausen forwarded her the letter he received after consulting the president of the International Mauthausen Committee on the matter. In it, Robert Sheppard pointed out that he had not read the book in question but added that one only needs to visit the Mauthausen camp to see that it was equipped with a gas chamber: "Consequently I absolutely cannot understand how one can be so negligent in the writing of a doctoral dissertation."[33]

Sheppard mostly wished to express his feelings about the "heart" of the matter:

What I find shocking is the kind of discrimination between the camps equipped with a gas chamber and those without, which strikes me, pardon the expression, as a classification more suitable to the Michelin Guide than coming from a historian who claims to be objective, and which in fact lacks any direct correlation with the subject.

Sheppard, however, goes on to surreptitiously reverse the sinister hierarchy of martyrs:

I believe that author intends to prove that the gas chambers were reserved for Jews. I would never imagine distinguishing between those that died in one manner and those who died in another, but I would like to add a nuance for which my comrades of the deportation will understand and forgive me, even the Israelite comrades who survived: if one had asked those who died to choose between death by dogs, by hunger, in the quarries, by injection, by beating and death in the gas chamber, I can assure you which death they would have chosen.

In a belated feeling of scruples, Sheppard concludes by backtracking: "Let me not be misunderstood. I simply wish to demonstrate how unwelcome this form of discrimination is."

Pierre Serge Choumoff, meanwhile, was undertaking a more scientific and argued repudiation of Olga Wormser's conclusions. His association published the fruits of his labor in 1972, under the title *The Mauthausen Gas Chambers.*

More reserved was the initial tone among the women once detained at Ravensbrück. In the ADIR's[34] newsletter *Voix et Visages,* Geneviève Anthonioz-de Gaulle praised the dissertation across two full pages, followed by lengthy excerpts from the book. This former resistance member applauded the monumental task accomplished with such modesty and emphasized the "powerful interest" of numerous passages. Anthonioz did chastise the sensitive issue of the gas chamber at Ravensbrück, but in a tone of "amicable grief," by citing the testimonies from the Hamburg trials that Olga Wormser seemed to have ignored. This reservation had little influence on her judgment of the work as a whole: "It seems impossible to truly understand the history of our times without taking into account this brilliant analysis of the concentration camp system."[35]

Germaine Tillion was less indulgent. But one can imagine her pain and disgust at doubts about the existence of a gas chamber in which her mother Émilie was murdered in March 1945, at the age of sixtynine. In the second edition of her book *Ravensbrück* published in 1973, the ethnologist did not spare her colleague:

I admit to my consternation at reading Olga Wormser-Migot's dissertation. The author spent many long years on an analysis of the concentration camp system and the adoption of legislation that governed them throughout the German civil and military administration, a useful and ungrateful task for which I would have thanked her in advance.

Germaine Tillion admitted that the part of the thesis devoted to administrative texts strikes her as "valid" as far she is "able to judge." However, she quickly added:

Unfortunately, where the facts are concerned, she refers to a giant mass of information that she has visible trouble coming to grips with. This ranges from slight error to grave mistake and culminates in a stance she formulates in the introduction.[36]

Deeply affected by this painful dispute with the deportees to whom she devoted a large part of her life and some of whom she

believed to be friends, Olga Wormser-Migot made a gesture of appeasement. She wrote an "addition" to her dissertation that would be added to all as yet unsold copies. Yet, this brief text did little more than acknowledge the controversy:

> Following the publication in 1968 of this thesis on *The Nazi Concentration Camp System,* a single disputed point has emerged regarding the problem of the gas chambers.
>
> In fact, on page 12 of the introduction and pages 541 through 544, I affirm that there were no gas chambers in the western camps (except for the "experimental" gas chamber at Struthof), since the gas chambers were, according to my thesis, exclusively intended for the mass exterminations in the eastern camps.
>
> This conclusion provoked categorical denials by survivors of Ravensbrück and Mauthausen, for whom the existence of gas chambers in those camps cannot and should not be doubted.
>
> I feel compelled to make the readers of this thesis aware of this fact.[37]

This incomplete gesture found mercy in the eyes of the Amicale de Mauthausen, which published the text, preceded by a conciliatory comment from Raymond Hallery: "The historian of the deportation Olga Wormser demonstrates her sincerity, which to us was never in doubt."

Where Choumoff devaluated the historian's efforts, Hallery recognized its interest in spite of its mistakes, while at the same time voicing the more deliberate stance of the Amicale:

> Survivors of Mauthausen and relatives are deeply grateful to all the historians and writers that are doing so much to expose the concentration camp system. It is precisely because they are aware of the impact of such efforts that the deportees are severe, not just for their own sake, but for the sake of future generations. It would not wish for the entire history of the deportation to become subject to doubt as a result of a single mistake, to which even the historian is not immune.

However, Olga's text did not satisfy the former deportees of Ravensbrück and the ADIR, who considered that their associations had done more than "categorically deny" but in fact produced studies and publications (those of Choumoff and Tillion), which the historian did not bother to cite.

The editorial in *Voix et Visages* entitled "Ravensbrück's gas chamber" interprets Wormser's additional text as a flat refusal:

> We do not demand that the author "renounce a scientific conviction" if it has a basis, but we demand what basis there could be for expressing a "historical faith" that takes none of history's data into account.... The ADIR's board of directors unanimously regrets that Olga Wormser-Migot was content to reiterate our protest without examining its underlying principle.[38]

It is true that Olga did not admit her error. In fact she sincerely believed she had made no mistake at all. As she herself wrote of certain testimonies, let us suppose that we would need to investigate the subconscious to understand the process behind her refusal. Through a psychological defense mechanism, the person who at great pain and effort had managed to map out her career and secure her status as an authority and her documentary competence could probably neither imagine nor accept that she had made a historical error.

In her memoirs Olga qualifies the period following the publication of her dissertation as "hellish." That she acted beyond a shadow of a doubt in good faith made the episode even more painful. Olga felt that she was being attacked for a mistake she had not committed. In the heat of controversy she saw the work at which she had labored so long invalidated in its entirety. Yet, in spite of Choumoff's verdict, her book is still cited as a pioneering work and remains of great value to all who investigate the concentration camp system. But she had to endure the criticism and accusations of the very people whose gratitude she expected and for whom she defended France's very first dissertation on the deportation. From one day to the next, Olga found herself estranged from her base, blacklisted by a part of the circle that she considered a surrogate family.

Her son Frédéric remembers how Olga's house, which was ruled by an open-door policy, suddenly became quiet and that only a select few loyal friends, including Gilbert Dreyfus, Michel Borwicz, and Charlotte Delbo, still showed her friendship and respect. The blow was severe: the historian fell prey to depression and dark thoughts, and found herself alone with her Siamese cat Pénélope, a gift from Chris Marker.

THE WOLF OUT OF THE WOODS

The opportunity was too good to pass up for a certain Robert Faurisson, who attempted to trap Olga by exploiting her distress. In May 1974, the man who was still a lecturer in literature at Sorbonne Nouvelle and whose main activities seemed limited to counting Rimbaud's *Voyelles* and rereading Lautréamont, addressed to Olga an amiably voiced correspondence on university letter-headed paper:[39] "Might I ask you whether, without casting doubt on what we know of the camp system, the crematoria, etc., you did not arrive at the same conclusion as I did: that the Nazi gas chambers are very likely a myth?"

In the same civilized tone he had adopted a month earlier in a letter sent to several World War II specialists and former deportees,[40] Faurisson added:

> I am distraught at so openly posing you questions about such a delicate matter. Believe me when I say I do this in the spirit of pure historical curiosity and as someone who, for a dozen or so years, has been trying, in his spare hours, to create some clarity in a very muddled affair. Can I trust you will reply to me soon? I consider you the greatest specialist of the history of the camps.

It must be noted that while Robert Faurisson had been interested in the issue of the Nazi camps for some fifteen years, his allegations were known only within a strictly limited circle. It was in 1978 that they would become public knowledge. After a first lightning bolt in January (his presentation at a symposium in Lyon and the release of a pamphlet exposing his "theories"), he would grow notorious with the publication, again in *Le Monde*, of a text entitled "The 'Problem of the Gas Chambers' or 'The Auschwitz Rumor.'"[41] The first part of the title quite perfidiously adopted the heading of the contested chapter in Olga's dissertation.[42]

In his letter of 1974, Faurisson cautiously avoided linking his doubts about the gas chambers in Poland to his denial of the genocide of the Jews. This letter was followed by a meeting[43] and an exchange of correspondence. On November 7, 1977, Olga Wormser-Migot wrote back to decline Faurisson's invitation to meet together with *Le Monde* reporter Pierre Viansson-Ponté[44] and to clearly emphasize her fundamental disagreement on the issue: "The first difference between my

position and yours, and you know this well, is that I believe in the existence of gas chambers at Auschwitz and Majdanek, as well as in the 'experimental chamber' (one by two by three meters) at Struthof."[45]

The issue of method, however, Olga Wormser-Migot covers in a more ambiguous manner. She regretted her interlocutor's "inflexible attitude," which led him to "increasingly oppose" himself to and "harm" the deportees: "Given the feelings of the deportees, deeply traumatized by the suffering they underwent, it is obvious that your attitude can only offend them. There are occasions where history must wait until time allows a nonaggressive investigation into certain horrific problems."

Olga's "advice" revealed her still sensitive wounds and the lessons she had drawn from them:

I remind you that, in a similar situation—being my thesis "The Nazi Concentration Camp System" in which, as you know, I placed doubts and more at the existence of gas chambers in Ravensbrück and Mauthausen—and after a historian's obstinacy that only served to aggravate the situation, I simply inserted a rectification explaining the deportees' position on the matter. Because to me, the deportees always come first.

In 1977, Olga was therefore still convinced that she was historically right but had been morally wrong to oppose the deportees. The similarity to her own misadventures—she declared herself "depressed and concerned"—probably informed the empathic tone of her letter. While she did not budge an inch on the issue, perhaps she was flattered by the praise of an academic who recognized the merits of her work and allowed herself to be moved by a man she considered acting "in good faith" and who declared himself the subject of "relentless persecution."[46]

REBOUND

One imagines Olga's consternation when Faurisson's true intentions were revealed a few months later. The blow was all the more severe because she found herself implicitly associated with his rhetoric of denial in a report in *Le Monde* that marked the start of the "Faurisson affair." This anonymous text referred to an article by Faurisson in the June issue of *Défense de l'Occident* and demanded that Deputy Pierre

Sudreau open an investigation. The report ended with this astonishing paragraph:

> It should be noted the Mrs. Olga Wormser-Migot, in a thesis on the Nazi concentration camp system, . . . stated that there were no gas chambers in the western camps, but only in the territories of the current eastern countries, then under occupation. The association of former detainees of Mauthausen subsequently published a thoroughly documented study by Pierre Serge Choumoff, . . . a former deportee, proving that this camp situated in Austria was most certainly equipped with gas chambers.[47]

The author then ended his writing by giving the Amicale de Mauthausen's address.

A devastated and furious Olga Wormser-Migot demanded the right to retort, which she obtained in abridged form. She declared herself "stupefied" by the article's conclusion, not understanding how the Amicale's address could possibly "clarify the debate that opposes me to so-called 'revisionist' writers."[48] She was astonished that the newspaper would practice "the amalgamation of a nine-year-old controversy (a controversy not of the objectives or results of the extermination in certain western camps but of the *practical details* of that extermination) and the malicious rantings of so-called 'revisionist' writers." In the first draft of her text, she also referred to the response she and four researchers of the CDJC had formulated to the statements by Louis Darquier de Pellepoix. She could also have mentioned that she had served as a witness for the prosecution against Paul Rassinier in 1965.

In this new struggle Olga received the support of the Amicale d'Auschwitz, while Mari-Elisa Nordmann-Cohen sent a letter to *Le Monde* to express her astonishment at the implications in the last paragraph of the November article.[49] After a phase of profound confusion, Olga regained her fighting spirit and renewed the bonds with certain members of her adoptive family. At the publication of Faurisson's article in December 1978, Jean Planchais asked her and Georges Wellers to write counterarguments.[50] This garnered her a letter from Jean Pihan, who praised her for having been one of the first to mobilize herself against Faurisson and to "ring the bell."[51] In her riposte entitled "The Final Solution," Olga proposed a well-argued synthesis of the principal stages of the persecution and the genocide of the

Jews, pointing to documents and archives that could be consulted on the matter. In an unexpected move, she referred to the beloved film "on which she had the honor of serving, alongside Henri Michel, as historical adviser." While *Night and Fog* hardly deals with the genocide of the Jews, the historian pointed toward the Russian footage of the orphans of Auschwitz used by Resnais,[52] while adopting several of Jean Cayrol's expressions ("It's necessary to annihilate, but productively," "Manual killings take time"), which she now clearly tied to the Final Solution. Olga ended her text with the last sentences of the commentary, which she cited approximately, from memory:

> Who among us, in this strange observatory, watches for the arrival of new executioners? Do you believe their faces will be different from ours? Everywhere there are rehabilitated commanders, lucky *kapos*. . . . There were those who did not believe or only on occasion. . . . And we who pretend to believe that all of this belongs to a certain time and a certain country, we who fail to hear the endless screams.

At the close of the 1970s, Olga Wormser-Migot broadened the scope of her work by writing multiple essays on the genocide of the Jews and opening up her thoughts on "the era of the camps" to include other countries, the Soviet Union in particular, while delineating the difference between each system. Throughout the 1980s she continued the fight against the deniers. She wrote her last work in collaboration with Vercors, entitled *Assez mentir!* In this book-length pamphlet, product of a "shared furor" against Nazi nostalgia and falsifiers of history, Olga went back over the Faurisson affair, citing Resnais's short film multiple times.[53]

Despite these publications and efforts, fragility remained. The historian had lost the assurance that she had acquired at such great pains, and her confidence proved definitively broken. In the intermediate version of her retort to *Le Monde*, she felt the need to list all her publications, the names of her doctoral defense committee, her work with the members of the Réseau du Souvenir, and, like a talisman, her contributions to *Night and Fog*. Proof of a wound that refused to heal, she also recounted the most painful aspects of the controversy: "Some reprimanded me for 'attempting to make the gas chamber the exclusive honor of the Jews'—a statement as dumb as it is detestable."[54]

Olga was not alone in revisiting that sorrowful episode to the point of its becoming hackneyed. In her third edition of *Ravensbrück* from 1988, Germaine Tillion no longer refers to Olga Wormser-Migot's works, but she includes as an appendix Serge Choumoff's investigation and a text by Anise Postel-Vinay entitled "Extermination by Gas in Ravensbrück." In her new introduction, the former deportee revisits the affair in a veiled manner:

> In 1970, two Mauthausen survivors, Pierre Serge Choumoff and Jean Gavard, showed me part of a text in which, for the first time, the gas chamber at Ravensbrück and the gas chambers at Mauthausen were treated as myths, while the deportees that spoke of extermination by gas (meaning, for Ravensbrück, *all* detainees held there during 1945) learned that they should be seeing a psychologist or psychiatrist.

before adding this terrible phrase that perpetuated the "amalgamation": "Not much later, the existence of the giant human slaughterhouses Auschwitz, Chelmno, Belzec, Sobibor, Treblinka, and Lublin-Majdanek was in turn contested."[55]

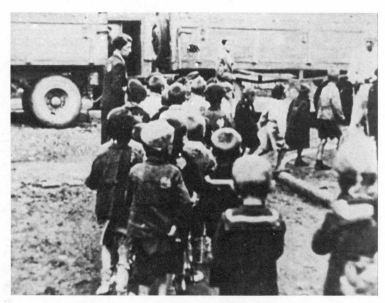

FIGURE 20. Children of Lodz. Screen shot. Reprinted by permission of Argos Films.

Olga Wormser would never fully recover from the affair that, in spite of occasional appeasement, would not stop rebounding. Her self-depreciation would inspire effacement, and the clouds never would disappear. The historian confessed: "I can never feel at ease when I meet some of my former opponents. I surely would not have reacted as strongly if I hadn't had the feeling of carrying inside me all the victims and never having betrayed them."

In the final pages of her memoirs initially entitled *Kantse, Kantsov* ("At the End of Ends" in Russian) this woman of goodwill, still upset in the twilight of her life, consoles herself by evoking her "tribe" and unrolling before her the red carpet of generations: "Here I am, blessed with five children (or equivalent), four grandchildren, and a dozen or so nieces and nephews. I feel like a grandmother down to my soul when I relive the days of Frédéric's childhood—yesterday. At the end of all ends, I have achieved something after all."

However, the absorbing presence of those grandchildren soon awoke memories of those who were not given the chance to grow up and, always, the pride in the film to which she clung desperately, like the shipwrecked to her buoy:

> What haunts my soul, through the visions of all my loved ones, is the image of a child of two or three, during the Korean War (I don't know if he was from the North or the South) screaming in pain and raising his fist in a devastated world. This is also the image we included in *Night and Fog,* of little schoolchildren neatly walking toward the gas chamber,[56] that group of children who would never grow up.

Kantse, Kantsov, at the end of ends, Olga had accomplished something.

NOTES

FOREWORD

1. She continued this approach with *Univers concentrationnaire et géno-cide. Voir, savoir, comprendre,* together with Anne Wieviorka (Paris: Fayard / Mille et Une Nuits, 2008) and *La Voie des images: Quatre histoires de tournage au printemps-été 1944* (Lagrasse: Verdier, 2013).

2. Jean-Louis Schefer, *L'Homme ordinaire du cinéma* (Paris: Cahiers du cinéma, 1980).

3. Serge Daney, "Le Travelling de Kapo," in *Trafic,* no. 4, Autumn 1992, reprinted in *Persévérance* (Paris: POL, 1994). Jacques Rivette, "De l'abjection," in *Cahiers du cinéma,* no. 120, June 1960. For the strategic dimension in terms of a conception of cinema articulated, explicitly or otherwise, around the extermination camps, see my text "Intersecting Paths," in *Cinema and the Shoah: An Art Confronts the Tragedy of the Twentieth Century,* ed. Jean-Michel Frodon (New York: SUNY Press, 2010).

4. The censor demanded the removal of all elements that allowed the viewer to identify a guard's uniform at a transit camp for deportation as belonging to the French military. The sizable role played by French law enforcement personnel under the German occupation, and notably in the mass deportations, was not a topic of public conversation at the time. Relaunched in the 1970s and continuing until the forbidden image was restored in its original form in the film forty years later (!), the "kepi affair" was hardly an innocuous one: its notoriety became such that it obscured other issues.

INTRODUCTION

1. Alain Fleischer, *Les angles morts* (Paris: Seuil, 2003), 378.

2. Ibid., 379.

3. Ibid., 378.

4. See Marie-José Mondzain, *L'image naturelle* (Paris: Le Nouveau Commerce, 1995) and *Le commerce des regards* (Paris: Seuil, 2003).

5. In Annette Wieviorka's powerful words.

6. "Could Auschwitz leave a memory of what happened there anywhere but in a film?" wrote Alain Fleischer in *Les angles morts*, 379.

7. *Lettres françaises*, April 12, 1956.

8. Ruth Klüger, *Weiter leben* (Göttingen: Wallstein Verlag, 1992). In her original German text, the author uses the word *Zeitschaft*, translated as "timescape" by the French translator: *Refus de témoigner: Une jeunesse* (Paris: Éditions Viviane Hamy, 1997), 87. (French translation by Jeanne Étoré.)

9. See Daniel Arasse, *Le détail: Pour une histoire rapprochée de la peinture* (Paris: Flammarion, 1996), 206–7 and *Histoires de peinture* (Paris: Denoël, 2004), 21, 194.

10. To use and continue Serge Daney's reflection, itself inspired by Jean-Louis Scheffer, see chapter 16.

11. On the "black box" method borrowed from Bruno Latour and on the notion of "palimpsest film," see S. Lindeperg, *Les écrans de l'ombre: La Seconde Guerre dans le cinéma français (1944–1969)* (Paris: CNRS Éditions, 1997).

12. Jacques Revel, "Microanalyse et construction du social" (particularly regarding the works of Carlo Ginzburg and Giovanni Levi), in *Jeux des échelles: La mircoanalyse à l'expérience*, ed. J. Revel (Paris: Hautes Études, Gallimard/Seuil, 1996), 19.

13. Walter Benjamin, "Un marginal sort de l'ombre: À propos des *Employés* de S. Kracauer," *Oeuvres II* (Paris: Gallimard, 2000), 188.

14. I refer here to Siegfried Kracauer's famous analysis of the passage from *In Search of Lost Time* in which the narrator, during an improvised visit, finds his grandmother with an odd expression that he assimilates with a photograph: "Marcel has hardly entered his grandmother's room or her spirit becomes a palimpsest, where the stranger's observations superimpose themselves over the momentarily erased traces retained by the loved one," in Siegfried Kracauer, *L'histoire: Des avant-dernières choses* (Paris: Stock, 2005), 144.

15. Pierre Nora referring to the stone tablets in "Entre Mémoire et Histoire," in *Les lieux de mémoire: I. La République*, ed. Pierre Nora (Paris: Gallimard, 1984), xl.

16. Jacques Revel adopts and develops this analogy (which ends the text "Microanalyse et construction du social," 36) in "Un exercice de désorientation: *Blow Up*" in *De l'histoire au cinéma*, eds. Antoine de Baecque and Christian Delage (Brussels, Éditions Complexe, 1998).

17. Ibid., 103.

18. Walter Benjamin, *Paris, capitale du XIXe siècle: Le livre des passages* (Paris: Éditions du Cerf, 2000), 477.

19. Michel de Certeau, *L'Écriture de l'histoire* (Paris: Gallimard, 1975), chapter 2.

20. A portrait written thanks to her private archives, access to which I received from her son, Frédéric Wormser. I am deeply grateful to him, as well as to Olga's daughter-in-law Jenny Ecoiffier.

21. Sabina Loriga, "La biographie comme problème," in *Jeux d'échelles*, ed. Revel, 228.

PROLOGUE

1. Olga Wormser-Migot wrote multiple unpublished drafts of her memoirs. For the section pertaining to the period of 1940 through 1945, she uses the diary she regularly kept at the time. Her son, Frédéric Wormser, entrusted me with these documents as well as giving me access to his mother's complete archives. All unreferenced quotes in the remainder of the text are culled from Olga Wormser-Migot's memoirs.

2. Léon Poliakov, *L'Auberge des musiciens* (Paris: Mazarine, 1980), 15.

3. Who would later hold a minister's post in the Vichy government.

4. Renamed rue du Père Corentin after the liberation, in honor of the Dominican friar and resistance figure assassinated by the Milice.

5. *Le Retour des déportés: Quand les Alliés ouvrirent les portes* (Brussels: Éditions Complexe, 1985), 42.

6. Ibid., 13.

7. Mouvement National des Prisonniers de Guerre et des Déportés.

8. Within the MNPGD, at Edgar Morin's initiative, preparations for this exhibition were handed in the autumn of 1944 to Marguerite Duras and Dionys Mascolo. "The minister of Justice had sent over several bureaucrats as delegates, who quickly soured the ambiance.... Certain politicians at the time felt it better not to talk about this because it could have consequences for those still in the camps.... After a series of Homeric confrontations, Marguerite stepped back. However, all the documents on the concentration camps that the Americans had lent them to prepare for the exhibit were engraved in her memory." Laure Adler, *Marguerite Duras* (Paris: Gallimard, 1998), 236.

9. Marguerite Duras, *La Douleur* (Paris: POL, 1992), 41–42.

10. Extract from Olga Wormser's diary, partially cited in *Quand les Alliés ouvrirent les portes* (165), without the mention of "revolutionary days."

11. Ibid., 137.

12. Ibid., 140.

13. Élisabeth Bidault, sister of Georges Bidault, used the name Agnès in the resistance. Denise Mantoux was known as Dorine. Yanka Zlatin's official given name was Sabine. For more on Operation Lutetia, see Sabine Zlatin, *Mémoires de la dame d'Izieu,* foreword by François Mitterrand (Paris: Gallimard, 1992), 62–65.

14. Fanny Vergen, *France d'abord,* August 28, 1946, no. 165.

15. Annette Wieviorka, *Déportation et génocide: Entre la mémoire et l'oubli* (Paris: Plon, 1992), 431.

16. Olga Wormser-Migot, *Le Système concentrationnaire nazi (1933–1945)* (Paris: PUF, 1968), 7.

17. *Ravensbrück,* Les Cahiers du Rhône, no. 20, Neuchâtel, Éditions de La Baconnière, December 1946. All contributors to this volume were resistance deportees, and nearly half of its pages are taken up by a long text by Germaine Tillion. See also Wieviorka, *Déportation et génocide,* 457.

18. This committee had only just been established by an October 7, 1945, decree when the dissolution of the Ministry for Prisoners, Deportees, and

Refugees resulted in its being subsumed into the Ministry for Combat Veterans. See Wieviorka, *Déportation et génocide,* 424–25.

19. Archives Nationales (AN), archives of the Comité d'Histoire de la Deuxième Guerre Mondiale, 72AJ310.

20. Wormser-Migot, *Le Système concentrationnaire nazi,* 7.

21. It would take until 1991 for another dissertation on the same subject, by Anne Grynberg.

22. Biologist, resistance member, and former deportee, member of the central committee of the French Communist Party (PCF).

23. See chapter 1.

24. See chapter 1.

25. As written to Prof. Waitz, copy of an undated letter, Réseau archives (AN 72AJ2158).

26. Including such former deportees as Mr. Brunschwig, inspector general at the Ministry of the Interior.

27. At Henri Michel's invitation. For more on the Comité d'Histoire's efforts regarding the resistance, see Laurent Douzou, *La Résistance française: Une histoire périlleuse* (Paris: Seuil, collection Points Histoire, 2005).

28. Archives of the CHDGM, subcommittee on the deportation (AN 72AJ679). This inaugural session, chaired by Lucien Febvre, took place at Annette Lazard's house before finding a home at the Bibliothèque Nationale.

29. Ibid.

30. Undertaken in conjunction with the research for statistical data. Olga Wormser participated alongside Mrs. Aylé, Mr. Lacombe, and Mrs. Granet. The latter had spent four years interviewing former resistance fighters for the CHDGM.

31. Meeting of October 31, 1951 (AN 72AJ679).

32. Documentation on the Nuremberg trials joined the French SS administrative archive in the archives of the Commissariat Général aux Questions Juives gathered after the liberation by Poliakov.

33. See Annette Wieviorka's article "Du Centre de documentation juive contemporaine au Mémorial de la Shoah," in "Génocides: Lieux (et non-lieux) de mémoire," *Revue d'histoire de la Shoah,* no. 181, July–December 2004, Éditions CDJC, 11–36.

34. A publication whose existence the members of the subcommittee appeared to be unfamiliar with. In fact, at the meeting of October 31, 1951, Julien Cain inquired about the existence of any works on the internment camps; "None to my knowledge," replied Henri Michel.

35. Poliakov, *L'auberge des musiciens,* 177.

36. Léon Poliakov, *Bréviaire de la haine: Le IIIe Reich et les Juifs* (Paris: Calmann-Lévy, 1951; reprinted Brussels: Éditions Complexe, 1986).

37. Wieviorka, "Du centre de documentation juive contemporaine au Mémorial de la Shoah."

38. As Henri Michel explained in his foreword: "For this issue on the Condition of the Jews, we consulted the researchers and archives of the

Centre de Documentation Juive Contemporaine, France's largest archive on the subject. Its previous publications were a major source of information for the present collection of articles and reports." *Revue d'histoire de la Deuxième Guerre mondiale*, no. 24, October 1956. This issue notably included articles by E. Vermeil, "L'antisémitisme dans l'idéologie nazie," J. Billig's "La condition des Juifs en France," M. Borwicz's "Les 'solutions finales' à la lumière d'Auschwitz-Birkenau," and L. Poliakov's "Quel est le nombre des victimes?" As a token of mutual recognition, Léon Poliakov published at the same time in *Le Monde juif* an article entitled "Une grande institution française: Le Comité d'histoire de la Deuxième Guerre mondiale" (*Le Monde juif*, April 1956, cited in Douzou, *La Résistance française: Une histoire périlleuse*, 302).

39. Réseau du Souvenir (AN 72AJ2158).

40. See Renée Poznanski, "L'historiographie de Vichy," in Jean-Pierre Azéma and François Bédarida, *Vichy et les Français* (Paris: Fayard, 1992), 59.

41. Ibid.

42. In Pierre Laborie's well-chosen words, "Histoire et résistance: Des historiens trouble-mémoire," in *Écrire l'histoire du temps présent: En hommage à François Bédarida* (Paris: CNRS Éditions, 1993), 140–41. For a very subtle approach to these questions, see also Pierre Laborie, *Les Français des années troubles: De la guerre d'Espagne à la Libération* (Paris: Desclée de Brower, 2001; reprinted Seuil, 2003).

43. Meeting of February 4, 1974 (AN 72AJ679). This statistics affair is examined in detail in Wieviorka, *Déportation et génocide*, 429.

44. Wieviorka, *Déportation et génocide*, 429.

45. Meeting of June 20, 1951 (AN 72AJ679).

46. Meeting of March 5, 1952 (AN 72AJ679).

47. Ibid.

48. Ibid.

49. Olga Wormser, Henri Michel (texts selected and presented by), *Tragédie de la déportation, 1940–1945: Témoignage des survivants des camps de concentration allemands* (Paris: Hachette, 1954); *Revue d'histoire de la Deuxième Guerre mondiale*, no. 15–16, July–September 1954.

50. Particularly on the subject of the evolution of the concentration camps toward a function of extermination during the last months of the war, consecutive to the "liberation" of the camps in the east.

51. The first issue contained schematic presentations of future endeavors, the second contained summaries of previously published works.

52. Subcommittee on the history of the deportation, meeting of January 13, 1962 (AN 72AJ679).

53. General board meeting of December 19, 1953, Réseau du Souvenir (AN 72AJ2147).

54. *Tragédie de la déportation*, 9–10.

55. Report by Robert d'Harcourt, in *La Revue de Paris*, October 1954.

56. The Association des Déportées et Internées de la Résistance (ADIR) united female former resistance members; the Fédération Nationale des Déportés et Internés Résistants et Patriotes (FNDIRP) formed part of the

communist movement; the Union Nationale des Associations de Déportés, Internés et Familles de disparus (UNADIF) represented the Third Force.

57. Letter by Paul Arrighi to Mrs. Delmas, president of ADIR, January 18, 1954, Réseau archives (AN 72AJ2159).

58. The volume originally translated and published in France in 1946 is today criticized for containing numerous errors. Vasily Grossman is better known for his literary work, notably *Life and Fate*.

59. The captions with the illustrations are also enlightening. The chapter on the arrival at the camps contains a drawing of baby carriages, captioned with an extract from Odette Elina's *Sans fleurs ni couronnes*, which mentions prams "still warm from the babies that had occupied them and who had just been incinerated" (63).

60. Wormser-Migot, *Le Système concentrationnaire nazi*, 10.

61. Ibid., 9.

62. Meeting of the subcommittee on the history of the deportation, January 26, 1967 (AN 72AJ679).

63. See chapter 1.

1. THE "INVISIBLE AUTHORITY"

1. To use Lucie Varga's expression, see Peter Schöttler and Lucie Varga, *Les autorités invisibles: Une historienne autrichienne aux Annales dans les années trente* (Paris: Editions du Cerf, 1991).

2. See Henry Rousso, *Le syndrome de Vichy, 1944–1948* (Paris: Seuil, 1987), 256–57 and 262–63; Douzou, *La Résistance française*, chapter 2.

3. The first four issues appeared under the name *Les cahiers d'histoire de la guerre*.

4. Henri Michel published the first *Que sais-je* in 1950, dealing with the occupation years and entirely devoted to the history of the French resistance. His dissertation on "Resistance philosophies" was published by PUF in 1962 as part of the collection *L'esprit de la Résistance*, which was under the editorial direction of Michel and Boris Mirkine-Guetzevitch; cf. Rousso, *Le Syndrome de Vichy*, 262.

5. Olivier Lalieu, "Le Devoir de mémoire" in *Vingtième siècle*, "D'un siècle à l'autre," no. 69, January–March 2001, 86. Lalieu researched his dissertation on deportee associations and the Cold War within the Réseau du Souvenir.

6. General Pierre Saint-Macary, "Historique du Réseau," Réseau du Souvenir archives (AN 72AJ2141–2170).

7. Not being a deportee himself, H. Michel joined the Réseau in his guise as a historian specializing in the resistance, in which he himself participated, including as "member of the Comité Départemental de Libération du Var" (see Douzou, *La résistance française*, 69).

8. Resistance fighter Gilbert Dreyfus was imprisoned at Mauthausen, Father Riquet at Mauthausen and Dachau. Mrs. Aylé was part of the Comet

Line network (as was her husband, Robert Aylé, executed by firing squad in March 1943) and was deported to Ravensbrück. Journalist Rémy Roure was a member of Combat; he was deported to Buchenwald, and his son and wife died in the deportation. See *Allemagne, avril-mai 1945 (Buchenwald, Leipzig, Dachau, Itter): Photographies d'Erich Schwab. Documents des archives nationales* (Éditions Centre Historique des Archives nationales, 2003).

9. Historian Julien Cain, former adviser for cultural matters to Léon Blum, ran the Bibliothèque Nationale from 1930 through 1940, the year the Vichy government removed him from his post through its anti-Jewish legislation. As a member of the resistance network of the Musée de l'Homme, he was arrested in February 1941 and arrived in Buchenwald in July 1944. After the liberation, he returned to his post at the Bibliothèque Nationale, where Resnais would shoot *Toute la mémoire du monde* in 1956. Louis Martin-Chauffier was one of the founders of the Comité National des Écrivains. He was arrested in May 1944, deported to Neuengamme and subsequently to Bergen-Belsen, an experience he would describe in *L'Homme et la Bête* (Paris: Gallimard, 1948).

10. Serge Barcellini and Annette Wieviorka, *Passant souviens-toi! Les lieux du souvenir de la Seconde Guerre mondiale en France* (Paris: Plon, 1995), 413. The authors of this pioneering book were among the first to emphasize the existence and unique role of the Réseau du Souvenir.

11. This former resistance fighter, deported to Mauthausen, succeeded Paul Arrighi and Father Riquet as president. He was in charge of dissolving the association in 1993 (its assets were transferred to the newly created Fondation de la Résistance).

12. Interview with the author on February 9, 2004.

13. Typescript of January 30, 1954, Réseau archives (AN 72AJ2160).

14. During the general assembly of the year 1954, Arrighi estimated the number of members to be between 1,160 and 1,170.

15. Four subcommittees were installed: the historical committee (led by Julien Cain, Henri Michel, Germaine Tillion, and Olga Wormser); the artistic committee (led by Jean Cassou); the religious committee (Edmond Michelet, Father Riquet, Pastor Westphal, and Rabbi Bauer); the "press and propaganda" committee, led by Annette Lazard. See Saint-Macary, "Historique du Réseau."

16. Document of January 30, 1954.

17. Law of April 14, 1954, "devoting the last Sunday of April to the memory of victims of the deportation and those who died in the concentration camps of the Third Reich during the war of 1939–1945."

18. The future memorial on the Île de la Cité, inaugurated in 1962. Note that this vote took place the year after the first stone was laid for the "Tomb of the unknown Jewish martyr" on a plot offered by the city of Paris.

19. Invitation card dated April 17, 1951 (AN 72AJ2158).

20. See Wieviorka, *Déportation et génocide*, 425.

21. Typed minutes of the February 5, 1955 meeting (AN 72AJ2147).

22. A report by H. Michel states a figure of sixty thousand visitors, including thirty thousand schoolchildren. Archives of the Comité d'Histoire de la Deuxième Guerre Mondiale (AN 72AJ695).

23. Olga Wormser is credited in the exhibit catalogue alongside Henri Michel and Odette Routis. However, her name does not figure among the list of twenty-nine members (all male) of the organizing committee.

24. Sound archive reproduced the remarkable radio broadcast "*Nuit et Brouillard,* film d'Alain Resnais: 1954–1994," created by André Heinrich and Nicole Vuillaume and broadcast by France Culture in 1994 (it is included in the French DVD edition of *Night and Fog,* Argos Films/Arte Video, 2003). This program, which forms a rich source of information and interviews, will be referenced hereafter as broadcast France Culture.

25. Feature films: *Au coeur de l'orage* (J.-P. le Chanois); *La Bataille de l'eau lourde* (J. Dréville); *La Bataille du rail* aka *The Battle of the Rails* (R. Clément); *The Last Stop* (W. Jakubowska); *Odette* (H. Wilcox); *Le Père tranquille* aka *Mr. Orchid* (Noël-Noël; R. Clément); *Rome, Open City* (R. Rossellini); *Un ami viendra ce soir* aka *A Friend Will Come Tonight* (R. Bernard); *Un giorno nella vita* (A. Blasetti). Short films: *Les Camps de la mort/The Death Camps; De la nuit à la lumière; Ils étaient tous des volontaires; La Libération de Paris; La Loi du talion; Port artificiel d' Arromanches; La Prise de Strasbourg; La Rose et le réséda.* List drawn up by Claudine Drame in her doctoral dissertation in contemporary history, "Les Représentations de la Shoah au cinéma en France, 1945–1985" (supervisor: Pierre Nora) (Paris: EHESS, 2001), 143.

26. This montage documentary consisted of juxtaposed sequences of the liberation of different western camps, narrated in the style of newsreels of the period. See Sylvie Lindeperg, *Clio de 5 à 7: Les actualités filmées de la Libération: Archives du futur* (Paris: CNRS Éditions, 2000), and Claudine Drame, "Représenter l'irreprésentable: Les camps nazis dans les actualités françaises de 1945," *Cinémathèque,* no. 10, Autumn 1996. The original list drawn up by H. Michel (in a document to prepare for the exhibit) also included *Distant Journey* (*Dalekà cesta,* 1946) by Czech filmmaker Alfred Radok, plus several compilations and sequences recorded by the Allies during the liberation of the camps (AN 72AJ695).

27. This project, undertaken with the active support of the Réseau, never saw the light of day in Paris in accordance with his initial wish, but it would lead to the construction of the museum in Besançon.

28. Archives of the Comité d'Histoire, note of September 1958 (AN 72AJ310).

29. "Thèse complémentaire: Essai sur les sources de l'histoire concentrationnaire nazie," typescript, 1968, 343–44.

30. Olga Wormser-Migot's memoirs.

2. THE "MERCHANTS OF SHADOWS"

The quotation in the chapter title refers to J. Durand's description of the producers, quoted in René Bonnel, *Le Cinéma exploité* (Paris: Seuil, 1978),

163. I thank Frédérique Berthet and François Porcile for their attentive proofreading of this chapter.

1. Letter dated December 15, 1954, archives of Argos Films stored at the Institut Lumière in Lyon (my gratitude goes to Florence Dauman, Thierry Frémaux, and Nicolas Riedel). All references below originating from this fund (five archive boxes on *Night and Fog*) will be mentioned as: Institut Lumière.

2. The expression "Résistance et Déportation" formed the subtitle to the anthology *Esprit de la Résistance* edited by Henri Michel.

3. I refer here to Frédérique Berthet's very well-documented doctoral dissertation in film studies, "Anatole Dauman, un producteur dans le cinéma français (1950–1998): Contribution à une histoire économique du culturel" (Université Paris III, 2001), in which the author reveals that Philippe Lifchitz was the sole signatory of the original document registering the company's statutes. Still, the increasing presence of Anatole Dauman in the management of Argos, which ran parallel with an increase of his financial share in the company, contributed to erasing the name Philippe Lifchitz (who sold his stake in 1970) from the annals of film history.

4. See Berthet, "Anatole Dauman," 82.

5. Minutes of the production meeting of March 1, 1955, Institut Lumière.

6. Conceived and commissioned by Gaston Diehl and Robert Hessens.

7. In the words of Alain Resnais in *Ciné-Club*, no. 3, December 1948.

8. See Alain Fleischer, *L'Art d'Alain Resnais* (Paris: Éditions du Centre Georges Pompidou, 1998), 23.

9. See chapter 9.

10. In an interview with Richard Raskin, Resnais said: "I wasn't particularly attractive from a commercial viewpoint. I'm trying to say that producers didn't—how shall I put this?—not that they didn't trust me, not that, but they said: 'Look, Resnais, fine. Yes, he's made films about painters, but there's always trouble with him . . . so he was brave to ask me to work with him.'" Richard Raskin, *"Nuit et brouillard" by Alain Resnais: On the Making, Reception and Functions of a Major Documentary Film* (Aarhus: Aarhus University Press, 1987, 48).

11. The risk was all the greater for the turmoil in the state funding of short film production. In December 1954, at the same moment Argos agreed to join the project, the selection committee for the *prime à la qualité* suspended its activities and would not recommence until March 1955. See François Porcile, *Défense du court-métrage français* (Paris: Éditions du Cerf, collection 7e Art, 1965).

12. Letter dated June 20, 1955, from Dauman to the president of Zbowid, the National Federation of Polish Deportees (see above), Institut Lumière.

13. For more information on Alain Resnais's life and works, see in particular: Gaston Bonoure, *Alain Resnais* (Paris: Seghers, 1962); Robert Benayoun, *Alain Resnais arpenteur de l'imaginaire: De Hiroshima à Mélo* (Paris: Stock, 1980); Suzanne Liandrat-Guigues and Jean-Louis Leutrat, *Alain*

Resnais: Liaisons secrètes, accords vagabonds (Paris: Éditions de l'Étoile/Cahiers du cinéma, 2006); René Prédal, *Alain Resnais* (Paris: Lettres Modernes, collection Études Cinématographiques, nos. 64–68, 1968) and *L'Itinéraire d'Alain Resnais* (Lettres Modernes, collection Études Cinématographiques, nos. 211–22, 1996); Jean-Daniel Roob, *Alain Resnais. Qui êtes-vous?* (Paris: La Manufacture, 1986). On the visit to Heidegger, see Laure Adler, *Dans les pas de Hannah Arendt* (Paris: Gallimard, 2005); Frédéric de Towarnicki, *À la rencontre de Heidegger: Souvenirs d'un messager de la Fôret-Noire* (Paris: Gallimard, 1993) and *Martin Heidegger: Souvenirs et chroniques* (Paris: Payot-Rivages, 1999), as well as his interview with André Heinrich in broadcast France Culture.

14. Towarnicki, *À la rencontre de Heidegger*, 73.

15. In Alain Resnais's words during his interview with Richard Raskin, *"Nuit et brouillard" by Alain Resnais*, 48.

16. In Roger Vrigny's program *Entretiens avec: Jean Cayrol*, France Culture, June 19, 1970, interview transcribed by Marie-Laure Basuyaux in "Écrire après. Les récits 'lazaréens' de Jean Cayrol," doctoral dissertation in comparative and French literature (supervisor: Michel Murat), Université Paris IV, 2005, vol. 2, 805.

17. Minutes of the meeting of July 18, 1955, Institut Lumière.

18. F. Berthet notes that this partnership was dissolved after the production of *Hiroshima Mon Amour*, when the two companies entered litigation in 1960, "Anatole Dauman," 229.

19. CNC public register.

20. Comptoir Cinématographique du Nord.

21. The remaining 80 percent came from Argos (55 percent) and Como (45 percent).

22. As Madeleine Morgenstern, daughter of the founder of Cocinor, points out, in the 1950s it was not uncommon to ask distributors to "help finance a project" through prebuying the distribution rights. In this manner they effectively became coproducers of the films they committed to distributing. Telephone interview of January 14, 2004, with Madeleine Morgenstern. For more details on these issues of financing, see Bonnel, *Le Cinéma exploité*, 190 ff.

23. See notes 45 and 53.

24. Minutes of general assembly of February 5, 1955, 16 (AN 72AJ2147).

25. A relative of Julien Cain.

26. Member of the Réseau's sponsor committee. Letter by Henri Michel to Annette Lazard dated June 11, 1955; copy of Annette Lazard's letter to Raymond Triboulet dated June 13, 1955 (AN 72AJ2160).

27. Copy of Henri Michel's letter to the minister for combat veterans head of staff, June 9, 1955 (AN72AJ2160).

28. Letter dated June 23, 1955. Institut Lumière.

29. Moscovitch represented the committee for combat veterans and victims of war at the municipal council. Fevre occupied the same position at the Conseil Général. See the official municipal *Bulletin* of the city of

Paris, July 22, 1955, and the *Bulletin* of the Conseil Général de la Seine, July 25, 1955.

30. Since the decision of March 21, 1955, the production of short films depended on authorization from the director of the CNC. A request had to be submitted at least two weeks before the start of production and had to contain a scenario/shooting script (or treatment), a detailed estimate, the final financial planning, and any coproduction contracts. Cf. Porcile, *Défense du court-métrage français*, 34–35.

31. Letter from Dauman to Henryk Matysiak, president of Zbowid, June 20, 1955. Institut Lumière.

32. Its French subsidiary mainly served to promote Polish cinema in France, to encourage and help film shooting in Poland. It also possessed a sizable film archive.

33. Jan Korngold, an industrious figure in French-Polish relations in the field of cinema, notably represented Poland at the first edition of the Cannes Festival in 1946.

34. Celebrated in April, like the liberation of the western camps, and not, as today, on its "actual" date of January 27.

35. Union of Combatants for Freedom and Democracy.

36. B. Mark was the first to publish the "Auschwitz Scrolls." A letter from the Warsaw Institute (dated July 21, 1955) announced to Argos that following a meeting with Olga Wormser, the decision was made to allow the production access to the Jewish Historical Institute's photography archives.

37. Zbowid agreed to cover the film crew's travel and accommodation expenses. It suggested to Lifchitz to include this post in his budget for the first semester of 1956. Letter from Henryk Matysiak to Argos, July 25, 1955. Institut Lumière.

38. Copy of Lifchitz's letter to Zbowid, August 2, 1955. Institut Lumière. One of the main locations in Austria was the Mauthausen camp.

39. Second assistant director was Jean-Charles Lauthe. The role of Chris Marker, also credited as assistant director, would not be limited to this function, as we will see.

40. An unusual procedure for which the director had received signatory rights from Argos.

41. Contract dated September 26 with appendix, Institut Lumière. Film Polski received these rights for a term of seven years starting from delivery of the film print.

42. Institut Lumière.

43. An additional subsidy based on the artistic merit of a production. (—Trans.)

44. I thank François Porcile for this information.

45. When prompted about this issue, François Porcile offered a comparison with his first documentary, *La Saison prochaine*, shot ten years later in color with a crew of comparable size and two weeks of exterior shooting: the film "cost six million. It runs twenty minutes, Resnais's film thirty-two.

So if we add one third, you would arrive at a budget of nine million old francs (not counting inflation)."

46. In a letter to E. Muszka dated November 30, 1955, Anatole Dauman writes: "For the film to be released, the French authorities require an overview of expenses in Poland. Only your organization, which authorized them, is capable of drawing up such a document. We hope that you have already proceeded to accounting this for your own purposes. We need at all costs to receive this document during the month of December." The postscript is particularly worthy of note: "It goes without saying that the accounting of expenses incurred in Poland, which represent the price of the film's rights for Eastern Europe, must be certified as exact by your official organization. . . . The French services, on which we depend and whom we have consulted, have no objection if the total amount were to pass 250,000 zlotys to reach a sum equal to 400,000 zlotys." Institut Lumière.

47. 21,709,327 old francs.

48. Institut Lumière. The provisional estimate was 5,777,000 old francs. The overview of expenses amounted to 10,034,034 old francs.

49. François Thomas, *L'Atelier d'Alain Resnais* (Paris: Flammarion, 1989), 245.

50. Broadcast France Culture.

51. Calculations were made as follows: additional expense of 475,000 for Eastmancolor stock and 888,000 for additional cost of making prints (report of the meeting of August 31, 1955. Institut Lumière). This estimate was not final: further expenses came from making internegatives sent to Poland following the September agreement. In the summary of expenses, film stock and lab cost finally totaled 3,117,695, or an additional cost of 2,415,695 old francs.

52. Words relayed by Olga Wormser at the production meeting of March 1, 1955.

53. This formed a sizable budget for the time and corresponded to a large-scale documentary production. As a point of comparison, Henri Fabiani's film *La Grande Pêche*, which took two months of shooting, cost roughly 6 million, and Georges Franju's *La Première Nuit* (1958), an Argos production, came to 8 million. This does not make *Night and Fog* exorbitant, though, since the budget of the most expensive production from the golden age of French short film, Robert Enrico's *An Occurrence at Owl Creek Bridge* (1961), totaled 25 million old francs.

54. For more on the *prime à la qualité*, see Porcile, *Défense du court-métrage français*, and Roger Odin, ed., *L'Âge d'or du documentaire. Europe: Années cinquante*, vol. 1 (Paris: L'Harmattan, 1998).

55. See, in a literary context, Alain Viala's analyses in *Naissance de l'écrivain: Sociologie de la littérature à l'âge classique* (Paris: Éditions de Minuit, 1985), 217.

3. A JOURNEY TO THE EAST

1. Alain Resnais interview in Raskin, *"Nuit et brouillard" by Alain Resnais*, 49.

2. Letter of commitment, dated May 24, 1955. Institut Lumière.

3. The preparatory documents for the exhibition and the catalogues are kept at the Archives Nationales (72AJ695).

4. The same tone of Catholic piety can be found in the table of contents of *Tragédie de la Déportation* and in the foreword by the two historians, in which they use terms such as "passion" and the "Stations of the Cross which the deportees struggled along." This vision of the camps fits in entirely with the discourse on the camps created in the immediate postwar period (on newsreel footage, see Lindeperg, *Clio de 5 à 7*, 169–71). *L'Information* (November 1, 1954, quoted in *Bulletin* 29 of the CHDGM) presented the exhibition as "The photographic and topographic reconstruction of the voyage of a deportee from the jails of France to the mass graves and the gas chambers."

5. See Laurent Gervereau, "Un parcours: Entretien avec Boris Taslitsky," in *La Déportation: Le système concentrationnaire*, eds. François Bédarida and Laurent Gervereau (Nanterre: BDIC, 1995), 262–65.

6. Vanessa Schwartz retraces its genealogy and manifestations (particularly regarding the Musée Grévin and visits to the morgue) in *Spectacular Realities: Early Mass Culture in "Fin-de-siècle Paris"* (Berkeley and Los Angeles: University of California Press, 1998).

7. Explanatory leaflet of the exhibit, archives of the Comité d'Histoire de la Deuxième Guerre Mondiale (AN 72AJ695).

8. *Monde ouvrier*, January 8–14, 1955.

9. In the detailed synopsis they wrote in March and April 1955, Olga Wormser and Henri Michel suggested reusing—in a strange patchwork including photographs, maps, statistics, diagrams, objects, and drawings—the various sources they offered to visitors of the exhibition. In particular, they wanted to include toiletries and tools, plus the following documents: illicit pamphlets, posters, drawings, and even Goyard's diorama of Buchenwald. See chapter 4.

10. See chapter 4.

11. As mentioned in the first synopsis of the film written by the two historians in February (see chapter 4).

12. On the other hand, the insertion of a map of the camps and *kommandos* of Germany and Poland formed part of the plans until a late stage. It was intended for use in the section on labor, superimposed over a map of the Reich's industrial regions. In fact, among the rushes of unused material there exists a shot of this map originally created by Olga Wormser and Henri Michel for *Tragédie de la Déportation*. These reels of rushes, kept at the IHTP, consist of material cut during the successive stages of *Night and Fog*'s editing process, pasted back-to-back: trimmings; archive footage both used and, the majority, unused in the final edit; test shots of certain documents and photographs. Henry Rousso pointed out the existence of these reels and also offered me a first viewing before copying everything onto VHS. I am grateful for his help. In *Bulletin* 46 of the CHDGM (September 1956), Olga Wormser draws up an inventory of outtakes, also indicating their origins.

She emphasizes that Resnais entrusted these reels with the CHDGM "with the producers' permission."

13. "But a human being is incredibly resilient: the body is worn down by fatigue, yet the mind works, the hands covered in bandages work. They make spoons, puppets they conceal, monsters, boxes."

14. For more precise references, the notes will mention the number corresponding to the shot sequences in Richard Raskin's *"Nuit et brouillard" by Alain Resnais* (regarding his shot count, see chapter 6, note 10). For example, the photo of the oak at Buchenwald corresponds to shot 137.

15. Established in France to track down Belgian victims of the Nazis.

16. Shot 40. On the history of this photograph, see Serge Klarsfeld's investigation in *Vichy-Auschwitz: Le rôle de Vichy dans la Solution Finale de la question juive en France: 1942* (Paris: Fayard, 1983). On the consequences of its discovery and the reflections it can inspire on the uses of photography, see Lindeperg, "Itinéraires: Le cinéma et la photographie à l'épreuve de l'histoire," *CiNéMAS* 14, no. 2–3, Montreal, March 2005, 191–211. Resnais and his crew could not have known the actual subject of the photograph, as evidenced by Argos Films' detailed shot sequence, which includes all shots from *Night and Fog* numbered, timed, described, and captioned. For the photograph of the Vél' d'Hiv, it adopts all the information communicated by the CDJC. This shot sequence forms a precious document in understanding the film crew's efforts in the field of documents and archives: with each shot are indicated the site of consultation, the classification mark (in this case of the CDJC), and the caption containing the information relayed to the crew by the archive. This shot sequence was published by Richard Raskin, who accompanied each shot with the corresponding passage of Cayrol's commentary (*"Nuit et brouillard" by Alain Resnais*). Since this book does contain a few minimal errors in the transcription of handwritten annotations, I relied on a photocopy of the original document I received from Florence Dauman, whom I hereby thank.

17. See chapter 9.

18. The fiction films included Wanda Jakubowska's *The Last Stop*, Aleksander Ford's *Border Street*, and Alfred Radok's *Distant Journey*. The documentaries included *The Death Camps, Nazi Concentration Camps*, and Yannick Bellon's *Varsovie quand même* (1954). Argos's request to Gaumont also mentions compilation films on the Ravensbrück and Buchenwald trials.

19. The production archives include some consulted shots. The visit to the SCA was planned for June 13, 1955.

20. After Argos had contacted the British Army Services located on the avenue Hoche in Paris.

21. "Le siècle du cinéma," special issue of *Cahiers du cinéma*, November 2000, interview with Alain Resnais by Antoine de Baecque and Claire Vassé, 74.

22. Raskin, *"Nuit et brouillard" by Alain Resnais*, 53.

23. According to Pierre Villon, this concerned the application of the cultural agreement between France and Germany, signed concurrently with the Paris agreements.

24. Session of July 23, 1955, *Journal Officiel,* July 24, 1955, 4148–49. The affair was also echoed in the *Bulletin* "Service d'Information," no. 49 of the Fédération Internationale des Résistants (FIR).

25. The trip to the Netherlands was confirmed at the meeting of June 29, 1955, and took place in the summer of 1955.

26. This footage was already known to Henri Michel and Olga Wormser, who had included it in their synopsis. Amsterdam owned a positive print, while the negative was kept in the Imperial War Museum.

27. As Ido de Haan emphasizes, Westerbork was "the most important camp in the racial persecution in the Netherlands." Nearly all Dutch deportees of the Final Solution (around 107,000 Jews and 254 Gypsies) passed through Westerbork (including Anne Frank and her family). See Ido de Haan, "Vivre sur le seuil: Le camp de Westerbork dans l'histoire et la mémoire des Pays-Bas," in *Génocides: Lieux (et non-lieux) de mémoire, Revue de l'histoire de la Shoah,* 37–60.

28. Shots 48–70.

29. Headed by K. Schlesinger, who also ran the Westerbork camp's administration. See de Haan, "Vivre sur le seuil."

30. The camp's third commander, who ran it from October 1942 until its liberation.

31. Etty Hillesum, *Lettres de Westerbork* (Paris: Seuil, 1988), 101–7.

32. For a detailed account of the album's discovery by Lili Jacob-Meyer and its first publication, see Serge Klarsfeld's text in the French edition published on the occasion of the sixtieth anniversary of the liberation of the camps (*L'Album d'Auschwitz*, Éditions Al Dante/Fondation pour la Mémoire de la Shoah, 2005). These photographs also formed the subject of a film by Alain Jaubert, *Auschwitz: L'Album, la mémoire* (available on DVD from Éditions Montparnasse Multimedia, 2005). For more on this film, see Lindeperg, *Clio de 5 à 7,* and Philippe Mesnard, *Consciences de la Shoah: Critique des discours et des représentations* (Paris: Éditions Kimé, 2000).

33. As Annette Wieviorka made clear in *Auschwitz, 60 ans après* (Paris: Robert Laffont, 2005), 89–96.

34. Though there is no complete certainty or knowledge of the reasons for their existence, we do know that the photographers were SS Bernhard Walter and Ernst Hoffmann, who were both employed by the Auschwitz camp's identification services. See Serge Klarsfeld's detailed investigation in *L'Album d'Auschwitz,* and Janina Struk, *Photographing the Holocaust. Interpretations of Evidence* (London: IB Tauris, 2004).

35. This film project is often compared with the well-known film produced in Theresienstadt. On the shooting of both films, see Sylvie Lindeperg, *La Voie de image: Quatre histoires de tournages au printemps-été 1944* (Lagrasse: Verdier, 2013).

36. Ido de Haan, "Vivre sur le seuil," 49. The author adopts the analyses of Koert Broersma and Gerard Rossing in *Kamp Westerbork gefilmd: Het verhaal over een unieke film uit 1944* (Hooghalen/Assen: Herinneringscentrum Kamp Westerbork/Van Gorcum & Comp B.V., 1997).

37. Shots 52 and 53.

38. As the film's shot sequence indicates for these two images.

39. Shot 61.

40. Aad Wagenaar, *Settela* (Nottingham: Five Leaves Publications, 2005, trans. Janna Heliot). Cherry Duyns also produced a documentary film about the girl: *Settela, gezicht van het verleden* (1994).

41. On the internment and extermination of the Gypsies, see Henriette Asséo, "Des Tziganes dans les camps," in *Présence du passé, lenteur de l'histoire: Vichy, l'Occupation, les Juifs, Annales ESC* (Paris: Armand Colin, May–June 1993).

42. *The Auschwitz Album. The Story of a Transport* (Institute Yad Vashem and Auschwitz State Museum, 2002).

43. Susan Sontag calls this photograph a "secular icon" and integrates it into the category of *memento mori*, "objects of contemplation to deepen one's sense of reality." The author adds: "But this use seems to require the equivalent of a sacred space, or a space for meditation, inside which we can regard them. Space devoted to solemnity has become a rare thing in a modern society whose principal model of public space is the shopping mall (which can also be an airport or a museum)." Susan Sontag, *Regarding the Pain of Others* (New York: Picador/Farrar, Straus and Giroux, 2003), 107.

44. Cf. Alain Bergala, *Nul mieux que Godard* (Paris: Éditions de l'Étoile/ Cahiers du cinéma, 1999), 202–3.

45. Sylvie Rollet (interview with the author), who finds in *Saraband* (I. Bergman, 2003) a similar function in the photograph of the dead on a night-stand. See also Jacques Aumont, *Ingmar Bergman, "Mes films sont l'explication de mes images"* (Paris: Éditions de l'Étoile/Cahiers du cinéma, 2003), 112; Ophir Lévy, "La mémoire clandestine: La douleur comme symptôme dans le cinéma européen des années 1960–1970," postgraduate thesis (supervisors: S. Lindeperg and R. Odin, Université Paris III, 2004), 78–79.

46. Within this system of connections, which often places one icon beside (or against) another, Godard also shows the image of the girl from Westerbork twice.

47. See Jeffrey Shandler, *While America Watches: Televising the Holocaust* (New York and Oxford: Oxford University Press, 1999), 197–99.

48. Cf. Mesnard, *Consciences de la Shoah: Critique des discours et des représentations*, 35. See also Richard Raskin, *A Child at Gunpoint: A Case Study in the Life of a Photo* (Aarhus: Aarhus University Press, 2004); Frederic Rousseau, *L'enfant juif de Varsovie: Histoire d'une photographie* (Paris: Seuil, 2008). On Samuel Bak's variations of the photograph from the Warsaw ghetto, see Alexis Nouss, "La ruine et le témoignage" in *Mémoire et archive* (Montreal: Musée d'art contemporain de Montréal, 2000).

49. The Warsaw snapshot and the photograph of the scene at Atzmona were published side by side in the *Jerusalem Post* (August 30, 2005, p. 9), with the headline "A Shocking Show of Hands."

50. In *Night and Fog* the Warsaw photograph is slightly reframed on the left side, and another woman and a small girl with their hands raised are no longer visible. Shot 35.

51. They kept photograph 24 showing a stage of the selection. A third shot, also from the Jewish Historical Institute in Warsaw and incorporated into the same sequence by Resnais, shows Jewish women and children from the Mizocz ghetto before their execution (on October 13 and 14, 1942) by Ukrainian police, see infra.

52. In a letter to Argos, the filmmaker estimates the length of film she preselected as 2,000 meters. The letter does not mention whether this concerned 35mm or 16mm film. In the former case, the total running time would be around 80 minutes, in the latter over three hours.

53. N. Bykow, K. Kutub-Zade, A. Pawlow, A Voronzov. For more on the recording of these sequences, incorporated into several versions of the Soviet compilation film *Chronicle of the Liberation of Auschwitz*, see in particular Teresa Swiebocka, ed., *Auschwitz: A History in Photographs* (Warsaw: Auschwitz State Museum, 1993), and Annette Wieviorka, *Auschwitz, 60 ans après*, 27–37.

54. See chapter 6.

55. Shots 205 through 215. Teresa and Henryk Swiebocka, *Auschwitz résidence de la mort* (Auschwitz State Museum, 2003), 20.

56. In November of 1955, Argos sent Veb-Defa in East Berlin a letter to request material on the concentration camps, particularly on Oranienburg. In a letter dated November 16, 1955, Veb-Defa replied that it would investigate and keep Argos informed. A second letter dated November 25 informed Argos that its request had been transferred to the director of Studio Babelsberg, who said he would keep Argos informed.

57. And particularly the, until then, unseen sequences filmed in the Warsaw ghetto. On this subject, see Béatrice Fleury-Vilatte, *Cinéma et Culpabilité en Allemagne: 1945–1990*, foreword by Marc Ferro (Perpignan: Institut Jean Vigo, 1995), and Martina Thiele, *Publizistische Kontroversen über den Holocaust im Film* (Münster: LIT Verlag, 2000), 207–34.

58. Interview with Resnais in Raskin, *"Nuit et brouillard" by Alain Resnais*, 53.

59. Actual expenses proved lower thanks to the efforts of the historical advisers who managed to borrow material for free or buy prints at reduced prices: Argos accounted these costs as 68,863 old francs, to which were added 172,555 old francs in screening expenses (expense accounting, Institut Lumière).

60. Letter dated June 22, 1955, to Korngold, Institut Lumière.

61. The footage recorded by the Americans was mostly culled from the Actualités Françaises archives.

62. And, to a lesser extent, in Majdanek.

63. I refer here to Judith Keilbach's article entitled "Des images nou-velles" in *Trafic* (2003). On the recycling of shots from *Night and Fog*, see chapter 14.

4. WRITING FOUR HANDS

1. The production meeting of March 1, 1955, mentioned a synopsis writ-ten in February by Henri Michel for the ministry of Combat Veterans. Insti-tut Lumière.

2. Words of Alain Resnais in his interview with R. Raskin, *"Nuit et brouillard" by Alain Resnais*, 61. The filmmaker notes that Henri Michel was a driving force in launching the project (as well as sparing no effort to se-cure the necessary funding). The division of roles between the two histori-ans therefore appears similar to their shares on *Tragédie de la Déportation*.

3. The contract of May 24, 1955, stipulates that Resnais collaborate with Henri Michel and Olga Wormser on documentation and scriptwriting. In-stitut Lumière.

4. Contract of May 31, 1955. Institut Lumière.

5. Two versions of the synopsis were sent to the selection committee in June 1955. Archives Nationales, CAC de Fontainebleau, 19890538, art. 945.

6. The prologue became one section, and the fifth chapter was split into two in order to separately treat the parts *"Revier"* and "death." This docu-ment was reproduced in Christian Delage and Vincent Guigueno, *L'Historien et le film* (Paris: Gallimard/Folio histoire, 2004), 218–24. In one of the book's chapters, the authors offer an analysis of the scripts that differs from mine, particularly on the state of the historiography of the genocide.

7. These panels refer to the persecution of France's Gypsies and Jews (wearing the star; a poster announcing a "census of Israelites"; statements by the bishop of Montauban and the archbishop of Toulouse on the persecu-tion of the Jews; photographs of pillaged synagogues supplied by the CDJC; arrests and roundups) (AN 72AJ695).

8. On these three films, see Lindeperg, *Les Écrans de l'ombre*.

9. Camille Maurel, master's seminar report, May 2004, Université Paris II.

10. Institut Lumière.

11. *Revue d'histoire de la Deuxième Guerre mondiale*, July–September 1954. See above.

12. Letter from Philippe Lifchitz to Alain Resnais, May 3, 1955. Institut Lumière.

13. On the NN procedure, see Abbé Joseph de la Martinière, *Le Décret et la procedure Nacht und Nebel (Nuit et Brouillard)* (Paris: FNDIRP, 1981); Wieviorka, *Déportation et génocide*, 223–29; Robert Steegmann, "Nacht und Nebel—Destinés à disparaître sans laisser de traces" in *Les Chemins de la Mémoire*, no. 131 *(Paris: Direction de la mémoire, du patrimoine et des archives* September 2003). Abbé de la Martinière notes that while the "NN" proce-

dure was initiated by the decree of December 7, 1941, the term *Nacht und Nebel* did not appear in a written text until August 1942.

14. The dwarf Alberich is the first to attempt the procedure: "'The helmet fits my head; will the spell work too?' / (Whispering) 'Night and fog, like to no one!' / (He becomes invisible: in his place is a column of vapor)." See Raskin, *"Nuit et brouillard" by Alain Resnais*, 15–22; Basuyaux, "Écrire après," 303.

15. Jean Cayrol, *Poèmes de la nuit et du brouillard* (Paris: Seuil, 1988). Odette Amery and Georges Martin-Champier, *Nuit et Brouillard* (Paris: Berger-Levrault, 1945). This latter volume is quoted in *Tragédie de la Déportation*; Odette Amery was a journalist deported to Ravensbrück in November 1943.

16. The expression is engraved in the Mémorial de la Cité monument: "In memory of the two hundred thousand French citizens vanished into the night and fog, exterminated in the Nazi camps" (quoted by Raskin, 22). Through this inscription, the Réseau du Souvenir associated the two projects (film and monument) it had funded.

17. Production meeting of June 16, 1955. Institut Lumière.

18. I refer here to two versions of the scenario: the eight-page typescript (with handwritten corrections and annotations) entitled "Preparatory Text Night and Fog," consulted in the Jean Cayrol archives of the IMEC; and the excerpts from another version of the script, quite close to the IMEC version, quoted in Delage and Guigueno, *L'Historien et le film*, 74–75 and 225–26.

19. "Preparatory Text Night and Fog," IMEC.

20. Delage and Guigueno, *L'Historien et le film*, 75, and "Preparatory Text Night and Fog," IMEC.

21. "Preparatory Text Night and Fog," Cayrol archives, IMEC.

22. Ibid.

23. Quoted by Olga Wormser in "Le travail concentrationnaire dans l'économie de guerre allemande," 85.

24. Ibid., 86.

25. The sentence in the screenplay reads: "The 'definitive solution to the Jewish problem,' decided in 1942." The dating of the "decision" is a subject of intense debate among historians: an entire library of publications is devoted to the question. In 1955, however, historians still agreed that the decision was made at Wannsee, January 20, 1942.

26. *Le concentrationnat*—a neologism often employed and most likely invented by Jean Cayrol.

27. Handwritten annotations on the screenplay in the Cayrol archives, IMEC.

28. It has been noted many times that this constitutes the sole occurrence of the word "Jew" in Cayrol's commentary. Annette, a diminutive of Anne and Hannah, was a very common name among Jewish girls at the time. This name change appears in an intermediate version of the commentary (BN, Arts du Spectacle, MY 1858).

29. Resnais would confirm this point in an interview with Charles Krantz, stating that directly mentioning the fate of the Jews would have

distracted from the universal warning message he wanted to get across (Charles Krantz, "Teaching *Night and Fog*: History and Historiography" in *Film & History* 15, no. 1, 1985).

30. "Inside, a fake shower room awaited the new arrivals." Jean Cayrol's typescript, "original version of the text with corrections, variations and additions referring to the final text; handwritten corrections by Jean Cayrol, annotations and suggestions by Alain Resnais in the margins" (the two other handwritings appear to belong to Olga Wormser and Chris Marker), Bibliothèque Nationale, Département des Arts du Spectacle, MY 1858.

31. In the introduction to her dissertation, Olga Wormser writes: "The Final Solution therefore sought to quite simply exterminate the 'inferior races,' Jews, Gypsies, Soviets, etc. The concentration camp system seems to have achieved the same goal by destroying around 75% of all the people subjected to it. In principle the two systems and the desire that formed their basis were diametrically opposed. . . . The difficulty lies in the fact that the difference is only noticeable in the facts between 1933 and 1942. Between 1942 and 1945 it disappears." *Le Système concentrationnaire*, 14.

5. THE ADVENTUROUS GAZE

1. Regarding *Night and Fog*, Alain Fleischer mentions "the figure of the aimless subjective tracking shot" in *L'Art de Alain Resnais*, 34.

2. As put forward by Georges Didi-Huberman, who established a relationship between the opening scenes of the two films in *Images malgré tout* (Paris: Éditions de Minuit, 2003), 161–66, and by Vincent Lowy, *L'Histoire infilmable: Les camps d'extermination nazis à l'écran* (Paris: L'Harmattan, 2001), 171–75. See also my later analysis of the different places assigned to camera and filmmaker in *Shoah* and in *Night and Fog*.

3. Daniel Arasse, *Histoires de peintures*, 20.

4. The eve of its departure, it was announced that the crew would bring along 1,500 meters of Eastmancolor stock and 1,500 meters of black-and-white film stock "as a safety measure, to be returned in the likely case that these remain unused." Minutes of the August 31, 1955, production meeting. Institut Lumière.

5. Ghislain Cloquet, "Alain Resnais ou la création au cinéma," in *L'Arc*, no. 31, 59–60.

6. Though without an assigned function on the film, he worked at Film Polski and had some experience as a producer.

7. Broadcast France Culture.

8. Ibid.

9. Olga Wormser-Migot's memoirs.

10. In a tribute to Sacha Vierny in 2001, Resnais remembered their first encounter around 1948 or 1949 (A. Resnais, "Sacha Vierny ou l'élégance," in *Positif*, no. 488, October 2001). Sacha Vierny was Cloquet's assistant on *Night and Fog* and *Le Mystère de l'atelier quinze* and director of photography on *Le Chant du Styrène* as well as on Resnais's first four features. As for Heinrich,

he had no qualms about quitting his job to follow Resnais to Poland, even after receiving his employer's agreement at the last minute (interview with the author on February 5, 2004).

11. Xavier Grall, "Quand la poésie naissait à Mauthausen," *CRI*, no. 5, March 1963, p. 25 (Seuil archives). I thank Marie-Laure Basuyaux for allowing me access to this document.

12. Probably in the corridors of block 6 or 7, which display "several hundred photographs of Polish detainees," cf. Jean-Charles Szurek, "Le camp-musée d'Auschwitz," in *À l'Est, la mémoire retrouvée*, eds. Alain Brossat, Sonia Combe, Jean-Yves Potel, and Jean-Charles Szurek (Paris: La Découverte, 1990), 553.

13. Words of André Heinrich in broadcast France Culture, supplemented with the February 5, 2004, interview.

14. As Alain Fleischer points out, the shot list always has great importance to Resnais: "The document of which Resnais remains the sole author is the strategic battle plan called the shot list," in *L'Art d'Alain Resnais*, 32.

15. According to his assistant director, Resnais arrived in Poland without a clearly delineated plan for the shoot (interview).

16. Document quoted by Delage and Guigueno, *L'Historien et le film*, 74.

17. As François Niney points out, the "night sequence" of *Blood of the Beasts*, written by Jean Painlevé, is reminiscent of Cayrol's commentary: "The day ends. In the park, the silence puts the still quivering lambs to sleep/ They do not hear the gates of the prison closing around them, or the little train of Pars-Villette that heads off for the countryside at sunset to search the following day's victims." François Niney, *L'épreuve du réel à l'écran: Essai sur le principe de réalité documentaire* (Brussels: Éditions de Boeck, 2000), 109. Both films also treat the merciless transformation of bodies into merchandise.

18. Paul Celan, *Unter der Bild*, quoted by Andréa Lauterwein in "'Les deux mondes' Paul Celan et Anselm Kiefer," doctoral dissertation (supervisor: Gerald Stieg, Paris III, December 2002), 414.

19. Quoted by Lauterwein, "'Les deux mondes,'" 409 ff.

20. Screenplay, Cayrol archive, IMEC.

21. Jean Cayrol, "Les rêves concentrationnaires," *Les Temps modernes*, no. 36, September 1948, 529.

22. Thierry Jonquet's expression, from *Les Orpailleurs* (Paris: Gallimard, "Folio Policier," 2003), 392.

23. Wieviorka, *Auschwitz, 60 ans après*, 84.

24. Today, as A. Wieviorka notes, "the grass at Birkenau is mowed regularly, the barracks, watchtowers, and barbed wire fences are constantly restored, replaced, and dusted off. A neat layer of gravel occupies the spaces between the beams of a train tracks once teeming with weeds." *Auschwitz 60 ans après*, 84. When Marceline Loridan returned to Birkenau to film *La Petite Prairie aux bouleaux* (2003), the order she had to fight this time was that of domesticated nature.

25. Screenplay, Cayrol archive, IMEC.

26. Gilles Deleuze, *Cinéma 2: L'Image-temps* (Paris: Éditions de Minuit, 1985), 160.

27. Niney, *L'Épreuve du réel sur l'écran*, 98.

28. Shot 237.

29. Interview with Teresa Swiebocka (at the time head of the Auschwitz State Museum and its publishing department), January 27, 2004.

30. The issue of the origin of the documents regarding the soap came up during a production meeting at the Argos offices (undated minutes, sometime between late November and early December 1955). It is necessary to point out that Cayrol's final commentary strongly nuances the issue and anticipates the work of future historians: "With the bodies, they *want to* make soap."

31. Broadcast France Culture.

32. Georges Perec, *W ou le souvenir d'enfance* (Paris: Denoël, 1975, reprinted Gallimard, 1997), 84.

33. As Vidal-Naquet notes, "Perec makes the common mistake of confusing gas chambers with crematorium ovens." Pierre Vidal-Naquet, *L'Atlantide: Petite histoire d'un mythe platonicien* (Paris: Les Belles Lettres, 2005), 137, 175.

34. Hwang Sok-yong, *L'Invité* (Paris: Éditions Zulma, 2004).

35. In the American compilation film *The Nuremberg Trial*, the narrator delivers an elaborate explanation of the working of the gas chambers, "supported" by a curious montage of shots: we successively see the doorway and ceiling of a room, a close-up of a showerhead, shots of emaciated inmates, nude, sitting or lying on the floor in a darkened room, a gloved hand working a valve, and a shot of a pile of corpses (documentary produced by the Cinematographic Department of the high commission for Germany of the United Nations, for viewers in West Germany and West Berlin, where it was shown as part of the Allied denazification process). The images of this montage were borrowed from the Dachau sequence of the film *Nazi Concentration Camps*. The latter shows the images in a different order and the shots of nude deportees on the floor are accompanied by the comment: "These have escaped death."

36. The monster in the shape of a crocodile and the victims' passports were both filmed in Majdanek.

37. Even though Birkenau officially, and originally, fell within the museum's perimeter.

38. In the context of an antifascist view that ignored the singular fate of the exterminated Jews. On the history of the museum, see Szurek, "Le camp-musée d' Auschwitz," and Wieviorka, *Auschwitz, 60 ans après*. James Young devoted a chapter to the Birkenau monument in his book *The Texture of Memory: Holocaust Memorials and Meaning* (New Haven / London: Yale University Press, 1993).

39. These three accounts of a trip to Poland would not be published until 1961, in *La Giustizia*. Giorgio Caproni, *Cartes postales d'un voyage en Pologne* (Bordeaux: Édition William Blake & Co., 2004), 29.

40. See Wieviorka, *Auschwitz, 60 ans après*, 38 ff.

41. Shot 83.

42. François Truffaut wrote about *Night and Fog*'s "terrifying tenderness" in *Arts*, February 22, 1956.

43. Shot 252.

44. *Les Temps modernes*, no. 36, September 1948, 529. Reinhart Koselleck and François Gantheret comment on this text in the afterword to Charlotte Beradt's book *Rêver sous le IIIe Reich* (Paris: Payot, 2002).

45. These hairs that testify to "the assault on the murdered bodies" today pose great problems of conservation, while at the same time provoking debate on what kind of treatment would preserve the victims' dignity. Cf. Wieviorka, *Auschwitz, 60 ans après*, 171–72.

46. Olga Wormser-Migot's memoirs.

47. Shot 73 (for Auschwitz I) and shot 96 (for the full moon).

48. Shot 222.

49. Fleischer, *L'Art de Alain Resnais*, 33–34.

50. See Lindeperg, *Clio de 5 à 7*, 199.

51. Arnaud de Pallières, in Lindeperg, *Clio de 5 à 7*, 200.

6. THE DARKNESS OF THE EDITING ROOM

1. Dionys-Films invoices show that the editing lasted from October 20 through December 24 (Institut Lumière). It consisted of two stages: the editing of the work print (images), followed by the sound editing (narration and music).

2. Henri Colpi and Jasmine Chasney are credited as "assistant sound editors" *(assistants à la sonorisation)*. An addition to Resnais's contract dated June 13, 1955, stated that he would be hired as "editor of the work print, with the exception of the sound editing, for which he will act as supervisor." Institut Lumière. Regardless of what their individual functions were, Colpi, Chasney, and Resnais collaborated on the sound editing, for which they also called on Chris Marker.

3. Broadcast France Culture.

4. Ibid.

5. Resnais studied editing at Idhec, and his first professional film activities were as assistant editor. Godard earnestly enshrined him as "the world's second greatest editor behind Eisenstein."

6. In reference to the subhead title, in *L'Atelier de Alain Resnais* (p. 23), François Thomas speaks of an "aesthetics of collision" with regard to the editing in Resnais's films. Screenplay, Cayrol archive, IMEC.

7. Straight cuts are a recurring element in Resnais's films. As François Thomas writes: "Resnais does not overlay elements, he does not superimpose them, he alternates them. . . . The straight cut reinforces the effect of an 'encounter' between two shots, the impression of deflagration, atomization of his films. . . . Straight cut editing metaphorically summarizes the principle of collision, of dialectic in his cinema," *L'Atelier d'Alain Resnais*, 22.

8. Vincent Pinel, "Fiche filmographique," no. 163, *Films et Documents* (Paris: Idhec, 1959).

9. Vincent Pinel counted 269 shots in black and white out of a total of 297 shots. I rely here on R. Raskin's very detailed shot count *("Nuit et brouillard" by Alain Resnais)*, which I've verified using the DVD, but which nevertheless overlooks one very brief shot: in the extracts from *Triumph of the Will*, the shot of soldiers carrying banners (shot 8) is first followed by a false matching shot in the axis of the flags (no. 9), and subsequently by another shot Raskin did not include and which I've numbered 9b so as not to modify the numbering of the published shot sequence. This 9b is a matching shot in the movement of the banners. Not counting the credit sequence, *Night and Fog* therefore contains 307 shots, of which 277 are in black and white and 28 are in color. The contrast between the duration of the color shots and the monochrome shots increases dramatically if we do not take into account the shots Resnais filmed in black and white, whose duration is generally longer than the archive footage: twenty-five seconds for the shot of the turning pages in the Mauthausen register, twelve seconds for the *kapo*'s room, thirty-one seconds for the shot of women's hair, etc.

10. Ibid.

11. Many thanks to Sylvie Rollet for her advice and useful suggestions.

12. It contains the following images also present in *Night and Fog*: shot of Himmler and Hitler, Streicher's speech, SS and SA processions, banner parade, drummer boys. The first shot of SS soldiers is included in a wider movement.

13. It is possible that Resnais chose some of these shots directly from Radok's film. A letter from Argos to the GTC laboratory contains an order of five interpositives of this film, to be struck from duplicates (copy dated October 26, 1955, Institut Lumière). I have not been able to ascertain whether this concerned the archive footage employed by Radok or fictional shots whose use was envisioned by the scriptwriters.

14. We will ignore the black-and-white shots filmed by Resnais and concentrate entirely on the archive material gathered during the research period.

15. See in particular Marie-Anne Matard-Bonucci and Édouard Lynch, eds., *La Libération des camps et le retour des déportés* (Brussels: Éditions Complexe, 1995); Clément Chéroux, ed., *Mémoire des camps: Photographies des camps de concentration et d'extermination nazis (1933–1999)* (Paris: Éditions Marval, 2001); *Allemagne, avril-mai*; Barbie Zelizer, *Remembering to Forget: Holocaust Memory Through the Camera's Eye* (Chicago, London: Chicago University Press, 1998); Teresa Swiebocka, *Auschwitz: A History in Photographs*.

16. Shot 97. Elie Wiesel, *Tous les fleuves vont à la mer: Mémoires* (Paris: Seuil, 1994), central photo section. This oft-reprinted shot originally shows an emaciated, half-undressed inmate standing in front of the bunk beds. In *Night and Fog*, the image has been reversed and reframed and does not show this man. To understand whether Alain Resnais was responsible for this reframing, one must look at the original document as supplied by the CHDGM; one indication that this was intentional is the fact that the origi-

nal photograph was included in the film's promotional material and on the packaging of the VHS release by the CNDP. For a study of the reframing of certain images in *Night and Fog*, see Chantal Postaire, "Analyse de l'utilisation de documents dans trois courts-métrages coréalisés ou réalisés par Alain Resnais," master's thesis in film studies (supervisor: René Prédal), Université de Caen, 1998, 101–4.

17. Where detainees from Neuengamme had been evacuated.

18. These four photographs correspond to: shot 164 (Sandbostel); shot 16 (Wobbelin); shot 174 (Vaihingen). In the film, the image from Vaihingen has been cropped and its diagonal composition corrected. There is no data to allow us to establish with certainty that this framing was the filmmaker's work, but it should be noted that Resnais tried to correct the diagonal framing of one of the Birkenau *Sonderkommando* photographs, as a viewing of the rushes proved (see above).

19. Each extract consisting of one to four shots.

20. In particular those of a group of corpses in a container of which the shot sequence indicates the source as "Soviet newsreel" and that they were recorded at Stutthof (shots 258–60), the concentration camp located at the mouth of the Vistula that is often confused with Struthof. Also of Soviet origin were several shots of mass graves and the pyre of corpses and wood (shot 244). A photograph of the same scene is part of the permanent exhibition at Yad Vashem, where the description indicates that it was taken in October 1944 at Klooga camp in Estonia.

21. These were incorporated into the different versions of the Russian film *Chronicle of the Liberation of Auschwitz*.

22. Of May 18, 1945. On the topic of Actualités Françaises newsreels on the deportation and the Nazi camps, see Lindeperg, *Clio de 5 à 7.*

23. In a recent interview, Alain Resnais indicated that he owns a 16mm print of "French newsreel films" (Suzanne Liandrat-Guigues and Jean-Louis Leutrat, *Alain Resnais: Liaisons secrètes, accords vagabonds,* 217).

24. Reels kept at the IHTP; see chapter 3, note 13.

25. Shot 71 (the transport's arrival). Shot 155 ("black transports"). The issue of the "black transports" to Ravensbrück is raised in *Tragédie de la Déportation,* 409. The same term is used regarding Mauthausen; cf. Wieviorka, *Déportation et génocide,* 201.

26. Shots 55 and 56 from the section on arrests. Bifi archives, Collection Jaune CJ1068B143, document carrying the name Hanns Eisler. In this shot sequence, other shots were cut out during editing: shot 191 captioned "Deportee Suffering from Dysentery" very likely corresponds to one of the famous photographs by Erich Schwab captioned "Dying Dysentery Patient," taken at Buchenwald in April 1945 and widely reprinted in the French media after the liberation.

27. Appendix, *L'Historien et le film,* 222.

28. Cf. *Clio de 5 à 7,* 158 and 216–17. Note that even today numerous French school textbooks illustrate their section on the resistance with a still from *The Battle of the Rails.*

29. Several seconds of a shot that lasts thirty-five seconds in Jakubowska's film.

30. The shot ends with a fade-out and thereby forms the only exception to the principle of straight cuts.

31. Jean Cayrol, "Les rêves concentrationnaires," 529.

32. Shots 221–37.

33. Five of these shots were consulted at Warsaw's Jewish Historical Institute, a sixth (shot 230) at the CDJC. Three of these (227, 228, 231) were published as early as 1945 in a Polish volume entitled *Extermination of Polish Jews*.

34. Shot 229.

35. Chéroux, ed., *Mémoire des camps*, 13.

36. This is not the case of *Mein Kampf*, in which Leiser uses the photograph from Mizocz (shot with a horizontal pan in order to suggest the victims' entry into the gas chamber).

37. Typescript of *Night and Fog*'s commentary, Bibliothèque Nationale, Département des Arts du Spectacle, MY1858.

38. Pierre Vidal-Naquet, "L'épreuve de l'historien," in *Au sujet de Shoah, le film de Claude Lanzmann*, ed. Michel Deguy (Paris: Belin, 1990), 206.

39. On this issue, see Chéroux, ed., *Mémoire des camps*.

40. The author considers the destruction of the European Jews as "a broad, complicated historical phenomenon with manifold ramifications" (*Images malgré tout*, 77).

41. The mixed character of the Auschwitz-Birkenau complex—prison camp, concentration camp, and subsequently extermination center—has not facilitated a clear understanding of these images. In fact, a considerable number of photographs exist of the camp in its first two guises, since photography formed part of the concentration camp system in the west as well as in the east: visits of Nazi luminaries; constructions sites of the *Bauleitung;* labor in the factories and *kommandos;* photos for identification and biometry; medical experiments; executions; shots of deceased detainees taken by the identification services, etc. Cf. Swiebocka, *Auschwitz: A History in Photographs*.

42. *Le Monde*, March 3, 1994.

43. Jean-Jacques Delfour, "La pellicule maudite: Sur la figuration du réel de la Shoah: Le débat entre Semprun et Lanzmann," in *L'Arche* 508, June 2000, 14.

44. *Les Inrockuptibles*, 170, October 21–27, 1998, 28.

45. *Clio de 5 à 7*, 266–73. Relaunched debate between Claude Lanzmann and Jorge Semprun, in *Le Monde des débats*, May 2000, 11–15.

46. As Arnaud des Pallières underlines, to admit that an image of this kind is missing is to say, "It is missing to our thirst for the truth. To say that it is missing to our thirst for the truth is to pretend that it ruins, by its very absence, what we believe we know and are able to transmit. This is to allow one's self to be dragged far into the debate with the Holocaust deniers . . .

since this is precisely the spot where their systematic venture of confusion situates itself," *Clio de 5 à 7*, 272.

47. These four shots, long attributed to David Szmulewski, were in fact taken by Alex, a Greek Jew whose family name remains unknown. Three other members of the *Sonderkommando* appear to have taken part in their recording: Szlojme and Josel Dragon and Alter Szmul Fainzylberg. Cf. Chéroux, ed., *Mémoire des camps*, 86, and Didi-Huberman, *Images malgré tout*.

48. Whether or not these two photographs of the act of incineration were taken from inside a chamber—a much debated point on which I neither am capable nor desire to speak out—does not seem to fundamentally change the factual observation.

49. Chéroux, ed., *Mémoire des camps*, 217.

50. Even though Godard's statement depended on the caveat of a recording by the Nazis.

51. More so because the special feature on these four photographs published in the magazine *Télérama* under the title "The Horror Seen from Inside" presented them as "the only known images of the extermination of the Jews in the gas chamber [*sic*]." F. Chapuis, *Télérama*, January 10, 2001. This erroneous reading, for which the curators of the exhibit were not responsible, hardly defused the squabble.

52. Gérard Wajcman, "De la croyance photographique" in *Les Temps modernes* 56, no. 163, 2001, 47–83; Élisabeth Pagnou, "Reporter photographe à Auschwitz," *Les Temps modernes* 56, no. 163, 2001, 84–108; Georges Didi-Huberman, *Images malgré tout*. This controversy was the subject of a recent study by Jacques Walter, who looked at the "violent discourse" in *La Shoah à l'épreuve de l'image* (Paris: PUF, 200), 97–126.

53. See Chéroux, ed., *Mémoire des camps*, 86–91, and Didi-Huberman, *Images malgré tout*, 50–52.

54. This concerns the photograph number 267 in *Mémoire des camps*. The photograph incorporated into *Night and Fog* (no. 240) presents a cropped framing that excludes the black area around the edges (it corresponds to the reproduction in Teresa Swiebocka's *Auschwitz: A History in Photographs*, 174). For a history and an analysis of the different forms of reframing and retouching of these images, see Didi-Huberman, *Images malgré tout*, 50 ff.

55. Likely a phonetic transcription of the name David Szmulewski, who we know today was not the person who took the picture (see above). In Argos's shot sequence, another caption explicitly indicates an image that was taken illicitly, no. 41, captioned: "Illicit photograph taken at Compiègne, supplied by Jean Mermet 'Parisien Libéré.'"

56. On the image as testimony, see Didi-Huberman, *Images malgré tout*, 127–30.

57. The shot sequence contains the mention "naked asphyxiated corpses." Origin: Actualités Françaises.

58. Which simply function to bookend them in the film's conclusion.

59. Wieviorka, *Déportation et génocide*, 205–9.

60. Cf. Toby Haggith, "Filming the Liberation of Bergen-Belsen," in *Holocaust and the Moving Image: Representations in Film and Television Since 1933*, eds. Toby Haggith and Joanna Newman (London: Wallflower Press, 2005).

61. For more on this publicity campaign, see Wieviorka, *Déportation et génocide*; Marie-Anne Matard-Bonucci and Édouard Lynch, eds., *La Libération des camps et le retour des déportés*; Chéroux, ed., *Mémoire des camps; Allemagne, avril-mai 1945*; Zelizer, *Remembering to Forget*; Lindeperg, *Clio de 5 à 7*.

62. On screenings of these images in occupied Germany, see chapter 11. The images from Bergen-Belsen were the first ones used in accusing the Nazi criminals, as part of the Lüneberg trial where the guards and commanders of the Belsen camp were tried. The Belsen images also close the film *Nazi Concentration Camps*, which was screened on November 29, 1945, at the Nuremberg tribunal. A brief commentary accompanied this British-shot footage: "This was Bergen-Belsen." The same footage was also intended as the core of Sidney Bernstein's film project *Memory of the Camps*, but this idea was abandoned in August 1945 at the request of the Foreign Office. On the history of the film and a reflection on the montage it inspired, see in particular Tony Kushner, *The Holocaust and the Liberal Imagination: A Social and Cultural History* (Oxford, Cambridge: Backwall, 1994); Nicolas Losson, "Notes sur les images des camps," *Cinergon*, no. 2, 1996; Martine Joly, "Le cinéma d'archives, preuve de l'histoire?" in *Les institutions de l'image*, eds. Jean-Pierre Bertin-Maghit and Béatrice Fleury-Vilatte (Paris: Éditions de l'EHSIS, 2001), 201–12; Lindeperg, *Clio de 5 à 7*, 231–35; Kay Gladstone, "Separate Intentions: The Allied Screening of Concentration Camp Documentaries in Defeated Germany in 1945–1946: *Death Mills* and *Memory of the Camps*" in *Holocaust and Moving Image*. For an analysis of this British footage, see Jean-Louis Comolli's beautiful text "Fatal Rendezvous," in *Cinema & the Shoah: An Art Confronts the Tragedy of the Twentieth Century*, ed. Jean-Michel Frodon (Albany: State University of New York Press, 2010).

63. On this topic, see the investigation by Frederick Alexander Riches, recorded September 19, 1987, and stored at the Imperial War Museum (no. 9937/3), quoted by Clément Chéroux in *Mémoire des camps*, 15, note 10.

64. See Lindeperg, *Clio de 5 à 7*, 183 and 192–96.

65. Alain Resnais interviewed in "Le Siècle du cinéma," 73.

66. As Annette Wieviorka explains in *Déportation et génocide*, 205–9.

67. On this topic see Stuart Liebman's thoroughly documented essay "La libération des camps vue par le cinéma: L'exemple de *Vernichtungslager Majdanek*," in *Les Cahiers du judaïsme*, no. 15, 2003, 49–60.

68. On the recording of this footage, see Wieviorka, *Auschwitz, 60 ans après*, 27–37, and Swiebocka, *Auschwitz: A History in Photographs*, 44–45.

69. Testimony by A. Voronzov, quoted by Matard-Bonucci in "Le difficile témoignage par l'image," in *Libération des camps et le retour des déportés*, 83.

70. Other generations of images were recorded by the Soviets in the weeks and months that followed (see Wieviorka, *Auschwitz, 60 ans après*, 27 ff.). A final "reconstruction" was filmed, probably on May 7, 1945, in which,

with the help of extras, the arrival of Soviet troops was greeted with joy by the deportees (ibid., 33).

71. Shots 293–95. Resnais's choice of images of the survivors demonstrates the concern for preserving the victims' dignity, contrary to the options chosen by the editors of *The Death Camps* and *Nazi Concentration Camps*, which gave their audience a danse macabre of naked, skeletal deportees exposing their wounds to the camera.

72. The film's middle section, devoted to the operation of the camps during the Nazi period, does, however, contain a shot (no. 138) recorded by the Soviets in Auschwitz showing children emerging from a barracks.

73. Undated Argos meeting, which cross-checking allows us to situate at the end of November 1955. A text by Henri Michel on a rough cut of the film was discussed during this meeting, which also referred to the issue of using maps of the camps in the film (see chapter 3, note 13).

74. As well to certain representatives of deportee associations connected with the project, as the following extract from a letter by Dauman to Muszka shows: "We recently organized a screening of the rough cut for certain heads of French deportee associations. The general opinion was that the work fulfills all its promises. Its authenticity was not questioned" (copy of letter by Dauman dated November 30, 1955, Institut Lumière).

7. SUFFOCATED WORDS

1. The term used by Sarah Kofman to describe the aporia of a writing born of powerlessness: "To speak, because one must, but devoid of power: without the sovereign, dominant language overpowering the most aporetic situation, the complete powerlessness and distress," in *Paroles suffoquées* (Paris: Galilée, 1987), 16. Broadcast France Culture.

2. Jean Cayrol, *Il était une fois Jean Cayrol* (Paris: Seuil, 1982), 108–9. In 1963 Cayrol admitted to Pierre Billard how much of an ordeal it had been to write this text: "When I returned home with all those photos from the camps, I really thought I was going mad." *Cinéma 63*, no. 80, November 1963.

3. Broadcast France Culture.

4. For the film to qualify for the *prime à la qualité*, it needed to be finished in December.

5. Broadcast France Culture.

6. Cayrol refers twice to the decisive role Chris Marker played, though without mentioning his participation in the writing explicitly. In the interview with Billard (see note 3), he admitted: "I would doubtlessly have given up on taking part in the film if Chris Marker had not proven such a great supporter in that difficult moment." In an interview with Roger Vrigny on June 19, 1970, Cayrol added: "Chris Marker came to my aid, told me to persevere. His approval also helped because he worked on the film. At that moment, with Chris Marker's help, I decided to continue working on *Night and Fog.*" Quoted in Basuyaux, "Écrire après," vol. 1, 72, and vol. 2, 806.

7. Alain Resnais's words, broadcast France Culture.

8. The subheading refers to "It is clear that we are entering mankind's sleepless night, and all the burning wicks of memory will not suffice to illuminate us and not leave us wanting," Jean Cayrol in *Lazare parmi nous* (Paris / Neuchâtel: Seuil / Baconnière, 1950), 11. The Confrérie Notre-Dame (CND)-Castille network, created and headed by Colonel Rémy (see François Marcot, ed., *Dictionnaire historique de la Résistance* [Paris: Robert Laffont, 2006], 148–49). The sources used here are the following: interview with Jean Gavard, companion of Cayrol in the resistance and in deportation (March 11, 2004); text by Louis Deblé, survivor of Mauthausen and Gusen, fellow laborer alongside Cayrol (text supplied by J. Gavard); Cayrol, *Il était une fois Jean Cayrol*; Basuyaux, "Écrire après"; "Jean Cayrol: Lazare parmi nous," *Un siècle d'écrivain,* dir: Jean-Luc Alpigiano and Jacques Loiseleux, broadcast by FR3 on November 23, 2000.

9. Cayrol, *Il était une fois Jean Cayrol,* 95.

10. In various interviews and in his autobiography, Jean Cayrol reminisces about the death of his brother, who died at Ellrich. In an article in *Les Lettres françaises* of February 9, 1956, Cayrol writes that he died in Oranienburg.

11. Jean Gavard, interview with the author (March 11, 2004).

12. He read, before its publication, the first translation done by his friends Lotte and Jean Carrive.

13. Interview with Roger Vrigny, "Entretiens avec: Jean Cayrol," *France Culture,* June 12, 1970.

14. Cayrol, *Il était une fois Jean Cayrol,* 97–98.

15. Ibid., 101.

16. Ibid.

17. Cayrol's testimonial in Philippe de la Trinité's tribute volume *Le Père Jacques,* 439, quoted by Louis Deblé.

18. Interviews with Roger Vrigny, June 13, 1970, transcribed in Basuyaux, "Écrire après."

19. These were not published until 1997, under the title *Alerte aux ombres: 1944–1945* (Paris: Seuil, 1997). As Jean Cayrol explains in the foreword: "In 1955, the survivors were advised to forget, to keep their mouths shut. . . . So, forgotten, yet found by chance," 5.

20. Despite variations in Cayrol's recollections, cf. Basuyaux, "Écrire après," 13.

21. Ibid., 42.

22. Serge Groussard, "Je ne puis rompre ma chaîne et briser mon destin," *Biblio* 31, no. 9, November 1963, quoted by Basuyaux, ibid.

23. Ibid.

24. Cayrol, *Il était une fois Jean Cayrol,* 102.

25. Basuyaux, "Écrire après," 24–25.

26. *Pour un romanesque lazaréen,* reprinted alongside the *Night and Fog* commentary under the title *De la mort à la vie.* Jean Cayrol, *Nuit et Brouillad suivi de la mort à la vie* (Paris: Fayard, 1997); *Pour un romanesque lazaréen,* 12 and 84.

27. Roland Barthes, in *Les Corps étrangers*, reprinted in *Essais critiques IV : Le bruissement de la langue* (Paris: Seuil, 1984), 218. Quoted in Basuyaux, "Écrire après," 39.

28. Cayrol, *Pour un romanesque lazaréen*, 72.

29. Cayrol stated that his works "illicitly testify" to what he lived through (interview with Pierre Dumayet, quoted by the author, 26).

30. This is one of the propositions of Marie-Laure Basuyaux's very subtle work.

31. Whom I will semantically analyze after this.

32. Basuyaux, "Écrire après," 73.

33. You would exchange two or three cigarettes for a bowl of soup. / You would observe in fear, watching out for familiar symptoms. / You would make spoons, puppets that you would hide. / You would manage to write, to take notes. / You would take care of your weakest companions. (—Trans.)

34. They selected immediately . . . they ordered canisters of Zyklon gas; they closed the doors and observed. (—Trans.)

35. But there is nothing to say. (—Trans.)

36. Today the sun shines down on that same road. We traverse it slowly in search of what? (—Trans.)

37. There is us sincerely watching those ruins . . . and who fail to hear the endless screams. (—Trans.)

38. Who among us watches from the strange observation post to warn us about new executioners? Will their faces really be different from ours? (—Trans.)

39. This reality of the camps, despised by those that created it, imperceptible to those who lived it, for us in turn it is in vain that we try and understand it. (—Trans.)

40. Basuyaux, "Écrire après," 73.

41. "As I speak, the cold water of the swamps and the ruins fills the pits of the mass graves." (—Trans.) Another "*je*" opened the text before the final rewrite. After the listing of camp names, Cayrol wrote: "And now *I* no longer dare pronounce them." Typescript of *Night and Fog*, BN, MY1858.

42. This short film, codirected with Claude Durand in 1960, revolves around the monologue of a camp survivor who wanders through a dreamscape, a field full of ruins of war (a pentagonal blockhouse, objects pointing toward the sky, a mound of German helmets, a tangle of metallic cords, rusting shells amid kelp, cement girders, an overgrown stairway). The film follows the deportee's amble, like a fleeing silhouette who hesitates and stumbles. A prisoner of the waters of memory whose recollections come to him in waves, the survivor finds himself confronted with the impossible return: "Jeanne didn't seem to recognize me. . . . She had chosen to leave and seemed more dead than alive to prevent me from taking her back. . . . Nobody awaited me . . . everyone is asleep. How to wake them? They were put aside, earth covering their mouths, like stubs. That's it, close your door tightly in weather like this. When you come back, you can have the room upstairs. It's a nice place to die peacefully. So why was I killed when I am not yet dead?"

NOTES TO CHAPTER 7

For an analysis of Cayrol's films, see Jean-Luc Alpigiano, *Le Cinéma lazaréen*, postgraduate thesis, Université Paris 3, UFR Cinéma et Audiovisual, June 1994.

43. Pierre Dumayet, *Lectures pour tous*, ORTF, broadcast on January 24, 1968, dir: Jean Bertho, transcription by Basuyaux, "Écrire après," 841.

44. The same statement opens *Pour un romanesque lazaréen.*

45. The commentary contains eight mentions of the term *kapo.*

46. Primo Levi, *Les Naufragés et les rescapés: Quarante ans après Auschwitz* (Paris: Gallimard, 1989). Regarding the dominant figure of the *kapo* in camp literature, see Wieviorka, *Déportation et génocide*, 216–23.

47. M.-L. Basuyaux writes: "The circumstances of condemnation are indeed very similar in the two universes. It is visible in the complete unawareness of his error in which the condemned lives, the arbitrary judgments, the incomprehensible, literally illegible, nature of the sentence, the importance of corporal punishment, its duration, and its intensity, the inevitably lethal way out, and the use of the most technically advanced and precise means to inflict the most inhuman suffering. The general atmospheres of both universes also resemble one another, made up of a mixture of the grotesque and despair, and marked by anxiety and pitiless terror, by an absolute rationality that goes hand in hand with the most absurd and intolerable measures. Beyond the common point that forms the argument of this text—the construction of inhuman punishment—J. Cayrol proves very sensitive to two less obvious aspects of both Kafka's universe and that of the camps: the fantastical and the humor," "Écrire après," 46–47.

48. Grall, "Quand la poésie naissait à Mauthausen," 25.

49. Cayrol, *Il était une fois Jean Cayrol*, 108–9.

50. *Cléo de 5 à 7* by Agnès Varda (1961). As if echoing *Night and Fog*, its prologue presents a game with time, in this case between the present of the narrative and the future of the prophecy, by switching between color and monochrome: the tarot game was filmed in color, Cléo's face (and that of the card dealer) are in black and white like the rest of the film.

51. Jean Cayrol and Claude Durand, *Le Droit de regard* (Paris: Seuil, 1963), 69.

52. As Cayrol said to Roger Vrigny about *Night and Fog*: "It is a film based on the gaze and on a Kafkaesque vision of the world of the concentration camp," June 19, 1970.

53. Cayrol and Durand, *Le Droit de regard*, 23.

54. Interviews with Roger Vrigny, June 18, 1970.

55. "Horror" was a word Cayrol always avoided. A handwritten note by his wife Jeanne confirms this, with regard to a sentence in the first draft of Michel Pateau's foreword to the Seuil edition of the *Night and Fog* text. In a reaction to the passage: "and so Jean Cayrol, with only the gaze of astonishment and a quotidian precision tells of the horrors of our planet," the poet's wife remarked: "Jean wishes at all cost to avoid the word 'horror': why not use 'drama' instead" (proofs of October 30, 1996, Jean Cayrol archive, IMEC). The film's commentary had been published before, in the Réseau du Souve-

308

nir's newsletter *La Voix de la Résistance*, February 15–March 15, 1956, and later in the film magazine *L'Avant Scène*, no. 1, February 1961, 51–54.

56. Cayrol and Durand, *Le Droit de regard*, 21.

57. Alexis Nouss, "Parole sans voix," in *Dire l'événement, est-ce possible? Séminaire de Montréal, pour Jacques Derrida* (Paris: L'Harmattan, 2001), 74. Giorgio Agamben, *Ce qui reste d'Auschwitz* (Paris: Payot et Rivages, 1999), 207.

58. "How to return to a background?" wrote Cayrol in the first pages of his autobiography, *Il était une fois Jean Cayrol*, 10.

59. Cayrol and Durand, *Le Droit de regard*, 20.

60. Ibid., 22 and 23.

61. J. Cayrol quoted in Basuyaux, "Écrire après," 479.

62. Cayrol and Durand, *Le Droit de regard*, 20.

63. "The concentration camps were experienced differently by their victims. Some died there, others died slowly for being unable to return" (Cayrol, *Pour un romanesque lazaréen*, 47, Fayard edition). In analyzing the articulation of time in Cayrol's works, M.-L. Basuyaux quotes from one of Roger Vrigny's interviews with the author (June 13, 1970): "A *kapo* told me: 'Here ... there is no past, no present, and no future.... You can only live in the current moment.' ... The current moment contained the past, the present, and the future all at once.... These are experienced together, in the same instant ... perhaps all literature is precisely this gathering of everything, you write with everything." The author added: "It is hard to ignore how Cayrol transforms the *kapo*'s statement, when it seemed like he merely adopted it. Far from conforming to the original statement, which excludes the camp from any idea of past and future ('no past, no present, and no future'), Cayrol rephrases this and gives it a meaning of inclusion, of an absolute compression ('contained the past, the present, and the future') which culminates in a precise superimposition ('experienced together, in the same instant'). We see here how he turns the concentration camp into the location of a unique temporal experiment: that of concentrated time. In this sense, the camp is not only a place of human concentration, but also of a concentration of existence: a whole lifetime, with its past as well as its possibilities, is contained in each day." "Écrire après," 320.

64. Cf. Pinel, "Fiche filmographique."

65. Cayrol and Durand, *Le Droit de regard*, 93.

66. These hesitations and modifications can be read in an early version of Cayrol's commentary annotated by Olga Wormser, held in the Réseau du Souvenir's archives (AN 72AJ2160) and in a typescript kept at the Bibliothèque Nationale (MY1858). At the end of this document, Resnais added the following note: something "missing: it's not our task to judge another nation."

67. Handwritten annotation—possibly by Chris Marker—on the first page of the first draft of the epilogue (typescript, Bibliothèque Nationale, MY1858).

68. Ibid., 19.

69. Pierre Bouretz, "Les intellectuels et l'anticolonialisme 1944–1954: Situation des *Temps Modernes*," thesis, Institut d'Études Politiques de Paris, 1983, 83.

70. In *Le Droit de regard*, Cayrol and Durand write that "cinema is not only entertainment but also a warning," 17.

71. *Les Lettres françaises*, February 9, 1956. Cayrol's anticolonial commitment was as strong as Resnais's, who signed the *Manifeste des 121*. In his autobiography, Cayrol pokes fun of the behavior of colonists: "I come from a time when we had colonies, when losers could go far away to recapture their virginity and act like men of intellect and reason. How many times have I overheard these people returning from Indochina! They had boy-slaves for every hour of the day, grew tangerines, did a bit of trafficking on the dollar, brought back lacquered screens; they played bridge among educated people; they lived in luxury over the backs of the poor they ignored. Unfortunately, like in Algeria, they also put barbed wire around their villas" (Cayrol, *Il était une fois Jean Cayrol*, 190). And later: "I wore a red rose in 1936 and the Croix de Lorraine in 1940, I had an insult on my tongue at General Ridgway's passage, death on my lapel during the Algerian War, and shame on my forehead during the Vietnam War. I wrote an editorial called 'Sacre et massacre' in *Esprit* about the Korean War" (ibid., 200).

72. *L'Express*, January 31, 1956. Resnais told R. Raskin: "We were in France during the Algerian War, which was just beginning to be felt at home. You had these zones in central France where there were holding camps—okay, they were not concentration camps—but where passing drivers were not allowed to stop their cars. They had gendarmes and everything. So we made a film, or I did in any case, with this idea that these things were happening again in France. You see, there was a viewpoint and I had all the more reason to be afraid, with all these 'monuments to the fallen' and 'everyone agrees on this terrible past that must never happen again.' Well, I felt that it could happen again." Raskin, *"Nuit et brouillard" by Alain Resnais*, 51.

73. Cayrol and Durand, *Le Droit de regard*, 21.

74. Minutes of general assembly of December 19, 1953, report of the artistic committee (Réseau du Souvenir archives, AM 72AJ217). In his letter dated January 18, 1954, to the chairwoman of the ADIR, Mrs. Delmas, in which he asked her to sign the foreword to *Tragédie de la Déportation*, Paul Arrighi presented the Réseau's mission in the following words: "It is a duty for the Réseau, whose sole objective is to preserve by the pen, by the word, on the screen, in stone, and in metal, mention of that epic tragedy that was the Deportation" (AN 72AJ2159).

75. Cayrol and Durand, *Le Droit de regard*, 77.

76. Broadcast France Culture.

77. Jean-Paul Sartre, *Situations III* (Paris: Gallimard, 1949), 24.

8. EISLER'S NEVERENDING CHANT

1. Copy of a letter from Dauman to Muszka, November 30, 1955. Institut Lumière.

2. In 1951, as Suzanne Liandrat-Guigues and Jean-Louis Leutrat point out, Chris Marker directed *L'Homme et sa liberté* (a montage of texts by Prévert) for the Spartacus group, in which Eisler participated (*Alain Resnais: Liaisons secrètes, accords vagabonds*, 214).

3. He began in 1917.

4. Feyder: *Le Grand jeu;* Dudow: *Kuhle Wampe;* Lang: *Hangmen Also Die!;* Renoir: *The Woman on the Beach;* Ivens: *New Earth; The 400 Million; Rain.*

5. Adorno and Eisler, *Composing for the Films* (New York: Oxford University Press, 1947).

6. The producer also sent Eisler a letter on October 18, 1955, which listed Resnais's "celebrated short films" and outlined the form and intention of the film "on the Nazi concentration camp system," emphasizing that it enjoyed "the unanimous support of Deportee Federations." In a letter dated November 3, Dauman presented Eisler the terms of his contract: "It goes without saying that the conditions we are eager to offer you far surpass what is customary in the area of short film making, given your personality and your travel and accommodation expenses. Instead of limiting you to the usual copyright benefits of the use of your score, as defined and received on your behalf by Sacem, we would like to offer an additional sum of 200,000 francs, which you will receive in its entirety upon arrival in Paris." Institut Lumière.

7. Alain Resnais and Édouard Pfimmer, "Für Hanns Eisler" in *Sinn und Form*, "Sonderheft Hanns Eisler," Berlin, 1964, 372.

8. Handwritten letter, November 8, 1955. Institut Lumière.

9. Where he was welcomed by countrymen who had previously made the move to the United States, including Marlene Dietrich and Ernst Lubitsch. In California, Eisler was reunited with Adorno, Brecht, and his former master Schönberg.

10. See KÖSTER, Maren, Musik–Zeit–Geschehen: Zu den Musikverhältnissen in der SBZ/DDR 1945–1952 (Sarrebruck: PfauVerlag 2002). Eisler would die in East Berlin in 1962.

11. Cf. Albrecht Dümling, "Musikalischer Kontrapunkt zur filmischen Darstellung des Schreckens. Hanns Eislers Musik zu 'Nuit et Brouillard' von Alain Resnais" in *Kunst und Literatur nach Auschwitz*, ed. Manuel Köppen (Berlin: Erich Schmidt, 1993), 113–23.

12. Interview with Ida and André Pozner, broadcast France Culture.

13. André Pozner, ibid.

14. Ibid.

15. Thomas, *L'Atelier d'Alain Resnais*, 256.

16. Interview with Alain Resnais by R. Raskin, *"Nuit et brouillard" by Alain Resnais*. Introducing *Night and Fog* for a 1987 television broadcast, Michel Pollac was of the opinion that "You will perhaps be surprised like me by the music, which forms the only aspect that seems dated." (TF1, *Droit de réponse*, May 16, 1987).

17. As Arnaud Desplechin suggests, the music ensures "that transmission continues." Frodon, ed., *Cinema & the Shoah*, 123.

18. Cayrol and Durand, *Le Droit de regard*, 98.

19. To use Henri Colpi's expression.

20. Eisler used the expression "mickeymousing" to describe the musical imitation of visual, rhythmic action.

21. In *Musique et société: Essais choisis et présentés par Albrecht Betz* (Paris: Éditions de la Maison des Sciences de l'Homme, 1998, 153), Eisler provides some examples of these conventions and presumptions: "A mountain view inevitably suggests a tremolo of strings with a horn motif; morning scenes, particularly on a ranch, demand some sylvan magic à la Wagner, with a flute solo; lakes, especially in the moonlight, are reduced to a waltz" (149). Later, the composer analyzes with a good deal of humor the perverse effects of musical illustration on our codes of perception: "When we hear a simple quarter note, it always announces a march, usually military, independent of the composer's intention. . . . Our ears and senses are no longer free. Even today, this process continues under the influence of conventional film music. The use of old models developed by the classic masters and now reduced to clichés retroactively imposed these associations on naive listeners. Today, a symphony sounds like the kind of music one hears in film titles and credit sequences; it is as if a tourist, when encountering a lion in the jungle, expected its roar to be followed by those mythical words projected onto the sky: 'MGM Presents!'"

22. Resnais and Pfimmer, "Für Hanns Eisler."

23. Ibid.

24. Dümling, "Musikalischer Kontrapunkt zur filmischen Darstellung des Schreckens."

25. Ibid.

26. An ensemble of notes constantly repeated. Correspondence with the author, July 9, 2006. I thank Vivien Villani for her attentive proofreading of this chapter.

27. Dümling, "Musikalischer Kontrapunkt zur filmischen Darstellung des Schreckens."

28. *Entretiens avec: Jean Cayrol*, broadcast France Culture, June 19, 1970.

29. Pinel, "Fiche filmographique." Eisler gave this melody a name: "To the Funeral," in reference to the funeral march in Beethoven's third symphony. Cf. Jürgen Schebera, "Musik und Politik: *Nuit et Brouillard*" in *Hanns Eisler—Komposition für den Film*, ed. Christian Kuntze (Berlin: Freunden der Deutschen Kinemathek Berlin-W, "Materialen zur Filmgeschichte no. 12," 1982).

30. Günter Mayer, CD liner notes, *Hanns Eisler Orchesterwerke II* (Berlin Classics, 1996).

31. On the sequence devoted to the political organization of the camp, cf. Harald Olkus, "Historische und filmische Analyse von *Nuit et brouillard* von Alain Resnais" (master's thesis, Freie Universität Berlin, September 1995), 73.

32. The three passages borrowed from the stage score correspond to the following sections of the commentary: "Train doors locked, deportees hud-

dled a hundred a wagon, no day, no night, thirst, asphyxiation, madness." "Nothing distinguished the gas chamber from an ordinary block. Inside, a fake shower room awaited the new arrivals." "When the crematoria can no longer cope, they build pyres. The new ovens nevertheless absorbed thousands of bodies every day." I thank François Porcile for his precise spotting and André Heinrich for drawing my attention to this aspect of the score.

33. On the playwright's exile in the Soviet Union, see Giorgi Dimitrov, *Journal 1933–1949* (Paris: Belin, 2005). The author discusses the matter on pages 575, 602, 619, 696, and 705–6. Regarding the pamphlet ("Deutsche Sendung") Becher wrote in the USSR, Dimitrov notes having explained to the playwright that it was not "politically just to present the German people as being," in their entirety, "deplorable, with nefarious and dangerous characteristics." Dimitrov added: "It is necessary to make a distinction and to show the positive qualities inside the German people, upon which the German people can build and liberate themselves from Hitler's ilk. . . . What is needed is earnest national self-criticism, not unbridled self-flagellation" (752).

34. Manfred Wekwerth in *Hanns Eisler Heute. Berichte—Probleme—Beob-achtungen* (Berlin/DDR, 1974). Quoted by Mayer.

35. Eisler, *Musique et société*, 143–44.

36. Dümling, "Musikalischer Kontrapunkt zur filmischen Darstellung des Schreckens," 120.

37. In September 1954, before writing the score to *Winter Battle*, Eisler composed the stage music for *Hamlet* performed at the Neues Theater in Vienna. However, the idea to connect Shakespeare's text with World War II for *Winter Battle* was supposedly inspired by Karl Krauss's book *Weltgericht*, in which the author refers to Horatio's lines to evoke the disastrous consequences of World War I, the ruins of a regime, and the need to rebuild over a devastated era: "If this is not a decisive turn, then the world knows none."

38. William Shakespeare, *Hamlet*, act 5, scene 2, lines 380–88.

39. Like a ghostly reappearance, Kluge incorporates images from the Russian front and the battle of Stalingrad into his film. For more on this film, see chapter 15. There exists another echo of Eisler's score in Resnais's oeuvre. In analyzing Giovanni Fusco's music for *Hiroshima Mon Amour*, Henri Colpi notes the following: "There is a surprising encounter in the museum scene, which has certain analogies with the universe of the concentration camp. A brief motif resurges whose first bars repeat almost identically a theme from *Night and Fog*. Yet, the Italian composer Giovanni Fusco had never seen the film on the death camps or heard Eisler's score. 'Not so surprising,' he said, 'it is Resnais who guides the musician's hand.'" Henri Colpi, *Défense et illustration de la musique dans le film* (Lyon: Serdoc / Société d'édition de recherches et de documentation cinématographiques), 130. In *L'Atelier d'Alain Resnais* (270), the filmmaker talks about the "mystery" of this piece of music: "How could it be that Giovanni Fusco wrote, for the museum scene at the start of *Hiroshima Mon Amour*, a theme that is almost identical to the one Hanns Eisler used in *Night and Fog*, when Fusco had never

seen *Night and Fog?* Maybe they both drew from something that already existed? It's eerie."

40. Dümling, "Musikalischer Kontrapunkt zur filmischen Darstellung des Schreckens."

41. Later renamed Bundeszentrale für Politische Bildung.

42. This version is kept at the Bundesarchiv-Filmarchiv in Berlin.

43. According to Ida Pozner, Eisler only accepted with hesitation and took care to write music to which one could not march. Broadcast France Culture.

44. Georges Delerue confirmed this anecdote and remembered that it concerned a horn and not a clarinet. He added that Eisler, after requesting that the remark be translated, replied to the musician: "My music is not an operetta." (Interview with Delerue by François Porcile.)

45. Jacques Doniol-Valcroze, *Cahiers du cinéma*, no. 59, May 1956.

9. TUG OF WAR WITH THE CENSORS

1. Subcommittee meeting. Unless otherwise indicated, all documents cited below (on the films *Night and Fog, Guernica,* and *Statues Also Die*) originate from the archives of the "Commission de contrôle des oeuvres cinématographiques" kept at the CNC (film classification board). I thank Sylvie Hubac and Pierre Chaintreuil for allowing me to consult them.

2. The chairmanship of which had been largely limited to the minister of National Education, André Marie.

3. AN 72AJ695.

4. Joined by the representatives of the Defense Department, Public Health, and Family Associations.

5. This discovery was made in November 2012 by Catherine Thion, head of research at the Cercil. On the back of the original photograph provided by the CDJC, the camp is mentioned as being Pithiviers.

6. Shot 39.

7. The application of the law of July 3, 1945, installing the control of cinematic works on a permanent legal basis met with no opposition, thanks to a general consensus on what was deemed presentable and to the liberal step forward this law presented. In fact, while it made the circulation of films subject to the reception of a *visa d'exploitation* delivered by the supervising ministry, the latter had to consult the opinion of a board consisting of an equal number of civil servants and film professionals. In the case of French films, the minister could take no action harsher than that suggested by the board. In this sense, the principle of equal representation formed a step forward. It is no coincidence, therefore, that from March 1948, in a growing Cold War climate, the Ministry of Information sought to modify this balance. The successive, stealthily made changes to the board's membership provoked a mass walkout of film professionals on May 3, 1950. While redressing the balance calmed the waters a year later, tensions persisted and would come to a head in several emblematic cases, including André Cay-

atte's *Before the Deluge,* Claude Autant-Lara's *The Game of Love,* and Louis Daquin's *Bel ami.*

8. Administrative memo dated February 16, 1954, to the Ministry of Information (AN F4123718A).

9. At the request of the representative for German and Austrian Affairs.

10. See chapter 11.

11. The film's censorship file (CNC archive) and archive of the ministry of Information (AN F4123718A).

12. Letter by the minister for Overseas Territories, April 14, 1953 (AN F4123718A), signed on behalf of the minister (Louis Jacquinot) by his chief of staff, J.-N. Adenot.

13. Letter by Henry de Ségogne to Tadié-Cinéma, July 31, 1953. The board reconvened on July 8, 1953, to discuss the complete deletion of the film's third reel, but did not go to this extreme due to the absence of some of its members.

14. In the draft, this third part was entitled "Palingenesis."

15. One of the film's premises was the following question: why can Greek and Egyptian art be admired in the Louvre, while African art is presented in the Musée de l'Homme, thereby confining it to the domain of ethnography?

16. Alain Resnais quoted in Jean-Luc Douin, *Dictionnaire de la censure au cinéma* (Paris: PUF, 1998), 380.

17. Transcript of the commentary submitted to the *commission de contrôle,* kept in the censorship file.

18. To borrow Robert Benayoun's expression in *Alain Resnais arpenteur de l'imaginaire,* 49.

19. Like the images of Pope Pius XII or of François Mitterrand's official visit to North Africa, probably taken from newsreels and accompanied by a completely different sort of narration.

20. The chairman's voice was decisive in case of a tie vote.

21. Spoken questions of January 11, 1955, *Journal Officiel* of January 12, 1955. Intervention also mentioned in the memo the CNC sent to the Ministry of Information on January 11, 1955 (AN F4123728A). Sédar Senghor belonged to the collective Présence Africaine, which commissioned the film.

22. Author's italics.

23. The film was finally passed on January 3, 1957, in a version with its final part truncated, but the possibility of an uncensored noncommercial release was refused. In June 1961, the president of the Conseil de la République of Senegal, Mamadou Dia, sent a plea to Minister of Culture André Malraux, who forwarded it to his colleague at Information, Christian de la Malène, who saw no reason to revise the board's decision. In July 1962, André Tadié again addressed the supervising minister, arguing that the film now only represented "a historical character" as a result of "the evolution of events." Alain Peyrefitte, who answered by means of a letter on July 25, disagreed: "I have had the film screened to me and ... it strikes me as unwelcome

to revise the decisions taken by my predecessors." After a second screening in October 1964, the same Alain Peyrefitte decided to allow the film's distribution in an unexpurgated edition (Ministry of Information, AN F412383B).

24. All the more because the censorship, restricted to this one cut, posed no threat to the film's distribution.

25. Interview with Jean-Luc Douin, in *Dictionnaire de la censure au cinéma*, 379.

26. The same year *Night and Fog* was awarded the gold medal at the Grand Prix du Cinéma Français.

27. See *L'Express*, January 31, 1956; *Les Lettres françaises*, February 2–8, 1956; *L'Humanité*, February 5, 1956. The last two publications habitually opposed film censorship, which often showed open hostility toward Soviet cinema and communist filmmakers (such as Louis Daquin).

28. *L'Humanité*, February 5, 1956. The critic at *Combat* (February 2, 1956) wrote: "Night and Fog should be shown on television. Fear? Fussy government? In any case, the film was banned . . . for lack of authorization."

29. Weill, *Contribution à l'histoire des camps d'internement dans l'anti-France.*

30. In the film's shot sequence, the photograph from Beaune-la-Rolande is captioned as "Pithiviers Camp. Agence Fulgur 46 rue Laffitte 'authorized by censor May 7, 1941.'" The date was in fact May 17, as the indication on the back of the photograph (which can be consulted at the CDJC, CIII-53) shows. For more on Parisian press agency Fulgur, see Françoise Denoyelle, *La Photographie d'actualité et de propagande sous le régime de Vichy* (Paris: CNRS Éditions, 2003), 198 ff.

31. CHDGM (AN 72AJ679).

32. *Revue de l'Histoire de la Deuxième Guerre Mondiale*, 3. Ten years later, in his book *Vichy, année 40*, the historian suggested that the autonomy of the state of France was the "result of specific and indigenous anti-Semitism." Even before the publication of Paxton's epoch-making book, "the regime's anti-Jewish politics" emerged from its "status as a side note" to be "integrated into the global analysis" (Poznanski, "L'historiographie de Vichy," 60). Henri Michel, *Vichy, année 40* (Paris: Robert Laffont 1966); Robert O. Paxton, *Vichy France: Old Guard and New Order, 1940–1944* (London: Barrie & Jenkins, 1972). The French translation of German historian Eberhard Jäckel's important volume *La France dans l'Europe de Hitler* was published by Seuil in 1968, which according to Henry Rousso was too early for it to receive any recognition or success in France (cf. *Le Syndrome de Vichy*, 286 ff.).

33. Such a photograph had been presented at the exhibit at the Musée Pédagogique.

34. The commemorative plaque placed at Beaune-la-Rolande in the 1950s at the initiative of the Amicale des Anciens Déportés Juifs de France reads: "Here were detained by Hitler's occupation forces on May 14, 1941, several thousand Jews subsequently deported to Germany, where most perished. Never forget." Text cited in Barcellini and Wieviorka, *Passant, souviens-toi!*, 460.

35. The text was submitted to the board in the following form: "We would like to alert the viewer's attention to the tragic nature of the documentary *Night and Fog* on the Nazi concentration camps. Certain scenes in this short film are both tragic and horrific, and therefore particularly painful. Images of suffering and dead bodies are likely to strongly affect children and the sensitive." In its letter of March 2, 1956, the board demanded that this warning also be shown before the film's credit sequence. Was this wish carried out in the first reels upon its release in cinemas? The warning message is not present in any of the prints of the film currently known to be in existence, but it did feature on the posters printed for the film's original commercial release in 1956.

36. A study of several case files of the 1950s demonstrates that the representatives of distributors, exhibitors, producers, and the UNAF (Union des Familles) voted, like the representatives of public services, in favor of partial censorship of certain films.

37. Letter dated March 2, 1956.

38. *France-Observateur,* April 12, 1956.

39. *Les Lettres françaises,* April 12, 1956.

40. To borrow Henry Rousso's expression in *Le Syndrome de Vichy.*

41. *Le Monde,* December 19, 1979.

42. *Le Canard enchaîné,* December 19, 1979.

43. The program *Libre Court* (FR3, May 9, 1997) presented the "new version" of the film for the first time, accompanied by an interview with Alain Resnais. During this conversation, Resnais declared himself shocked: "I wonder whether this formulation isn't simply meant to attract customers.... I asked if they could replace that sticker with 'And featuring for the first time the gendarme's kepi.'" This part of the interview was cut from the final edit, but it was shown on the program *Metropolis* (Arte, May 24, 1997). Inathèque de France.

44. *Libre Court* (FR3, May 9, 1997); *Metropolis* (Arte, May 24, 1997); *Le Cercle de Minuit* (FR2, May 24, 1997). A first reference to the censorship of the gendarme happened in the evening news of April 18, 1992, on the TF1 network, devoted to the exhibit "Le Temps des rafles" (The era of roundups). The report by Corinne Lalo ends with the camera panning left to right over the famous photograph, accompanied by the following narration: "To not obscure the past, like this memory from the 1950s, this photograph from the film *Night and Fog,* which was censored because on the left it shows a gendarme's *kepi.*" Inathèque de France.

10. THE CANNES CONFUSION

1. Among whom were Pierre Braunberger, Henri Calef, Nino Frank, Jacques Doniol-Valcroze. Filmmaker Jean Dréville chaired the committee.

2. Brassaï's *Tant qu'il y aura des bêtes* replaced it in the official selection. The committee had suggested this film for an invitation (even though invitations did not fall under its jurisdiction). Not content to meddle in the

committee's choices, Lemaire suggested inviting the short film *Nuits royales*, a documentary on sound and light events under the French monarchy. This initiative was interpreted as a provocation. Confronted with the critics' venom, its producers, Élisabeth and Georges Freedland, announced on April 18 that they would withdraw their film, declaring that they could not envisage "taking a comrade's place."

3. Jean Dréville's viewpoint was published in *Les Lettres françaises* on April 12, 1956.

4. See in particular Simone Dubreuil, "Dialogue autour d'une interdiction," *Les Lettres françaises*, April 12, 1956. *L'Express*, April 13, 1956.

5. *L'Information*, April 10, 1956; *La Croix*, April 15–16, 1956; *Le Monde*, April 10, 1956; *L'Humanité*, April 9, 1956; *Libération*, April 9, 1956. In his interview with Richard Raskin, Alain Resnais mentioned that deportees from Nice and Cannes had threatened to parade in their deportee outfits on the steps of the Palais as a sign of protest. *"Nuit et brouillard" by Alain Resnais*, 63.

6. In particular in *Le Monde* of April 10, 1956, and *La Croix* of April 15–16, 1956. The different drafts of this question are kept at the Centre d'Études Edmond Michelet, and the final text was widely reprinted in the media. Yet, there is not a trace of it to be found in the *Journal Officiel* (see on this topic Sylvie Lindeperg, "Cinéma, mémoire, histoire. Étude réalisée à partir de deux films d'Alain Resnais: *Nuit et Brouillard, Hiroshima mon amour*," doctoral dissertation (supervisor: Jean-Pierre Azéma, IEP de Paris, September 1987).

7. Drafts of his intervention show that the senator initially intended to address the issue more directly by asking whether the film had indeed been "banned at the German's embassy's request." I thank Patricia Reymond (Centre d'Études Edmond Michelet) for supplying these documents.

8. He was, as we have seen, one of the original members of the Réseau du Souvenir.

9. See *Franc-Tireur*, April 13, 1956.

10. "My German friends, what do you think of this attack on our friendship, for it truly is an attack, isn't it, dear Heinrich Böll, since they take away what united us: this same disgust with the degradation and humiliation of man. They are suppressing our common protest," *Le Monde*, April 11, 1956.

11. Sent to the AFP on April 11 and widely reported in the media the following day.

12. Film banned by military censorship on April 12, 1945, cf. Lindeperg, *Clio de 5 à 7*, 194–95; see also the correspondence between the minister of information's staff and Léo Figuères (Bureau National de l'Union de la Jeunesse Républicaine de France), who objected to the ban (letter of April 16, 1956, and reply, AM F4123788B). For more on this film, see Liebman, "La libération des camps vue par le cinéma."

13. *Le Monde*, April 13, 1956.

14. Foreign Ministry archive, Minister C. Pineau's staff, no. 36.

15. *Les Lettres françaises*, April 12, 1956.

16. See chapter 3.

17. "La succession revendiquée," in *L'Humanité*, April 13, 1956.

18. See Alfred Grosser, *La IVe République et sa politique extérieure* (Paris: Armand Colin, 1967), 193 ff.

19. *Le Républicain Dinan*, April 19, 1956.

20. Extract from a communiqué by the Réseau du Souvenir, notably published in *Libération*, April 16, 1956.

21. The term "SS" is mentioned nine times, "Nazi" four times.

22. *Le Parisien libéré*, April 9, 1956.

23. Quoted in *Libération*, April 9, 1956.

24. *L'Observateur*, February 21, 1954. Among the rare voices to raise the Algerian issue and the distortion of the resistance heritage were former deportees Joseph Rovan (*Témoignage Chrétien*, April 13, 1956) and Pierre Daix (*Les Lettres françaises*, April 12, 1956).

25. In *Libération* (April 12, 1956), critic Jeander openly accused both ministers, while *Combat* (April 14, 1956) headlined: "The *Night and Fog* affair affects Mr. Pineau."

26. Letter from P. Arrighi to C. Pineau, April 11, 1956, Réseau du Souvenir (AN 72AJ2160). Arrighi also contacted Guy Mollet, Mendès-France, Mitterrand, Chaban-Delmas, Tanguy-Prigent, Masson, Champaix, and Bourges-Maunoury. The correspondence is kept in the Réseau du Souvenir archives.

27. Letter of April 13, 1956, ibid.

28. Foreign Ministry, Pineau staff.

29. Ibid. With Edgar Faure also absent, it was finally François Mitterrand who introduced the screening.

30. Association Nationale des Familles de Résistants et d'Otages Morts pour la France (ANFROMF); Association Nationale des Familles de Fusillés et Massacrés de la Résistance Française (ANFFMMRF); Association des Déportées et Internées de la Résistance (ADIR); Fédération Nationale des Déportés et Internés de la Résistance (FNDIR); Fédération Nationale des Déportés, Internés Résistants et Patriotes (FNDIRP); Réseau du Souvenir; Union Nationale des Associations de Déportés, Internés et Familles (UNADIF).

31. *France-Observateur*, April 19, 1956.

32. In a letter to Paul Arrighi, Marie-Elisa Nordmann-Cohen, chairwoman of the Amicale des Déportés d'Auschwitz, suggests accepting this compromise (letter dated April 19, 1956, AN 72AJ2160). The exchanges between the Réseau and the various associations and federations demonstrate that the struggle against the film's withdrawal was fought as a united front and with mutual consultation.

33. Particularly the Guingouin affair of 1953. See Fred Kupferman, *Les Premiers Beaux Jours* (Paris: Calmann-Levy, 1985); Rousso, *Le Syndrome de Vichy*; Paul-Marie de La Gorce, *Naissance de la France moderne: L'Après-guerre 1944–1952* (Paris: Grasset et Faquelle, 1978).

34. See chapter 11.

35. Written question of April 19. Parliamentary debates, Assemblée Nationale, *Journal Officiel*, 1956.

36. Archives now in the possession of the Bibliothèque du Film (Bifi) and currently being inventoried, year by year. I thank Valdo Kneubühler, Régis Robert, and Marc Vernet for allowing and facilitating access to the archives for the year 1956.

37. Loredana Latil, "La création de l'exposition cinématographique cannoise en 1939," in *Cahiers de la Méditerranée*, vol. 62, and *Le Festival de Cannes sur la scène internationale* (Paris: Nouveau Monde Éditions, 2005).

38. Also awarded was the propaganda film *Luciano Serra Pilote* by Goffredo Alessandrini.

39. "Comment naquit le Festival de Cannes," catalogue for the Festival de Cannes's fortieth anniversary, 1946–1986, Édition du FIF, 270. See also Latil, "La création de l'exposition cinématographique cannoise en 1939."

40. See Philippe Erlanger, *La France sans étoile: Souvenirs de l'Avant-guerre et du temps de l'Occupation* (Paris: Plon, 1974), 105 ff.

41. "Comment naquit le Festival de Cannes."

42. Here is an incomplete indication of the films related in some way to World War II presented in Cannes in 1946. France: *Réseau X* (short), *Mr. Orchid*, *The Battle of the Rails*. Switzerland: *GIs in Switzerland* (short), *Prisonniers de guerre* (short), *The Last Chance*. USSR: *Berlin* (short), *The Turning Point, Girl No. 217*.

43. See Latil, "La création de l'exposition cinématographique cannoise en 1939" and *Le Festival de Cannes sur la scène internationale*, 105–17. During the postwar period, the organizers were particularly concerned with gaining U.S. interest in the festival. See also Vanessa R. Schwartz, *It's So French! Hollywood, Paris, and the Making of Cosmopolitan Film Culture* (Chicago: University of Chicago Press, 2007).

44. Letter dated March 27 to Michel Plouvier, minister of trade and industry (Bifi, FIFA 425B73).

45. This fiction film tells the story of a Yugoslavian deportee who escapes from a concentration camp and reaches the Swedish border thanks to a Norwegian family of lumberjacks.

46. Festival regulations for the year 1955.

47. The festival did not take place in 1948 and 1950: in the former case officially due to lack of funds; in the latter case a delay in the construction of the Palais de la Croisette.

48. Letter from the head of Cultural Relations to the minister's staff, March 1, 1956, Foreign Ministry.

49. The Unifrance Film (UFF) organization was founded in 1949 by a group of film producers, with the aim of promoting French film abroad and to facilitate contact with film professionals around the world.

50. Underlined in the original text. This emphasis regarding *Night and Fog* was added manually by Jacques Flaud, in a note at the bottom of the typed letter. Note by Jacques Flaud for the president of the FIF to Robert Favre Le Bret, March 26, 1956 (Bifi, FIFA 425B73).

51. Letter dated March 27, 1956, to Michel Plouvier (Bifi, FIFA 425B73).

52. According to the critic Jeander, who had just interviewed the producers at Argos, *Libération*, April 12, 1956.

53. Broadcast France Culture.

54. Letter from the cultural attaché of the West German embassy, Dr. V. Tieschowitz, to Favre Le Bret, April 11, 1956 (Bifi, FIFA 424B72).

55. See chapter 11.

56. Guy Desson confirmed again that "the German embassy unofficially intervened."

57. Foreign Ministry archives, C. Pineau staff.

58. Several German historians have tried, so far in vain, to discover traces of these negotiations. The archives of the German embassy in Paris were destroyed in 1965. See Walter Euchner, "Unterdrückte Vergangenheitsbewältigung: Motive der Filmpolitik in der Ära Adenauer," in *Gegen Barbarei*, eds. Rainer Eisfeld and Ingo Müller (Frankfurt: Athenäum, 1989), 348, and Christoph Classen, *Bilder der Vergangenheit: Die Zeit des Nazionalsocialismus im Fernsehen der Bundesrepublik Deutschland 1955–1965* (Cologne, Weimar, Vienna: Böhlau Verlag, 1999), 91.

59. *Franc-tireur*, April 13, 1956.

60. Copy of C. Pineau's letter to M. Lemaire, April 10, 1956, Foreign Ministry, Pineau staff.

61. As historians of international relations have pointed out, it is not unusual that the culture within a ministry, created by relatively irremovable civil servants, proves stronger than the political will of certain ministers attempting to fight the traditional inertia in their departments. It is, however, rare that a minister would disown their services in the press, even off the record. What's more, as Alfred Grosser notes in his book *La IVe République et sa politique extérieure*, Christian Pineau had "very precise ideas about a minister's interaction with his subordinates, who were simply there to execute, while all the real power should belong to the politician."

62. Doniol-Valcroze, *France-Observateur*, April 19, 1956. Jeander, *Libération*, April 12, 1956. Jeander had already criticized the Cannes festival in 1946. In the same article he reminded his readers that Erlanger had run it "quite badly" at the time. The press also pointed with irony at Philippe Erlanger's double guise as historical adviser on Jean Delannoy's film *Marie-Antoinette*, in competition at the 1956 edition.

63. Desson, Erlanger, and Plouvier asked the Foreign Ministry for clear instructions to avoid the previous year's bungling. The three men made clear that they intended to assume their responsibilities "in accordance with the [minister's] instructions." Foreign Ministry archives, Pineau staff.

64. Board meeting, April 24, 1956, Bifi (FIFA 390B66).

65. Letter from Guy Desson to Christian Pineau, April 5, 1956, Foreign Ministry, Pineau staff, no. 36.

66. Jack Lee's *A Town Like Alice* deals with the Japanese occupation of Malaysia through the odyssey of a group of Brits. In a sign of the times, at the request of the Chinese embassy, in 1946 the Foreign Ministry demanded

that the word "Chinese" be replaced by "Japanese" to refer to a character of "oriental type" presented as an agent of the Nazis in Maurice de Canonge's film *Mission Spéciale*. Copy of the letter dated March 25, 1946, from the head of Cultural Relations to the minister of information (archives Foreign Ministry, Relations Culturelles 1945–1947 Œuvres diverses, Box 243).

67. Board meeting, April 13, (FIFA 388B66).

68. *Genbaku no ko*, feature film by Kaneto Shindo.

69. *Himmel ohne Sterne*. Käutner is also known for directing *The Devil's General (Der Teufels General)*.

70. Board meeting, April 26, Bifi (FIFA 390B66).

71. Letter from Favre Le Bret to Michel Plouvier, March 27, 1956, Bifi (FIFA 425B73).

72. Replacing Charles Chézeau, representative of the Fédération Nationale du Spectacle. I thank Valdo Kneubühler for all the information he supplied on FIF regulations and the composition of the administrative council.

73. *Tuntematon Sotilas*, a film by Edwin Laine. During the board meeting of April 26, Erlanger and Desson reported on their conversations with the Soviet delegation, who were of the opinion that "(1) the film is an indictment of their European policies; (2) they consider the role of the Russian officer, whom the French might consider sympathetic, as very unpleasant, since the act of supplying an East German woman with a pass to the West is a stand against Russian policy, which is unthinkable in a member of the armed forces." Bifi (FIFA 390B66).

74. Words reported by Jacques Flaud at the board meeting of April 24 (FIFA 390B66).

75. Minutes of board meeting of April 26 (FIFA 390B66).

76. *Pod Jednym Niebem*.

77. Board meeting of April 24, Bifi (FIFA 390B66).

78. Letter from Leonard Borkowicz to Guy Desson, dated April 28, 1956, Bifi (FIFA 426B74), and board meeting of April 27, 1956 (FIFA 390B66). The draft letter the FIF sent to Leonard Borkowicz indicates that while the film seems "admirable for both the quality of its images and the elevation of its narration, it nevertheless delivers a painful impression through its at once objective and stunning realism" (FIFA 426B74).

79. Minutes of board meeting of April 27 (FIFA 390B66).

80. Telegram of April 10, 1956. *Jan Zizka* formed the second part of director Otakar Vávra's trilogy, the first episode of which was *Jan Hus*. The director of *Dalibor* is Vaclav Krska.

81. Board meeting of April 27, 1956 (FIFA 390B66).

82. Article 3 stipulated that no film could compete that had already been released theatrically in Europe, aside from in its home country. *Sky Without Stars* had already been released in Holland and Switzerland.

83. The media scapegoat for this diplomatic blunder was Philippe Erlanger, harshly taken to task by Jeander, who made him the *deus ex machina* of the French–German affair:

"[The incident] seems to have been entirely constructed by Mr. Erlanger and only Mr. Erlanger.

"Blamed for the *Night and Fog* affair, he sought his revenge and got it.

"It is ridiculous and outrageous. It is ridiculous not only to refer to the famous article 5 of the Festival's regulations . . . given that *Sky Without Stars* is, like the road to Hell, paved with good intentions.

"It is even more ridiculous to withdraw it during the festival under the pretext that Mr. Erlanger is on edge. In any case it is an outrage to try and place the blame for the film's withdrawal on the Soviet delegation. We will no doubt return to this affair and to Mr. Erlanger" (*Libération*, May 1, 1956). This intentionally or unintentionally ill-informed article was read out at the April 28 board meeting. All board members supported Erlanger and decided to send a letter to *Libération*. The board did not, however, grant him his wish to publish a denial from the head of the Soviet delegation (who had in fact authorized him to publicize his unofficial protest).

Another victim of the affair was Helmut Käutner, who demonstrated impeccable elegance that went over the organizers' heads due to a case of faulty translation. On May 2, 1956, the filmmaker sent a telegram in which he declared regretting "greatly the German objection to *Night and Fog* and the departure of the German delegation due to the withdrawal of my film *Sky Without Stars*." A rushed translation misrepresented the meaning of his message, which now read: "regret greatly to protest against *Night and Fog* and against the departure of the German delegation due to the refusal of my film," Bifi (FIFA 424B72).

84. Letter from G. Desson to J. Flaud, dated May 1, 1956, Bifi (FIFA 424B72).

85. As explained in a memo from the Unifrance office in Germany to Cravenne, dated April 7, 1956, Käutner's film was selected at the request of the representatives of the film industry and against the opinion of a majority of the government representatives, which had voiced doubts about the suitability of the choice: "Bonn nevertheless decided not to veto the selection and to announce the film as Germany's official entry. However, the issue has since continued to preoccupy Bonn, following the opinion of secretary of state for the two Germanys, Mr. Thediek, who considers the method of treating the subject insufficiently adequate and likely to attract complications with the Eastern nations." CAC, 19760010, art. 43.

86. Dauman's letter to Muszka of May 7, 1956, Institut Lumière. Alain Resnais had more examples of Cannes diplomacy to look forward to: in 1959 *Hiroshima Mon Amour*, selected alongside *The 400 Blows* and *Black Orpheus*, was withdrawn by the festival organizers and subsequently screened out of competition on May 8, 1959 (see Lindeperg, "Cinéma, mémoire, histoire," 44–47). In 1966, *The War Is Over* (1966) was in turn removed after pressure from Franco's Spain (see Latil, "La création de l'exposition ciné-matographique cannoise en 1939," 127, 168).

This film had been subject to an earlier intervention from the Spanish government, as early as the scriptwriting stage, as a memo from the Ministry of Information indicates: "Our ambassador in Madrid was summoned to the Spanish Ministry of Foreign Affairs, and an adviser of the Spanish embassy had a meeting at our Foreign Ministry." The Foreign Ministry and the censor board examined the screenplay and decided not to intervene, though not without warning the producer of the "risk of cuts if the attacks on the Spanish government prove too fierce" and the risk of a possible export ban to certain countries. Memo by B. Cheramy, August 13, 1965, to the minister of information (AN F4123798B).

11. GERMANY GETS ITS FIRST LOOK

1. I am very grateful to Dominique Trimbur for her precious help with the chapters on Germany and for proofreading them so attentively.

2. Sozialdemokratische Partei Deutschlands (German social-democratic party).

3. Cayrol made a public appeal to Böll in *Le Monde* (see above), to which the German author replied by telegram on April 17, 1956: "Only tonight did I read your full statement in *Le Monde*. I will write again later. For now, you have this expression of my sympathy and friendship" (Jean Cayrol archive, IMEC).

4. Schallück was one of the cosignees, alongside Heinrich Böll and Eugen Kogon, of a declaration in favor of Alain Resnais's film. This text was published in Frankfurter Hefte, no. 11, 1956, entitled "'Nacht und Nebel'—Eine Erklärung" ("'Night and Fog'—A Statement"), quoted by Habbo Knoch, *Die Tat als Bild. Fotografen des Holocaust in der deutschen Erinnerungskultur* (Hamburg: Hamburger Edition, 2001), 526.

5. Quoted by Rémy Roure in *Le Monde juif, revue du CDJC*, June 1956.

6. Press compendiums consulted at Institut Lumière and in the Deutsches Rundfunkarchiv (DRA) in Babelsberg. Karl Korn was one of the first to react in the *Frankfurter Allgemeine Zeitung* of April 13, 1956: "When will we at last understand that the world will not sympathize with us as long as we do not fully sympathize with the moral values of a world that will not forgive us for dealing with mankind's most fundamental questions in an opportunistic way."

7. The *Neue Volkszeitung* of April 21, 1956, headed: "Identifiziert sich Bonn mit KZ-Verbrechen?" (Does Bonn identify with concentration camp crimes?)

8. *Das Parlament*, no. 17, April 25, 1956, 8. "Angeordnete Fragen-Minister antworten." This discussion was partially reproduced and translated into French in an article by René Wintzen in *Documents: Revue mensuelle des questions allemandes*, May 1956, 507–9.

9. Theodor Heuss, West Germany's first president, proposed this distinction between *Kollektivschuld* and *Kollektivscham* on December 7, 1949, in a speech held at Wiesbaden during "Brotherhood Week," arranged by West

German Jewish–Christian friendship organizations. He repeated the distinction in his speech at the unveiling of the Bergen-Belsen monument on November 30, 1952 (I thank Dominique Trimbur for this information).

10. As well the intellectual debate and critical examination of National Socialism that fizzled out after the immediate postwar years, as Jean Solchany noted in his book *Comprendre le nazisme dans l'Allemagne des années zéro (1945–1949)* (Paris: PUF, 1997). On questions related to the national-socialist past in German memory, see in particular: Norbert Frei, *Vergangenheitspolitik: Die Anfänge der Bundesrepublik und die NS-Vergangenheit* (Munich: Beck, 1996); Mary Fulbrook, *German National Identity After the Holocaust* (Cambridge: Polity Press, 1999); Pierre-Yves Gaudard, *Le Fardeau de la mémoire* (Paris: Plon, 1997); Jeffrey Herf, *Divided Memory: The Nazi Past in the Two Germanys* (Cambridge, London: Harvard University Press, 1997); Andréa Lauterwein, *Essai sur la mémoire de la Shoah en Allemagne fédérale (1945–1990)* (Paris: Odile Jacob, 1998); Régine Robin, *Berlin chantiers: Essai sur les passés fragiles* (Paris: Stock, 2001).

11. Robin, ibid., 41.

12. To borrow the title of Karl Jaspers' celebrated volume, *The Question of German Guilt* (New York: Fordham University Press, 2001).

13. Alfred Bauer nevertheless requested that the screening be officially organized by the "Congress for the freedom of Culture," to avoid rejuvenation by the communists. Around the same time, on August 17, 1956, the KPD was officially banned and dissolved.

14. Extract from a report of May 24, 1956, under the direction of Herbert Antoine, assistant to Senator Tiburtius , quoted by Wolfgang Jacobsen, in *50 Years Berlinale: Internationale Filmfestspiele Berlin* (Berlin: Filmmuseum Berlin—Deutsche Kinemathek, Nicolaische Verlagsbuchhandlung, Beuermann, 2000).

15. Letter by B. Guillonneau (Institut Français de Berlin) to Cravenne (Unifrance), dated May 24, 1956. Archives Nationales, CAC 19760010, art. 30. The letter ends as follows: "[I will tell Bauer] to not give this project any publicity, because if the French authorities definitely decide to not send the film, this could put Paris in a predicament, and a part of the press could latch on to the matter, and we can guess what kind of comments they will make."

16. Ibid.

17. In Bonn on June 30, 1956, and Munich in August 1956.

18. Organ of the German section of the European Youth Movement.

19. The results of the Bonn questionnaire (screening of June 30, 1956, at the Metropol Theater) were recorded by *Die Europäische Zeitung* (typed memo, DRA, Babelsberg). A partial French translation of the outcome was published in the magazine *Documents: Revue mensuelle des questions allemandes*, August 1956, 900–904. Unifrance also provided a translation based on the *Bulletin* of the Press and Information Office of the West German government (dated July 20, 1956); this document is kept in *Night and Fog*'s censorship file. The results of the Munich questionnaire were partially published in *Die Süddeutsche Zeitung* (Munich) and *Die Tat* (Frankfurt) on August 4, 1956. For

this book I have used and translated the questions and answers directly sup-
plied by *Die Europäische Zeitung*, with the valuable aid of my students at the
Freie Universität (Berlin) and my colleague Alexandra Schneider.

20. The Bonn panel consisted of thirty-odd journalists, a dozen deputies,
and a large number of employees and civil servants from ministries. The
largest group consisted of members of the student cine-club of Bonn Uni-
versity and students from Cologne.

21. Jean Neurohr (see article by Jean de Baroncelli, *Le Monde*, July 3, 1956).

22. Some of those questioned refused to answer the first question, ex-
plaining they could not judge the commentary because of their lack of
knowledge of the French language.

23. See Solchany, *Comprendre le nazisme dans l'Allemagne des années zéro*,
34–38.

24. Notably during the Nuremberg trials, see on this topic Lawrence
Douglas, *The Memory of Judgment: Making Law and History in the Trials of the
Holocaust* (New Haven: Yale University Press, 2001).

25. Between June 5 and 12, 1945, it was entirely devoted to the concentra-
tion camps.

26. Burger held the rank of lieutenant in the Psychological Warfare De-
partment. The film was produced by the Office of Military Government
(U.S.) and the Information Control Division. A first cut of 96 minutes was
judged too long. Wilder was given the task to reduce it to 22 minutes. On
the origins of this film, see the article by Jeanpaul Goergen, "Aufnahmen
beglaubigter Kameraleuter: *Die Todesmühlen*" in *Filmblatt*, no. 19/20, Spring–
Summer 2002, 25–31; Brewster S. Chamberlain, "*Todesmühlen:* Ein früher
Versuch zur 'Massenumerziehung' in besetzten Deutschland 1945–1946" in
Vierteljhefte für Zeitgeschichte, 29, 1981, 420–36; Kay Gladstone "Separate Inten-
tions: The Allied Screening of Concentration Camp Documentaries in De-
feated Germany in 1945–1946: *Death Mills* and *Memory of the Camps*" in *Ho-
locaust and the Moving Image*, 50–64.

The British commissioned Sidney Bernstein to direct the documentary
Memory of the Camps, which was abandoned in August 1945 by decision of
the Foreign Office (see chapter 6, note 63).

27. *Der Spiegel*, no. 33, 1992, 177, translated into French by Pierre-Yves
Gaudard, in *Le Fardeau de la mémoire*, 63.

28. Alexandre and Margarete Mitscherlich, *Le Deuil impossible* (Paris:
Payot, 1972), 41. These reactions are echoed in the reports of visits by Ger-
man civilians to the liberated camps organized by the occupying forces.
Christian Pineau described the procession of inhabitants of Weimar who
were forced to come to Buchenwald by American troops:

"A most curious spectacle, this compulsory pilgrimage! Men of a certain
age watch in horror, others in shame. Many women cry. The young, those in
their twenties, the most intoxicated, avert their eyes, indicating that they do
not wish to see. One of them, barely eighteen years old, sniggers when he
passes the oven. The American sergeant at his side slaps him upside the head,

hard enough to knock down an ox. The boy, violently shaken from his hostile dreams, suddenly becomes a child again." Quoted by Marie-Anne Matard-Bonucci, "Le difficile témoignage par l'image," in *La Libération des camps et le retour des déportés*, 65.

29. At the request of the Psychological Warfare Branch, "German Reactions to Nazi Atrocities" in *American Journal of Sociology*, September 1946, 141–46. Quoted by Clément Chéroux in *Mémoire des camps*, 122–23.

30. Inquiry quoted by Solchany, *Comprendre le nazisme dans l'Allemagne des années zéro*, 35–36.

31. Comments on the Bonn questionnaire only.

32. Partially adopted by the Press and Information Office of the West German government: thirty out of an original sixty.

33. The audience in Bonn consisted of: 18 people under twenty years of age (4.37 percent); 199 aged between twenty and thirty (48.30 percent); 87 aged between thirty and forty (21.11 percent); 51 aged between forty and fifty (12.38 percent); and 57 aged fifty or over (13.84 percent).

34. *Le Monde*, August 1, 1956, 8.

35. Among the eighteen viewers in Bonn under the age of twenty, seventeen considered the film objective and one had no comment. This was the only category of viewers that had not been directly exposed to the events, since they were no older than nine when the Third Reich surrendered.

36. The age bracket of almost half of the people who answered the questionnaire.

37. As Béatrice Fleury-Vilatte explains (in *Cinéma et culpabilité en Allemagne*), postwar German film production supplied diversion from the supposed aggressiveness of the former Western Allies by playing the Cold War trump card and stigmatizing the Soviet Union and the GDR, sometimes also by offering deflection from guilt by focusing on more recent crimes committed by the colonial powers (France chief among them).

38. *"Die Henker sind unter uns,"* wrote this viewer. Staudte directed *Die Mörderer sind unter uns (The Murderers Are Among Us)* in the Soviet-occupied zone after the screenplay had been rejected by the French and American authorities. Emblematic of the "cinema of the ruins" *(Trümmerfilme)*, it is considered the first—and for a long time the only—film to directly address the issue of the Nazi heritage and its persistence in defeated Germany. However, in her analysis, Béatrice Fleury-Vilatte is of the opinion that Staudte's characters do not confront the past so much as the perspectives offered by the future and the reconstruction (*Cinéma et culpabilité en Allemagne*, 34–35). Infused with the themes of remorse and error, Staudte's film at least invited German audiences to a critical examination of their recent past, contrary to the West German cinema of the 1950s. The East German films produced by Defa followed a resolutely antifascist route by conveniently placing the blame on West Germany.

39. Guidelines that judges, lawyers, and administrators were supposed to follow in applying these laws. Globke later stated in his defense that he had

written the commentary in such a way as to emphasize the strictness of these laws. His argument could not satisfy his critics, who argued that by agreeing to compose this text, even though he was not a Nazi, Globke legitimized them. See Dennis L. Bark and David R. Gress, *Histoire de l'Allemagne depuis 1945* (Paris: Robert Laffont, collection "Bouquins," 1992), 81. On the Globke affair, see "Braune Eminenz: Hans Globke und die Nürnberger Rassegesetze (1950–1963)" in Thomas Ramge, *Die großen Polit-Skandale: Eine andere Geschichte der Bundesrepublik* (Frankfurt: Campus-Verlag, 2003), 46–63.

40. A neighborhood in East Berlin that was the seat of the East-German administration, "Pankow" was also used pejoratively to designate the GDR without recognizing it. Another viewer remarked that he found the musical transformation of the "Deutschland Lied" inappropriate.

41. The presentation of the film at the Berlinale in 1955 had led to intense debate. Jacobsen, *50 Years Berlinale*, 59–60.

42. In July 1957, at the initiative of the Jungen Europäischen Föderalisten, *Night and Fog* screened in Hannover to tie in with the commemoration of the July 20 assassination attempt against Hitler. Upon its commercial release in Berlin, *Night and Fog* was paired with Wolfgang Kiepenheuer's *Ernst Reuter* (a portrait of the former exile and first mayor of West Berlin, who had risen to the occasion during the city's blockade). In Kiel, in March 1957, it was accompanied by *Evangelium in Stein*.

43. On West German films of the 1950s devoted to "military resistance," see Bernard Eisenschitz, *Le Cinéma allemand* (Paris: Nathan, 1999), and Fleury-Vilatte, *Cinéma et culpabilité en Allemagne*. Notable films include *Canaris* (Alfred Weidenmann, 1954), *The Devil's General* (Helmut Käutner, 1955), and *08–15* (Paul May, 1954–1955).

44. Sociological limitations, in addition to too broad a definition of age brackets, which did not allow for noting the effect of exposure to the event. The experience of Nazism cannot be considered identical for those who were nine years old in 1945 and those who were nineteen.

45. See chapter 15.

12. EXILE FROM LANGUAGE

1. Who at the time chaired the Parliamentary Committee for Film, Radio, and the Press.

2. See Thomas Heck and Peter Gossens, "'Nacht und Nebel' Ein Film wird übersetzt" in *Fremde Nähe. Celan als Übersetzer,* ed. Axel Gellhaus (Marbach: Deutsche Schillergesellschaft, 1997), 223–34. The authors note that Celan had visited the exhibit at the Musée Pédagogique and that the West German government had two hundred 16mm prints made for free loan. See also Ewout van der Knaap's chapter "Enlightening Procedures: *Nacht und Nebel* in Germany" in *Uncovering the Holocaust: The International Reception of* Night and Fog, ed. van der Knaap (London: Wallflower Press, 2006), 59, 83; and Jörg Frieß's essay "Das Blut ist geronnen. Die Münder sind verstummt?

Die zwei Deutschen Sychronfassungen von Nuit et Brouillard," in *Filmblatt*, no. 28, Autumn 2005, 40–57.

3. Cf. van der Knaap, "Enlightening Procedures," 56.

4. Letter from A. Dauman to Defa (GDR) dated November 13, 1957. Institut Lumière.

5. Cf. van der Knaap, "Enlightening Procedures," 58.

6. Bertolt Brecht would not have been able to complete the task, since he died in August 1956.

7. Bukovina formed part of the Habsburg Empire, then of Rumania, and of the Soviet Union. Today it belongs to the Ukraine.

8. Alexis Nouss, "Parole sans voix" in *Dire l'événement, est-ce possible?*, 71.

9. According to Bertrand Badiou, in Paul Celan and Gisèle Celan-Lestrange, *Correspondance, éditée et commentée par Bertrand Badiou avec le concours d'Éric Celan* (Paris: Seuil, Librairie du XXie siècle, 2001).

10. "Discours de Brême," in *Poèmes* (Le Muy: Éditions Unes, 1987).

11. Claude Mouchard, "'Ici'? 'Maintenant'? Témoignages et oeuvres" in *La Shoah: Témoignages, savoirs, oeuvres*, eds. Annette Wieviorka and Claude Mouchard (Vincennes: Cercil / Presses Universitaires de Vincennes, 1999), 253.

12. Gellhaus, ed., *Fremde Nähe*, 223–34.

13. Jean-Pierre Lefebvre, "Paul Celan traducteur des camps (sur cinq vers du poème 'Engführung')" in "Les Camps et la littérature: Une littérature du XXe siècle," *La Licorne*, 1999, no. 51.

14. With Andersch, also a member of the group (see chapter 11).

15. Including *Todesfuge* and *Ein Lied in der Wüste*.

16. See Lauterwein, *Essai sur la mémoire de la Shoah en Allemagne fédérale*, 127–34.

17. Ibid., 130.

18. See Andréa Lauterwein's analysis, ibid. The author also points out that while former members of the Nazi party were not allowed into the group, most of its participants had served in the Wehrmacht.

19. Letter from Dauman to Defa, November 2, 1956. Institut Lumière.

20. Walter Benjamin, "La tâche du traducteur" in *Œuvres I* (Paris: Gallimard, collection "Folio," 2000).

21. Sylvie Rollet, "Une impression fruedienne: Rejouer, déjouer la mort" in *L'Imprimerie du regard: Chris Marker et la technique*, eds. A. Habib and V. Paci (Montréal, Paris: L'Harmattan, 2007), 9; Walter Benjamin, "La tâche du traducteur," 244–62. The similarities between Celan's translation work and Benjamin's concepts of translation were suggested by Peter Szondi, "Poetik der Beständigkeit: Celans Übertragungen von Shakespeares Sonett 105" in *Schriften II* (Frankfurt: Suhrkamp, 1978).

22. See in particular Thomas Heck and Peter Gossens, "'Nacht und Nebel' Ein Film wird übersetzt"; Alexis Nouss, "La traduction mélancolique. (Sur Paul Celan)" in *Psychanalyse et traduction: Voies de traverse: Études sur le texte et ses transformations*, ed. Ginette Michaud, Association Canadienne de Traductologie, McGill University, 9, no. 2 (second semester 1998), 201;

Jean-Pierre Lefebvre, "Paul Celan traducteur des camps"; David N. Coury, "'Auch ruhiges Land . . .': Remembrance and Testimony in Paul Celan's *Nuit et Brouillard* Translation," *Prooftexts* 22, 2002, 55–76; Olkus, "Historische und filmische Analyse von Nuit et Brouillard von Alain Resnais," 78–86; Lauterwein, "'Les deux mondes,'" 724–36. The following pages are particularly indebted to this last work. Most of these authors worked with Cayrol and Celan's published texts, both of which contain slight variations from the commentary as used in the films. The extracts quoted here are from the commentaries transcribed during viewings of the French and West German versions. I ignore in this comparison the comments of the authors on the typographical disposition of Celan's text as published in his *Œuvres complètes* (Suhrkamp, 1983): although of great interest for understanding the translator's work and oeuvre marking the passage from prose to poetry, they do not directly relate to my arguments.

23. Nouss, "La traduction mélancolique," 213. I thank Janine Altounian for proofreading and improving my translations, as well as Claude Mouchard, who proofread this chapter and gave me his comments and valuable suggestions.

24. Lauterwein, "'Les deux mondes,'" 735.

25. Ibid., 727.

26. Ibid., 732. Cayrol wrote: "Close to the camp, the commander has his villa where his wife helps to maintain a household, sometimes a social life, like in any other garrison. Maybe she's just a little more bored: the war simply won't end." Celan translated: *"In unmittelbarer Nähe des Lagers ist die Villa des Kommandanten, die seine Frau zum trauten Heim zu gestalten weiß. Auch seinen gesellschaftlichen Verpflichtingen kommt man hier nach wie in irgendeiner Garnison. Nur daß die Zeit hier langsamer vergeht."* (Close to the camp stands the commander's villa, which his wife duly transforms into a comfortable home. Social obligations are also tended to, like in any garrison. Except that time passes more slowly here"). On the replacement of "war" with "time," see Lauterwein's analysis. Also on the list of omissions is the concise translation of Cayrol's sentence "Soup. Every spoon less is a day less to live," which Celan translates as: *"Jeder Löffel Suppe ist unschätzbar"* ("Every spoonful of soup is invaluable").

27. Lauterwein, "'Les deux mondes,'" 726.

28. Ibid., 735.

29. Nouss, "La traduction mélancolique," 224.

30. "The dark transports—their destination are the crematoria," Cayrol wrote: "Black transports that depart at night and of which no one will ever know a thing."

31. Roundups in Warsaw, expulsions from Lodz, from Prague, Brussels, Vienna, Athens, from Budapest, Rome. Roundup in the French countryside, manhunt in Paris. Deportation of resistance fighters. The mass of those arrested, those taken along, the companions, start walking the road to the camps. (—Trans.)

32. See Nouss, "La traduction mélancolique," 221. Zagreb was only replaced by Vienna at a later stage: on Celan's typescript, the German name of the Croatian city (Agram) was crossed out and replaced by a handwritten Vienna (see Heck and Gossens, "'Nacht und Nebel.' Ein Film wird übersetzt," 232). The city of Vienna is also mentioned in the Bremen Speech, as a destination of books and knowledge.

33. Which can also mean "exhausted."

34. Lauterwein, "'Les deux mondes,'" 731.

35. In this same sentence, as J.-P. Lefebvre notes, Celan removes the proposition "as if the plague of the concentration could be cured" ("Paul Celan traducteur des camps," 253). To Charles K. Krantz, Cayrol took his expression from the final pages of Camus's *The Pest*, which had greatly impressed him ("Alain Resnais Nuit et Brouillard: A Historical and Cultural Analysis," in *Literature, the Arts and the Holocaust* (Greenwood: Penkevill, 1987, quoted in Olkus, "Historische und filmische Analyse von Nuit et Brouillard von Alain Resnais," 82).

36. John Felstiner, *Paul Celan: Poet, Survivor, Jew* (New Haven: Yale University Press, 1995).

37. Nouss, "La traduction mélancolique," 218.

38. Name reduced to Belsen in Cayrol's text. Alexis Nouss analyzes another intervention by the translator in the order of words: "no day, no night, thirst, asphyxiation, madness" / *"kein Tag, keine Nacht, Hunger, Durst, Wahnsinn, Ersticken."* "Celan corrects the order of afflictions by reversing the last two words, establishing a succession in which asphyxiation forms the last stage, the end, as it did in the gas chambers, and also the end of the representable (the paragraph continues in Cayrol's text, but ends there for Celan)." "La traduction mélancolique," 216.

39. Friedrich Franz Bauer's photographs were published under the title "Die Wahrheit über Dachau" (The truth about Dachau) in *Münchner Illustrierte Presse* (July 16, 1933) and later in *Illustrierte Beobachter* (no. 49, December 3, 1936). See Ilsen About, "La photographie au service du système concentrationnaire national-socialiste (1933–1945)," in Chéroux, *Mémoire des camps*, 41.

40. The same images feature, as noted, at the end of the film *Nazi Concentration Camps*.

41. See chapter 11, note 9.

42. Lauterwein, "'Les deux mondes,'" 733.

43. Van der Knaap, "Enlightening Procedures," 56–57.

44. Cayrol: "Heavy industry is interested in this infinitely renewable manual labor"; Celan: *"Die Industrieplanung zeigt Interesse für dieses unerschöpfliche Arbeitskräftereservoir"* ("Industrial planning shows an interest in this inexhaustible source of manual labor").

45. Correspondence with the author, August 9, 2006.

46. In the steel industry, the first waves of dismantling and replacement of compromised management saw a notable change from 1946 onward, before making way for a process of reconcentration and restitution that began

in the mid-1950s. On this issue, see Philippe Mioche, "La reconstruction de la sidérurgie européenne 1945–1949: Sérénité des uns, nouveau départ pour les autres," in *Histoire, Économie et Société. Revue d'Histoire économique et sociale,* April–June 1999, no. 2, 397–412.

47. Gerhart Baumann, *Erinnerungen an Paul Celan,* 135, quoted in Lauterwein, "'Les deux mondes,'" 734. Lauterwein and Nouss also study the disappearance of the date 1945 from the text; in fact, it is present in the West German version of the film but was omitted from Celan's published text.

48. See chapter 7.

49. Lauterwein, "'Les deux mondes,'" 729.

50. Nouss, "Parole sans voix," 64, note 70.

51. See Lauterwein, "'Les deux mondes,'" 730.

52. Van der Knaap, "Enlightening Procedures," 56.

53. This space is modified further by effects of silence as a result of Celan's text being shorter than the original and the later start of sentences that lightly desynchronize text and images compared to the original. On this issue, see Harald Olkus's analysis, "Historische und filmische Analyse von Nuit et Brouillard von Alain Resnais," 87–100.

54. Rebus-Film handled commercial distribution of *Night and Fog* in West Berlin, Ring-Film in Munich, and Willy Karp in Düsseldorf (see *FilmDokument,* no. 71, January 28, 2005, Jörg Frieß and Jeanpaul Goergen, CineGraph Babelsberg / Berlin–Brandenburgisches Zentrum für Filmforschung).

55. For a detailed study of the film's reception in the FRG, see Martina Thiele, *Publizistische Kontroversen über den Holocaust im Film,* 183–206, and van der Knaap, "Enlightening Procedures," 60–81.

13. TRANSLATION BATTLES IN THE GDR

1. In occupied Germany, Defa (Deutsche Film Aktiengesellschaft) was the first film production and distribution company to obtain a license (awarded by the Russians). Between 1947 and 1953, its stock was in both German and Soviet hands. Under state control, Defa answered to the Ministry of Culture, which itself reported to the Socialist Unity Party. Cf. Bernard Eisenschitz, *Le Cinéma allemand,* 87–90.

2. Letter dated May 29, 1957, Institut Lumière.

3. See chapter 12.

4. Ibid. In a letter dated February 28, 1957, to the minister of culture, Veb-Defa repeats in more detail the same complaints (quoted in Jörg Frieß, "Das Blut ist geronnen," 51–52).

5. Letter dated November 13, 1957, to Mrs. Schlotter. Institut Lumière.

6. Ibid. In the absence of the German commentary, certain comments and references (which refer to specific passages) remain obscure.

7. See chapter 6, note 21.

8. The full passage was quoted in chapter 7.

9. Olga Wormser's diary, private archive.

10. See Herf, *Divided Memory*, and Sonia Combe's article "Mémoire collective et histoire officielle. Le passé nazi en RDA," *Esprit*, October 1987, 36–49. It should be remembered that the GDR, feeling that it had conclusively ended fascism through the establishment of a "socialist and democratic" system, believed that it had no obligation to pay reparations to victims of the Nazi regime. In spite of a few failed negotiations, the GDR never paid any reparations to Jews or to the state of Israel (which had requested it through several memos addressed to the occupying powers, in particular one dated March 12, 1951); cf. Dominique Trimbur "L'Attitude de la RDA face au problème de la réparation aux Juifs" in *Revue d'Allemagne* (Centre d'Études Germaniques, Strasbourg) 26, no. 4, October–December 1994, 591–607.

11. This instrumentalization of the past to demonize an adversary was high on the French communist party's agenda. An example is the film *Buchenwald* (1954), conceived by the Amicale Française des Déportés Résistants Patriotes et Familles de Disparus, which suggested that West Germany lacked the will to preserve the memory of the camps and that only the communists could be relied on to do this. See André-Pierre Colombat, *The Holocaust in French Film* (London: Scarecrow Press, 1993), 15.

12. At the time prime minister of the GDR; see Herf, *Divided Memory*, 177.

13. Correspondence with the author (December 10, 2003).

14. Dauman used the term betrayal in his letter to Film Polski dated March 6, 1958. Institut Lumière.

15. In her book *Le Retour des déportés*, reprinted in 1985, Olga Wormser-Migot devotes the entire epilogue to this event. After quoting the final sentences of a "desperately pessimistic" commentary, she notes: "Text written in 1954 [*sic*], even before the term Gulag became notorious worldwide and no longer the secret of a minority 'in the know'" (p. ii). It must be noted that it was the Kravchenko and Rousset affairs (1949–1950) that formed the start of the discussion on the concentration camps among the circle of ex-deportees.

16. Interview with Richard Raskin in *Nuit et Brouillard by Alain Resnais*, 57.

17. Film Polski did authorize Argos to "immediately contact" the GDR in order to create a version that respected the authors' moral rights (letter from Dauman to Film Polski, March 6, 1958. Institut Lumière).

18. Letter dated December 5, 1957. Institut Lumière.

19. Keisch may have also written the first version, but the Argos archives offer no evidence to verify this.

20. After being arrested by the Gestapo, he was wounded badly when jumping from the transport on which he was being deported.

21. Sozialistische Einheitspartei Deutschlands / Socialist Unity Party of Germany, the official name of the East German communist party.

22. Handwritten letter dated February 23, 1958. Institut Lumière.

23. In the same vein, Keisch lengthens the sentence "and even—yes—a prison" through this doubling effect: *"Im Gefängnis ein Gefängnis!"* (Inside

the jail, a jail!). Another example of extension of the text: Keisch translates "The dead are crossed out in red" as *"Die Namen der Toten werden mit Rotstift ausgetrichen"* (the names of the dead are crossed out with red crayon), where Celan, as we have seen, condensed Cayrol's words (*"Durchgestrichen heißt tot"*).

24. I am very grateful to Dominique Trimbur for her very efficient translation of texts and material necessary for this chapter.

25. She also pointed out a change and doubling of the sentence: "the air vents cannot muffle the screams," which was translated as: *"Die Luftschächte können den Blick nach draußen verwehren, sie können nicht die Schreie ersticken"* (The air vents may block the view, they cannot muffle the screams).

26. Burger, the German laborer, was this time replaced by *"Der Arbeiter in einer deutschen Stadt"* (The worker in a German city).

27. Letter dated February 26, 1958. Institut Lumière.

28. Version viewed at the Bundesarchiv-Filmarchiv. Keisch's text was published in *Film und Fernsehen*, 13, no. 8, 62–64. Aside from a few minor changes, the principal difference with the recorded commentary lies in the suppression of a dozen sentences that were probably cut during recording. This print was projected for the first time, alongside the West German version, at the Cinegraph Babelsberg, January 28, 2005, at the initiative of Jörg Frieß and Jeanpaul Goergen. For a first analysis of the discovery of this version, see Lindeperg, "Le cinéma à l'épreuve de l'histoire," unpublished dissertation, Université Paris III.

29. In this credit sequence, Eisler's name comes third, just after the title and the mention of the Grand Prix du Cinéma Français. Georges Delerue's orchestration, featured in the West German credits, is absent from the Defa version. The West German credits are more faithful, even though they do not mention the document sources and the names of certain assistants. Jörg Frieß and Jeanpaul Goergen reproduced both credit sequences in detail in *FilmDokument*, no. 71.

30. I thank Wolfgang Schmidt of the Bundesarchiv-Filmarchiv for this information. Raimund Schelcher worked with Defa and East German television on several films related to World War II. In 1957, he narrated the Defa documentary *Urlaub auf Sylt* (directed by Annelie and Andrew Thorndike), which fit snugly into Cold War politics and the battle for memory between the two Germanys. The film is a reconstruction, through photographs and archive footage, of the career of former SS Heinz Reinefarth in occupied Poland. After investigating his part in the destruction of the Warsaw ghetto, the film jumps forward to 1957 to discover the same Reinefarth, now a member of the CDU and mayor of the isle of Sylt. In the second half of the 1960s, Raimund Schelcher took part in several films on the Frankfurt trials: in 1965 he worked (alongside Erwin Geshonneck) on the film *Willst du dir ein schönes Leben zimmern*, produced by East German television; in 1966, he played a witness in the same trial in an adaptation of the Peter Weiss play *Die Ermittlung*, also produced by the DDF (directed by Lothar Bellag and

Ingrid Fausak). For more detail, see the website of the Fritz Bauer Institute (www.cine-holocaust.de).

31. Veb-Defa was most content with Schelcher's performance. A letter dated August 8, 1958, to the censorship board (Ministry of Culture), said that the narrator's voice fulfilled all its demands and that it could be "likened to a survivor of this terrible event" (quoted in Frieß, "Der Blut ist geronnen," 54).

32. Minutes of August 15, 1958 (Bundesarchiv-Filmarchiv), quoted in Frieß, ibid., 55.

33. Minutes of September 22, 1958 (ibid.).

34. Letter from the board (Ministry of Culture) dated November 22, 1958 (ibid.).

35. See van der Knaap, "Enlightening Procedures," 77, and Frieß, ibid., 56.

36. A letter from Dauman to Film Polski indicates that the producer had his revenge by rejecting the request for an extension of the rights to the film, acquired for five years by the GDR, but counted from the shipment of the reels in 1957 and not from the completion of the new version in 1959. "If Defa thought it correct to create at its own expense an alternative version, we are of the opinion that this possible betrayal of the authors' moral rights deserves no encouragement from us" (letter to Film Polski dated July 9, 1963, Institut Lumière). Film Polski at that date no longer held the screening rights, which the contract assigned it for a period of seven years (from 1956 to 1963). According to Jörg Frieß, *Night and Fog* was shown in 1966 as part of the international documentary week in Leipzig. After this date, the film print was deposited in the state archives (Frieß, "Der Blut ist geronnen," 56).

37. September 4, 1974, on the first channel, at 22:35. Rerun on September 5 at 11:20.

38. I have found no information on Eveline Matschke, aside from the fact—communicated by Matthias Steinle—that Matschke is featured as coauthor, with Rolf Liebmann and Friedrich Salow, of the book *Filmdokumentaristen der DDR* (Berlin: Henschel Verlag, 1969).

39. This Berlin-born actor worked with the Piscator collective in the early 1930s and is mentioned in the credits, alongside Eisler, of *Kuhle Wampe*. He became a member of the KPD (German communist party) in 1929, at the age of twenty-three. In 1933, he left for Warsaw with a Yiddish theater troupe on a tour that also took him to Prague and the USSR. Arrested in 1939, he was detained in concentration camps for six years, in Sachsenhausen, Dachau, and Neuengamme. In Dachau in 1943, he was one of the leading actors in two stage plays mounted by inmates. In 1963, he relied on his detainment experience to star in *Nackt unter Wölfen* (*Naked Among Wolves*, Frank Beyer), one of the most striking fiction films on the concentration camps produced in the GDR, an adaptation of Bruno Apitz's famed novel (DRA).

40. With the collaboration of Manfred Grabs, Eberhard Richter, K.-O. Kerner, and Eugen Schneider. The credits of the broadcast mention Alain

Resnais and Gistel Perrin as codirectors. Perrin was likely charged with elaborating this new version as well as the entire broadcast *Filme contra Faschismus* (accompanying materials mention a running time for *Night and Fog* of thirty-five minutes).

41. Deutsches Rundfunkarchiv, Potsdam, Babelsberg. I thank Jörg-Uwe Fischer for allowing me access to these archives.

42. "Even a calm landscape; even a field of ravens at harvest time; even a road with passing cars, farmers, and couples; even a holiday resort, with a fairground and a bell tower, can lead quite simply to a concentration camp."

43. Among the long list of cuts, a few more missing sentences are worthy of note: "The skeletons with their baby's stomachs went seven, eight times a night. The soup was diuretic"; "the transports lose their way, stop, restart, are bombed, and arrive at last"; "They make spoons, puppets they conceal, monsters, boxes"; "a few of these guinea pigs will survive, castrated, burnt with phosphor."

44. The sentence "they organize themselves politically" is extended and emphasized with the words: *"Und ist nicht mehr so wehrlos in dieser Hölle"* (and become less defenseless in this hell). The numerous cuts are sometimes compensated for with additions and precisions. The sentence "Close to the camp, the commander has his villa" becomes: *"Der Kommandant wohnte natürlich nicht im Lager; seine Villa steht etwas abseits, wo es grün und idyllisch ist"* (Naturally, the commander does not live within the camp; his villa stands at a distance, where all is green and idyllic).

45. In this same paragraph, Matschke adds to the list of those taken by surprise, taken by chance, taken by mistake, the category of "the denounced" (*"die Denunzierten"*). Matschke's commentary occasionally takes the form of a guided tour of Auschwitz: to evoke the *Revier* and the operating room, the author lists the numbers of the camp's blocks: "Das Haus Nr. 20"; "Das Haus Nr. 21."

46. Literally: "grow over his head."

47. The last part of the film starts with the image of Kramer and his acolytes. Here another alteration of the original text took place. Cayrol's phrase "When the Allies opened the gates ... all the gates" was translated as: *"Bis die Alliierten die Türen öffnen, und die bewachten Bewacher abgeführt werden"* (until the Allies open the doors and the guarded guards are taken away).

48. This sentence coincides with the photograph of Himmler's visit to the Monowitz construction site. Those in charge of the adaptation thought they recognized Krupp in these photographs, as a note in the margins of the shot sequence shows: *Himmler—Besuch mit anschließender Besichtigung neben Krupp* (Himmler—visit followed by an inspection alongside Krupp).

49. In the East German television listing (*FF Dabei*, no. 36, September 1, 1974, 22), the screening of Alain Resnais's film is announced as follows: "The tortures in the tiger cages of Vietnam and the crimes of the Chilean military junta do not permit us to forget the criminal acts that took place in the concentration camps of Hitler's Germany. We have seen many documents

on the twelve-year National Socialist reign. Among these testimonies, *Night and Fog* remains unforgettable thanks to its artistic direction."

14. A PORTABLE MEMORIAL

1. Erwin Leiser translated the film into Swedish.

2. The film's participation in the official competition was against regulations, since *Night and Fog* had already been screened at other festivals. Dauman, however, argued that the film had never been shown in competition and had therefore not had a chance to show its mettle internationally (letter from Dauman to the CNC, April 1, 1957. Institut Lumière).

3. Letter from the French ambassador Armand Bérard to the minister of foreign affairs, August 16, 1956. Institut Lumière.

4. The first certificate recorded by the CNC for distribution in Japan dates from 1972.

5. *Nihon no yoru to kiri.*

6. In a subtitled version.

7. Judith Petersen, "A Little-Known Classic: *Night and Fog* in Britain" in *Uncovering the Holocaust*, ed. van der Knaap, 106–28.

8. Judith Petersen studies the film's censorship file in "A Little-Known Classic."

9. Ibid.

10. Ibid.

11. This shortened British version, if it still exists, would merit a more detailed analysis. Since the scenes that caused objection are for the most part found in the final part of the film, one could imagine that the cuts made to the film would require a reworking of the subtitles and the musical score. The complete version was eventually released on video (see Petersen, "A Little-Known Classic," 11).

12. See in particular *Le Journal de Genève*, September 5, 1956.

13. *Le Monde*, September 5, 1956; *Libération*, September 13, 1956; *Le Journal de Genève*, September 5, 1956.

14. Letter to Dauman, April 28, 1956. Institut Lumière.

15. For the full details of the affair, see Jeffrey Herf's very comprehensive study *Divided Memory: The Nazi Past in the Two Germanys*.

16. At the end of the "trial," Adenauer's adviser was condemned to life imprisonment for crimes against humanity (see Herf, *Divided Memory*, 184).

17. Interview with Buache, broadcast France Culture. In his letter about the screening to Dauman, Freddy Buache admits that he was called a "crypto-communist," which, he added, did not bother him much since he was used to it.

18. Buache and Dauman's efforts were not in vain, however: after a new attempt, a deal for distribution in Switzerland was made in January 1961.

19. Letter from Dauman to Youtkevitch, February 27, 1963. Institut Lumière.

20. The Filmoteka Narodowa archives in Warsaw, where records of film releases in Polish theaters are kept, seem to confirm this point: there exists no record of a commercial release of *Night and Fog* in Poland in the years following the film's completion.

21. Letter from Édouard Muszka read in broadcast France Culture.

22. In a letter to Argos dated July 25, 1955, Henryk Matysiak (of Zbowid) "is very happy to hear of this noble idea to make a film about Hitler's crimes in Poland." Institut Lumière.

23. I thank Grzegorz Balski and Agata Zalewska of the Filmoteka Nardowa in Warsaw for allowing me access to the Polish version of *Night and Fog*, and Jean-Charles Szurek for lending me his linguistic abilities in comparing the French and Polish versions.

24. On the site's history, see Szurek, "Le camp-musée d'Auschwitz," and Wieviorka, *Auschwitz, 60 ans après*. On the Birkenau monument, see Young, *The Texture of Memory*.

25. Hélène Liogier, "Le cinéma français en Espagne. 1939–1975," doctoral dissertation, University of Grenoble II, 1998, 593. The author explains that in March 1968, *Night and Fog* was submitted for commercial distribution and rejected by the Spanish censor (544). Symptomatic of Spain's erratic censorship, the film was banned from screening at the third international documentary film festival in Bilbao in 1961, but nevertheless was shown shortly before, at a single screening for the very pro-Franco cine-club Madrid (344, 379). My thanks to the author.

26. As part of the Semaine des *Cahiers du cinéma*. The ban of *Night and Fog* fit into a set of measures that aimed to outlaw "any film making the slightest reference" to the Nazis and fascism. Also included in the original lineup selected by the *Cahiers* staff was Jean-Luc Godard's *Weekend* (1967), which was banned for "offenses to decency and morality." I thank Sylvie Pierre for supplying me with this information.

27. Letter dated December 26, 1956, Foreign Ministry archive, Christian Pineau staff, no. 36.

28. In line with article 3 of the September 17, 1956, decree on import of American films.

29. Letter dated December 29, 1956, addressed to Daniel Mayer (Assemblée Nationale). Institut Lumière.

30. Born in Ethiopia in 1918 of a Greek father and an Abyssinian mother, Nico Papatakis became known in France as the director of the famed Parisian cabaret La Rose Rouge in the St.-Germain-des-Prés quarter (whose best-known artists included Juliette Gréco and Les Frères Jacques). He earned himself a reputation as a fiendish and revolutionary artist by producing Jean Genet's short film *A Song of Love*, which was banned by the censors. In 1963 he caused another scandal, this time by directing *Les Abysses*, an adaptation of Genet's *The Maids* intended as an allegory of the insurrection of the Algerian people. In 1976 Papatakis directed *Gloria Mundi*, about torture in Algeria.

31. All the more so because its broadcast would allow sales to syndicated stations. Letter from Nico Papatakis to Anatole Dauman, April 26, 1960. Institut Lumière.

32. Yates had served in the marines during the Korean War and worked as producer and correspondent for NBC from 1952, covering numerous armed conflicts. He died in the line of duty, killed by a bullet in Jerusalem at the start of the Six-Day War in June 1967. In 1964, at the age of 36, he became notorious by producing the famed NBC documentary *It's a Mad War*, which criticized America's military involvement in Vietnam.

33. A second broadcast took place on the New York affiliate on July 24.

34. Until now, there appear to have been no studies of this curious document, discovered in 2003 by a retired gentleman from Florida and kept at the United States Holocaust Memorial Museum in Washington, D.C. It was the American researcher Stuart Liebman's curiosity and generosity that brought it to my attention.

35. During her two years of confinement in Auschwitz, this gynecologist was assigned to work under the sinister Dr. Mengele. In 1948, Gisela Perl published her memoirs entitled *I Was a Doctor in Auschwitz.* Starting from the 1970s, she would frequently testify before the cameras (notably in *The World at War*).

36. And two other British films also produced by the Ministry of Information: *London's Reply to Germany's False Claims* (1940) and *Christmas Under Fire* (1941). Around the same time he also appeared in a fiction film, *The Big Blockade,* produced at Ealing Studios. In 1947, Reynolds played himself in Mitchell Leisen's *Golden Earrings,* whose story is set in Nazi Germany, featuring Marlene Dietrich as a Gypsy with a heart of gold. Director Harry Watt, who worked with him during his British period, called Reynolds "the first star of documentary film." See Anthony Aldgate and Jeffrey Richards, *Britain Can Take It: The British Cinema in the Second World War* (Edinburgh: Edinburgh University Press, 1986, reprinted 1994), 120.

37. *Ulica Graniczna.* I thank S. Liebman for supplying the information.

38. Filmed in their homes with two fixed cameras, alternating medium shots and medium close-ups. It was impossible to determine whether Nocks's own crew recorded these interviews or whether, more likely, they formed existing material that was reused. As an indication, Gisela Perl lived in England at the time (information supplied by S. Liebman).

39. This is one of many examples of misuse and decontextualization of images, which was characteristic of audiovisual productions of the time, but which also allow us to retrospectively evaluate Alain Resnais's rigorous efforts at documentation.

40. *Night and Fog*'s evolution into an image archive began around the same time in West Germany. In March 1960, Brevis-Film, a production outfit based in Cologne preparing a documentary on the *Kristallnacht,* sought to negotiate the use of four sequences from *Night and Fog.* The request concerned archive footage (the Westerbork embarkation; a shot of a pile of

corpses) and color tracking shots (sequences outside the Auschwitz blocks and inside the Majdanek crematorium). However, this first effort at recycling stumbled when Brevis-Film judged Dauman's asking price to be exorbitant. Correspondence between Argos and Brevis-Film dated March 21, 1960, and April 4, 1960, Institut Lumière. On the reuse of shots from *Night and Fog*, see chapter 3.

41. The opening sentence translates Cayrol's words quite faithfully: "These shots were taken moments before an extermination."

42. Rudolf Höss, *Le Commandant d'Auschwitz parle* (Paris: La Découverte, 1995, reprinted 2005), 183.

43. My thanks to Pietsie Feenstra for helping me transcribe this part of the commentary.

44. Reynolds makes a first reference to Hungary when mentioning the tragic fate of the insurgents of the Warsaw ghetto, whose call for help fell on deaf ears: "Like the Hungarian freedom fighters, the world allowed the Jews of the Warsaw ghetto to perish. They all died bravely, alone and dignified."

45. Letter from Papatakis to Dauman, July 25, 1960. Institut Lumière.

46. Peter Novick, *L'Holocauste dans la vie américaine* (Paris: Gallimard, 2001), 119–20.

47. Ibid., 166.

48. As Peter Novick points out: "Although today we value the status of victim, in the 1940s and the 1950s it inspired a mixture of pity and contempt at best.... Rare were those who wanted to consider themselves victims, rarer still those who wished to be seen as such by others" (171). Jewish American organizations felt it more useful to celebrate the heroic uprising of the Warsaw ghetto, which gave a more valorous and edifying image of the Jewish community during World War II.

49. Annette Wieviorka, *L'Ère du témoin* (Paris: Plon, 1998).

50. Novick, *L'Holocauste dans la vie américaine*, 188–189.

51. Letter from Dauman to Papatakis, March 25, 1960. Institut Lumière. Dauman wrote in this context: "It seems impossible to me that in a city that counts six million Jews, we can't find a measly twenty thousand dollars for this unparalleled work of commemoration."

52. The situation in the United States differed radically from that in Europe: the survivors of Nazi persecution who moved to this country were primarily Jews who represented various associations or who joined existing Jewish organizations. The United States therefore has no equivalent to the Amicale de Mauthausen, the FNDIRP, or the Réseau du Souvenir.

53. Letter from Papatakis to Dauman, June 27, 1960. Institut Lumière.

54. Letter dated June 29, 1960.

55. This program initiated by Amos Vogel (head of Cinema 16) came about at the last minute when *Statues Also Die* could not be shown. During the summer of 1960 *Night and Fog* also featured on the marquee of the New York cinema to "counterbalance" *Triumph of the Will*—a curious coupling that perhaps allowed some American viewers to notice the quotes from Riefenstahl's work in Resnais's short film. Letter from Papatakis to Dauman,

April 26, 1960, Institut Lumière. See also Warren Lubline's study "The Trajectory of *Night and Fog* in the USA," in *Uncovering the Holocaust*, 149–64, which looks at the evolution of the reception of Resnais's film over several decades.

56. Letters dated December 8, 1960, and February 3, 1961.

57. Novick, *L'Holocauste dans la vie américaine*, 146.

58. This information comes from Nitzan Lebovic's study "An Absence with Traces: The Reception of *Nuit et Brouillard* in Israel," *Uncovering the Holocaust*, 86–105.

59. Ibid.

60. Ibid.

61. Ibid.

62. According to Levana Frank's study quoted in Lebovic, "An Absence with Traces," 101. The version of the film that was distributed in Israel at the start of the 1960s was the American edition. A new version dubbed into Hebrew (which remains to be studied) was made next, at an unknown date that may have coincided with the wider distribution of the film.

63. According to the transcripts of the trial hearings consulted in French and English at the CDJC. The nine witnesses chosen for the identification were Mrs. Salzberger and Mrs. Kagan, and Messrs. Hoch, Aviel, Melkman, Ben-Zvi, Bakon, Chen, and Aharon Hoter-Yishai.

64. As soon as Eichmann's arrest had been announced, the Israeli ambassador in the United States contacted Symon Gould, who served as intermediary with Argos. In a letter dated February 3, 1961, he urgently requested Dauman to contact the ambassador, who expressed a desire to screen the film "in conjunction with the Eichmann trial" (Institut Lumière).

65. This community was massacred in December 1941. At the time of the trial, Hausner did not know the name of the cameraman, as he indicated at the hearing.

66. Haim Gouri, *Face à la cage de verre. Le procès Eichmann, Jérusalem, 1961* (Paris: Éditions Tirésias, 1995), 142 (originally published as *La Cage de Verre*, Paris: Albin Michel, 1964).

67. Decision taken at the sixty-eighth hearing.

68. At the screening, Hausner announced that he would establish the "direct responsibility" of the accused in this affair. On the issue of the pyre, the prosecution remained evasive. Regarding Belsen, he replied that he did not attribute these facts to the accused and his subordinates: these images, filmed by the "liberators," did, however, show the atrocious state in which they discovered the camp.

69. The translation was done by Alexander Allan. It must be noted that in this first American version, the translator removed the sole occurrence of the word "Jew": "Stern, Jewish student from Amsterdam" became "Stern from Amsterdam."

70. Robert S. Bird in *New York Herald Tribune*, June 9, 1961.

71. It is surprising that this scene was retained in the compilation, since it was shot after the fact and therefore raised Servatius's objections.

72. The screening was only partially kept (see note 74). Leo Hurwitz worked for the privately owned American company Capital Cities Broadcasting Corporation (CCBC), to which the state of Israel had outsourced the video recording of the trial (the country did not yet have its own television network). A pioneer of independent documentary filmmaking and son of Jewish immigrants from Eastern Europe, Hurwitz was one of the main proponents of three successive groups of American documentarians, all situated in the extreme left wing of the political spectrum: The Workers Film and Photo League (1930–1935), Nykino (1935–1937), and Frontier Films (1936–1942). He notably showed his concern for racism against African-Americans, an issue to which he would devote his first postwar film *Strange Victory* (1948). I am deeply grateful to Annette Wieviorka for supplying me with DVDs of the screenings kept at the Steven Spielberg Jewish Film Archive in Jerusalem.

73. This compilation was made by Leo Hurwitz (according to his son Tom Hurwitz, interview with the author of October 4, 2006, in New York).

74. The contents of these reels correspond to: the images that appear at the June 8 screening filmed by Hurwitz in shot / countershot (but missing approximately twenty minutes corresponding to the middle section); the descriptions in the press; the listing of the contents of the reels by Hausner during the hearing, as well as later in his memoirs (Gideon Hausner, *Justice à Jérusalem: Eichmann devant ses juges* (Paris: Flammarion, 1966), 453–54.

75. *New York Times*, May 28, 1961. Gilbert was also called up to testify at the Eichmann trial.

76. Lawrence Douglas, "Film as Witness," in *Yale Law Journal*, quoted in Lindeperg, *Clio de 5 à 7*, 243. The author returned to and developed his pioneering study in *The Memory of Judgment: Making Law and History in the Trials of the Holocaust*, chapter 1, 11–37.

77. *New York Times*, June 9, 1961. In his memoirs, Gideon Hausner also mentions the confusion of the three judges "riveted to their seats": "They seemed to be in a stupor and for the first time since the start of the trial, you could tell that they had cried" (Hausner, *Justice à Jérusalem*, 454).

78. Gouri, *Face à la cage de verre*, 143–44.

79. Comolli, "Fatal Rendezvous."

80. Hausner's explanations demonstrated a growing knowledge of images of the deportation and the camps. Yet, he declared, probably confused by the editing, that the sequence of the bowl of soup (shot by the British in Belsen) dated from the Nazi period.

81. Gouri, *Face à la cage de verre*, 143.

82. Perhaps this was the meticulous task to which he devoted himself for a moment during the screening, interrupting his impassive pose to take notes during a reel change.

83. As well as the Russian footage of the liberation of Auschwitz (this seems to be one of the versions of *Chronicle of the Liberation of Auschwitz*), those from Westerbork and from Liepaja.

84. Contrary to the screening of June 8, the protagonist also neglected to wear a necktie. Asked about this recording, cameraman Emil Knebel (a member of the film crew) remembers getting called up one evening to film, "separate of the hearings," this screening at which Eichmann was dressed differently from the other days. Assistant producer Alan Rosenthal states that Eichmann—because of his informal dress—had been annoyed by the presence of the camera (Stewart Tryster interviewed Knebel at my request, for which I thank him; Rosenthal's words are from his appearance at the "Antisemitism & Prejudice in the Contemporary Media" symposium, organized on February 18–20, 2003, by the Vidal Sassoon International Center for the Study of Antisemitism).

The only dissonant is the following phrase by Haim Gouri in the conclusion of his report of the seventieth hearing: "I learned that he was disgruntled today. Knowing that it would be a hearing behind closed doors, Eichmann came dressed in a sweater and without a necktie. After the hearing, he reproached his jailers for not warning him that there would be reporters at the screening; he would have worn, he said, his normal dark outfit" (*Face à la cage de verre*, 144).

Was Haim Gouri present at the preview screening and did he confuse the two sessions? I have not been able to solve this mystery.

85. As far as one can judge at the basis of the recording, the June 8, 1961, screening behind closed doors used a different lighting scheme.

86. Four cameras had been installed in the courtroom, hidden behind screens so as not to interrupt the proceedings. Hurwitz directed the cameramen from the control room (located in a different building on the same street and connected to the courtroom by cable), where he controlled the images on four monitor screens and gave instructions on framing and angles. The filmmaker chose which of the four cameras' images would be recorded, effectively editing while recording (see on this topic, Jeffrey Shandler, *While America Watches: Televising the Holocaust* [New York, Oxford: Oxford University Press, 1999], 81–132; Rony Brauman, Eyal Sivan, *Éloge de la désobéissance. À propos d'un spécialiste Adolf Eichmann* [Paris: Éditions Le Pommier-Fayard, 1999], 35–47; Alan Rosenthal, Jerusalem, *Take One! Memoirs of a Jewish Filmmaker* [Carbondale: Southern Illinois University Press, 2000], 65–87; Sylvie Lindeperg and Annette Wieviorka, "Les deux scènes du procès Eichmann," *Annales, Histoire, Sciences, Sociales*, November–December 2008, no. 6, 1249–74).

87. On several occasions Jurwitz shoots the screen itself from a sideways angle, which has a decentering effect on the spectator and incorporates the projection beam into the image.

88. Most of Hurwitz's shots of Eichmann last between five and twenty seconds, and those of the screen between eight and twenty seconds. Longer shots take between thirty and forty seconds. I was greatly aided in my analysis of this recording by tools developed by the staff of the IRI (Institut de Recherche et d'Innovation du Centre Pompidou). I thank Bernard Stiegler and Xavier Sirven in particular.

89. In 2008, after the French publication of the current volume, Chris Marker asked to view this recording. A few weeks later, I received from André Heinrich a copy of the film *Henchman Glance*, in which Marker made two interventions: he reinstated the original soundtrack into the silent footage, and whenever a scene from *Night and Fog* was shown full screen, he substituted it with the original footage, particularly the color sequences, which served to emphasize the poetic power of the original short film. This operation also allowed Marker to stealthily reinsert the two versions of the famous photograph of the gendarme: the censored version that obscured the guard's kepi as filmed by Hurwitz and the original version restored by Resnais in 1997 for the VHS and DVD releases. Sound-wise, *Henchman Glance* could therefore be regarded as a new version of *Night and Fog*, with the executioner's gaze integrated under the eye of two filmmakers: Marker watching Hurwitz filming the work of Resnais.

15. SHIFTING PERSPECTIVES

1. Serge Daney, "Le Travelling de *Kapo*," *Trafic*, no. 4, Autumn 1992.

2. Letters from Paul Arrighi to Resnais and Cayrol, dated January 4, 1956. Réseau du Souvenir (AN 72AJ2160).

3. Association Nationale des Familles de Résistants et d'Otages Morts pour la France; ADIF; UNADI ; Amicale Nationale des Prisonniers Politiques du Camp de Flossenbürg; Amicale d'Auschwitz, etc.

4. Litigation concerning distribution for noncommercial screenings. Institut Lumière.

5. It was shown alongside two other shorts: André Michel's *La Rose et le Réséda* (which was often paired with *Night and Fog*) and Alain Resnais's *Guernica*.

6. Réseau du Souvenir archives (AN 72AJ2157).

7. Text by Martin-Chauffier, "Journée de souvenir 1959," Réseau du Souvenir (AN 72AJ2160).

8. Speech in Rennes (AN 72AJ2157).

9. Statement by Marc Zamanski at the Réseau's board meeting of February 29, 1964 (AN 72AJ2147).

10. Statement by Father Riquet, board meeting of February 15, 1958, ibid.

11. Two contracts were signed, one at the stage of financing (June 27, 1955), the other after the film was finished (January 24, 1956). CNDP archives. I thank Jacques Beaujean for allowing me access.

12. Sunday, April 24, 1960 (RTF, 22:55), film introduced by Raymond Triboulet; Sunday, April 30, 1961 (RTF, 22:15, following *Mr. Orchid*). On Sunday, April 26, 1964, the channel broadcast Jean Cayrol's short film *On vous parle*. In 1967, it was the controversial *Kapo*'s turn (April 30, 1967, 20:44), and in 1969 George Stevens's *The Diary of Anne Frank* (April 27, 1969, as part of *Dossiers de l'écran*). *Night and Fog* was shown on FR3 on Sunday, April 27, 1975 (at 20:00), and Sunday, April 29, 1979 (at 21:35). Data from the Inathèque de France. I thank Christine Barbier-Bouvet and Jean-Michel Briard for their help.

13. Even Minister Edmond Michelet found the time to introduce *Night and Fog*, at the request of the priest of St. Francis of Assisi church in April 1958. Father Pézeril screened the film at Lent to meditate on the "Christian sense of mercy" and to mobilize an ever-diminishing parish (archives of the Centre d'Études Edmond Michelet, letters from the priest of St. Francis of Assisi church, Paris XIXe, February 7, 1958, and April 15, 1958).

14. Article published in the "Bulletin d'études et d'information" of publishing house Hachette, no. 3, 1963–1964, entitled *"Hitler connais pas:* Si les jeunes ignorent ce que furent la Résistance, la Déportation, la Libération, à qui la faute?" (Whose fault is it if the youth do not know the meaning of the resistance, the deportation, and the liberation?), CHDGM archive (AN 72AJ310).

15. Henri Michel, "Rapport sur l'enseignement de la Résistance et de la Déportation," February 1962, ibid.

16. Foreign Ministry archives, cultural relations section, subsection director general's staff, no. 27.

17. Among young viewers the warning sign sometimes functioned more in the vein originally desired by the film's creators. In November 1972, Henri Michel received a report from a teacher at the École de Guerre in Brussels who screened the film to his pupils and asked them to write down their reactions. A third of the youths referred to current affairs and engaged the question of responsibility in Vietnam, Biafra, and even Belgian Congo, where paratroopers had "distinguished" themselves in the use of torture. CHDGM archive (AN 72AJ310).

18. Article 4 of the contract of January 24, 1956, authorized the Ministry of Education, if it deemed it necessary to do so, to "adapt the film into a shorter version for educational purposes." The production companies would "bear the expense of editing and dubbing" this shortened version. It was agreed that this "educational film" would "belong entirely to the State" (CNDP archive).

19. Lalieu, "L'invention du devoir de mémoire."

20. Letter from A. Dauman to Christine Ragoucy, November 9, 1987, CNDP archive.

21. *Téléscope*, no. 10, May 7, 1992, special issue: "Le CNDP sur FR3: *Nuit et Brouillard*, pas de non-lieu pour la mémoire."

22. CNDP archive.

23. Quoted in Claudine Drame, "Les représentations du génocide et des crimes de masse nazis dans le cinéma en France 1945–1962: Contribution à l'étude de la formation d'une mémoire," postgraduate thesis (supervisor: Pierre Nora), École des Hautes Études en Sciences Sociales (EHESS), 1992, 51.

24. Contracts of May 21, 1992, and August 24, 1992, CNDP archive.

25. TF1, 13:00 news, March 4, 1988. Antenne 2, news of May 11, 1992 (12:00, 14:00, and 20:00).

26. From the 1980s onward, some TV news reports dedicated to Holocaust denial employed images of the liberation of the western concentration camps (some of which were also used in *Night and Fog*) as proof against the deniers' allegations. See on this topic Sylvie Lindeperg, "Scénarisation du

négationnisme par la télévision française: Les temps et logiques d'un média," in *French Television, French Cultural Studies*, ed. Lucy Mazdon, October 2002, 259–80.

27. Darquier stated in *L'Express* that "only the lice were gassed" in Auschwitz. *Aujourd'hui Madame*, Antenne 2, November 17, 1978, 14:04.

28. TF1, May 16, 1987 (22:09). Dauman allowed the film to be screened for free (letter from Dauman to Christine Ragoucy, November 9, 1987, CNDP archive). Since the FR3 broadcast of 1992, *Night and Fog* was shown on FR3 on May 9, 1997 (00:32, in the "complete version," see above) and on January 10, 2001 (00:16), as well as on FR2 on January 14, 2005 (23:49), and on Arte on October 24, 2006 (00:35). Inathèque de France.

Politicians did not sit still either: On June 5, 1987, the city of Montpellier organized a screening of *Night and Fog* for 1,800 high school students and primary school pupils aged nine and over. Georges Frêche, the city's socialist deputy mayor and initiator of the screening, declared on the occasion: "One is never too young to discover dignity and honor" (in *Midi Libre*, June 6, 1987, quoted in Claudine Drame, "Les représentation du génocide et des crimes de masse nazis dans le cinéma," 52).

29. In an article on *Night and Fog* in *Demain* (May 31, 1956), a still from the film was captioned: "You do not have the right to avert your eyes," a reference to a film on the Spanish civil war in which the narrator pronounces the same words over an image of a nurse tending to an atrocious wound. The slogan was used again in English and American newsreels on the liberation of the camps.

30. At 00:02 on TF1; 23:15 on A2; 00:32 on FR3.

31. Documentary series shot at Garcia Lorca junior high school in Saint Denis (I thank Michèle Lagny for pointing it out to me).

32. On these issues, see in particular: *L'Holocauste dans les programmes scolaires: Un point de vue européen* (Éditions du Conseil d'Europe, 1999); Jean-François Forges, *Éduquer contre Auschwitz: Histoire et mémoire* (Paris: ESF, 1997); "Sur la pédagogie de la Shoah," *Le Débat*, no. 96, September–October 1997; *Entre mémoire et savoir: L'enseignement de la Shoah et des guerres de décolonisation*, research report, Académie de Versailles, INRP, 2000–2003. On educational uses of *Night and Fog*, see in particular the article by Michel Montagne published in *Télescope*, no. 10, May 7, 1992, and the file compiled by René Vieu, "Aborder *Nuit et Brouillard* en classe" (online on the CNDP website: http://www.cndp.fr).

33. *Frankfurter Allgemeine Zeitung*, July 5, 1956; *Welt der Arbeit*, April 5, 1957; *Vorwärts*, March 15, 1957.

34. Jörg Frieß reports that on this occasion, fifty new prints were made by the Bundeszentrale für Heimatsdienst (equivalent of the CNDP), "Das Blut ist geronnen," 47, no. 38.

35. The first screening took place on April 18, 1957, on Bavarian television. Regarding this German broadcast, Alfred Gosser mentions "the shock pro-

duced by the television screening, on Easter Sunday morning, of Alain Resnais's overwhelming evocation," in *Le Crime et la mémoire* (Paris: Flammarion, 1989), 120. A letter to Christian Pineau from the French consul in Munich, Robert de Nerciat (April 23, 1957), details the reactions to this broadcast: "The Munich press took note of the screening of *Night and Fog* on Bavarian television the Thursday of Holy Week, and their opinions were far from favorable. In fact, a paper such as the *Süddeutsche Zeitung* reprinted the statement broadcast by the news program of the Land's radio and television services, which said that after watching the film, one may pose the question of who is to blame for the horrible events portrayed in *Night and Fog*. That it would refer to this controversy fits into the *Süddeutsche Zeitung*'s current tendency of general hostility toward the former Allies and Chancellor Adenauer's politics toward the West" (Foreign Ministry, section Europe 1944–1969, subsection Cultural issues, box 1219).

36. Press compendium of the Institut Lumière. Entitled "'Nacht und Nebel', nicht für Schulen," the article from the *Süddeutsche Zeitung* is entirely devoted to this issue.

37. In mid-November 1956, the film was passed for viewers aged sixteen and over. It was furthermore graced with the *"Prädikat besonders wertvoll,"* a seal that marks out a work of special value.

38. See Knoch, *Die Tat als Bild*, 523.

39. Ibid., 523–24; Thiele, *Publizistische Kontroversen über den Holocaust im Film*, 198–99.

40. Lauterwein, *Essai sur la mémoire de la Shoah en Allemagne fédérale*, 88.

41. Report quoted in Dudek, *Zur Pädagogischen Verarbeitung des Nazionalsocialismus*, quoted in Lauterwein, ibid., 73.

42. Ibid., 74.

43. Michael Schneider, *Den Kopf verkehrt aufgesetzt oder die melancholische Linke* (Darmstadt: Luchterhand, 1981), quoted in Gaudard, *Le Fardeau de la mémoire*, 99.

44. Often this questioning happened earlier. Interviewed for *Cinq colonnes à la une*, Paul Schallück (see chapter 11), who often screened *Night and Fog* to German students, mentions one occasion at which a young man stood up and said: "We can never believe the older generation again, because they concealed what happened." "Impressed by this passionate comment," an "older gentleman stood up" to declare: "Yes, you are right: I feel guilty." Paul Schallück added that he himself was never a member of the Nazi party but that he did something even worse, since he was "indifferent." (*Cinq colonnes à la une*, program broadcast on July 1, 1960, as part of a report entitled "Twenty Years Later: The Germans"), Inathèque de France.

45. Régine Robin, *Berlin chantiers*, 71–72.

46. Broadcast France Culture.

47. Quoted in Gaudard, *Le Fardeau de la mémoire*, 152.

48. Which is present in neither the original French version nor the first West German prints.

49. Successor to the Bundeszentrale für Heimatsdienst. Between 1996 and 2000, the Center distributed 1,500 copies of *Night and Fog* on video for educational use (van der Knaap, "Enlightening Procedures," 78).

50. This list can be consulted on the website of the Bundeszentrale für politische Bildung (http://www.bpb.de). I thank Matthias Steinle for pointing this out to me.

16. CONSTRUCTING THE CINEPHILIC GAZE

1. This program started on May 22, 1956, continued for six months and made over eight million francs (letter from A. Dauman to M. Enoch, November 26, 1957), Institut Lumière.

2. "One can only admire *Night and Fog* without reservations," wrote André Bazin in *Radio-Cinéma-Télévision*, February 9, 1956.

3. *L'Humanité*, February 1, 1956.

4. *Le Parisien*, May 24, 1956.

5. *La Croix*, May 27, 1956.

6. *Arts*, February 22, 1956.

7. *Positif*, no. 16, May 1956.

8. *Arts*, April 12, 1956.

9. *Cahiers du cinéma*, no. 59, May 1956.

10. *France Observateur*, May 24, 1956.

11. *Positif*, no. 16, May 1956.

12. *Cahiers du cinéma*, no. 56, February 1956.

13. Who began working for *Cahiers du cinéma* as a film critic in 1956, at the age of nineteen.

14. Fuller edited and commented on the footage he shot as a soldier into the two versions of Emil Weiss's film *Falkenau, vision de l'impossible—Samuel Fuller témoigne* (1988) and *Falkenau, Samuel Fuller témoigne* (2004). In his 1958 film *Verboten!*, Fuller inserted the images from the camps into the heart of the fictional story, reenacting the hearing at the Nuremberg trial of November 29, 1945, at which *Nazi Concentration Camps* was screened (on the topic of *Verboten!*, see Lindeperg, *Clio de 5 à 7*, 258–60). In *The Big Red One* (1980), Samuel Fuller returns to his experience as a soldier and devotes a lengthy sequence to the arrival at Falkenau.

15. Luc Moullet, "Sam Fuller sur les brisées de Marlowe," in *Cahiers du cinéma*, no. 93, March 1959.

16. Antoine de Baecque, *La Cinéphilie: Invention d'un regard, histoire d'une culture, 1944–1968* (Paris: Fayard, 2003), 201.

17. *Cahiers du cinéma*, no. 97, July 1959.

18. De Baecque, *La Cinéphilie*, 206.

19. Directed by Felix von Podmanitzky, 1958. Released in France as *Le procès de Nuremberg* in April 1959.

20. The scene takes place during the airport sequences: Charlotte enters the Publicis Orly cinema, under the watchful eye of an Alfred Hitchcock poster. The curtain opens and the screen shows the start of Resnais's first

vertical tracking shot. While Cayrol's long first sentence continues, the camera returns to Charlotte and her lover, sitting in the back of the theater. When the camera goes back to the screen, Godard employs a brief "reedit" of *Night and Fog*: as Cayrol's first sentence, which originally accompanied the first tracking shots, continues and ends, he inserts the last part of the shot of the *kapo*'s room, followed by the photograph of the commander's villa, thereby displacing both shots and desynchronizing them from the text.

21. *Cahiers du cinéma*, no. 120, June 1961.

22. Jean-Michel Frodon, text of a lecture given at New York University, October 7, 2002. I thank the author for supplying this text and for enriching this chapter through his attentive proofreading.

23. Serge Daney, *Persévérance. Entretien avec Serge Toubiana* (Paris: POL Éditeur, 1994), 54.

24. Ibid., 53.

25. Daney, *"Le Travelling de Kapo."*

26. Daney is in fact quoting Schefer's words from *L'Homme ordinaire du cinéma* (Paris: Éditions Gallimard / *Cahiers du cinéma*, 1980).

27. *Trafic*, no. 4, 1992.

28. On George Stevens, see *D-Day to Berlin–1944* (1945/1985) and the two versions of the Emil Weiss film. Laurent Le Forestier analyzes these films in "Fuller à Falkenau: L'impossible vision?" in *1895*, magazine of the AFRHC, no. 47, December 2005, 184–93.

29. *Trafic*, no. 4, 1992.

30. J.-M. Frodon lecture.

31. Daney, *Persévérance*, 53.

32. Daney, "Le Travelling de *Kapo.*"

33. Élisabeth Gille, *Le Mirador* (Paris: Stock, 2000), 313.

34. Words of H. Ostrowiecki, in *La Marche du siècle*: "Il y a cinquante ans, la rafle du Vél' d'Hiv,'" FR3, June 10, 1992 (quoted in Drame, "Les représentations du génocide et des crimes de masse nazis," 49).

35. See also author and literary critic Serge Koster's writing on *Night and Fog (Trou de mémoire)* (Paris: Éditions Critérion, 1991), quoted in Lowy, *L'Histoire infilmable*, 138.

36. François Maspero, *Les Abeilles et la guêpe* (Paris: Seuil, 2002), 29.

37. A generation whose words were, according to Maspero, doubly confiscated. Ibid., 30–31.

38. Claude Lanzmann in *Au sujet de Shoah*, ed. Deguy, 10.

39. Ibid., 10.

40. Daney, "Le Travelling de *Kapo,*" on the "retro cinema" of the 1970s, 11.

41. Michel Deguy, "Une oeuvre après Auschwitz," in *Au sujet de Shoah*, 30.

42. Ibid., 41.

43. De Certeau, *L'Écriture de l'histoire*, 7, quoted in Wieviorka, *Auschwitz, 60 ans après*, 20.

44. Annette Wieviorka, "Histoire, éthique et Seconde Guerre mondiale," in *Science et éthique*, Centre d'Études Edmond Michelet, Brive, 2003, 34.

45. Ibid.

46. Yosef Hayim Yerushalmi, *Zakhor: Histoire juive et mémoire juive* (Paris: La Découverte, 1984), 60.

47. Ibid.

EPILOGUE

1. Olga Wormser-Migot's memoirs, private archive. Unless otherwise stated, the documents quoted below are culled from the same archive. On Olga's role as a "messenger" in the meeting of Resnais and Duras, see Adler, *Marguerite Duras*, 339.

2. In her memoirs, Olga confesses that, at the time of Kravchenko's lawsuit against *Les Lettres françaises* and the trial of David Rousset, she became suspicious of the motivations of the author of *L'Univers concentrationnaire* and his investigative committee—in spite of Jacques Monod's warnings.

3. *Le Monde,* July 12, 1956, 8.

4. Letter from H. Michel to A. Dauman, May 31, 1960. Institut Lumière.

5. Dauman to Michel, letter dated June 9, 1960; Michel to Dauman, letter dated June 16, 1960. Institut Lumière.

6. Letter dated January 25, 1960. Institut Lumière.

7. Letter from Alain Resnais, January 25, 1960, and February 27, 1960, to Lifchitz. Institut Lumière.

8. Cayrol archive, IMEC. Letter dated April 5, 1960 to M. Valley, Amicale des déportés de Mauthausen.

9. Minutes of general meeting of February 4, 1956, Réseau du Souvenir archive (AN 72AJ2147).

10. Letter dated July 12, 1960. Institut Lumière.

11. Letter of July 12, 1960: "Agent P2 of Forces Françaises Combattantes," "Member of the Union National des Évadés de Guerre, Croix de Guerre, Croix de Combattant Volontaire de la Résistance."

12. Letters from Gilbert Dreyfus (July 26, 1960), M-E Nordmann-Cohen (August 6, 1960), and the CNC (August 17, 1960).Institut Lumière.

13. Also bogged down was the project of a soundtrack album of Hanns Eisler's music—proof that each component of *Night and Fog,* by its very quality, solicited great interest.

14. In the words of Dauman in a letter to Cayrol, August 19, 1960, IMEC.

15. Notably with regard to the Mouvement de la Paix and the meetings through her brother-in-law Pignon. She was the person who contacted and chose the painters and sculptors for the exhibit in Rennes.

16. Minutes of general meeting, April 3, 1965, Réseau du Souvenir archive (AN 72AJ2147).

17. According to custom, the main thesis was printed in 1968 at PUF (*Le Système concentrationnaire nazi*); the complementary thesis was duplicated.

18. Literally: dissertation = crap! (—Trans.)

19. *Le Monde,* August 30, 1973.

20. Letter dated February 9, 1970, private archive of Olga Wormser.

21. *L'Hitlérisme et le système concentrationnaire* (Paris: PUF, 1967).

22. *Le système concentrationnaire,* 10.

23. Ibid., 11.

24. Ibid., 12.

25. Ibid., 541.

26. A provisional gas chamber, which could kill 150 to 180 people at a time, was installed at Ravensbrück early in the year 1945. The most likely date of its first operation is February 8. The number of women killed, mostly aged or sick, could be around 4,000, half of whom were Jewish. See Bernhard Strebel, *Ravensbrück: Un complexe concentrationnaire,* foreword by G. Tillion (Paris: Fayard, 2005).

27. "Olga Wormser-Migot, une historienne de la déportation," *Le Monde,* August 8, 2002. François Delpech provided a similar analysis in *Historiens et géographes* (no. 273, May–June 1979).

28. *Le système concentrationnaire,* 12–13.

29. Ibid., 28.

30. In her article in *Revue de l'Histoire de la Deuxième Guerre Mondiale* (no. 15–16), Germaine Tillion points out with subtlety and finesse several errors in testimonies that overstated the number of deportees in transports from Paris to Ravensbrück: "This sum is not the product of the imagination, but of a contamination of images. Everything happens as if memory, like a camera, took snapshots and superimposed these, projected them all at once on the screen of memory" (34).

31. *Bulletin intérieur de l'amicale des déportés et familles de Mauthausen,* no. 146, September 1969, 2.

32. Letter dated June 9, 1969.

33. Letter dated June 10, 1969.

34. Association Nationale des Anciennes Déportées et Internées de la Résistance.

35. *Voix et Visages,* bimonthly newsletter of the ADIR, January–February 1969, no. 117. I thank the ADIR for supplying me with issues of the newsletter.

36. This excerpt from *Ravensbrück* was published as a preview in *Voix et Visages,* no. 135, November–December 1972.

37. Addition published and commented in *Le Bulletin de l'Amicale de Mauthausen,* no. 169, December 1973, and in *Voix et Visages,* no. 141, January–February 1974.

38. *Voix et Visages,* no. 141, January-February 1974.

39. Nadine Fresco notes that letter-headed paper forms his "guilty pleasure," Fresco, "Les redresseurs de mort," in *Les Temps modernes,* no. 407, June 1980.

40. Valérie Igounet, *Histoire du négationnisme en France* (Paris: Seuil, 2000), 211–12. The letter ended with the following words: "Could I be so bold as to ask for your personal opinion on a particularly delicate point in contemporary history: do you feel that the Nazi gas chambers are a myth or a reality?"

41. Preceded a few days earlier by an article in the daily *Le Matin* (November 16, 1978) that printed several excerpts from an interview with Faurisson; see Igounet, *Histoire du négationnisme en France*, 222.

42. On the use of this quote, see Fresco, "Les redresseurs de mort." The quote from Olga Wormser-Migot is referenced in a note as a scientific guarantee; the second quote is not, since it is taken from a pamphlet on Holocaust denial by Thies Christopherson, founder of a neo-Nazi publication.

43. September 24, 1974, at Olga Wormser-Migot's residence.

44. On August 6, 1977, the day *Le Monde* refused to publish Faurisson's article, Pierre Viansson-Ponté informs him of the need for a scientific opinion from Germain Tillion or Olga Wormser-Migot: "Without such a guarantee from either of these recognized and conscientious specialists, whom I trust entirely, I shall consider you a falsifier and a dangerous maniac."

45. Copy of Olga Wormser-Migot's letter to R. Faurisson, November 7, 1977.

46. Letter of November 7, 1977.

47. *Le Monde,* November 18, 1978.

48. *Le Monde,* December 7, 1978.

49. Letter dated November 20, 1978, from Marie-Elisa Nordmann-Cohen to the editor-in-chief of *Le Monde.*

50. *Le Monde* of December 29, 1978, for the texts by Faurisson and Wellers; of December 30, 1978, for that by Olga Wormser-Migot, published across a full page.

51. Jean Pihan, November 21, 1978. Olga Wormser-Migot's private archive.

52. Shot 138 (corresponding to the text "a fleeting orphanage, constantly renewed").

53. Vercors, Olga Wormser-Migot, *Assez Mentir!* (Paris: Ramsay, 1979), 110, 127 for *Night and Fog.*

54. Copy of her letter of November 20, 1978, to the editor-in-chief of *Le Monde.*

55. Germaine Tillion, *Ravensbrück* (Paris: Seuil, 1988), 17.

56. A shortcut by which she means the photograph of the arrest of children from the Lodz ghetto (shot 38).

INDEX

SYLVIE LINDEPERG, member of the Institut Universitaire de France, is professor of history at the University of Paris 1 Panthéon-Sorbonne, where she runs the Center of Studies and Research in the History and Aesthetics of Cinema (CERHEC). She is the author of several books in French. *"Night and Fog": A Film in History* won the French Prix de la Critique Cinématographique and the Italian Limina Prize and was translated into German.

JEAN-MICHEL FRODON is a professorial fellow in film studies and creative industries at the University of St. Andrews, Scotland. He is the author of several books and writes regularly for slate.fr.

TOM MES is a translator and film critic. He is the cotranslator of *Cinema and the Shoah* and the author or coauthor of *Agitator: The Cinema of Takashi Miike*; *Iron Man: The Cinema of Shinya Tsukamoto*; *Re-Agitator: A Decade of Writing on Takashi Miike*; *The Midnight Eye Guide to New Japanese Film*; and *Tokyolife: Art and Design*.